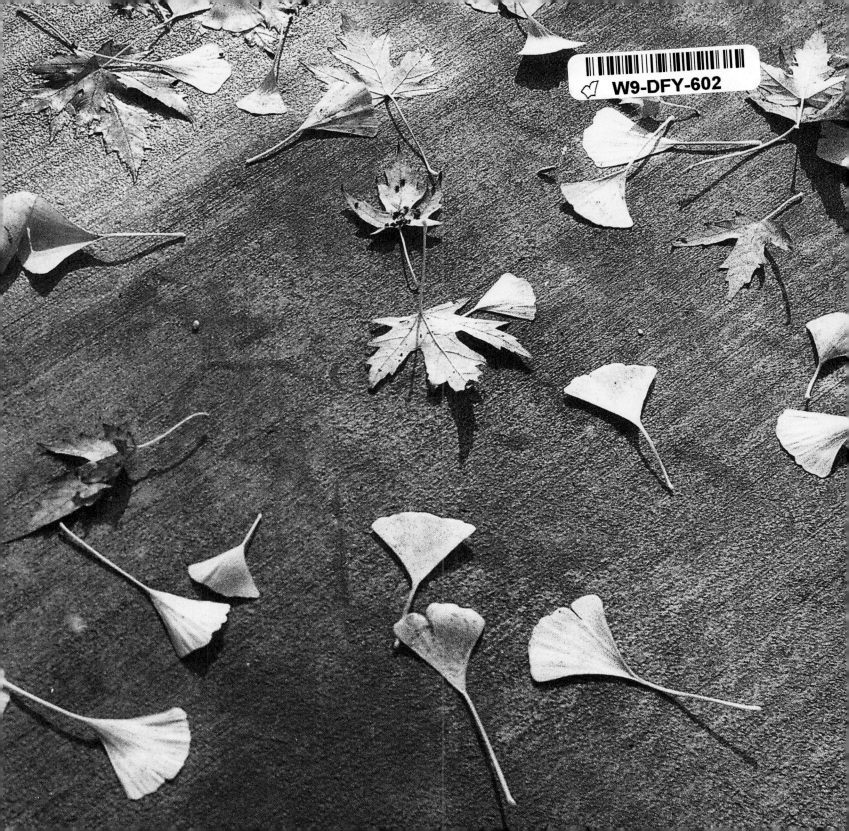

"SHE WAS A HUMANIST IN THE BEST TRADITION. SHE SHOWED REAL LIFE, AND THAT'S SO DIFFICULT TO DO."

—PHOTOGRAPHER MARY ELLEN MARK

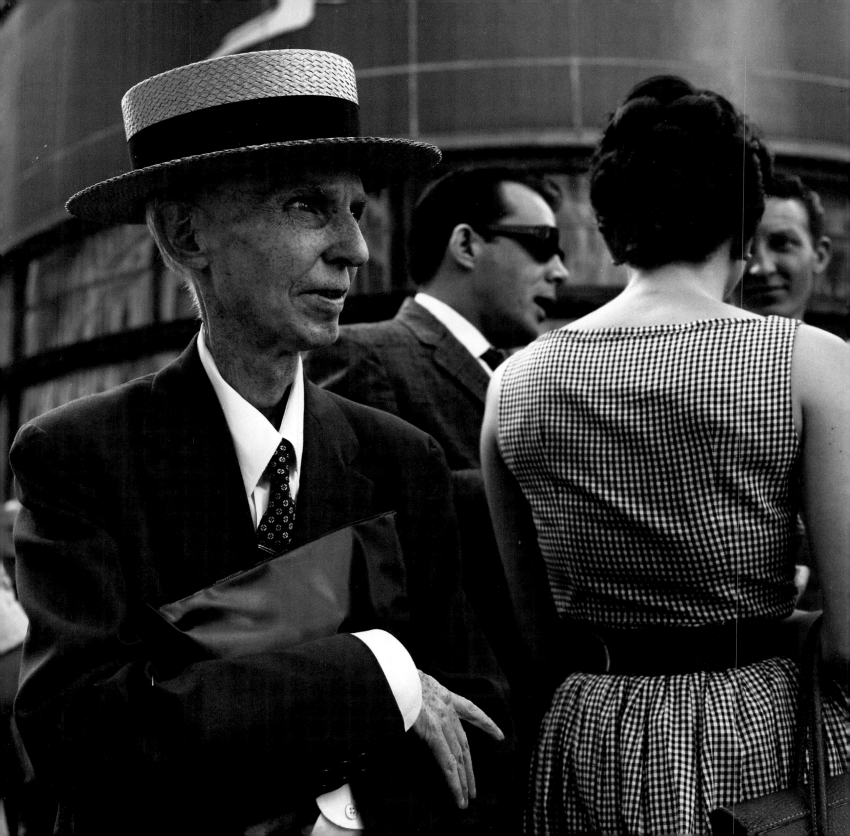

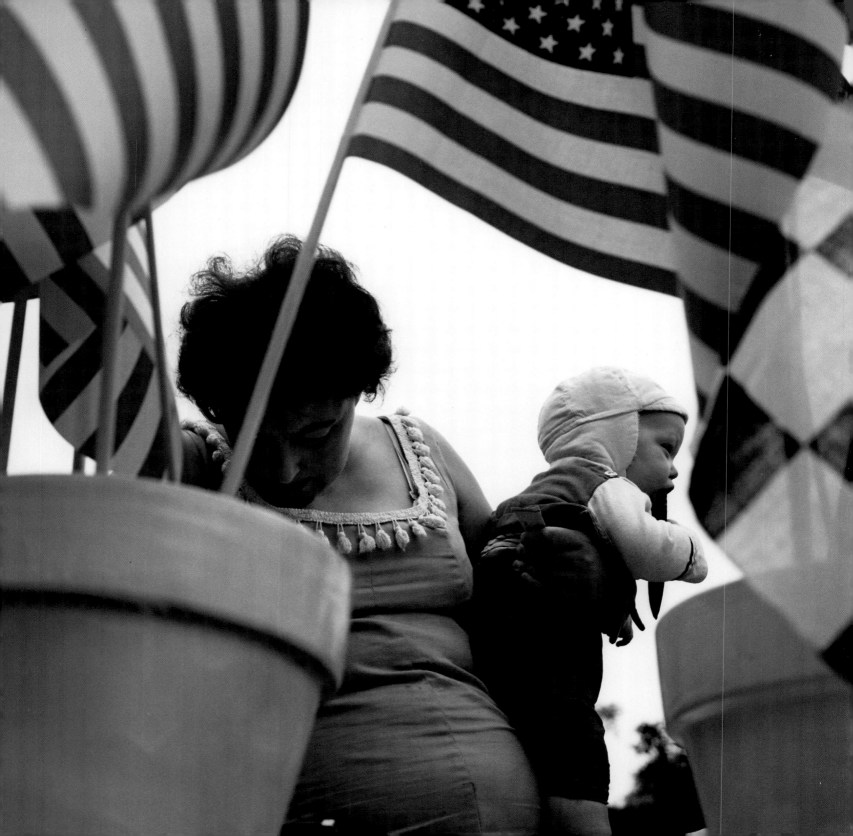

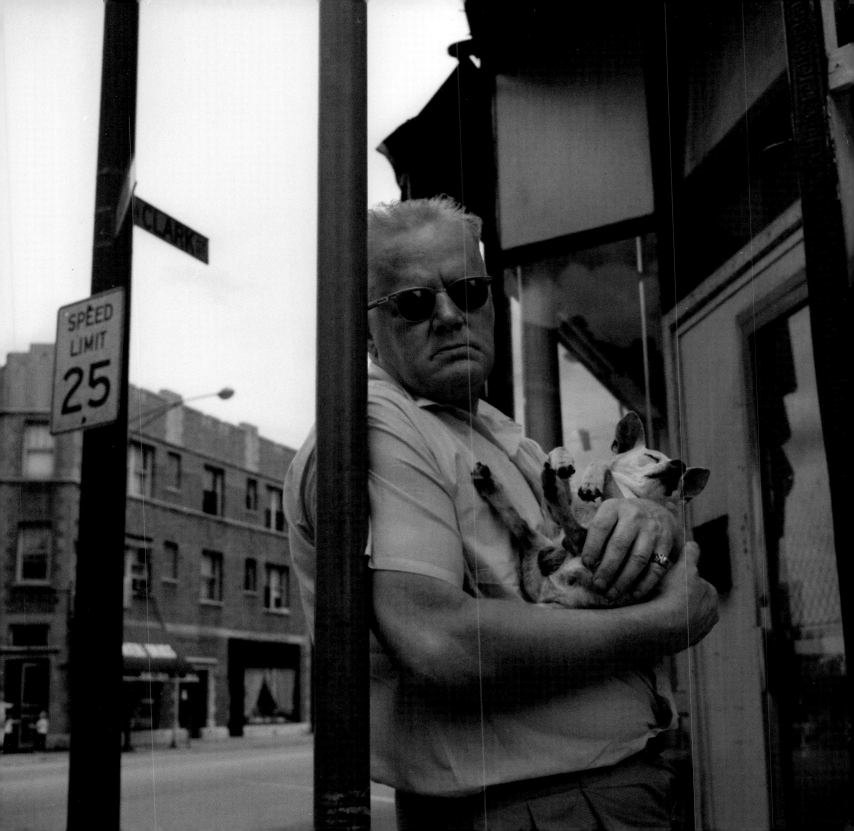

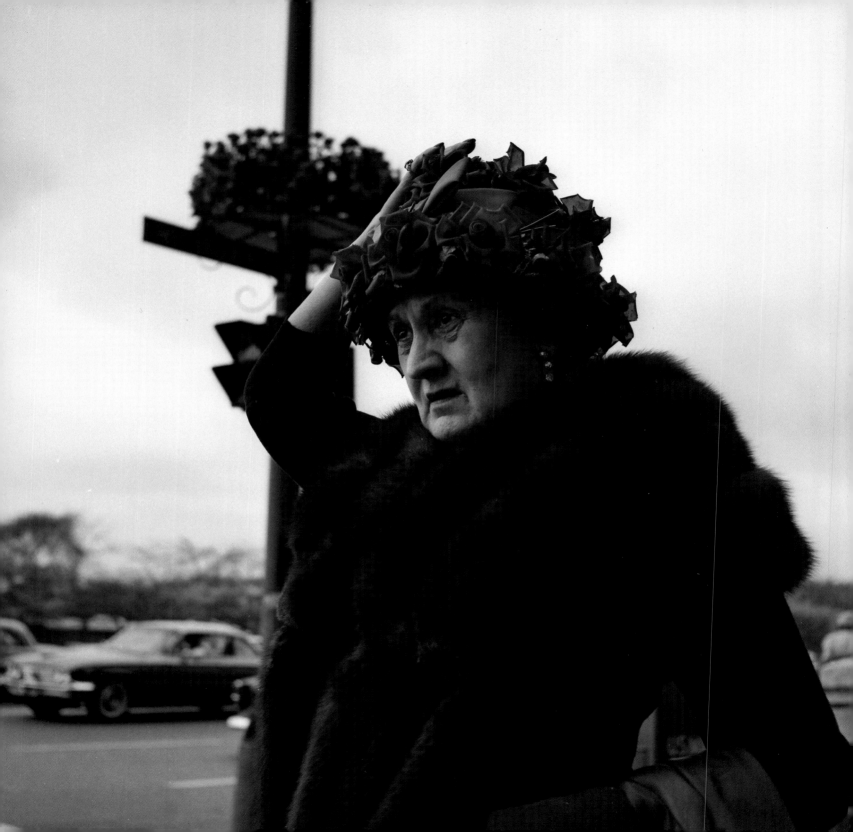

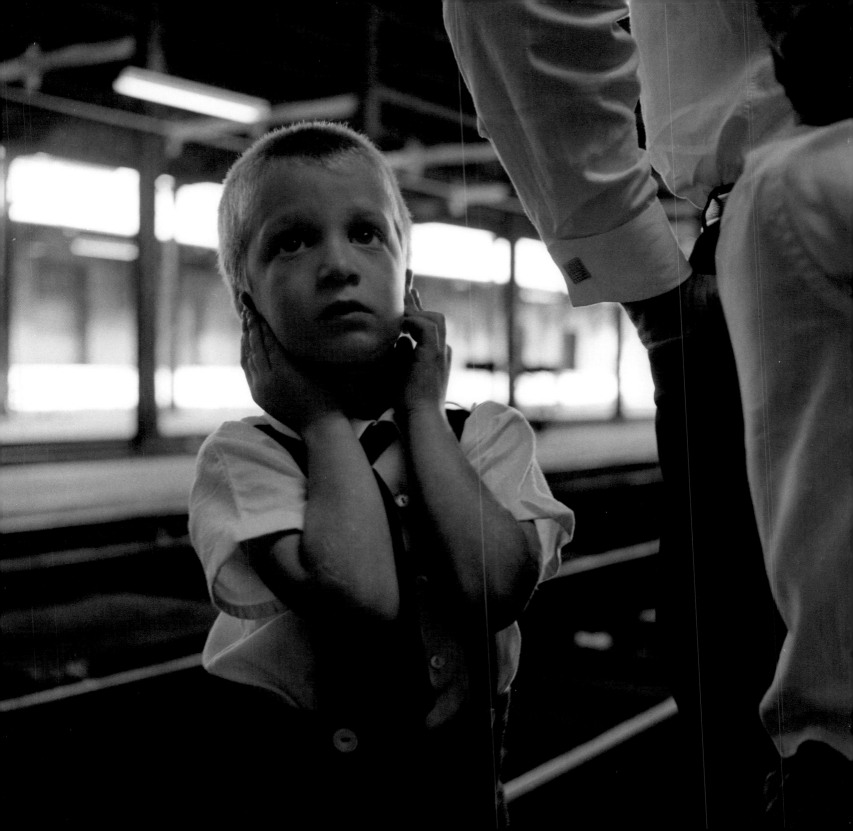

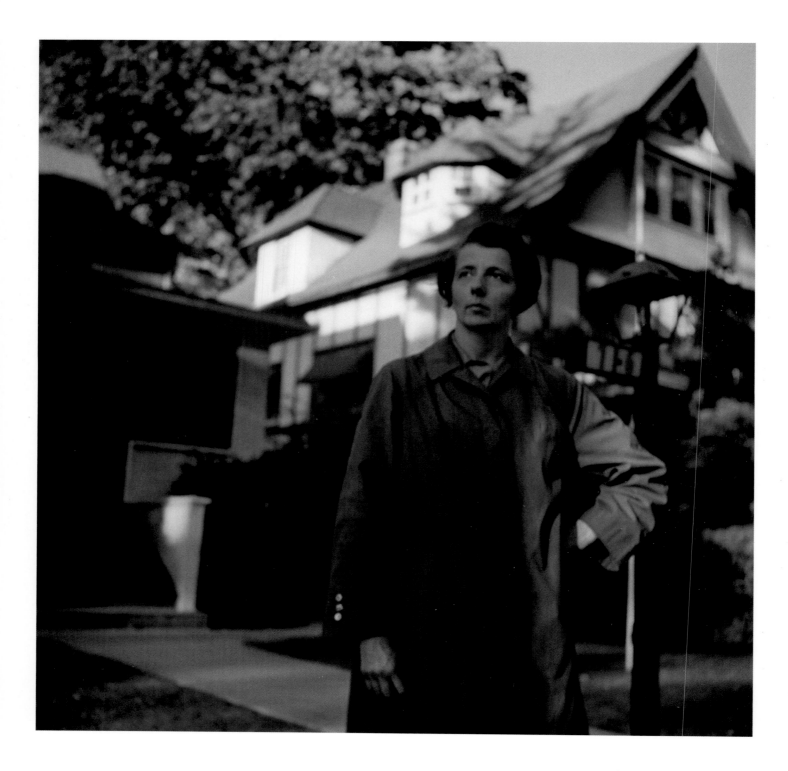

Vivian Maier

OUT OF THE SHADOWS

RICHARD CAHAN
MICHAEL WILLIAMS

A CITYFILES PRESS BOOK

All photographs used in this book
are from the Jeffrey Goldstein Collection.

Published by CityFiles Press, Chicago, Illinois
www.cityfilespress.com

Produced and designed by Michael Williams

ISBN: 9780978545093

Printed in China

First Edition

CONTENTS

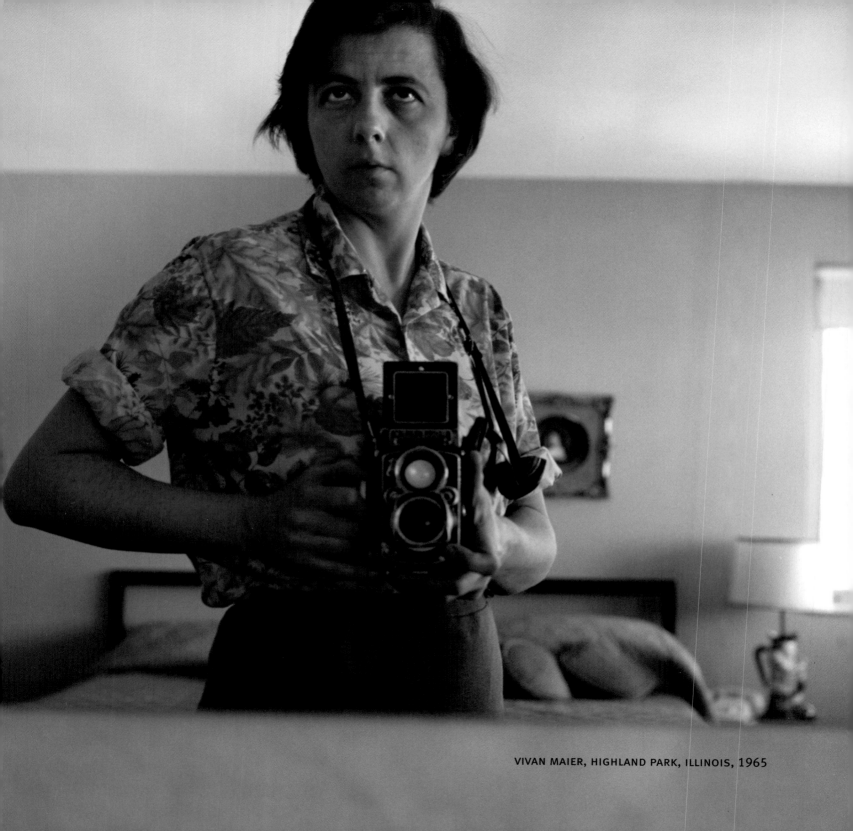

VIVAN MAIER, HIGHLAND PARK, ILLINOIS, 1965

A PHOTO MEMOIR

SHE WAS MADE FOR THIS OLD BLACK CAMERA. She cradled it in the palm of her left hand as her willowy fingers rotated the focusing knob and jostled the shutter. She set the lens speed and the aperture by turning tiny, awkward dials and wound the film with a silver crank. Holding it above her waist, she would look down into the ground-glass focal plane at a mirror image of what the camera was seeing. The bulky Rolleiflex that hung from her neck seemed oddly out of place in those easy 35 mm days. It created boxy negatives in an era that craved sleekness, producing only twelve at a time when people had long moved to thirty-six. But she relied on this beautiful camera, with its musty leather body. It was quiet and optically supreme. It became part of her.

Vivian Maier (1926–2009), an amateur photographer whose work has thrilled the world since its discovery, used a Rolleiflex and other cameras to take more than a hundred thousand pictures. These pictures were essentially invisible—only a few were seen by others during her lifetime—carefully tucked away in the bedrooms, basements, and garages of homes where she was a live-in caregiver. Eventually, she had to move her possessions into storage. At the time, she was impoverished, living on her own in a small apartment not far from the storage facility. When she fell behind on the monthly payments, she was notified that her belongings would be sold, but she failed to respond. The contents of her lockers—truckloads of trunks and boxes filled with newspapers, magazines, and personal effects, as well as her photo negatives, slides, and undeveloped rolls of film—were purchased in 2007 for about $250 by a Chicago auctioneer, who split them into small lots to be sold off at three evening auctions.

Maier died in April 2009. Six months later, John Maloof, who bought one of the auction lots, posted a large batch of her photographs—bold and breathtaking—on the Internet. Word spread quickly. Thousands of people must have seen her work those first few days, judging by the hundreds who responded online. And the thousands soon became tens of thousands. Just weeks after those early photos appeared, Vivian Maier, who had become known as the "nanny photographer," had a worldwide following.

"I just learned about Vivian tonight, and am absolutely stunned, touched, captivated by her work," commented one man. "There's an emotional accessibility to them. . . . They make me wonder what those people's lives were like, what were they thinking that second, what their desires and fears are." Another wrote, "I am mesmerized by her work. She is what photography is all about. You wait, you shoot, you learn, you shoot, you capture." And another: "Just plain awesome work, and the junk box find of the century."

After eighty-three years, Vivian Maier was no longer invisible.

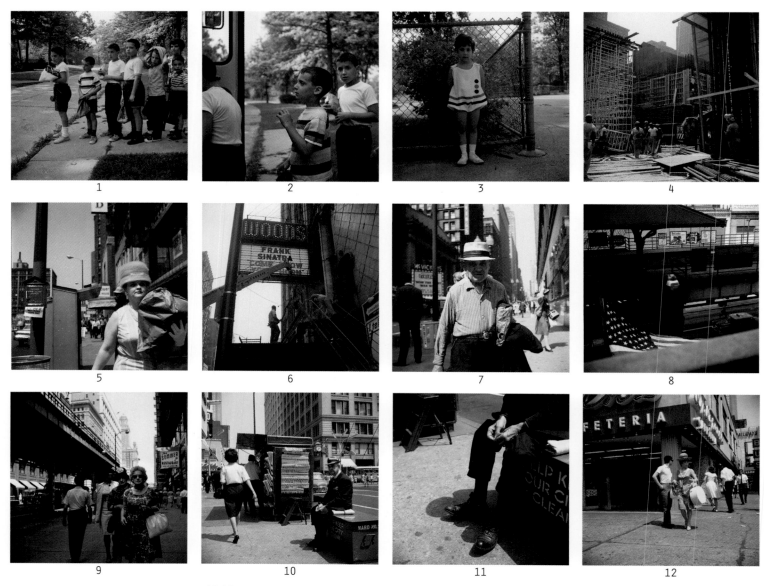

A CONTACT SHEET FROM EARLY JUNE 1963 SHOWS HOW VIVIAN MAIER PHOTOGRAPHED. SHE WOULD LEAVE HIGHLAND PARK IN THE MORNING AFTER THE CHILDREN WERE OFF TO SCHOOL AND SPEND THE REST OF THE DAY IN CHICAGO, SHOOTING FROM MANY VANTAGE POINTS.

MAIER'S STORY—a working-class woman leaves a stash of world-class photos no one has ever seen—is intriguing and raises many questions. Why did she take them? Why didn't she share them? And how did she lose them in the end? Little was known about Maier at first. Her photos were auctioned off with her battered cameras, floppy hats, wide shoes, and old suitcases—but little information. And years later, some answers remain elusive. Every picture adds to the mystery.

But Maier has emerged as much more than a first-rate curiosity. It is clear that she had an extraordinary talent, having repeatedly produced artful images that are so easy to understand but so open to interpretation. Her pictures are rich in meaning and beauty. Her subject is ordinary life, and her style is ordinary, too. Few of her pictures were taken with wide-angle or telephoto lenses, and most are straightforward, in-focus pictures of what she saw. From the late 1940s, when she took up photography, to the mid-1970s, she shot primarily in black-and-white, generally using an off-the-shelf box camera or a medium-format Rolleiflex that produced detailed 2¼-inch square negatives.

And what is also clear is that she took the photographs strictly for herself. She had no curators to please and no audience looking over her shoulder. Her agenda was to go out and record what she saw. She did so with a grace that has attracted the world's attention.

Announcements for the first exhibition of her photographs, *Viva Vivian,* which opened in 2010 in Aarhus, Denmark, were plastered all over the city. When teeming fans in Chicago were introduced to her photos in early 2011, a viewer wrote, "After tonight, I think it's completely fair to claim Vivian Maier is truly the People's Photographer." Later that year, a Los Angeles gallery had to turn away crowds on opening night. Across the country, two New York galleries,

Steven Kasher and Howard Greenberg, attracted record numbers when they exhibited Maier's work; many who came had never attended a gallery show before.

Maier's photos need little explanation. It's easy to appreciate her sense of wit, irony, and humor. Roberta Smith, art critic for *The New York Times,* wrote that the Kasher and Greenberg exhibitions nominated Maier as "a new candidate for the pantheon of great 20th-century street photographers."

STRONG, SMART, OPINIONATED, and painfully private, Vivian Maier (who pronounced her last name "Meyer") was always a presence. Her childhood friends in France recall her as "the girl with a bike and a camera." Teenagers in Chicago's affluent northern suburbs dubbed her the Bird Lady because of her awkward gait. They quietly laughed at her European accent, odd manner, and out-of-fashion clothes. And those in Chicago who noticed her knew that she always traveled with a camera or two around her neck, but chalked it up to artistic pretense. "I never even thought she had film in those cameras," said Jim Dempsey, who saw her most every week for a dozen years. "I thought it was just an accessory."

Maier had few friends and was known to be difficult and temperamental. Yet her photography shows an exceptional ability to relate to and connect with people. It was a very short connection—a sixtieth of a second—but in that sliver of time Maier and her camera did something remarkable. They seemed to unmask people, to see beyond the surface of their skin. Her ability to get close to her subjects is what makes her pictures so irresistible. She's not gawking, or judging, or creating caricatures. Her subjects—the men, women, and children who hardly noticed her—were often deep in thought. They seem isolated or perhaps lonely.

It would have taken enormous concentration and uncommon dexterity with the camera to capture those moments. Her contact sheets show that she usually took only one picture of her subject and moved on. But somehow she found the decisive moment, the instant her camera revealed something true and telling about life.

The "decisive moment" typically refers to a flash of action, as when the photographer Henri Cartier-Bresson captured a passerby jumping a puddle behind Paris's Gare Saint-Lazare. Instead of showing action, Maier's decisive moments were often the in-between instants of people's lives—moments that are seldom photographed. With the aperture set at f/10 or higher, Maier could change her shutter speed and bring into focus anything from three feet away and beyond. How she found those moments and caught them at such close range is perhaps the biggest mystery of all.

Many photographers plot and plan. Ansel Adams might figure out lighting for days beforehand. Maier was the opposite; it doesn't appear that she planned a thing. Her photographs are all about documenting what's before her camera and what intrigued her. She carried her camera everywhere—on walks, in the car, on her bike, in the grocery store, at the doctor's office, around the house. The burning of fall leaves, the beach in summer, the el at night—everything was a subject. She used the camera as a diary. "The frames are so spontaneous," observed the photographer Mary Ellen Mark. "She is just looking at life and capturing moments that are real. So few people know how to shoot like that."

Maier looked for small events—split seconds with universal meaning. In the process, she produced thousands of what the gallery owner Steven Kasher calls photo haiku—images that freeze blinks of life, lyrical and lasting. She sought resolution in a world flirting with dissonance, taking photos of shadows on sidewalks, postcard stands, a dead bird, a broom against the shed door. A worker loses something—is it a contact lens?—on the plaza of the Chicago Civic Center. Maier rushes over as others gather to help. No drama was too small. No person was too insignificant. We can all identify with the loss, with the helplessness, with the help that follows.

These are the kinds of modest subjects that today's amateur photographers, with their cell phone cameras and digital point-and-shoots, most prize. But Maier did this work in an age when film and processing were fairly expensive. There was a limit to how many pictures you could take before your camera needed to be reloaded. Maier's pictures of these everyday dramas give us an uncommon sense of the middle decades of the last century. She shows us how people hugged, how they waited at bus stops, how they carried packages wrapped in twine. She shows how they took in the sun and relaxed with a newspaper. She helps us remember what those years felt like. She captures flashes of life the rest of us are too busy to notice.

Perhaps she was able to create her distinctive photographs because she was not out to impress anybody. Maier did not seek exhibitions or book contracts; she seldom even talked about her work with the camera store countermen when she picked up her film. In fact, as she got older, she couldn't keep up with the processing and left hundreds of her precious rolls of film undeveloped. She took the photos purely for herself. The act of pressing the shutter seems to be the most important part of the process for Maier. She used the camera to remember and record.

She was, first and foremost, a worker. Maier noted on her 1950 passport application that she was a factory employee; in 1959, she listed herself as a child nurse. She worked so she could do her art. She went from job to job to support her unstoppable

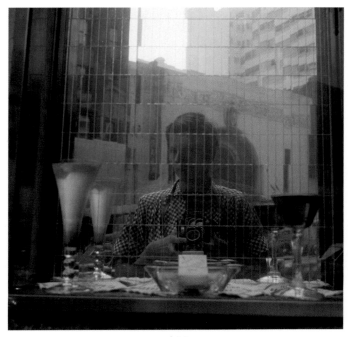

1955

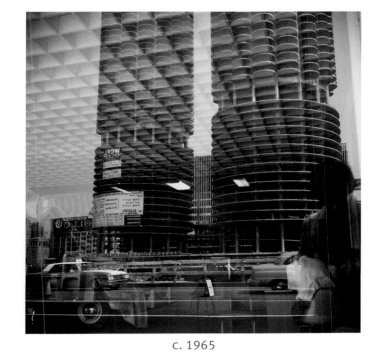

c. 1965

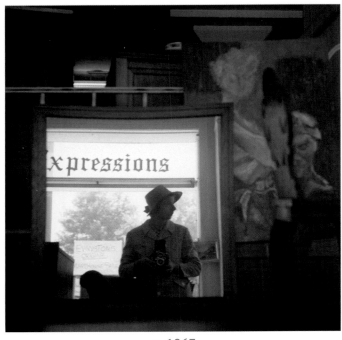

c. 1967

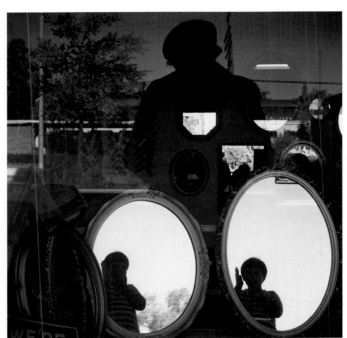

1968

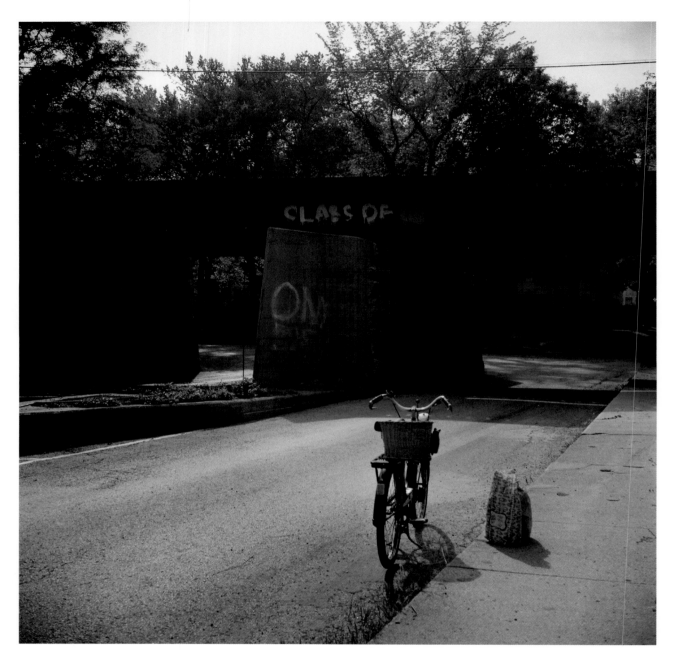

VIVIAN MAIER'S J.C. HIGGINS BIKE IN HIGHLAND PARK. MAIER ALSO RODE A MOTOR SCOOTER, BUT SHE GAVE IT UP AFTER SHE WAS TOLD SHE NEEDED A DRIVER'S LICENSE. SHE CONSIDERED THAT AN INVASION OF PRIVACY. "SHE JUST WOULD NOT CONFORM," EMPLOYER NANCY GENSBURG SAID OF MAIER. "NO RULES, JUST HER RULES."

desire to photograph. One of the first things she asked potential employers in the suburbs of Chicago was how far their homes were from rapid transit, because the city was Maier's prime motif. Nancy Gensburg, who hired Maier as a nanny for her sons, remembered how Maier showed up for her interview with a camera. She did a wondrous job with the children, but Gensburg could tell right away where Maier's heart was. "She wasn't really interested in being a nanny at all," Gensburg said. "She really wanted to be out on the street. She wanted to be taking pictures." Taking pictures was not a diversion. It was the point.

TO BETTER UNDERSTAND MAIER, we tracked down everyone we could find—from the suburbs of Chicago to the slopes of the French Alps, where she grew up. We talked to old acquaintances in the beautiful French valley of Champsaur who knew her as a schoolgirl, contacted those for whom she worked on Long Island during the 1950s, and interviewed people who knew her in Chicago. Their portraits of Maier are remarkably similar. She was a tough woman engrossed in photography, cinema (everything from classics to B movies), books (mostly biographies and autobiographies), and politics (liberal and feminist). She cared deeply about the poor and oppressed (Native Americans and African Americans, in particular) and showed little interest in the material world. Unwilling to talk about her background or her art, she was quick to give advice to others. She stopped to tell homeless men in Chicago where they might go for shelter and lectured young women (to their chagrin) on dressing more modestly. She was generous and incapable of lying. Some say she was eccentric; some say she was obsessive. Alone, isolated, and mostly dismissed, she became something of a hoarder as she got older.

Maier was five foot eight, but most people remember her as taller. She had light brown hair, and her eyes, either hazel or brown—she put down different colors on different passport applications—showed determination. She was pencil thin and angular in her early years. Picture the cartoon character Olive Oyl. But later, her big hats, long dresses, and masculine-style shoes made her look larger and eventually larger than life.

She was a strong woman, supporting herself and saving to travel the globe for her art at a time when it was unusual for a woman to live that way. Though Maier was never known as a warm person, her pictures are filled with heart and humanism. We see somebody inexorably drawn to others, somebody determined to get close enough to share their space, to feel their hair, their lips, their eyes—even if only for an instant.

Her pictures show what she could not: that she cared. And they celebrate their creator. She left behind hundreds of images of herself—serious, unflinching, and unsmiling self-portraits, as well as photographs she asked others to take so that she could be part of the picture.

THIS BOOK PUTS VIVIAN MAIER'S WORK IN CONTEXT. It is based on the Jeffrey Goldstein Collection, a trove of about sixteen thousand black-and-white negatives, 225 rolls of films, fifteen hundred color slides, eleven hundred vintage prints, and thirty home movies.

Most collections are built with forethought and determination; this collection came together by sheer chance. It was purchased at auction by the photographer and collector Randy Prow, who sold it to Jeffrey Goldstein. Both saw the beauty of the work the moment they looked inside the first box. The collection contains Maier's photos from 1940s France, from 1950s New York, and from her travels in the 1950s and 1960s, as well as pictures she took

during her first two decades in Chicago, where she arrived around 1956 to work as a nanny.

Maier's photographs have so far been presented online and in galleries and publications as works that stand alone. But because she used the camera to tell the story of her life, we have made an effort to re-create a few of her photo adventures. This is a book of nine journeys during pivotal years: her early endeavors in France and New York City as she learned photography; her first photo travels across the United States; her domestic life in the suburbs of Chicago; her trips to the city's legendary market on Maxwell Street; the days she spent at the beach; the tumultuous year of 1968; her camera expeditions downtown; the walks she took through the suburbs; and her evolving later life.

We examined the entire collection and chose about three hundred pictures we felt worked together. We tried to select from the collection those photographs that represent the themes she cared about most. We let her work talk to us. We paid attention to chronology and looked at contact sheets to get a sense of how she shot and to figure out what was most important. They reveal that Maier had, in the words of the photographer Walker Evans, a "hungry eye," one that was constantly devouring the world around her. She sought to capture more than the obvious and to show that things aren't exactly what we think. That spirit guided this book.

We were as faithful as possible. None of the photographs have been cropped, and almost all her early snapshots are reproduced at their original size. Negatives were scanned to restore their tonal quality, and the photographs on the following pages are often presented in the same order in which she shot them. Now we stand back and hope they tell her story.

What did we learn? First, that Maier is no fluke. Some have wondered whether a few good shots aren't inevitable given her prodigious output. We found it's just the opposite. Nearly all her rolls have something to offer. At every stage of her life as an artist, she was exploring, questioning, evolving, and growing. In photo parlance, she was a flâneur, strolling the city in search of meaning. Most flâneurs were men of leisure. She broke the mold.

We also learned that Maier was much more than a street photographer, the role in which she was originally cast. Her pictures go well beyond the street—both physically and intellectually. Here is a woman who lived her entire adult life through a camera, taking pictures from sunup to sundown and beyond. And most every day, she had something to record. This book is her journal: a singular record of youth, adventure, and the crush of old age.

In 1886, Emily Dickinson, the Hermit Thrush of Amherst, died in her family's redbrick home, leaving behind close to two thousand poems and hundreds of letters. Lacking confidence in her work, she asked her sister Lavinia to destroy all her correspondence upon her death, but she left no instruction for the poetry. Lavinia decided that her sister's poems—on life, love, nature, time, and eternity—needed to be published. The book, edited by two of her friends, begins:

This is my letter to the world,
That never wrote to me.

We are attracted to Vivian Maier because, like Emily Dickinson, she lived an irregular, mysterious life and was able to convey what she felt about our shared world in a way that helps us see that world anew. Maier photographs a grizzled man with safety pins attached to his vest, a boy in flip-flops emerging from a Miami Beach pool, and pumpkins rotting on the porch after Halloween. Her photos, slightly off, are so on point. Although outspoken, Maier was dismissed by many during her lifetime as someone who had little to say. And yet she said so much.

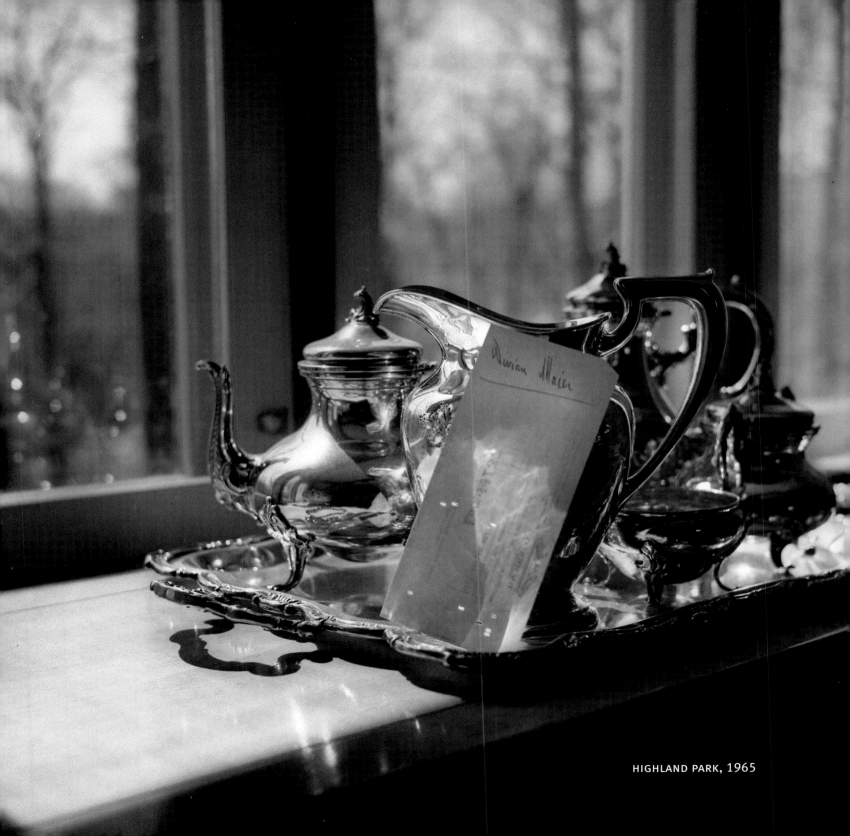

HIGHLAND PARK, 1965

VIVIAN MAIER

OUT OF THE SHADOWS

SNAPSHOTS

Vivian Maier's earliest photographs are of New York City, where she was born and spent her first years, and of the valley in the French Alps where she grew up.

Her pictures of France, taken on a return visit she made in her twenties, are her simplest. They document the countryside she loved and show her affection for the people who lived in and around her hometown of Saint-Bonnet-en-Champsaur, a small village in southeastern France. Here she photographed the Drac and the mountains and pastures that surround the peaceful river.

Like many novice photographers at that time, Maier used an old-fashioned box camera ("my small black box," she called it) that yielded negatives approximately 2¼ inches by 3¼ inches in size. It had no focus and minimal adjustments for shutter speed and depth of field, so its range was limited. To compensate, young Maier kept it simple. She generally shot on sunny days, making sure the sun was at her back, filled the frame with the image she wanted, and carefully watched the light. She looked for friendly faces, for subjects who would pose gratefully. Shepherds paused near their sheep, boys stopped their play, and farmers stood by their plows for her camera.

But she went beyond portraits. She took pictures of weddings, religious pilgrimages, political rallies, parades, carnivals, sleigh rides, and bike races. These give a sense of rural France just after World War II—before tractors changed the pace of life and highways connected the valley to cities. Maier showed a world she remembered from her childhood: a place of small farms and strong family bonds, a place where people lived primarily on what they produced. She always identified with the Alpine communities of her youth, and her fondness for France can be seen in what she later photographed in the United States: art fair paintings of the Arc de Triomphe, newspaper headlines about Charles de Gaulle, a sign advertising a French feast at a local church.

Vivian Maier was a child of both Europe and America. Her paternal grandfather, Wilhelm von Maier, was born in Austria. Her paternal grandmother, Marie Hauser von Maier, was born in the small town of Odenberg (now called Sopron) on the western border of Hungary, but she identified herself as Austrian. They had two children: Alma and Charles, Vivian's father, who was born in 1892 in Austria. The family immigrated to the United States in 1905, sailing from Germany. They arrived at Ellis Island with $230 and listed their ethnicity as Hungarian-German. In America, Wilhelm worked as a gardener, a

clerk, an engineer, and a warehouse relief man. Marie was a matron at an orphan asylum for a short while.

Maria Jaussaud Maier, Vivian's mother, was born out of wedlock to Marie Eugenie Jaussaud and Nicolas Baille in 1897 in Saint-Julien-en-Champsaur, a few miles east of Saint-Bonnet. Baille, born in the valley in 1878, had been a hired hand on the Jaussaud farm. After Marie Eugenie became pregnant, Baille was shunned by the Jaussaud family. He moved to the United States in 1901 to work as a shepherd in the West. Marie Eugenie, born in 1881 just south of Saint-Bonnet, remained in the valley for a few years after the birth of Maria. She, too, immigrated to the United States in 1901, but traveled on her own to New York City, where she worked as a cook and a housekeeper for the rest of her life. Young Maria was raised by her grandmother and aunt, Marie Emilie Jaussaud and Maria Florentine Jaussaud, in Saint-Julien, and was sent to live in Italy in 1911. Three years later, she found a job as a maid for an American named Louise Orio Heckler, who brought her to New York. There Maria reconnected with her mother and later met Charles Maier.

Maria and Charles were married in Manhattan by a Lutheran pastor on May 11, 1919, Maria's twenty-second birthday. At the time of his wedding, Charles, who held a variety of jobs, was a licensed mechanical engineer at a candy factory. The couple lived with his parents at 162 East 56th Street in Manhattan. In 1920, their first child, Charles Maier, was born. Vivian Dorothy Maier was born six years later, on February 1, 1926. Her parents separated not long after. The 1930 census shows Vivian living with her mother on the top floor of a six-story apartment building at 720 Saint Mary's Street in the southeast end of the Bronx. The building was full of European immigrants and first-generation Americans who worked as bookkeepers, traveling salesmen, sheet-metal workers, drivers, newspaper printers, real-estate salesmen, waitresses, typists, carpenters, bakers, tailors, clerical workers, and schoolteachers. Maria listed her job as a practical nurse but told the census taker that she was unemployed at the time. The census notes that four-year-old Vivian could not yet read or write, did not speak a language other than English, and was not in school. Her brother, Charles, lived nearby in the Bronx with his paternal grandparents.

It is intriguing that a prominent photographer named Jeanne Bertrand was registered as the head of Maria's home in 1930. At forty-nine, Bertrand was sixteen years older than Maria. Bertrand grew up in Saint-Bonnet, but there is no indication that she knew Maria back home. It is unclear how Bertrand may have inspired Vivian, who was quite young when they shared the apartment. But Bertrand lived the life of an artist. Her parents moved the family from the

French Alps to Torrington, Connecticut, in 1894. As a young woman, Jeanne took a job in a factory making needles for sewing machines, but she soon quit to work as a photographer's assistant. Within a few years, she had developed quite a reputation. In 1902, *The Boston Daily Globe* described her as "the factory girl, who has become one of the most famous photographers in Connecticut, and who gives promise—for she is only 21 years of age—of becoming one of the great artistic photographers of the country."

By 1908, Bertrand was in Boston taking portraits of the moneyed set, but business reversals and mental problems forced her to close her studio. She was admitted to an insane asylum in 1909 because of "overwork," according to *The Torrington Register,* and again in 1917 after a violent outburst. By 1930, she was living with Vivian and her mother in New York and working as a photographer at a portrait studio called Materne in nearby Union City, New Jersey. Portraits of Bertrand were found decades later in Maier's possessions.

In 1932, Maria took her six-year-old daughter to live in France. Maria was now recognized in legal documents as the daughter of Nicolas Baille, who had returned to the cresent-shaped Champsaur Valley and purchased land with his earnings from the United States. She was entitled to take his last name but never did. Vivian spent the next six years in Saint-Bonnet. Her childhood acquaintances remember a "mysterious girl" with blond hair from New York who at first spoke no French but quickly picked up the language—with an American accent. She attended the girls' school at Rue du 8 Mai and played games with her new friends, but she stayed close to her mother, they said. Her good looks left an impression on Raymond Pascal, who lived three doors down from Vivian's apartment on Place du Chevreril in the heart of the town. "She was a very beautiful girl," he said, "so every guy was looking at her." But she did not return the glances: "She was young."

Out of sight, Vivian was somewhat forgotten by her American family. When her grandfather Wilhelm died in 1936, the notice they put in *The New York Times* failed to mention her as a survivor. It was corrected the following day.

During their years in France, Vivian and her mother never quite found their place. They were not living on a farm or with family, so they didn't fit in with the valley communities. In 1938, they returned to New York aboard the SS *Normandy,* the largest and fastest ship in the world at the time. Vivian's parents appear to have reconciled shortly thereafter: the 1940 census has them living together with Vivian and her brother Charles at 421 East Sixty-Fourth Street on Manhattan's Upper East Side. The father was employed as a steam engineer, earning $2,000 a year, a fine salary. Maria did not have a job and was not seeking employment.

Vivian went back to France in 1949 to settle an estate—half of a large house known as Beauregard and the surrounding property, worth about $60,000 in today's dollars—in Saint-Julien that she inherited from the aunt who had raised her mother. It was then that Maier made her first photo excursion, traveling north to Grenoble, east to Geneva, and south toward Nice on the French Riviera, snapping about two thousand photographs. France was an austere place at that time, still recovering from the war, and it was unusual for anyone to be walking the streets with a camera. Most of Maier's photographs were taken in Saint-Bonnet and in the nearby town of Gap. What delighted Maier most was the mountains that hemmed in the valley; many recall her determination to hike to the top of Moutet, overlooking Saint-Bonnet.

It was in the French Alps that Maier first made a name for herself. When a neighbor commented that she was taking quite a few photographs, Maier retorted, "Did you count them?" And when friends questioned the safety of hiking the mountains alone, she told them she carried a gun. Six decades later, Cecile Escallier smiles at the thought; she and other acquaintances still remember Maier's boast.

Maier sailed back to New York in April 1951 and got a job caring for children. She started taking pictures with her box camera in the same manner as she had in France. Frenetic New York, so different from the tranquil Alps, presented huge new challenges. No longer was Maier in her comfort zone, surrounded by friends and family. Now she was photographing a city of strangers. Many of her first photos were of her young charges. Then she worked up to approaching people who were sleeping. Soon she was photographing passersby.

One summer, she ventured to Southampton, near the eastern tip of Long Island, to work as a domestic. Laura Walker Danforth, one of the children Maier photographed there, said that her parents partied on the weekends while their kids took tennis and swimming lessons and played on the "prettiest beach in the world"; child rearing was left to nannies. "It was definitely *Great Gatsby*–esque," noted Danforth, who was about six at the time and does not remember Maier.

Maier saw more than just the high life in Southampton. She found a small African American community not far from the Walker home. It was clear that Maier was using her camera as an excuse to get around—France, New York, Southampton—and experience life. The charm of the box camera's soft focus and inexact light metering made for pictures that take on the feel of snapshots. But by her midtwenties, Maier was ready for a more serious camera and more serious work.

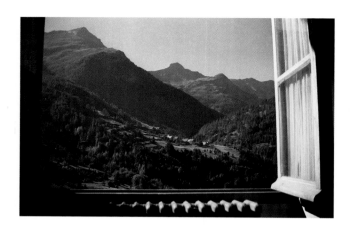

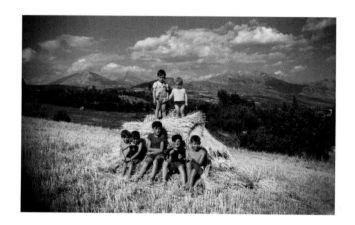

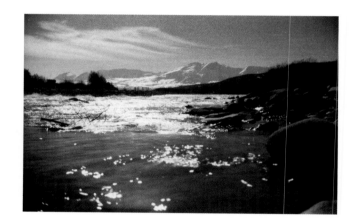

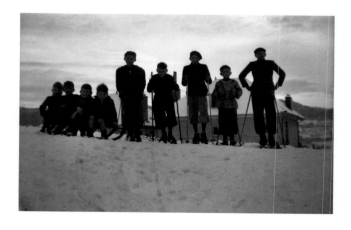

FRANCE, 1949-1951

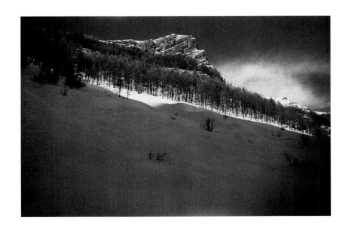
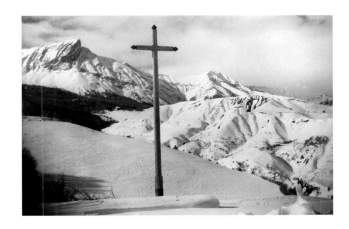
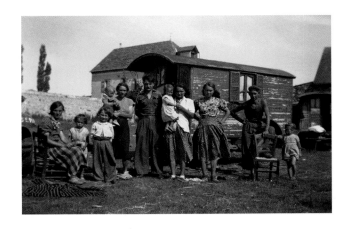
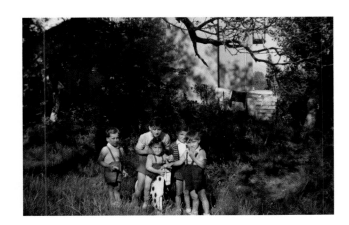
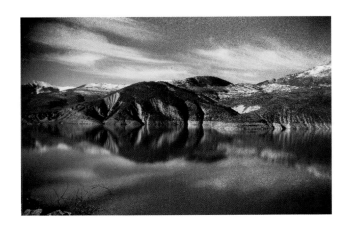
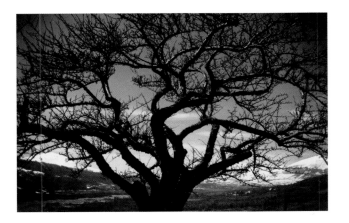

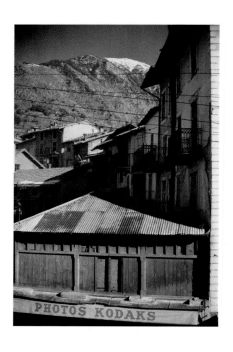

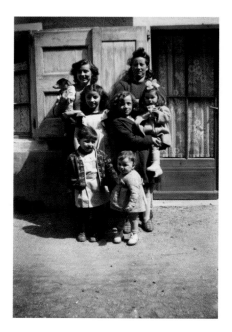

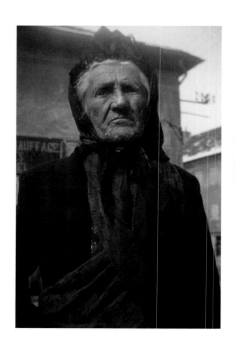

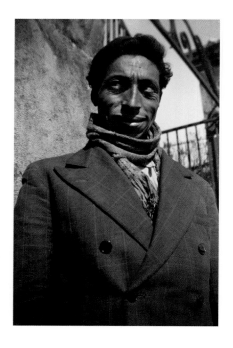

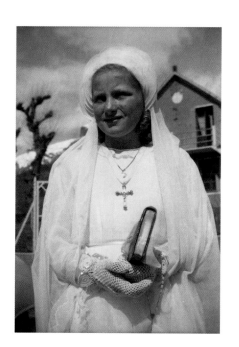

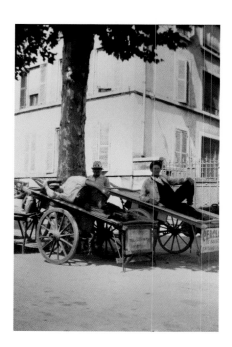

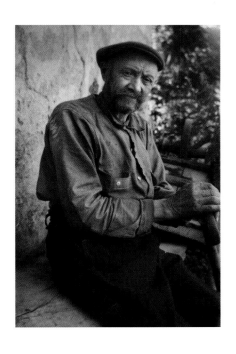
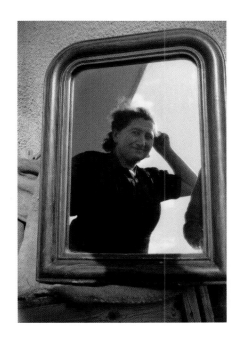
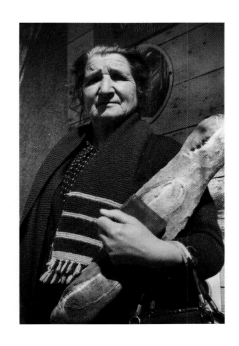
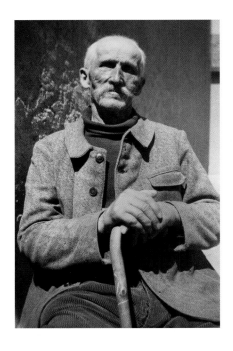
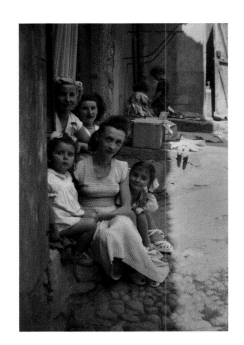
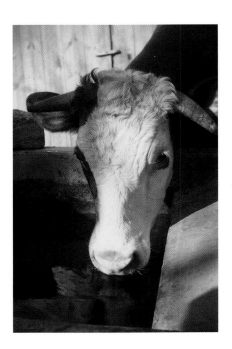

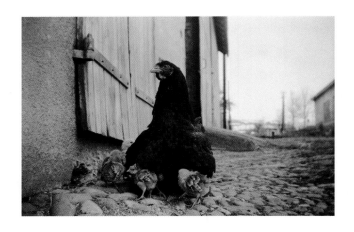
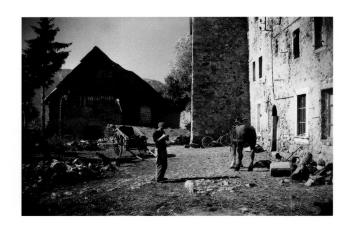
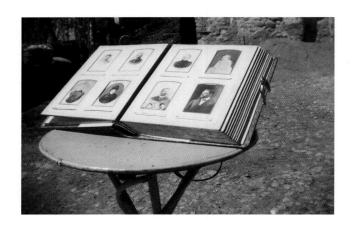
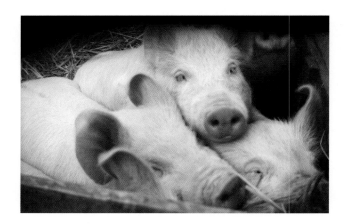
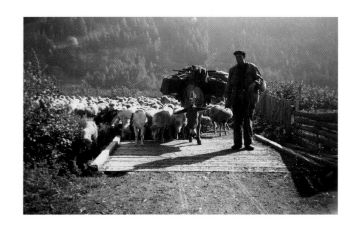
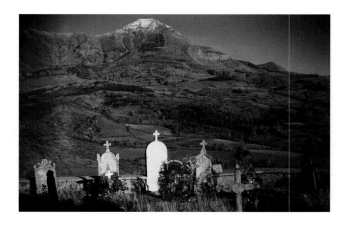

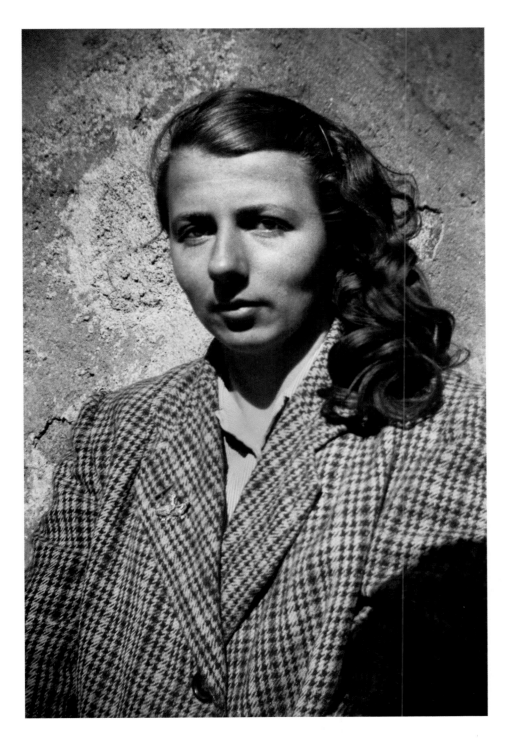

VIVIAN MAIER WORE LONG
DRESSES IN THE SUMMER AND
PUFFED PANTS IN THE WINTER
WHILE IN FRANCE. SHE TOOK
MANY SELF-PORTRAITS, BUT
WOULD ALSO HAND HER CAMERA
TO OTHERS SO THEY COULD TAKE
HER PICTURE. THIS IS FROM
HER 1949 TRIP TO FRANCE,
WHERE SHE PHOTOGRAPHED
THE COUNTRYSIDE AND HER OLD
FRIENDS AND NEIGHBORS, WHO
RETURNED THE FAVOR.

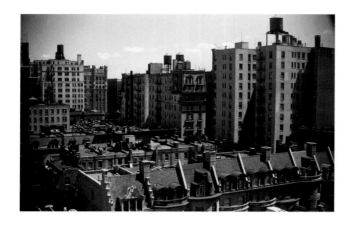
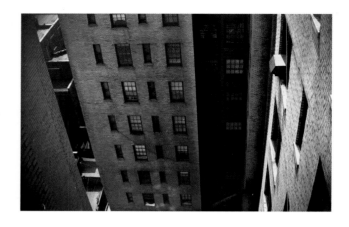
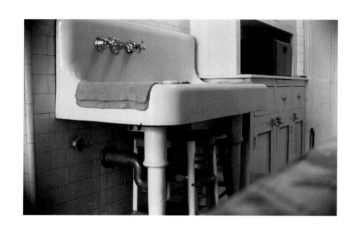
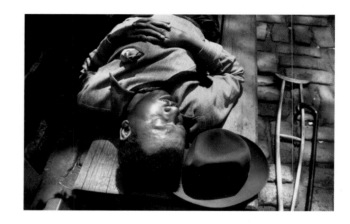
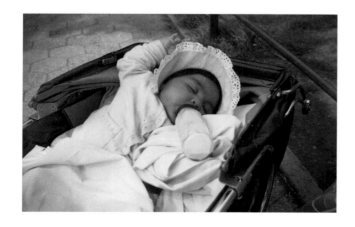
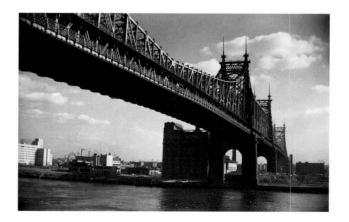

NEW YORK CITY, 1949-1952

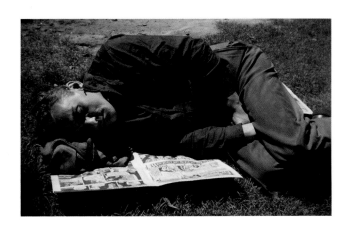

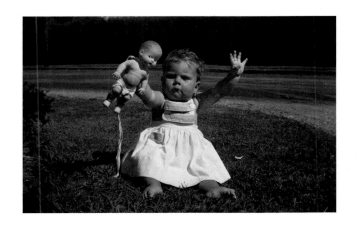

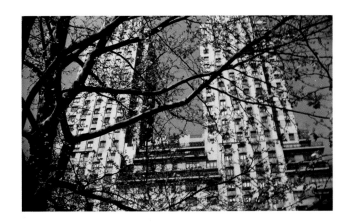

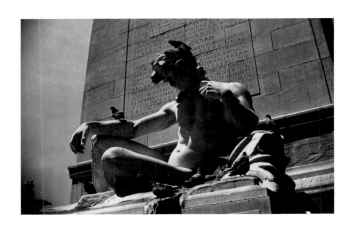

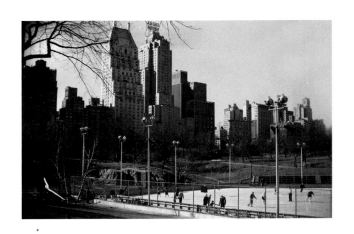

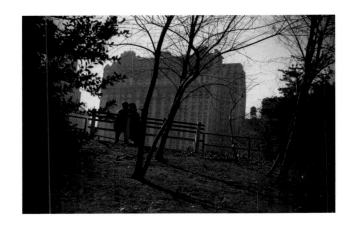

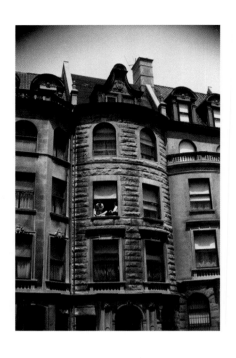
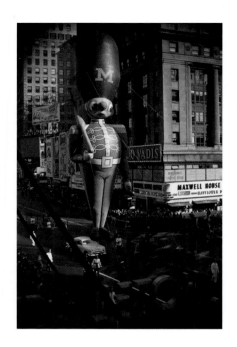
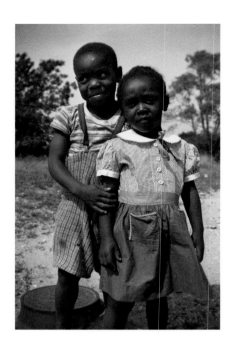
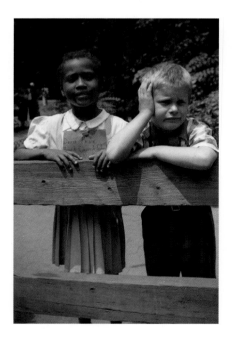

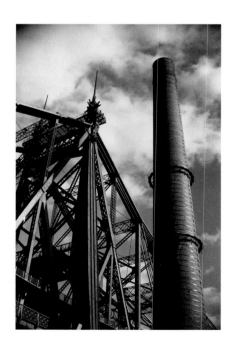

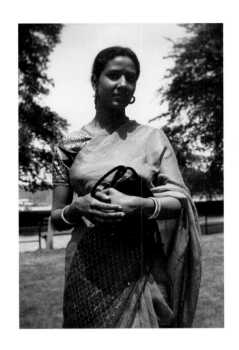
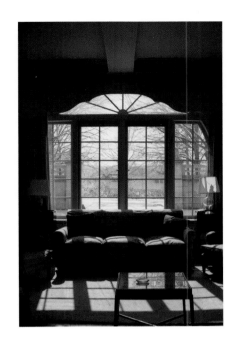
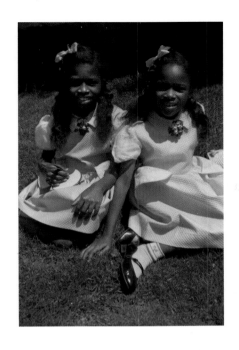
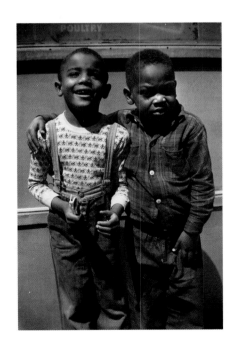
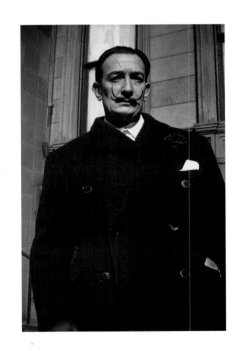
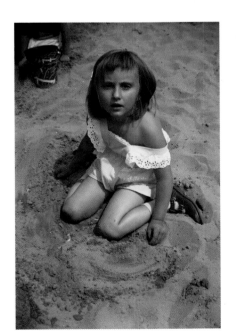

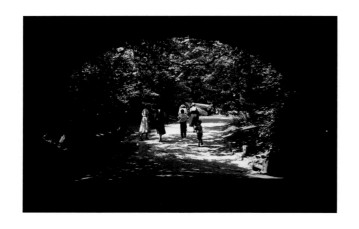

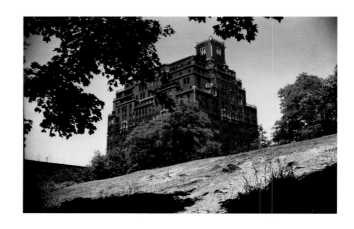

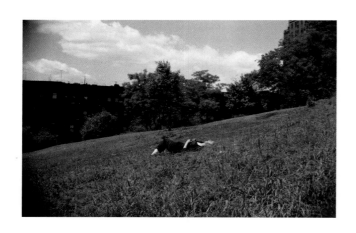

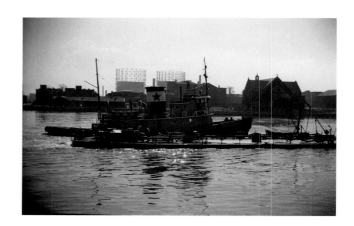

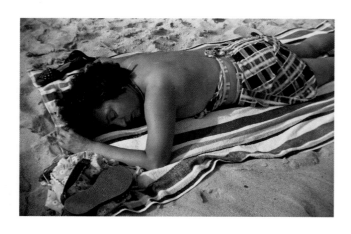

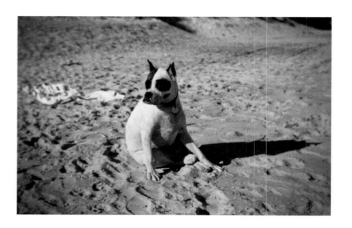

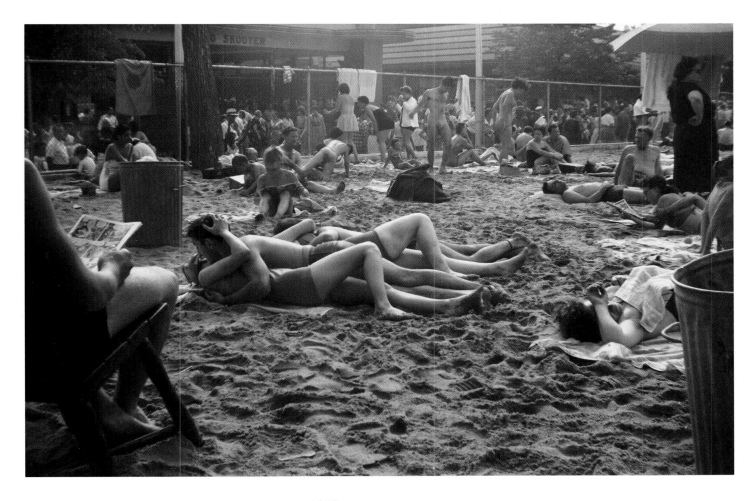

ON THE BEACH AT CONEY ISLAND DURING THE EARLY 1950S.
VIVIAN MAIER LEARNED TO PHOTOGRAPH USING A BOX
CAMERA, WHICH LENDS AN IMPRESSIONISTIC LOOK TO HER
EARLY WORK.

AMERICA

The 1950s and 1960s were a time of exploration for Vivian Maier. She surveyed America, the world, and the world of photography.

She longed for France. About a year after her return to New York City, she told Amédée Simon, owner of the photo shop in Saint-Bonnet, that she often looked with pleasure at her photographs of the Champsaur Valley. She had just purchased a Rolleiflex twin-lens reflex camera and told Simon that she'd been experimenting with it, even taking photos at night. She was pleased with her shooting but dissatisfied with the processing and developing of her film. She wondered if she could send her undeveloped rolls back to Saint-Bonnet, but the arrangement proved impractical.

The time Maier spent in France opened her eyes. "She had an open and inclusive and very fundamental idea of what constituted 'America' that was missed by a lot of photographers in the 1950s and '60s," says the photo critic Allan Sekula. He compares her to Robert Frank, the Swiss photographer who came to the United States in 1947, whose book *The Americans* is an immigrant's look at the nation. But Maier never had the support or backing that Frank had. "I find myself imaging her as a female Robert Frank, penniless, without a Guggenheim grant, unknown and working as a nanny to get by," Sekula wrote. "I also think she showed the world of women and children in a way that is pretty much unprecedented."

Using the money she inherited from her great-aunt, Maier traveled frequently during these years. Camera in hand, she seems to have navigated cities without attracting much attention. Her first major trip was to Los Angeles, where she worked as a child caretaker in 1955. Most of her photos there are of a little girl—in the bathtub, in a stroller, playing in a cardboard box—but Maier did have a chance to get out and see the city. She was fascinated by the lushness of Los Angeles, taking pictures of its palm trees, roses on the vine, and bulging mushrooms in the grass, and by the glamour that was Hollywood. She photographed the actor Richard Widmark in the Farmers Market and tourists at Grauman's Chinese Theater. She spent time in the old part of the city, which must have reminded her of New York with its crowded streets and tall buildings. Maier may have considered moving to Los Angeles—she opened a bank account there—but she returned to New York later that year.

She roamed New York incessantly during the early 1950s, sometimes on her own and sometimes with her charges in tow. She was drawn to the landscape of the city, its rivers

and bridges, wharves and ferries, but was far more intrigued by its people. With a growing confidence, she produced posed and candid portraits at point-blank range of vagrants, socialites, commuters on the run. Her photographs indicate that she worked as a caretaker on Riverside Drive at 106th Street and was comfortable in all types of neighborhoods. Even after moving to Chicago, she returned often to shoot New York.

Many of Maier's trips after that were with her Chicago-area employers. She visited Florida several times during the late 1950s and 1960s with the Gensburg family. Maier's Miami was quite sedate—a sea of retirees punctuated by photos of the Gensburgs' relatives. Somehow, she was able to capture a sense of the place and the era. She made detailed photo records of all her travels. In Florida, she photographed airports and airplane interiors (unusual for those days). Seldom did she shoot landmarks like Miami Beach's hotel row. Instead, she looked for telling moments: a tattered chaise longue or flip-flops waiting at the edge of a swimming pool.

Her photographs of Sturgis, where she went with the Raymond family in 1967, start with the long car trip itself—almost a thousand miles from Chicago to the western edge of South Dakota. She took pictures out the window and later turned the camera on the tired travelers, almost plastered to their seats, eating messy cotton candy at a rest stop. They arrived in Sturgis just as a parade was coming down Main Street. There are two rolls of film in the collection, about twenty-four pictures, that Maier shot that morning. Only one photograph was of the parade itself. She was more interested in the spectators—and it looks as if they were as interested in her.

Travel offered Maier a chance to study extremes and learn about the world. With the pictures now dispersed, it is difficult to get a full sense of her foreign trips, but we know that she visited Cuba in 1951 and Canada several times—as far north as Churchill, Manitoba, on the Hudson Bay, east to Nova Scotia, and west to Vancouver.

In 1959, she took a trip around the world on her own. She boarded a train for Los Angeles and crossed the Pacific Ocean on a cruise ship, disembarking in Manila in the Philippines, Hong Kong and Macau on the South China Sea, and Shanghai and Beijing on the mainland. From there, she sailed to Bangkok and Singapore, cruised around India and across the Arabian Sea to Yemen, then headed north up the Red Sea to Egypt, Lebanon, Syria, Turkey, and Greece and across the Mediterranean to Italy and France.

Before heading home, she returned to the Champsaur Valley, where she took hundreds of pictures of her former neighborhoods, creating a sort of photographic town census. Recalled Joseph Escallier, "She had surely took everyone in the village."

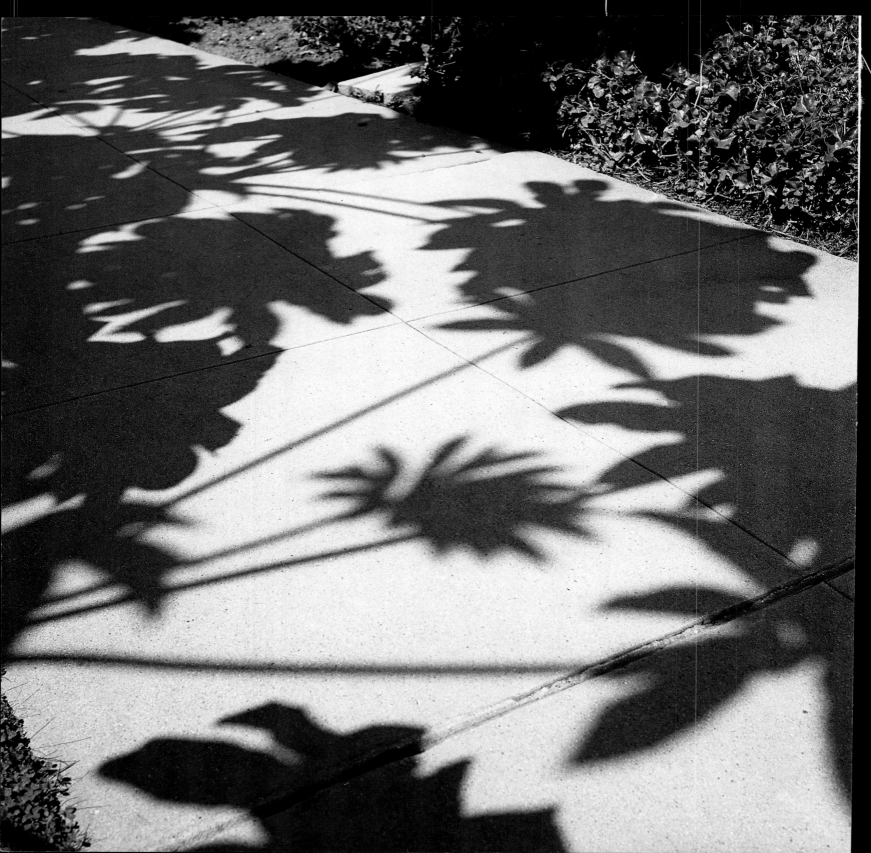

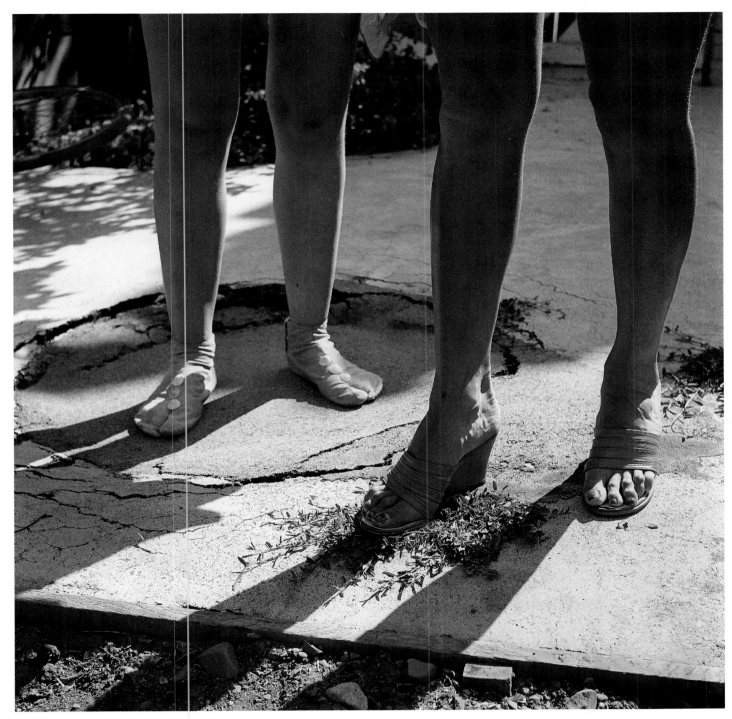

LOS ANGELES, 1955

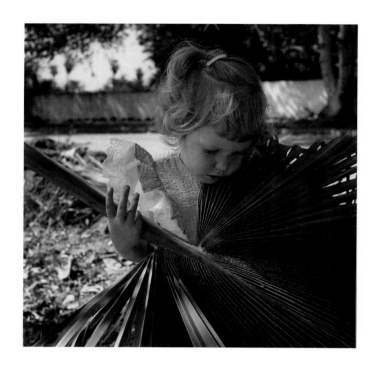
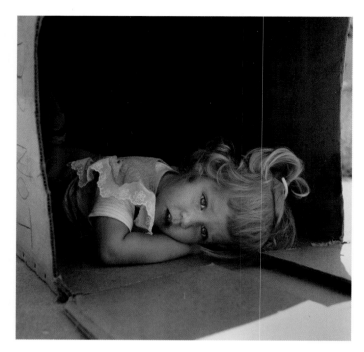
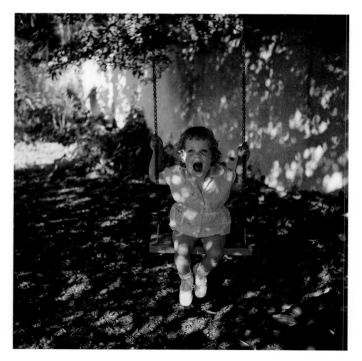
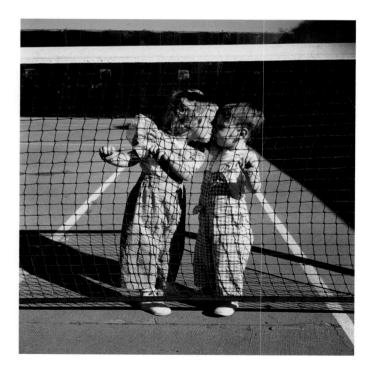

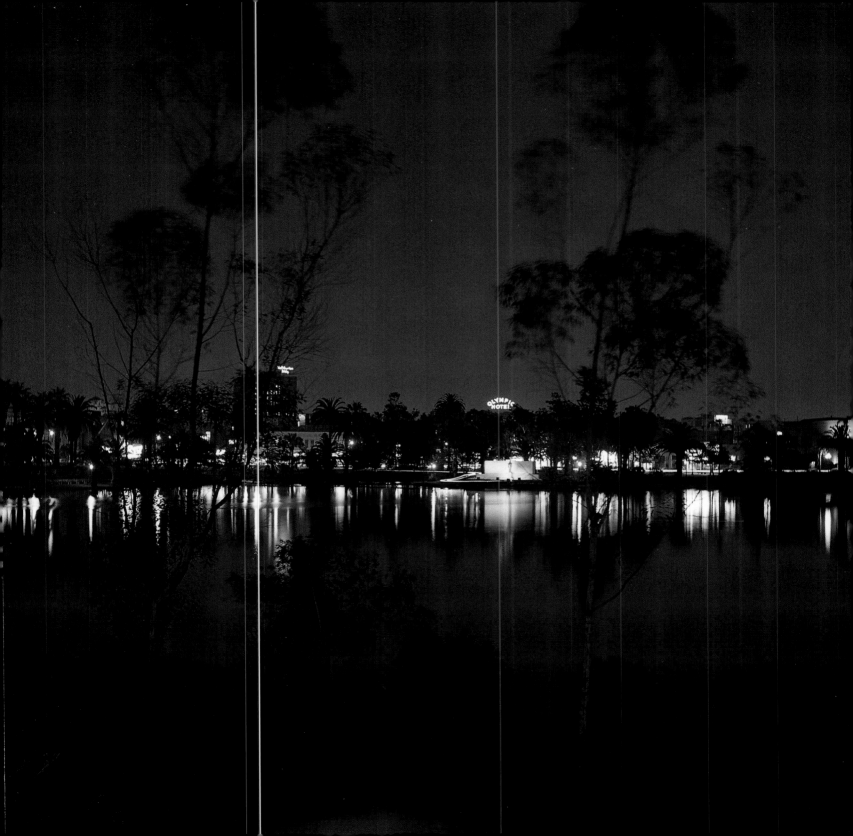

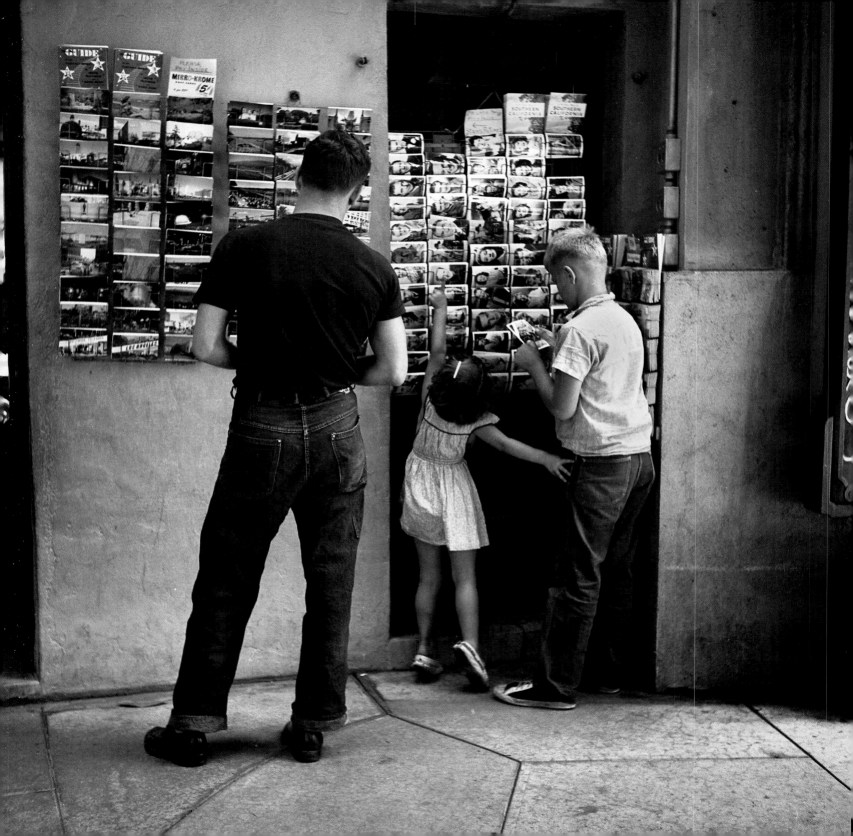

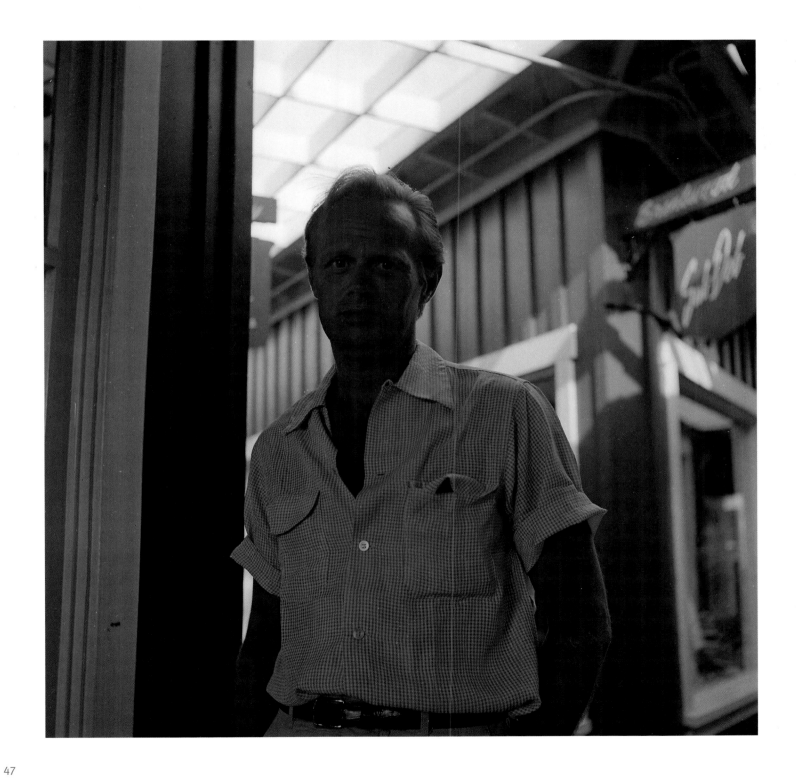

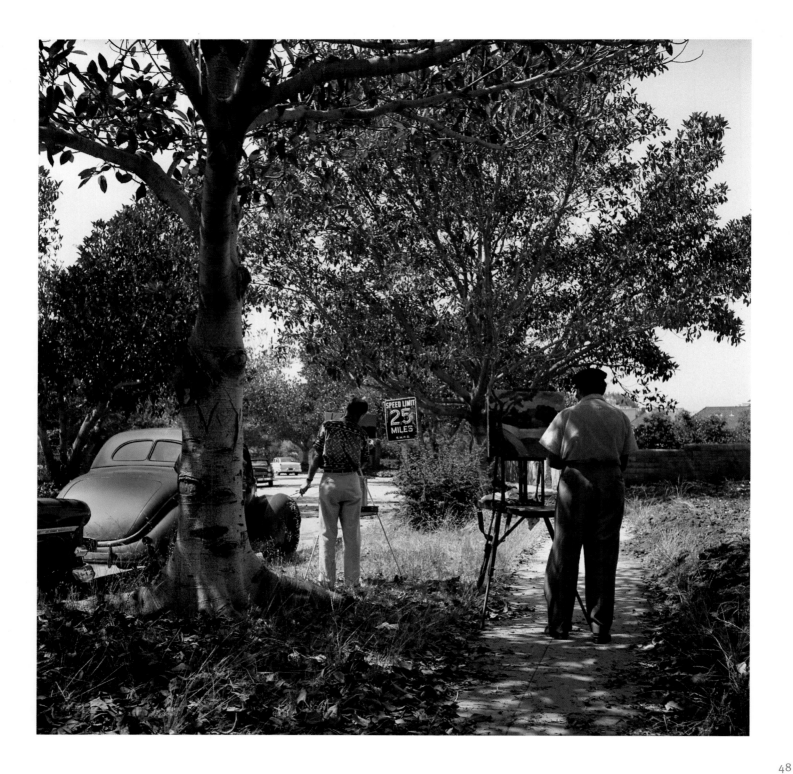

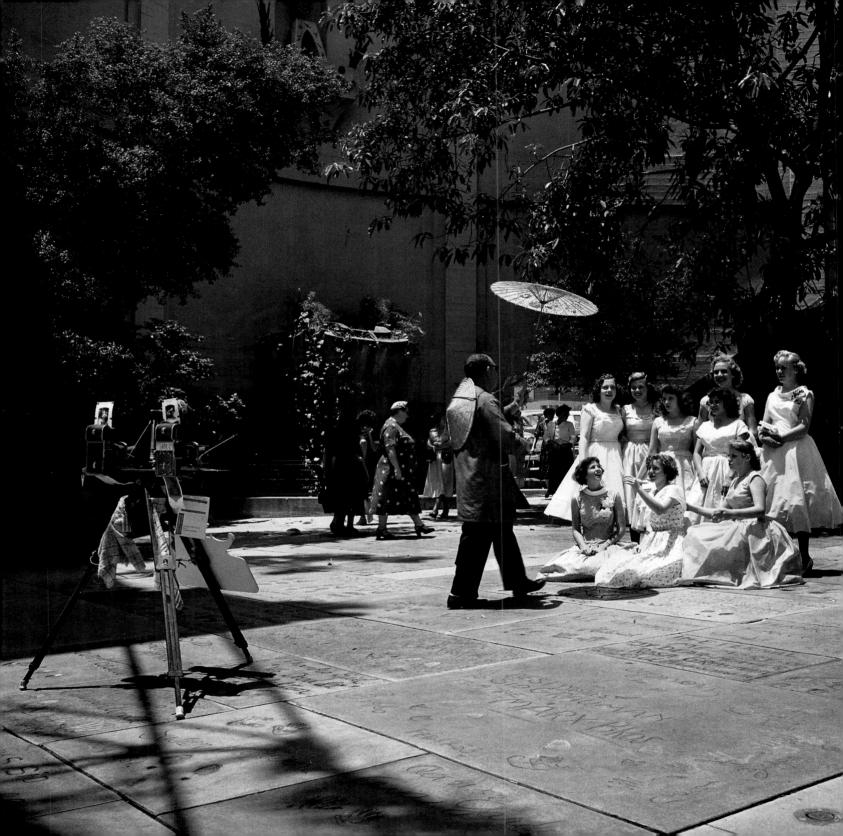

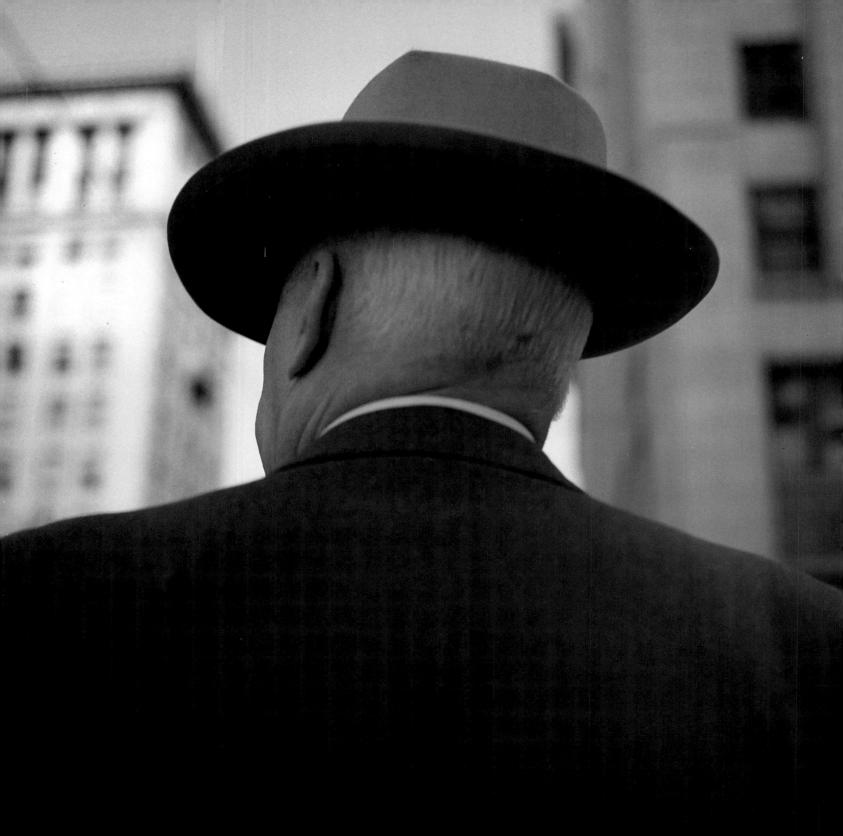

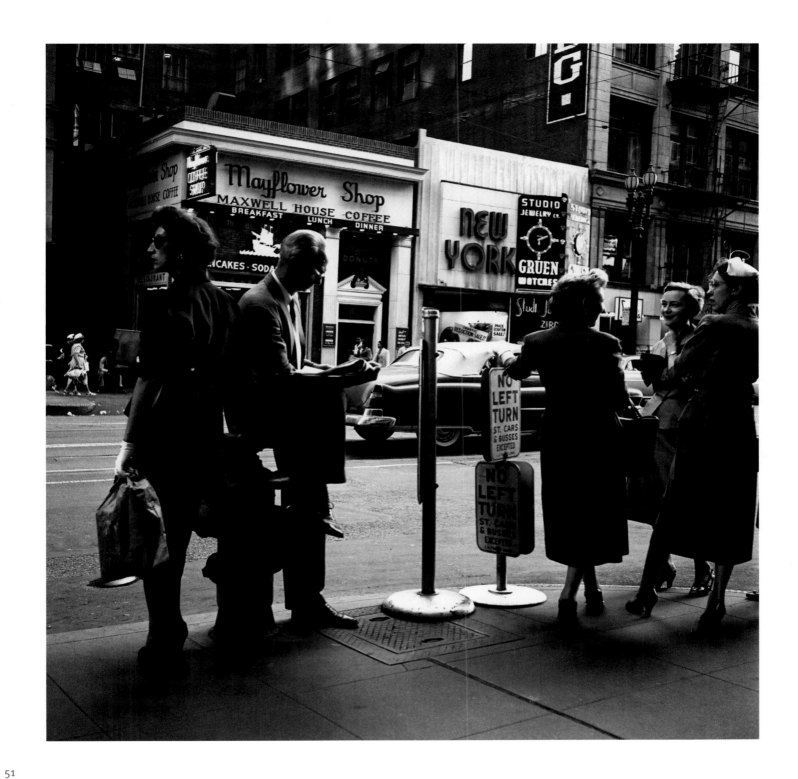

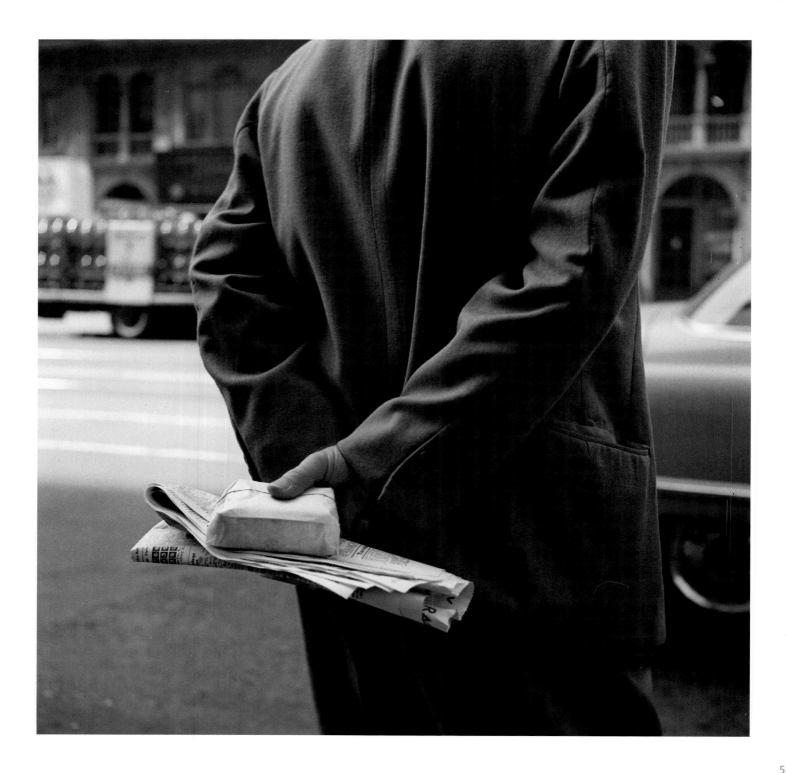

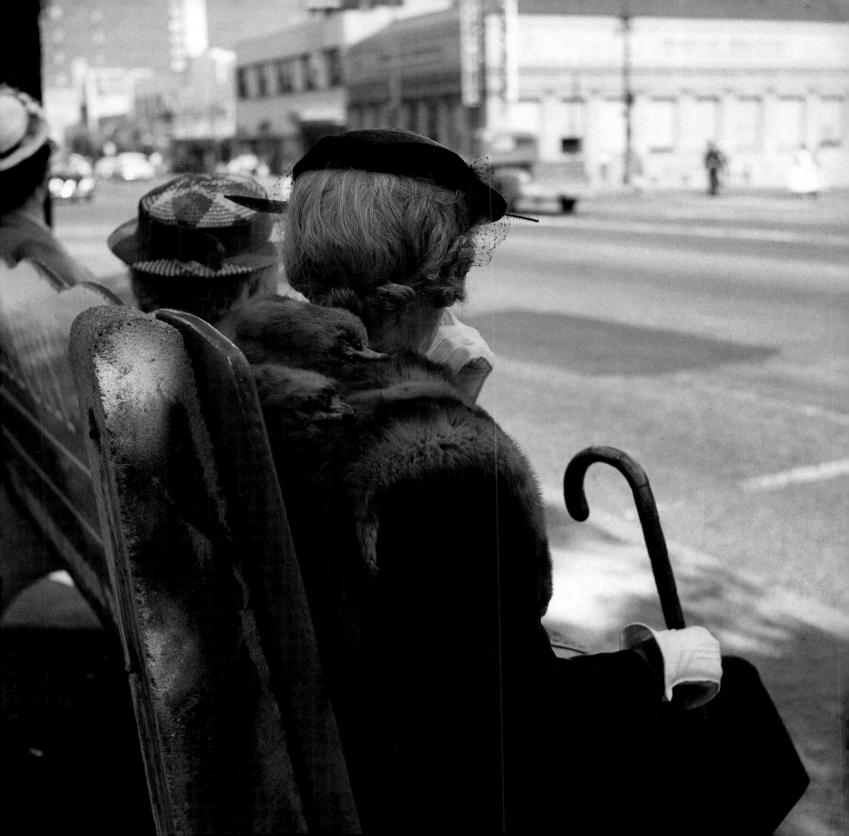

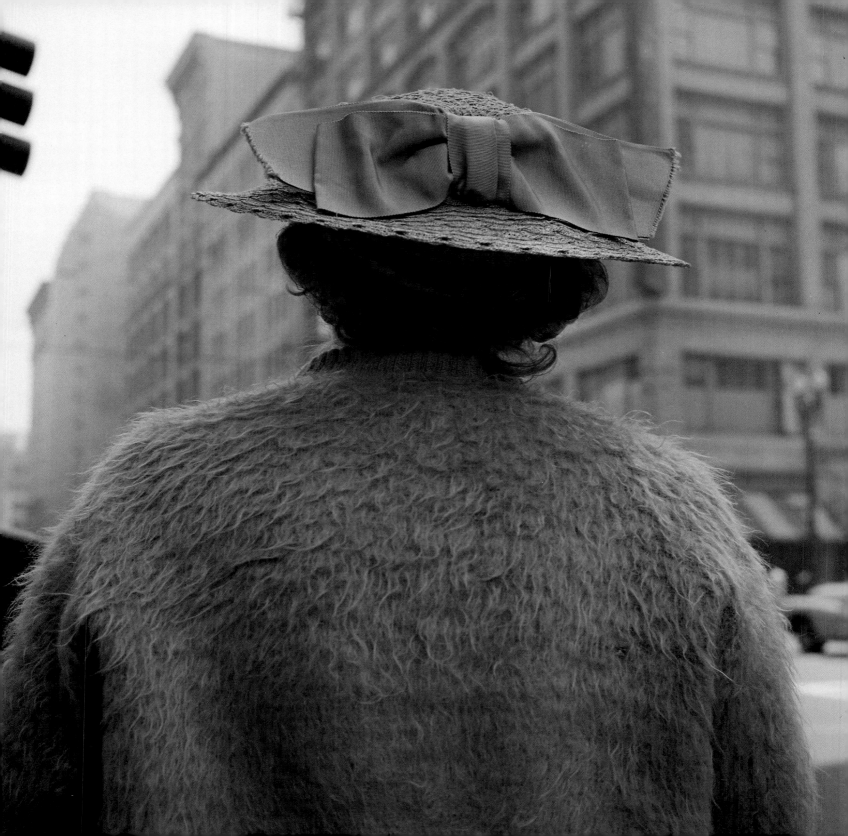

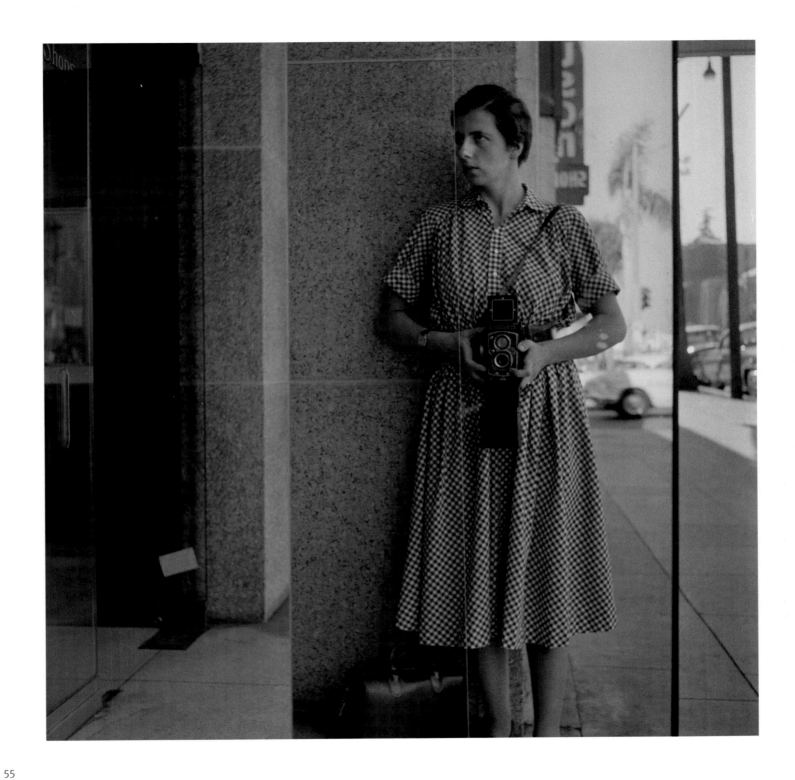

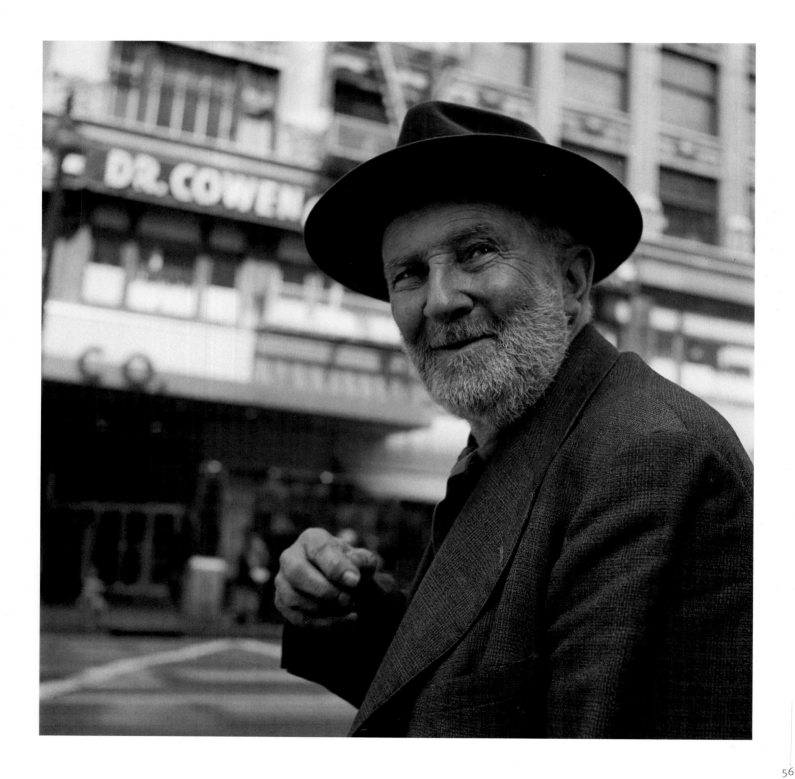

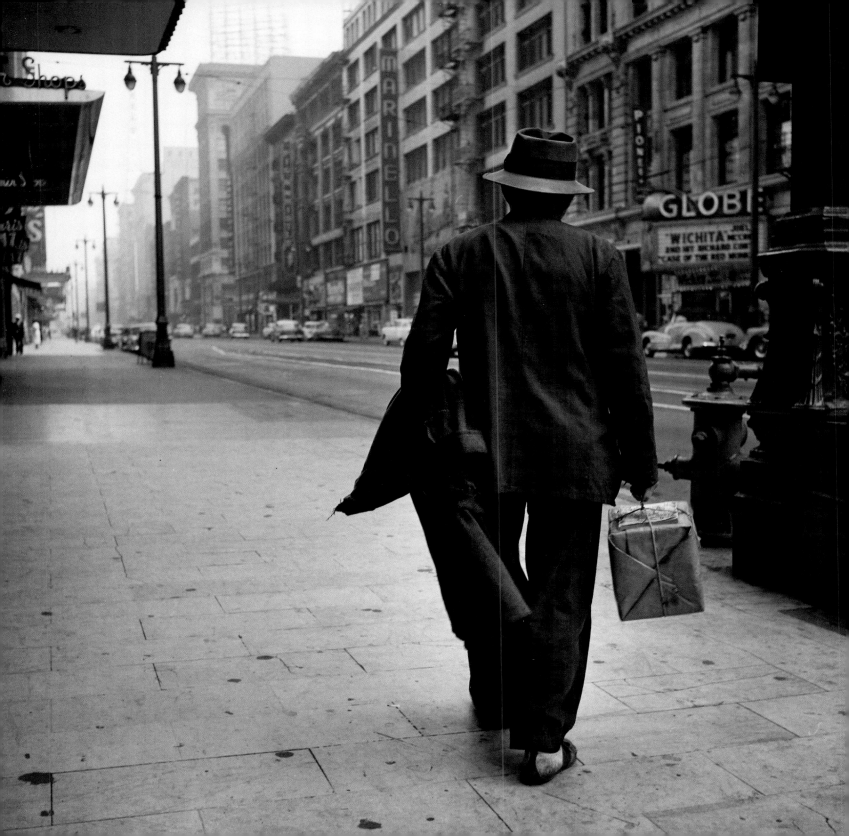

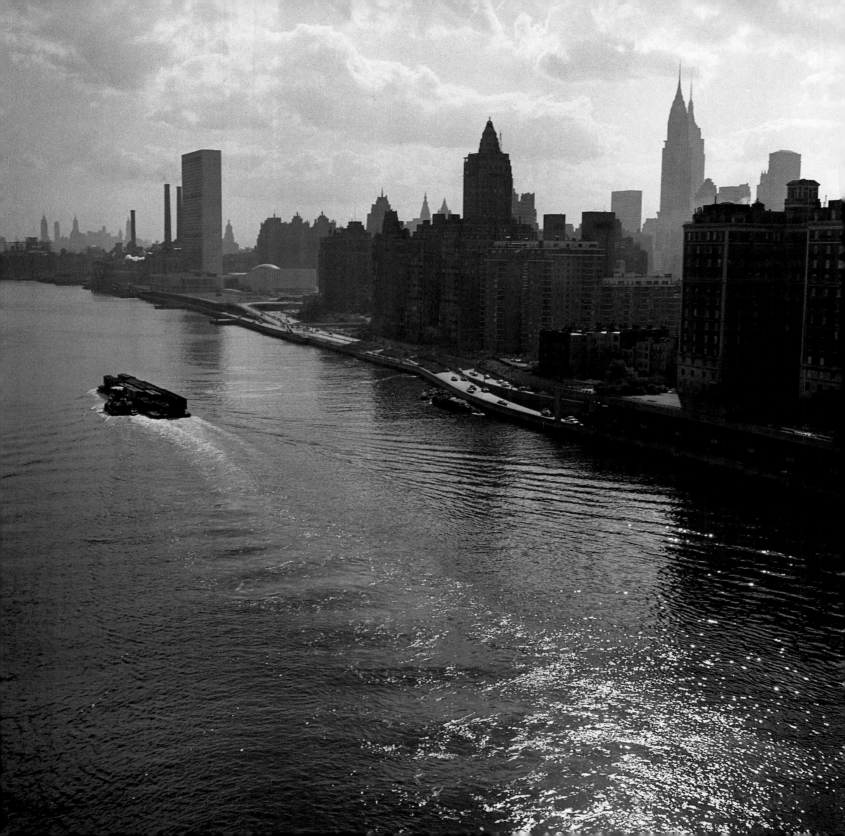

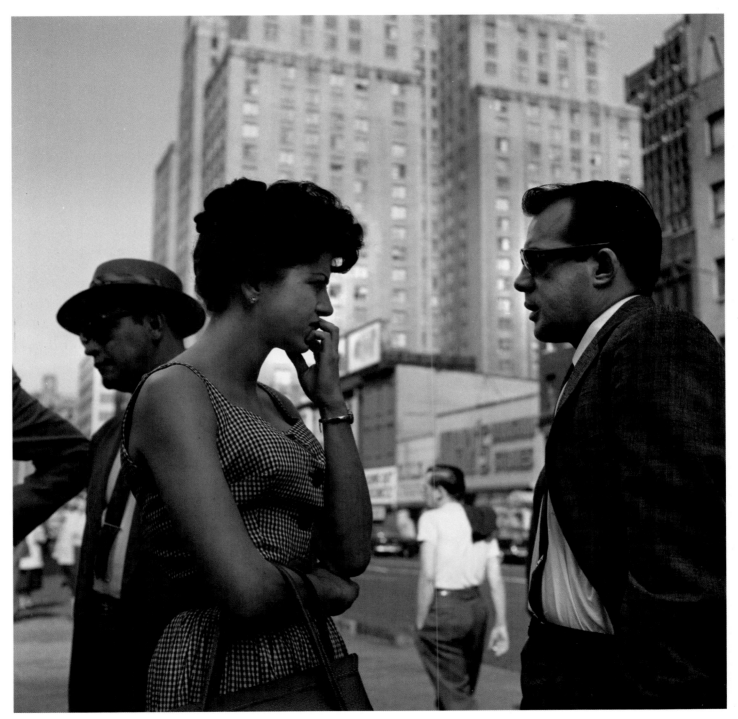

NEW YORK CITY, 1950S

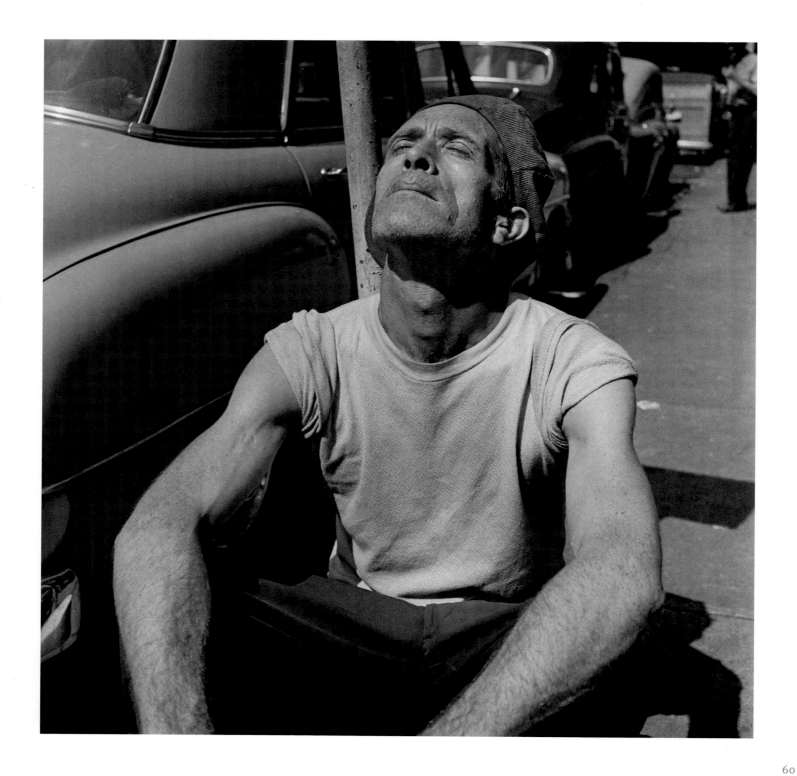

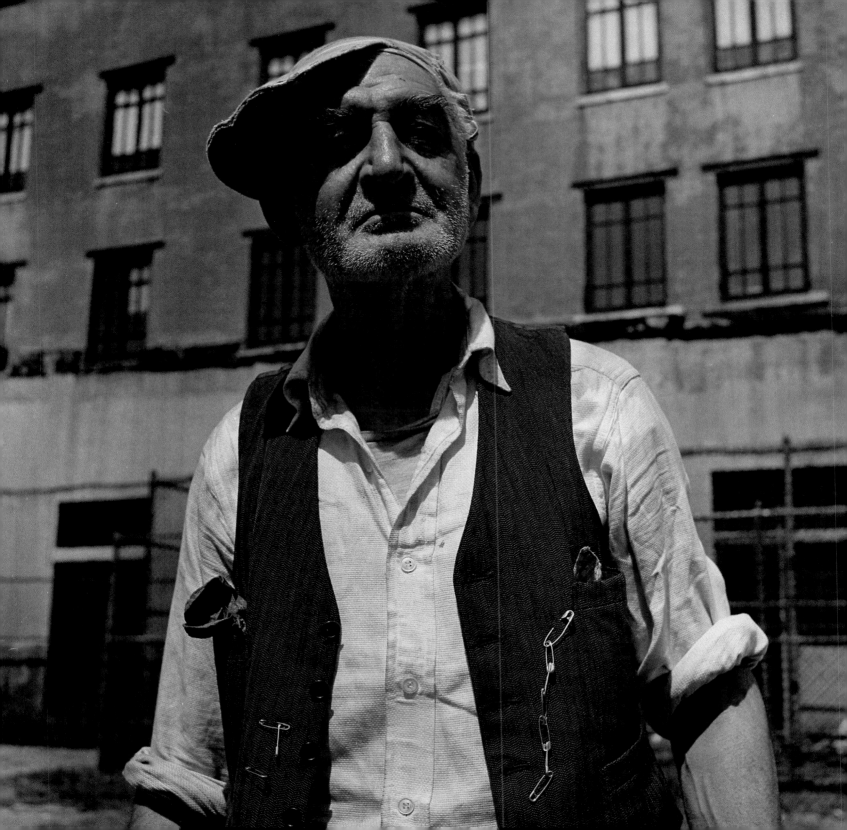

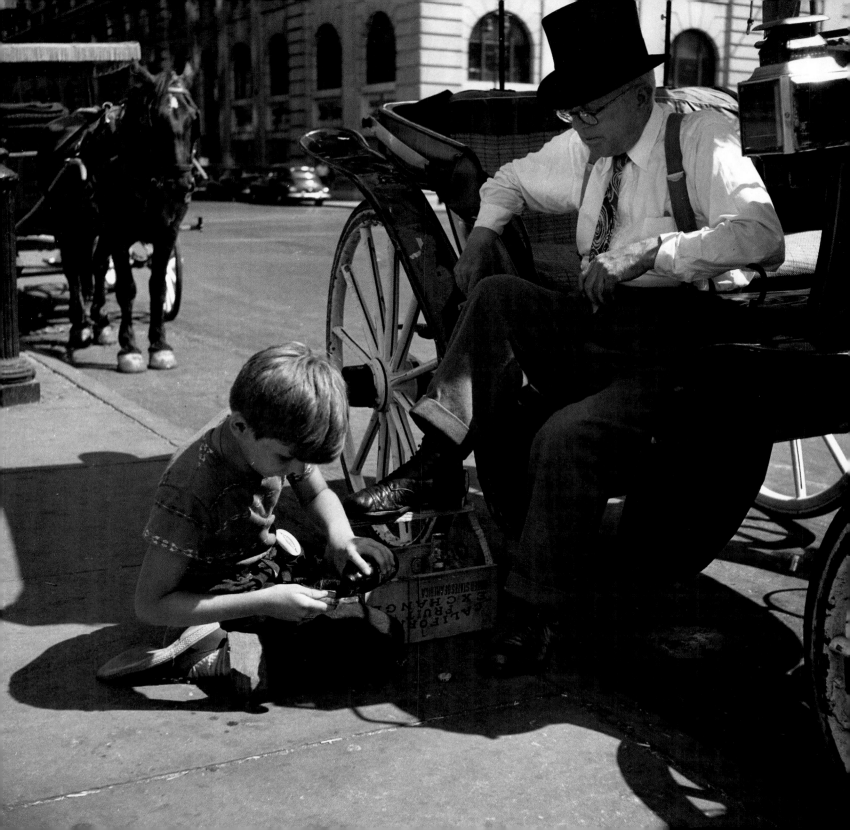

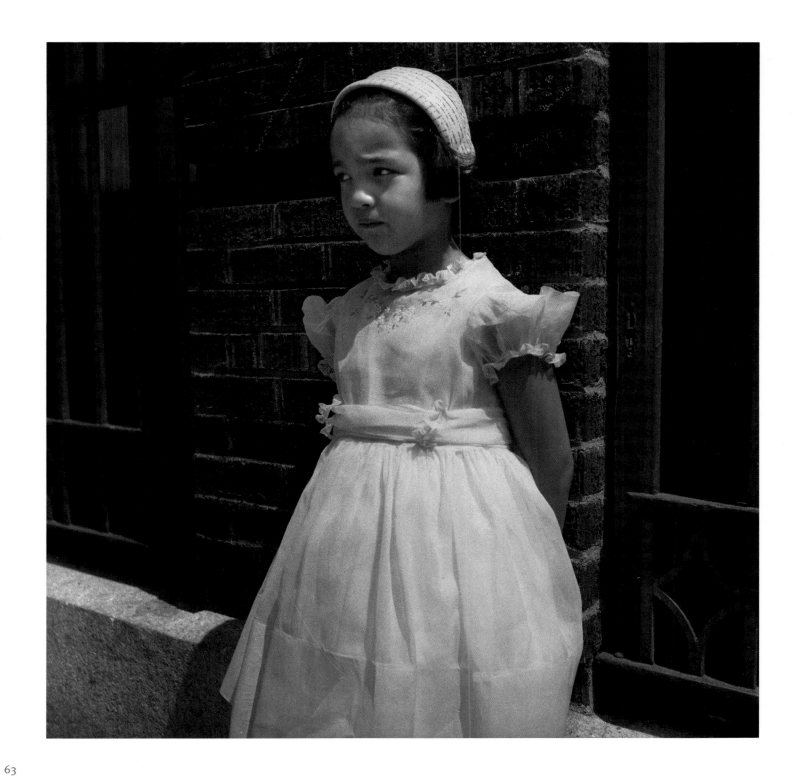

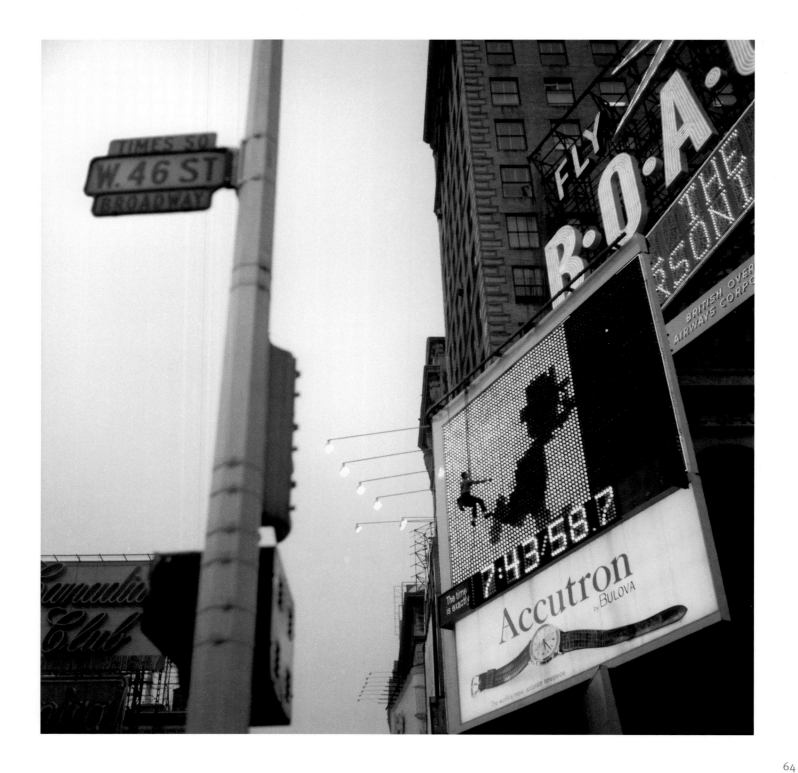

64

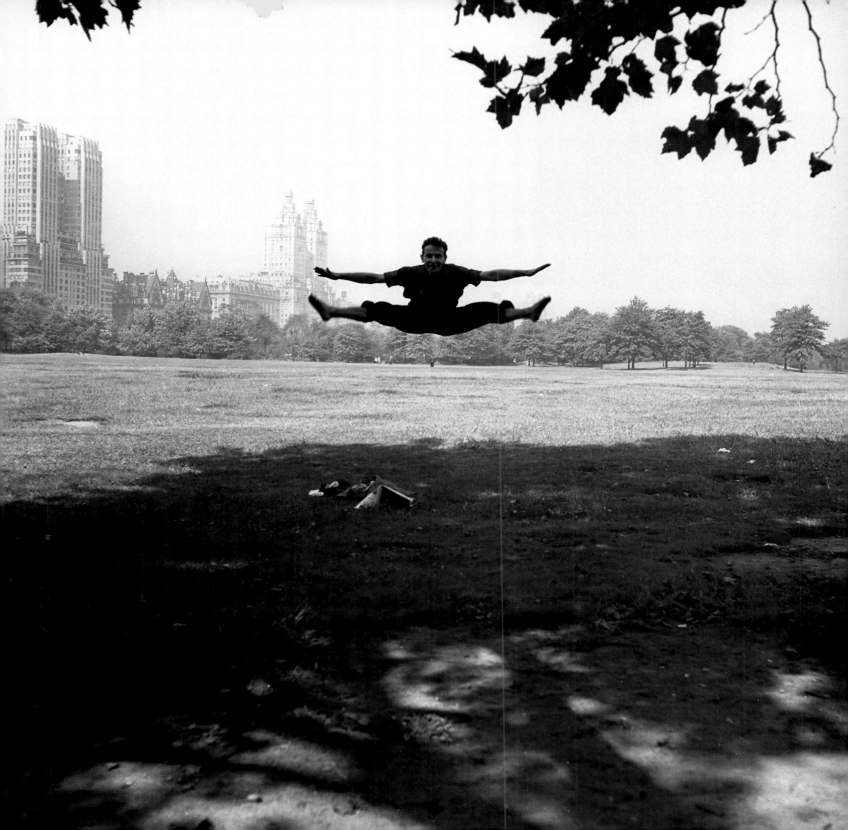

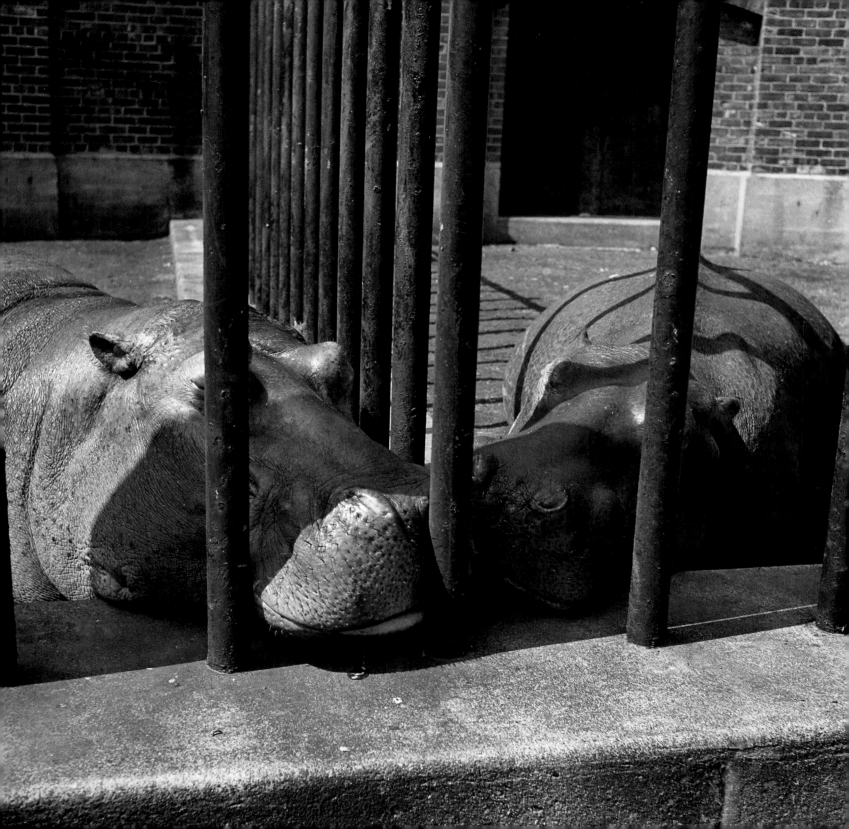

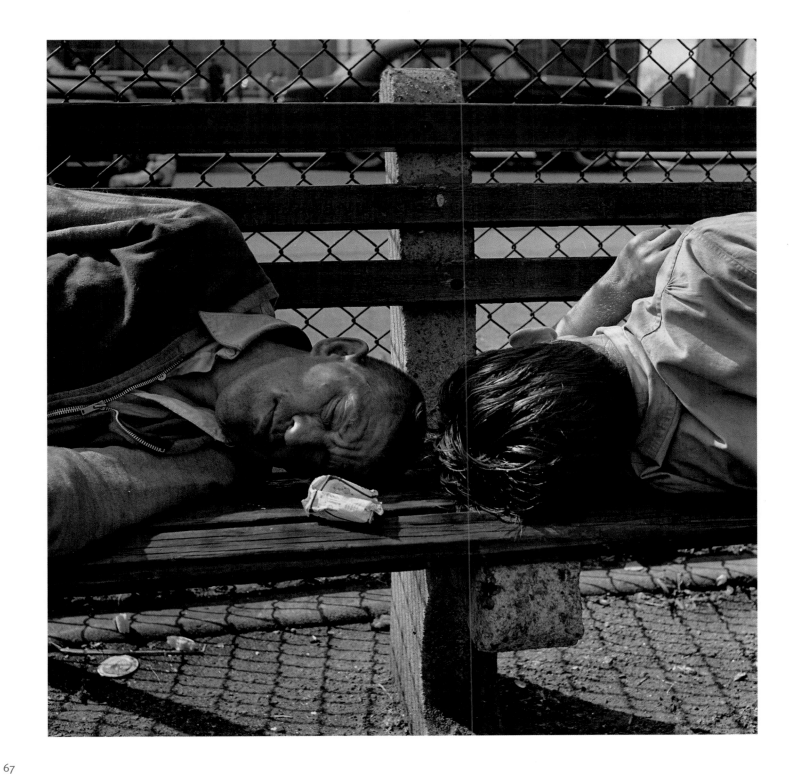

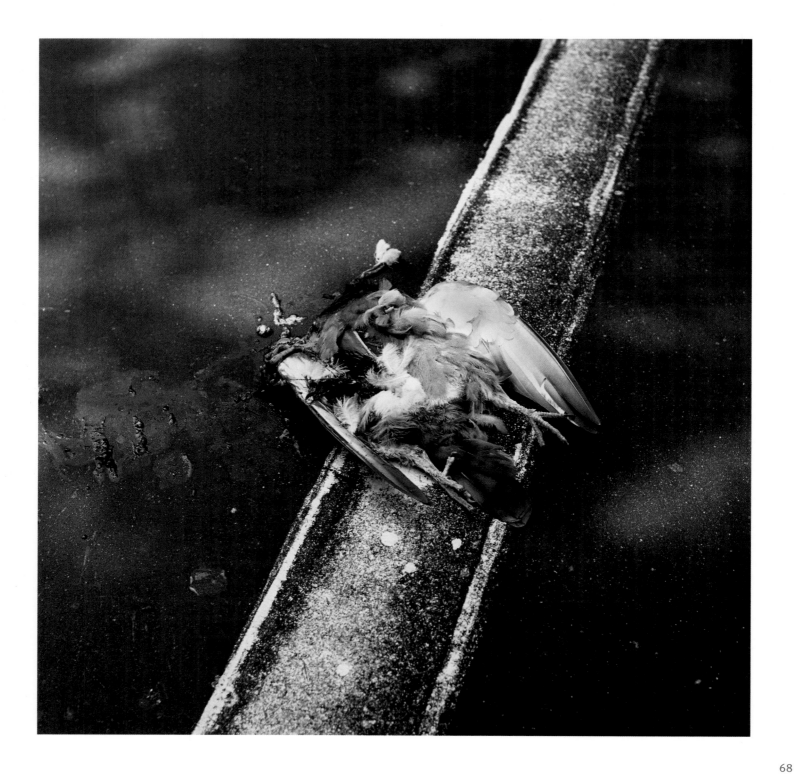

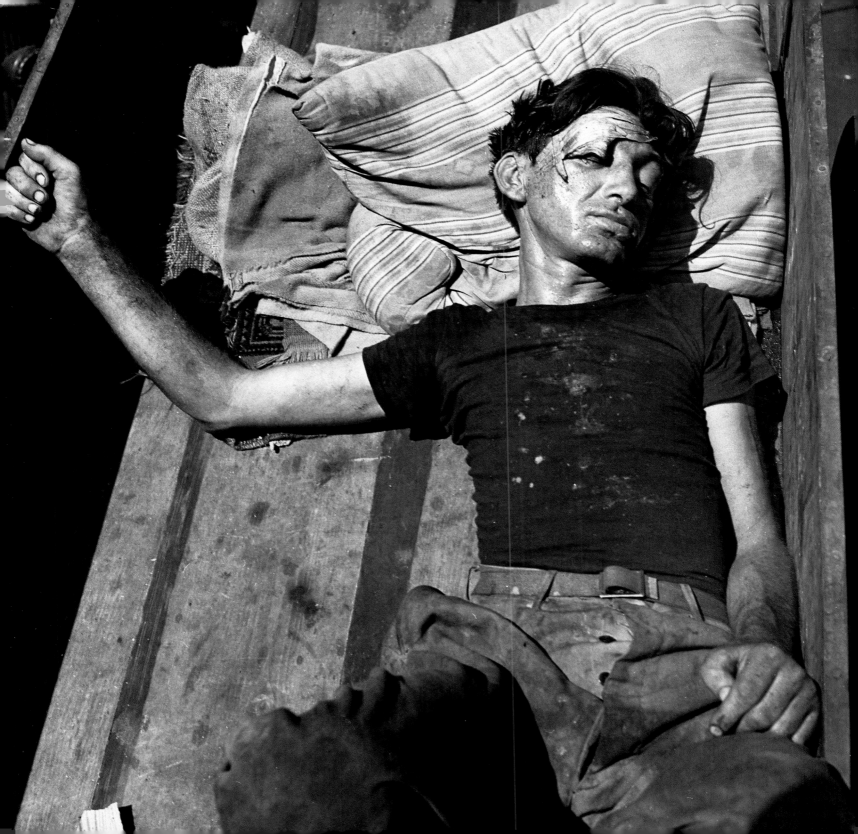

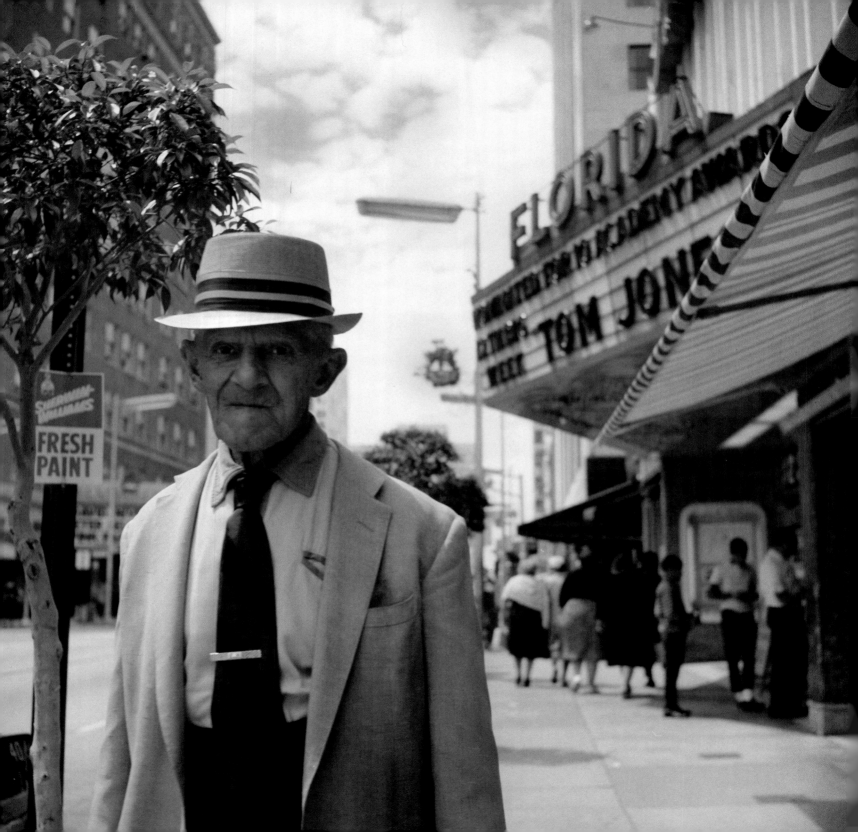

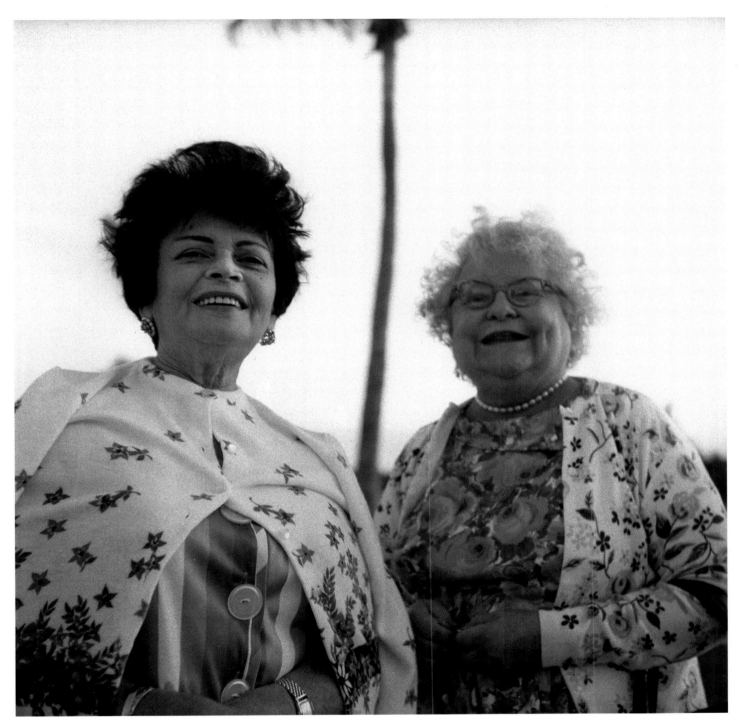

MIAMI BEACH, 1963

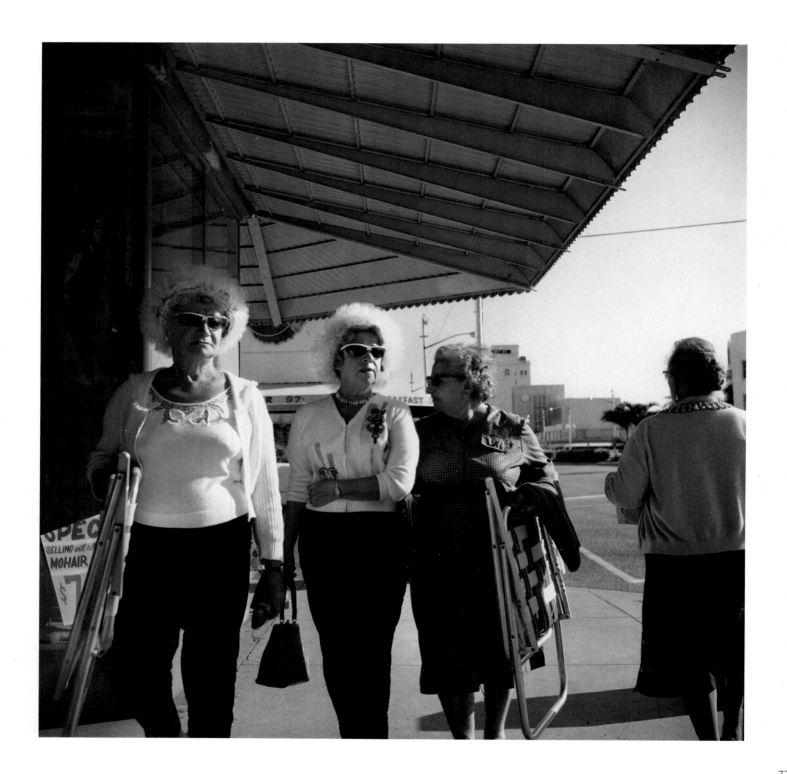

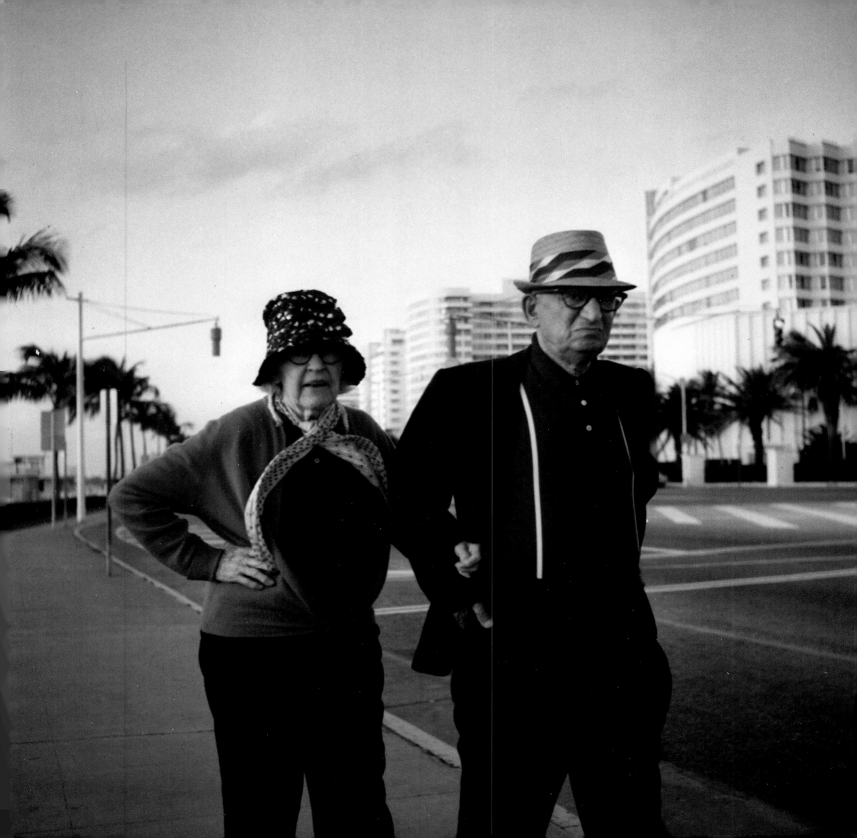

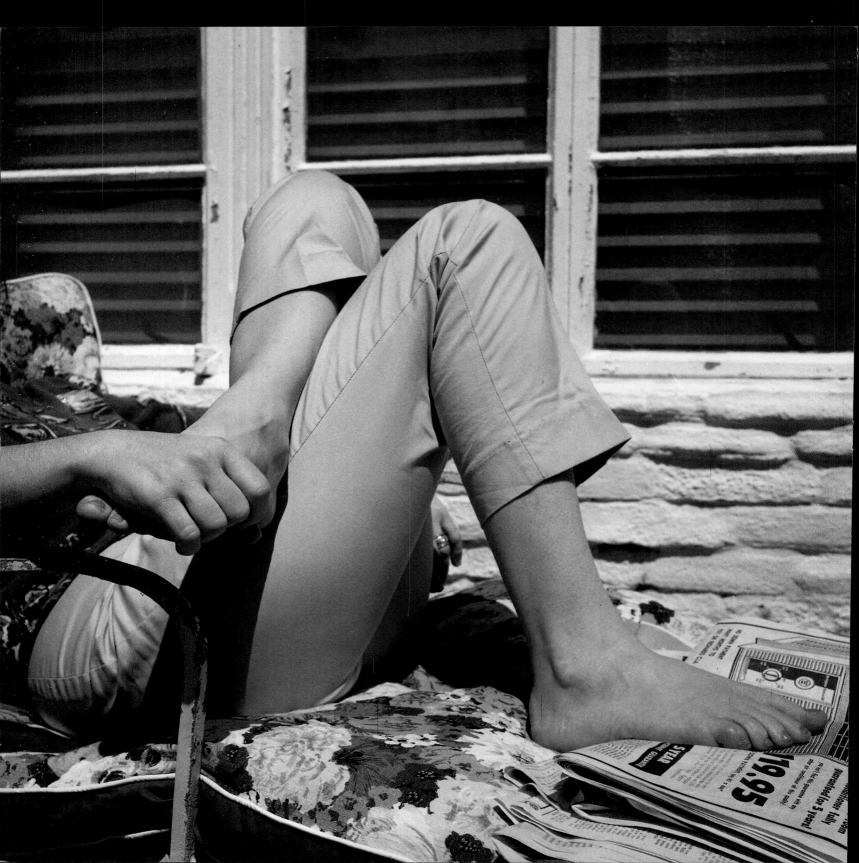

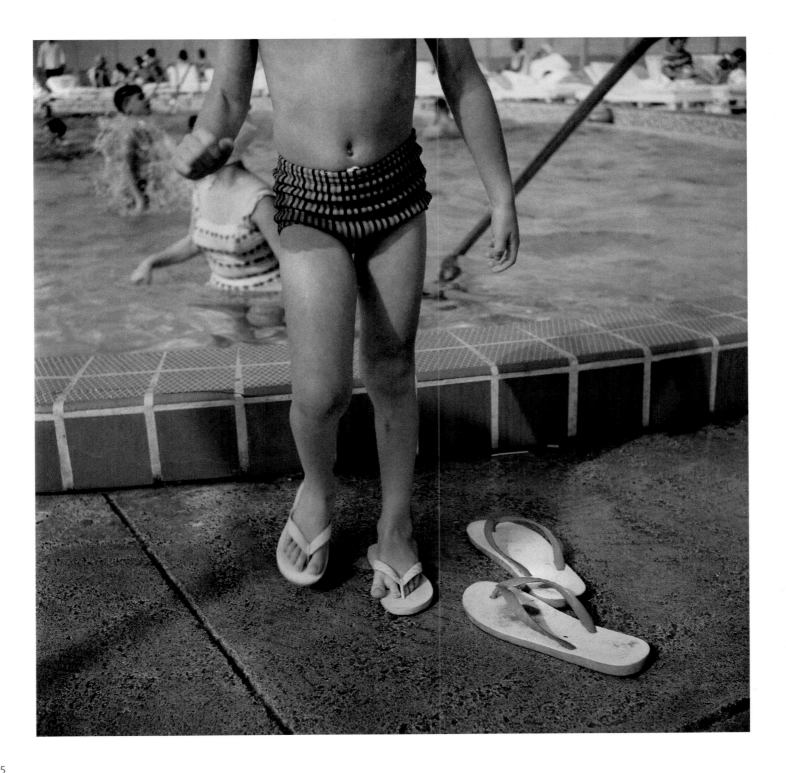

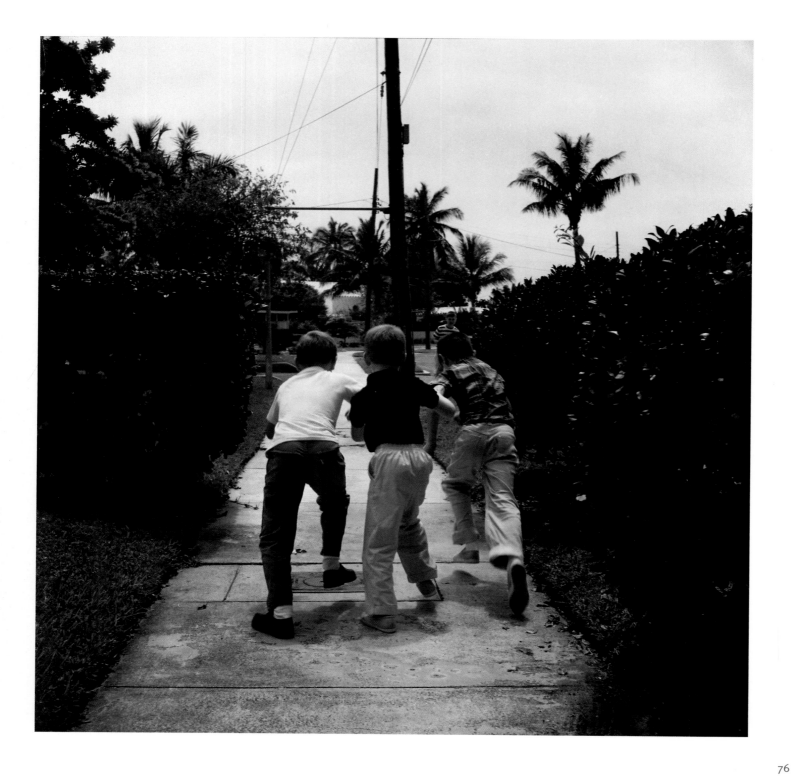

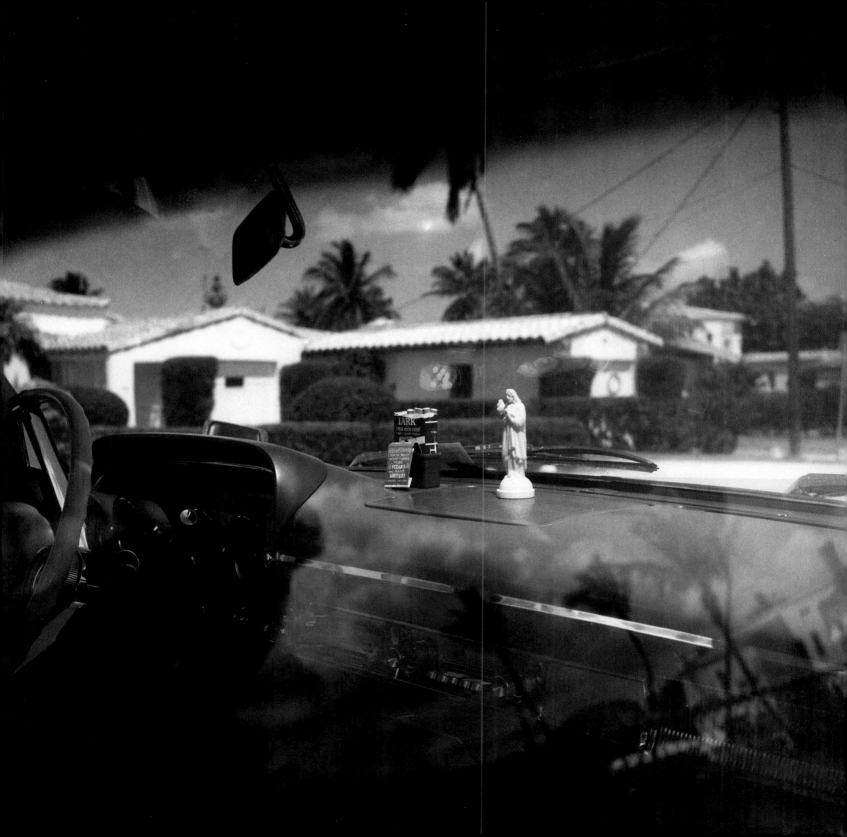

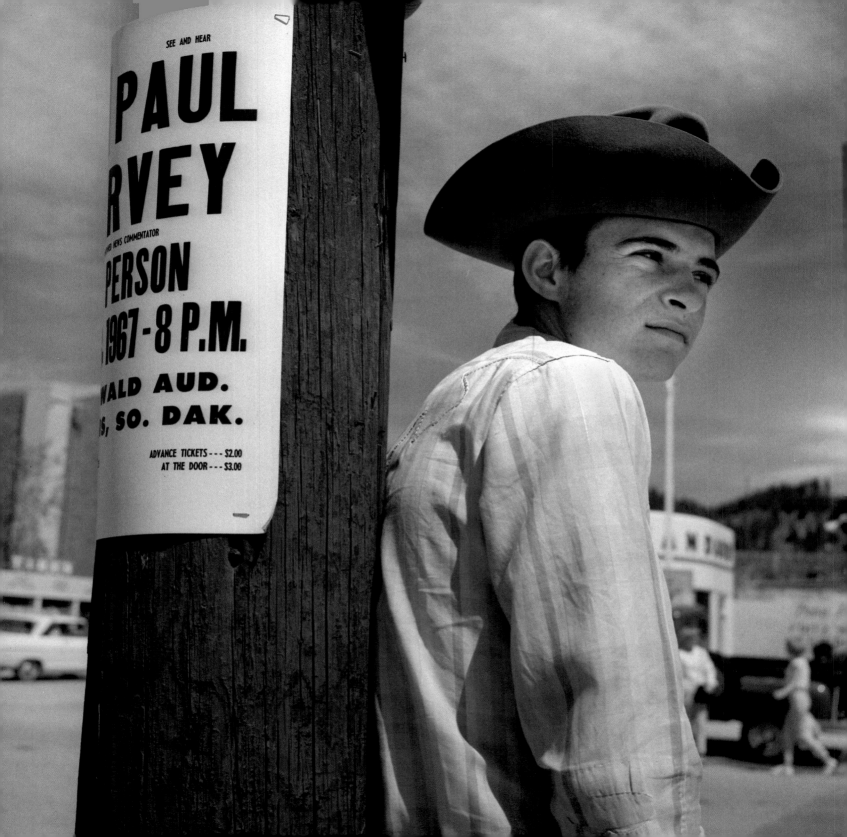

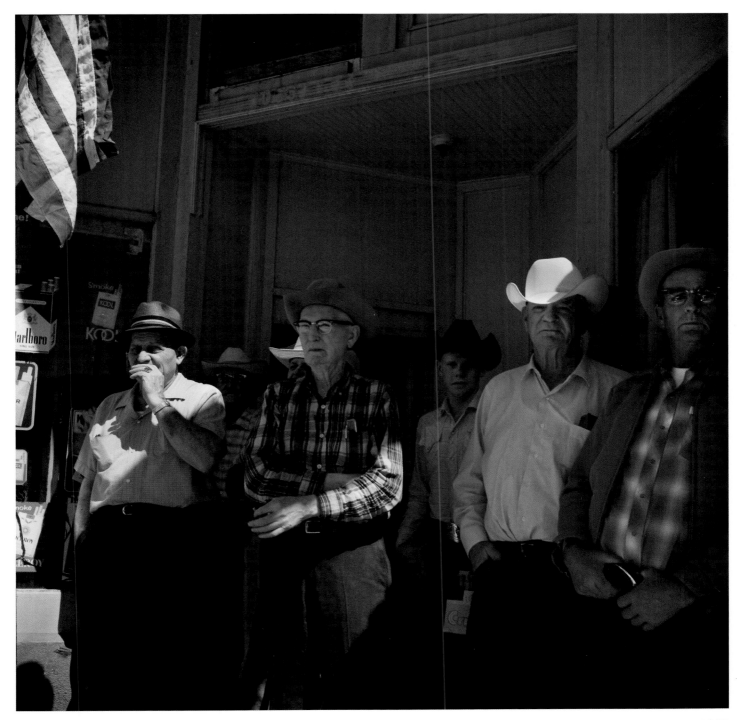

STURGIS, SOUTH DAKOTA, 1967

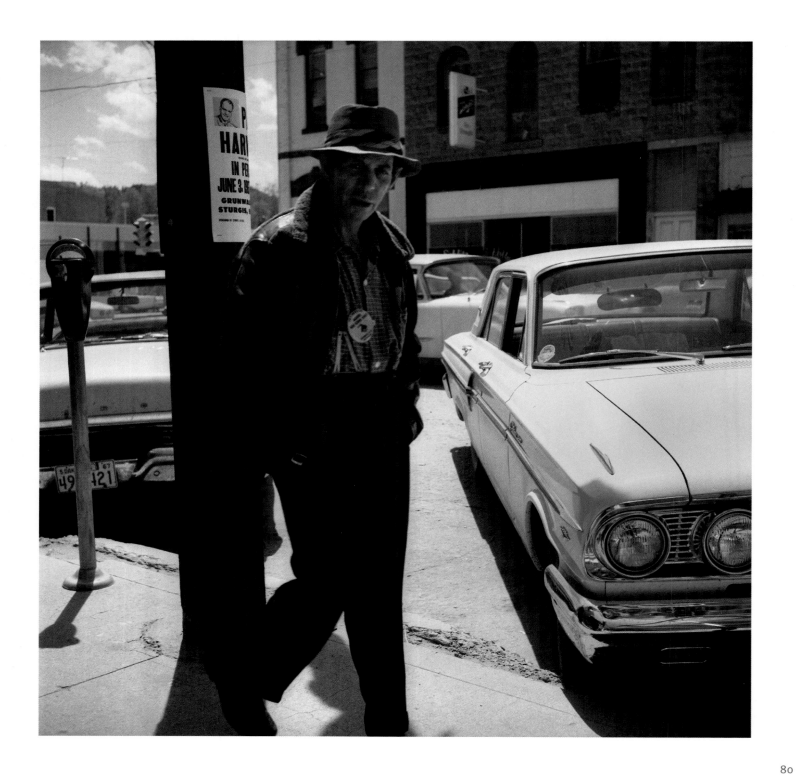

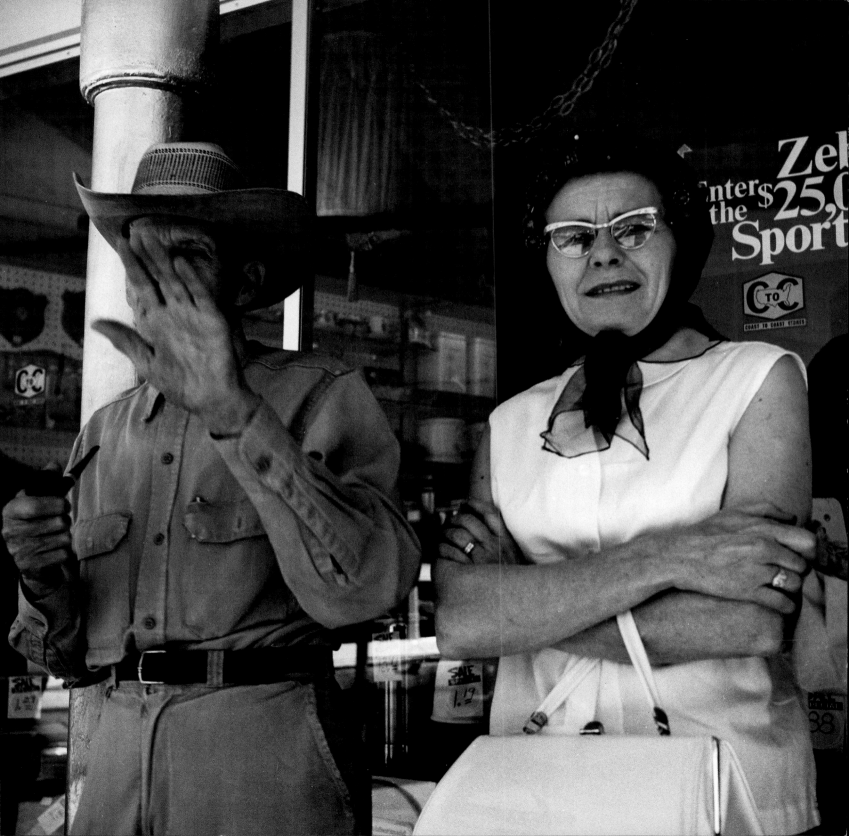

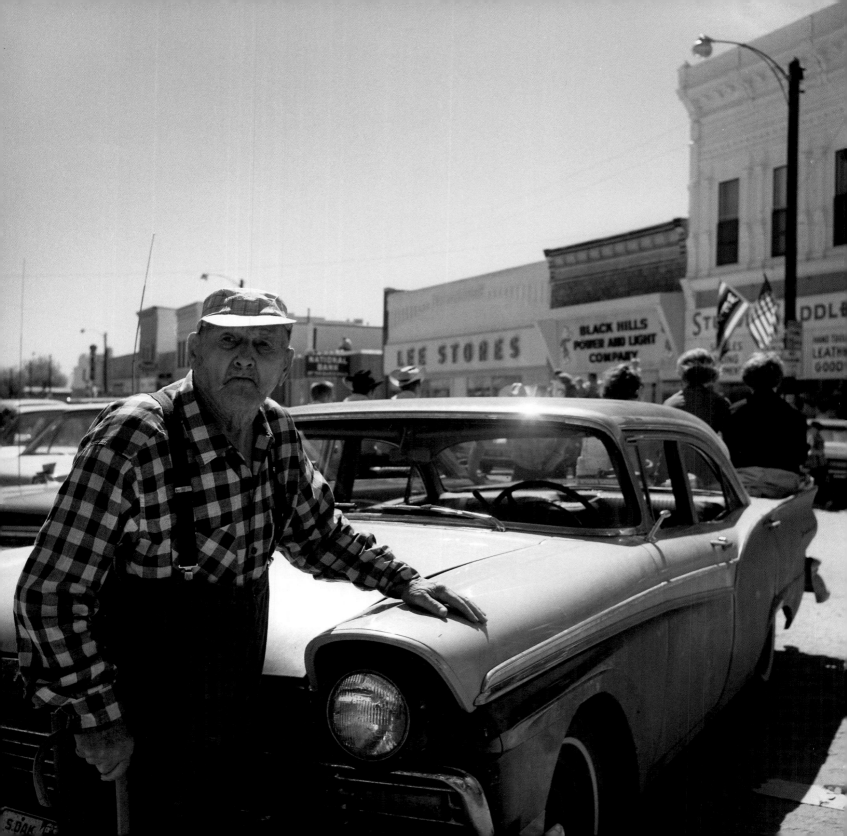

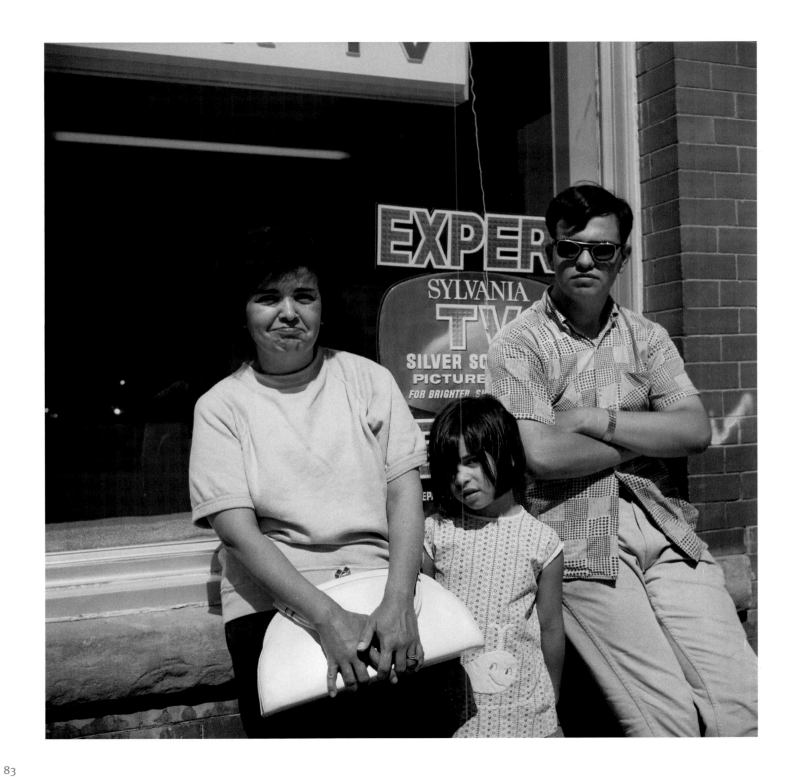

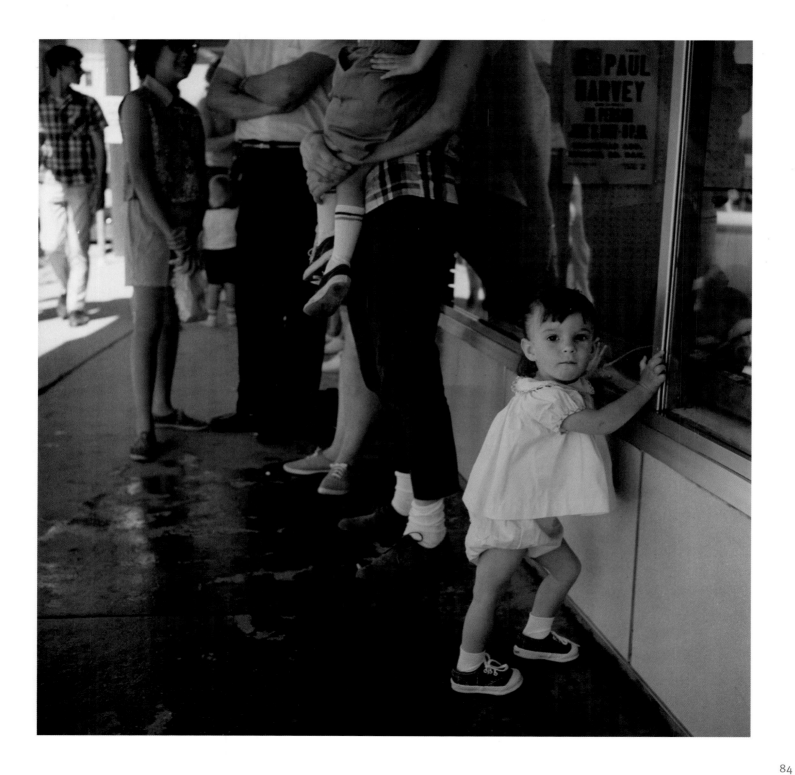

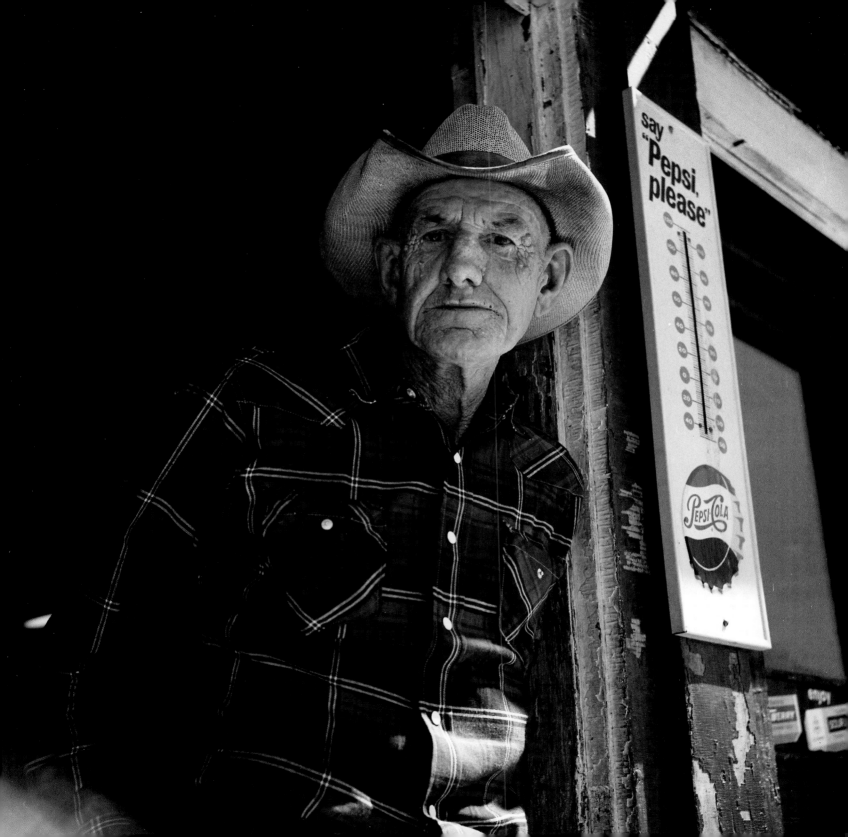

say "Pepsi, please"

Pepsi-Cola

DAY

It's the start of the day. Ginkgo leaves dot the sidewalk. Sneakers sit by the front door. Gardening gloves wait, and tomatoes ripen on the windowsill. The children are off at school as Vivian Maier surveys the house with her camera in the early-morning light.

After a life of change and travel, Maier found a home in the suburbs north of Chicago. Not her own home, but a home with families who valued her. A place where she could walk the cobblestone streets. Ride a bike around town. And take pictures.

The first of her posthumously published photographs were gritty urban scenes. But the heart of Maier's work is ordinary life as a nanny. Hers was the world of children: trikes and bikes, toy-strewn floors, Halloween loot spread across the bed, games of touch football, birthday parties with folding chairs and paper hats. She took thousands of pictures of the children she cared for: sleeping in cribs, discovering their shadows, putting on their pajamas, showing their bruises. She marked these negatives "Les Enfants" and classified some as *assez bon* (rather good).

For her first seventeen years in Chicago, Maier worked for two families: the Gensburgs, from 1956 to 1972, and the Raymonds, from 1967 to 1973. Their children— John, Lane, and Matthew Gensburg and Inger Raymond—filled her life. The kids' homes, possessions, friends, and parents became the subjects of many of her photographs.

Avron and Nancy Gensburg lived in a modern house in a wooded Highland Park neighborhood on the shore of Lake Michigan, about twenty-five miles north of downtown Chicago. Avron, an executive with a pinball company, and Nancy, a sculptor and interior decorator, responded to Maier's ad in the paper. "All I want to do is care for the babies and cook for them," she told Nancy, who was struck by Maier's manner, intelligence, and confidence. "I don't think anybody would have hired her for what I hired her for," Nancy said. "But I'm an artist, and I like interesting people. Vivian was lovely."

Thus began a remarkable relationship. The Gensburgs set up a bedroom for Maier in their basement, and she converted the bathroom into a darkroom, bringing in an enlarger, keeping stainless steel developing tanks next to the sink, and using the shower to hang processed film. "She always kept the door locked, and we could never get in—not that we wanted to," said Avron. "And that's where she developed a lot of her film." On Thursdays and Sundays, her days off, Maier would head into the city to take pictures if she wasn't spending the day in the darkroom. Most every day off she went to the movies—classics, foreign films,

independents—which she would then critique for the family.

She became an important part of the Gensburg home. In the boys' words, she was their "second mother." She taught them a bit of French and took them to all sorts of lessons, to museums, to Chinese New Year parades, and to the forest preserves to forage for wild strawberries. One day, they hitched a ride to school on a milk truck. "She was like Mary Poppins," Lane Gensburg told *Chicago* magazine. "That's about the best way to explain it. She was like a real, live Mary Poppins." Lane said she never talked down to kids and was determined to show the boys the world outside of Highland Park. "Everything she did was interesting."

And like the fictional nanny, Maier remained something of a secret. She seldom told the family where she was going, and rarely talked about herself. It was all part of her magic, which the family accepted, even embraced. Lane recalled the day she was organizing a neighborhood play. After asking the children whom they wanted to portray, one of the kids asked her the same question. "Oh, I'm the mystery woman," Maier responded.

As the boys grew older, Maier got a second job, as a governess for five-year-old Inger Raymond, in Wilmette, about nine miles south of Highland Park. Inger's memories are similar to the Gensburgs'. With long strides and a determined gait, Maier took the little girl all over Chicago. If Inger asked where they were going, Maier would say only that they were off on an adventure. "She was hard to keep up with," Inger recalled.

Domestic life became one of the major themes of Maier's photography during these years. Her pictures of Highland Park and Wilmette reveal the kinds of things that caught her eye. She photographed plumbers and telephone repairmen, tree trimmers and piano tuners. When one family donated its old washing machine to charity, Maier was there to document it being hauled away. Her quietly bold pictures illustrate what everyday life looked like back then.

As she slowed down and looked around, Maier saw the value in that life. She traded the thrilling landscapes of France and New York for lemonade stands, Valentine's Day cards, and vocabulary lists. Yet she was no less serious in her work, still carefully making her notes on negative sleeves. Sometimes they were about exposure or processing, but often they were memories. "Matt's first success with jungle gym, June 1960," she wrote on one. "John recited his part perfectly," she recorded after a school play. That she cared deeply about both parts of her life is unmistakable.

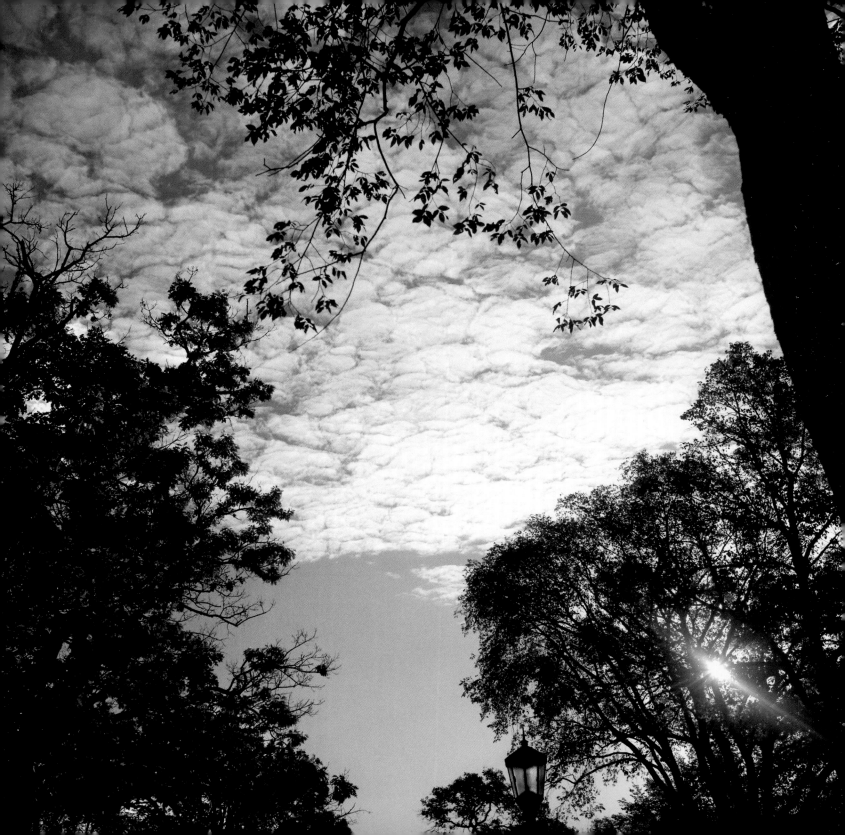

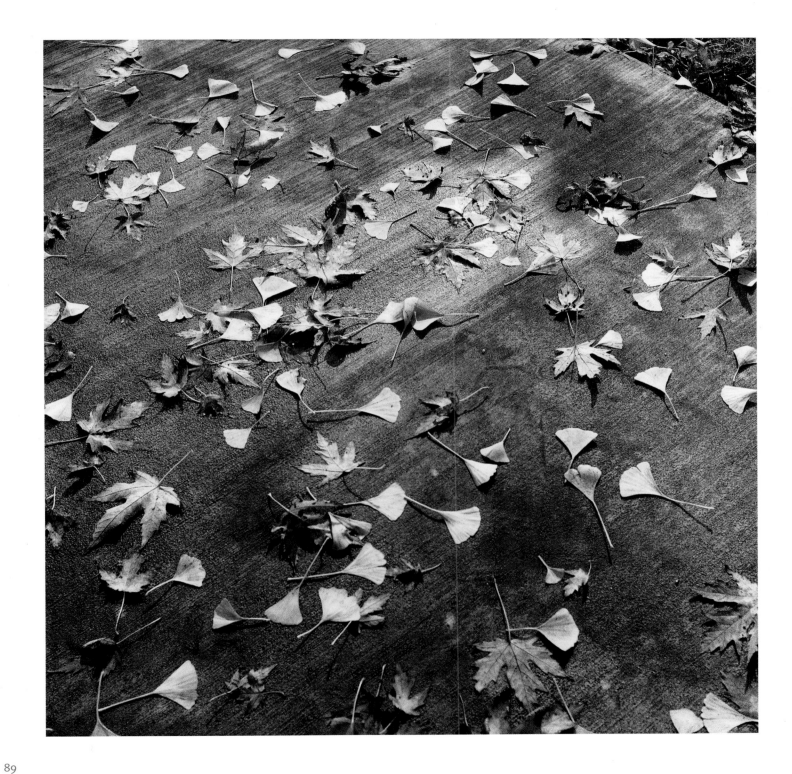

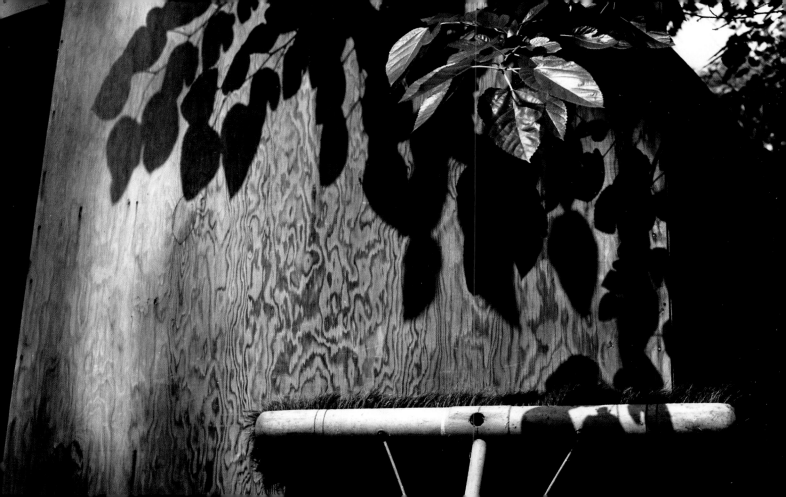

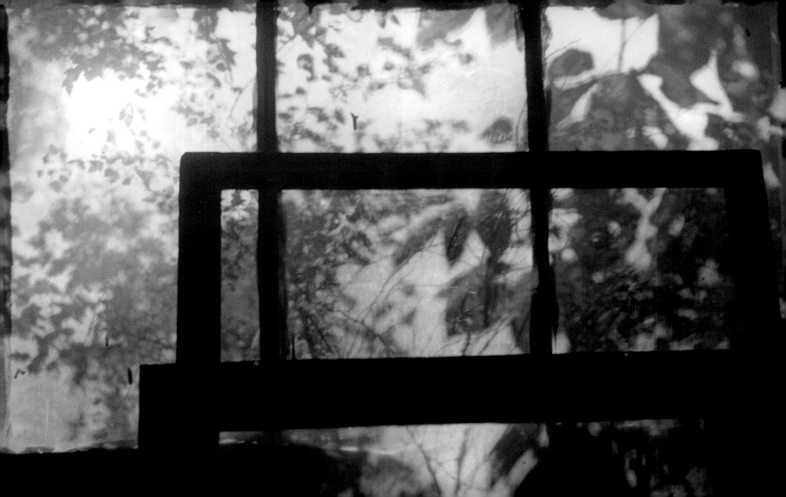

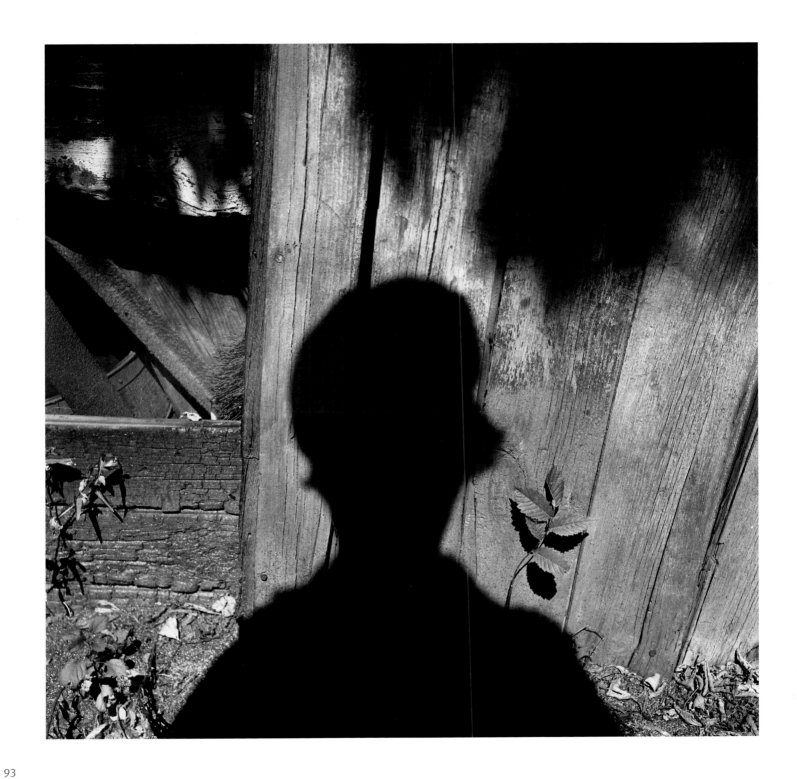

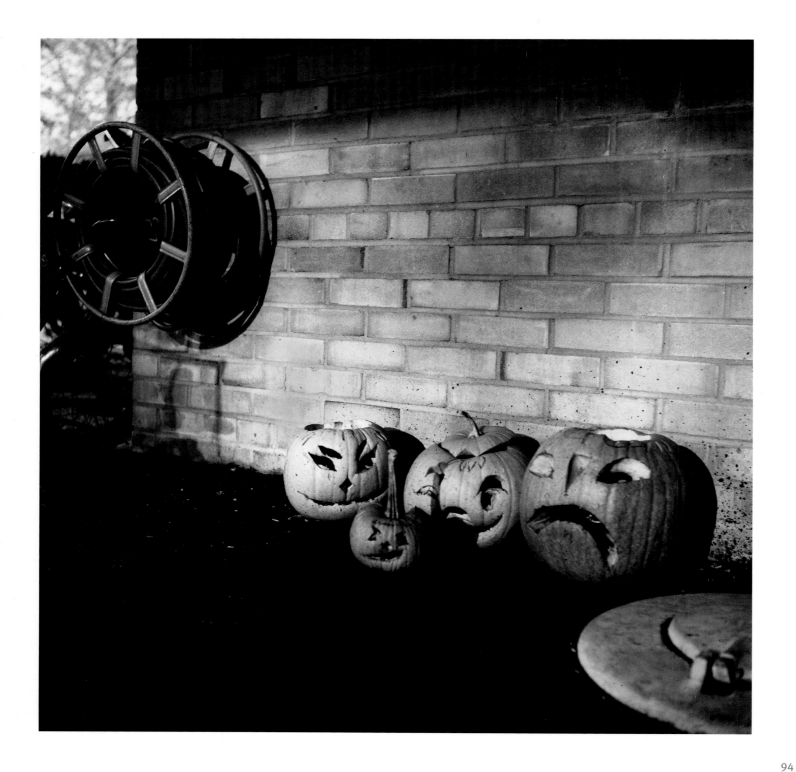

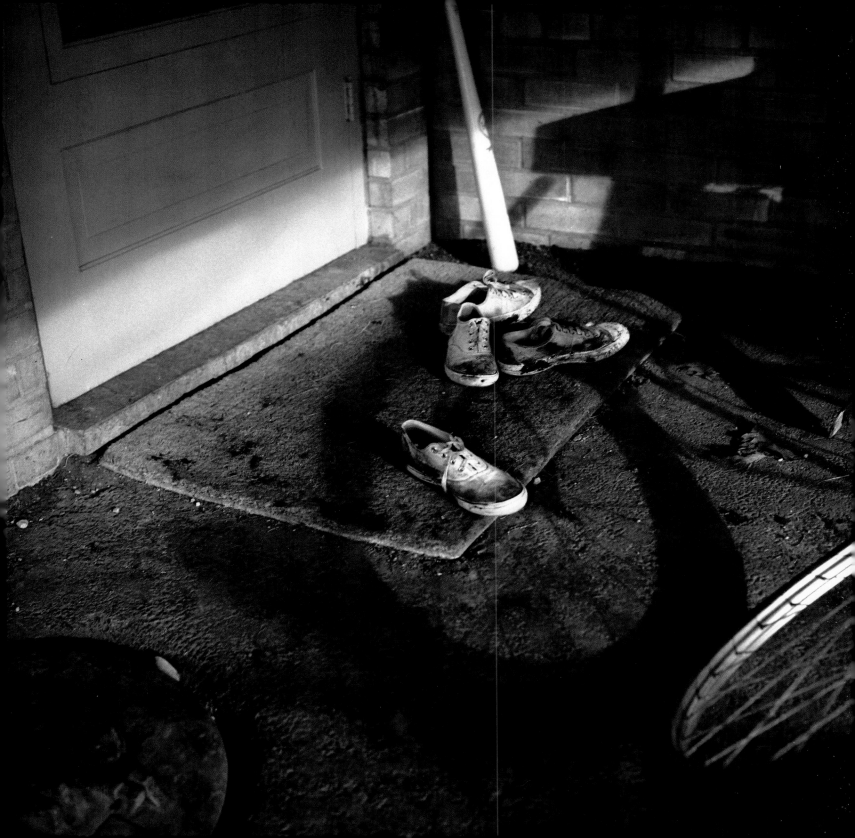

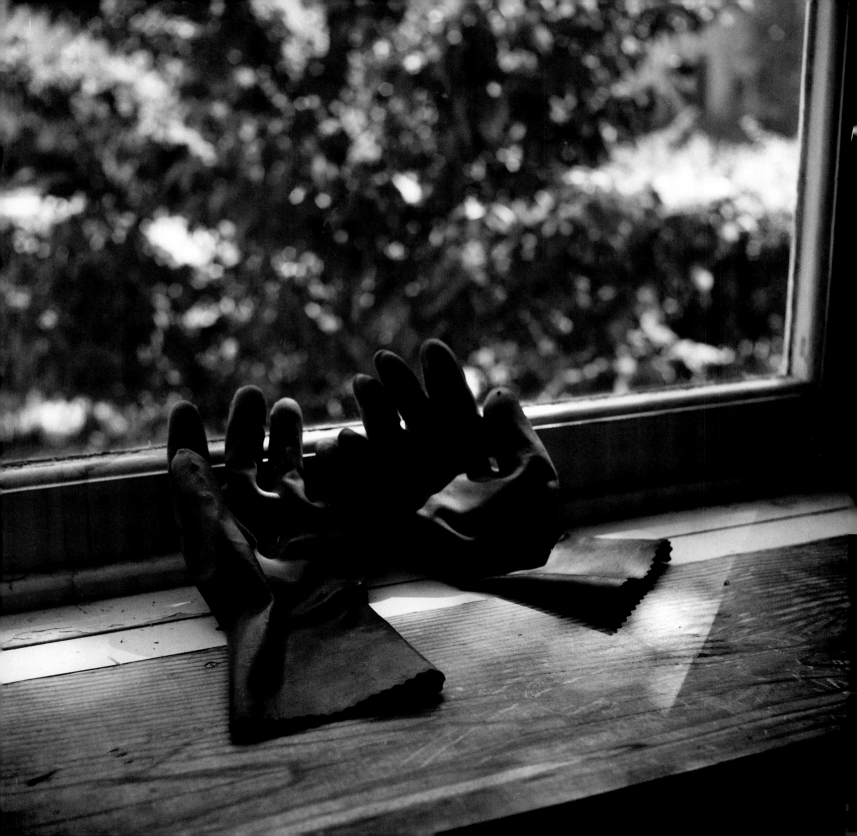

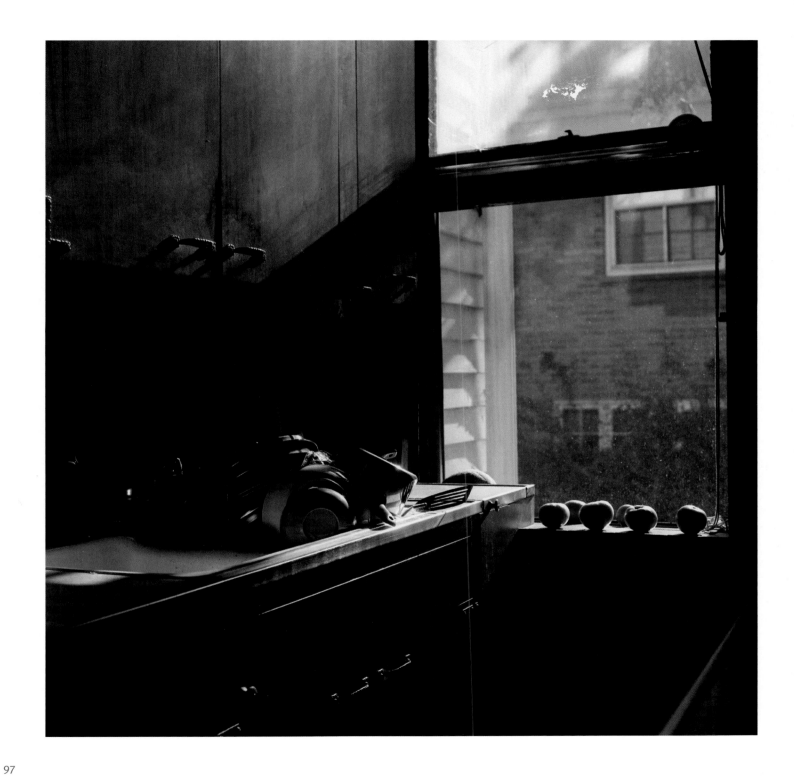

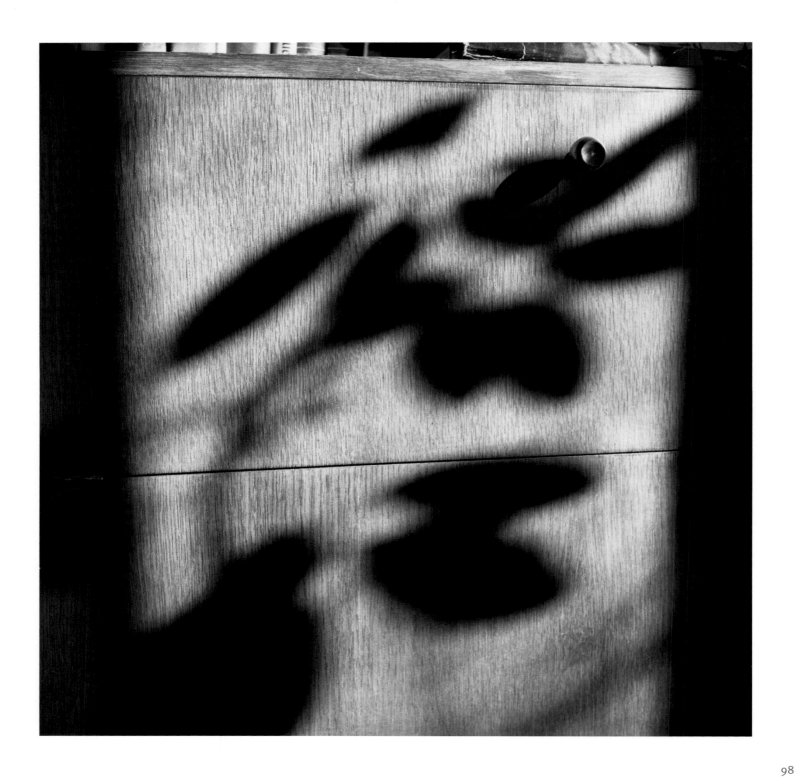

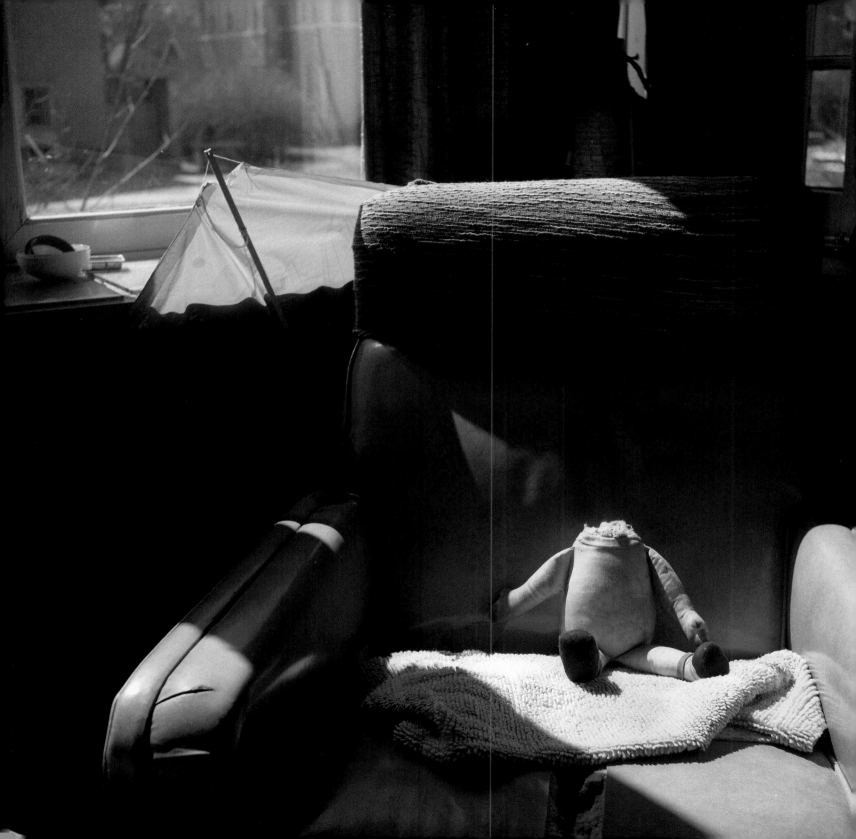

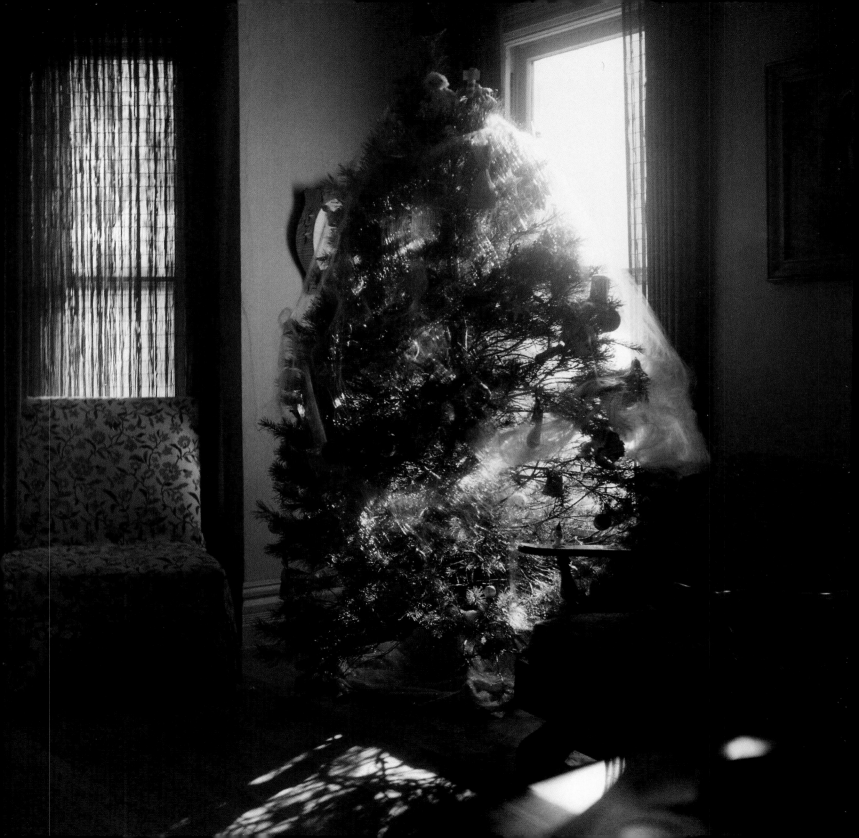

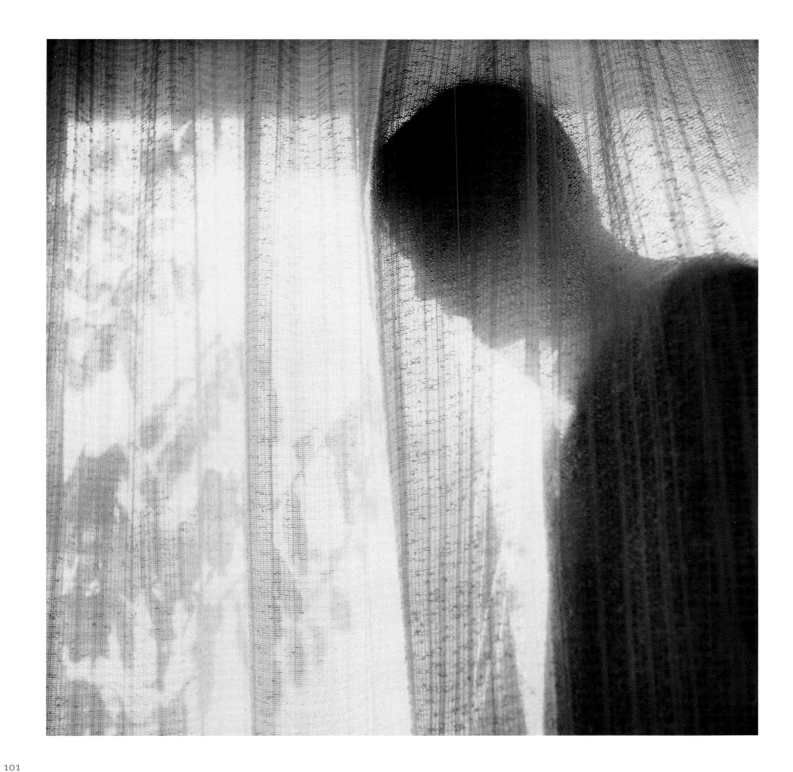

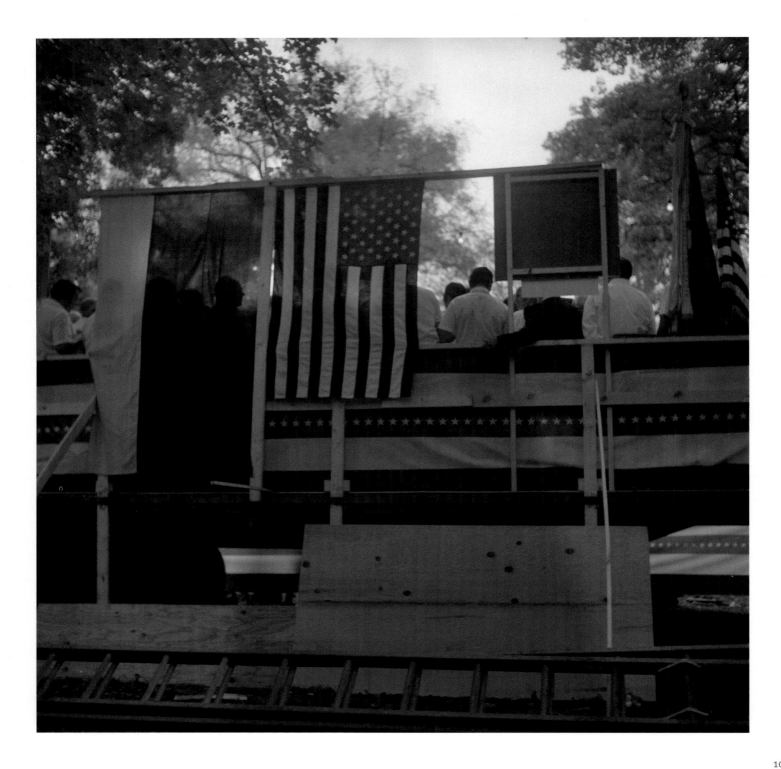

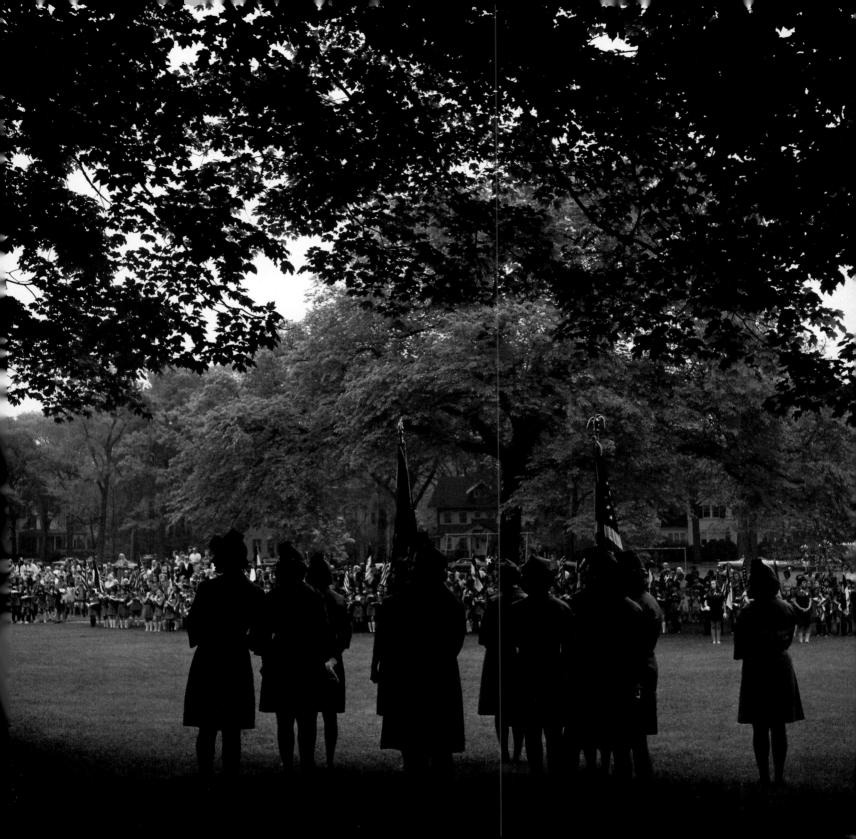

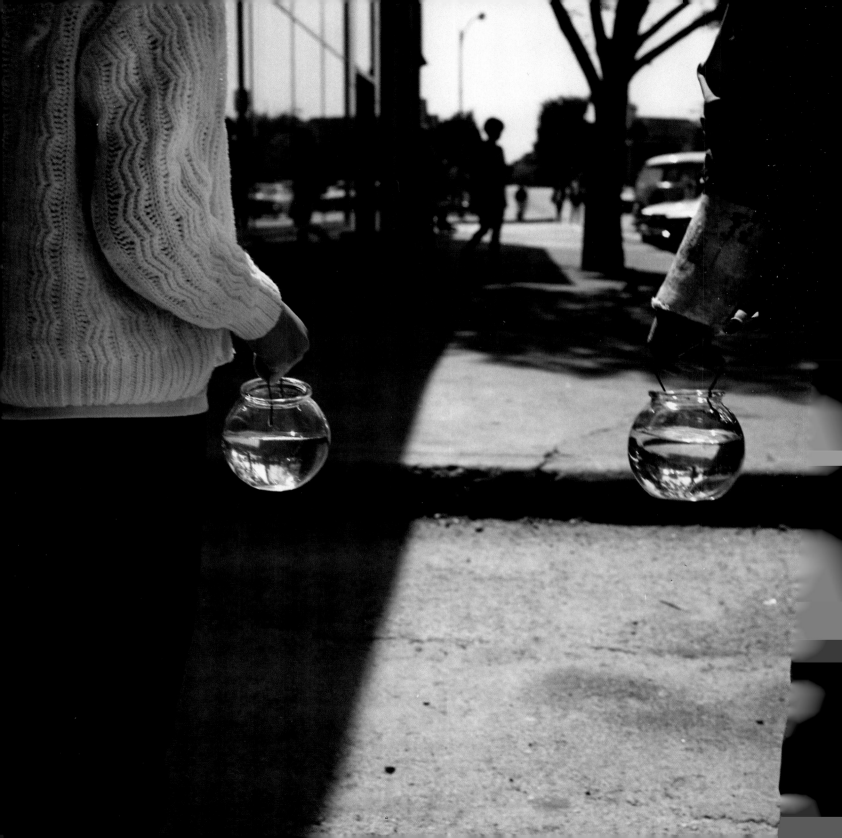

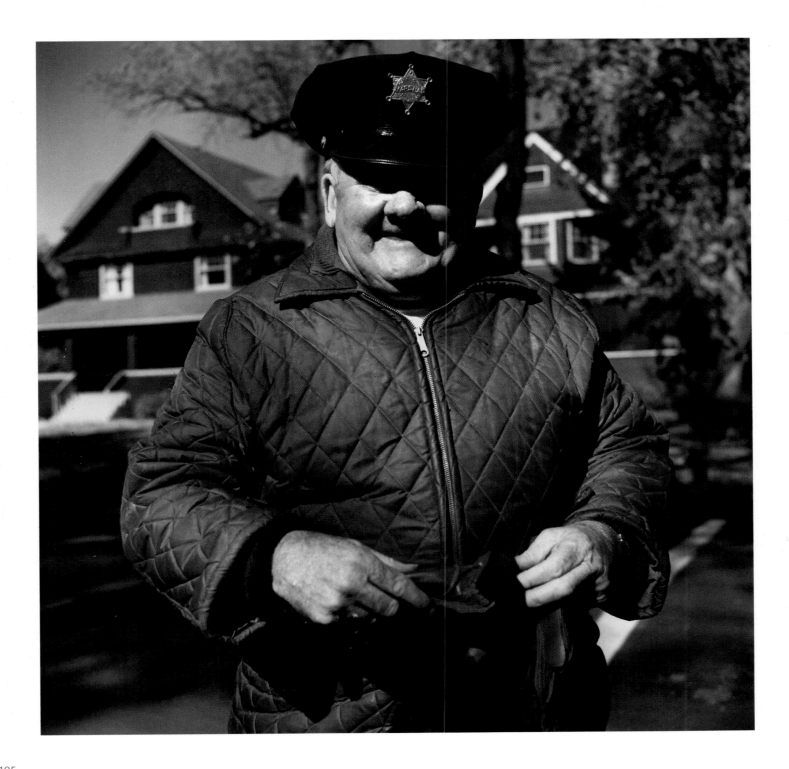

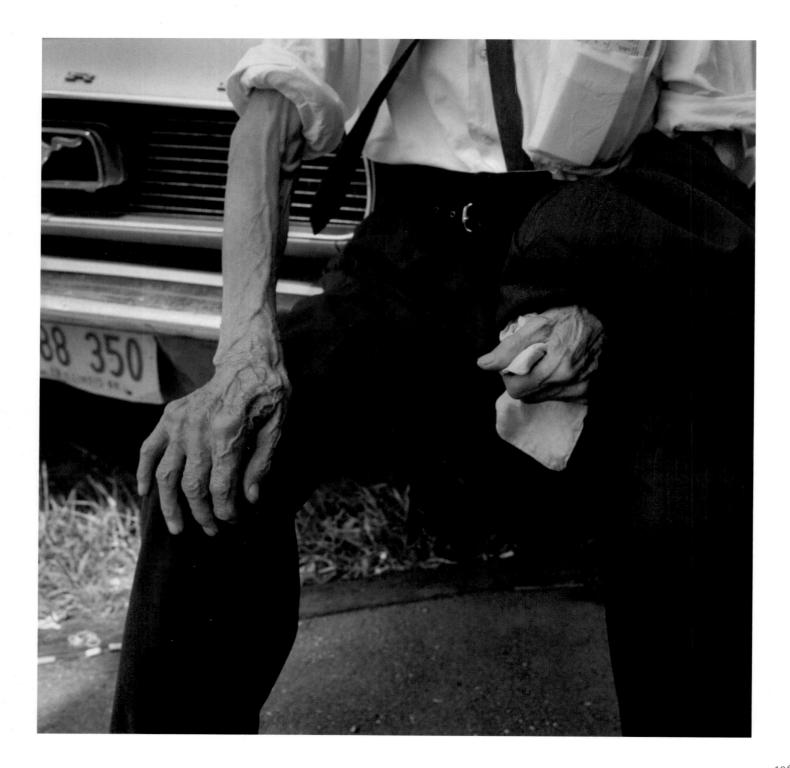

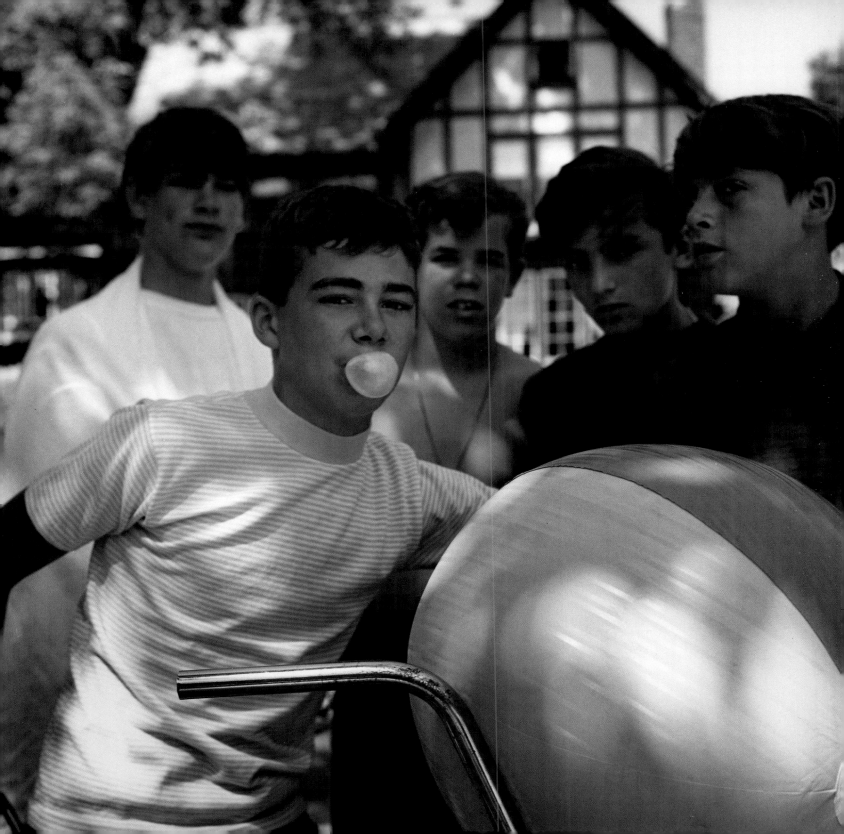

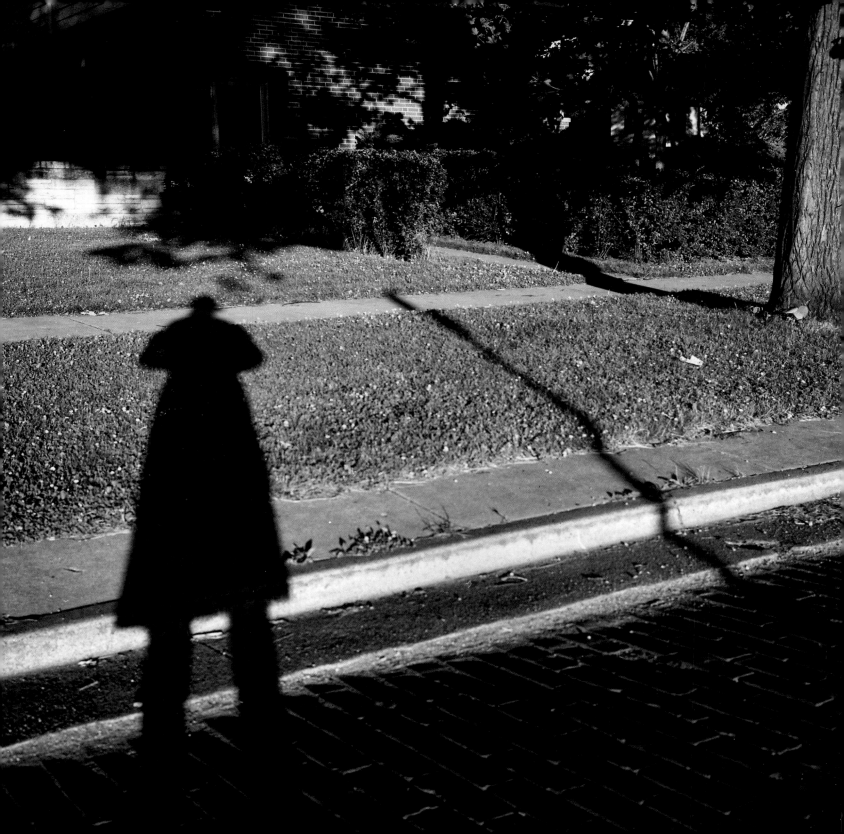

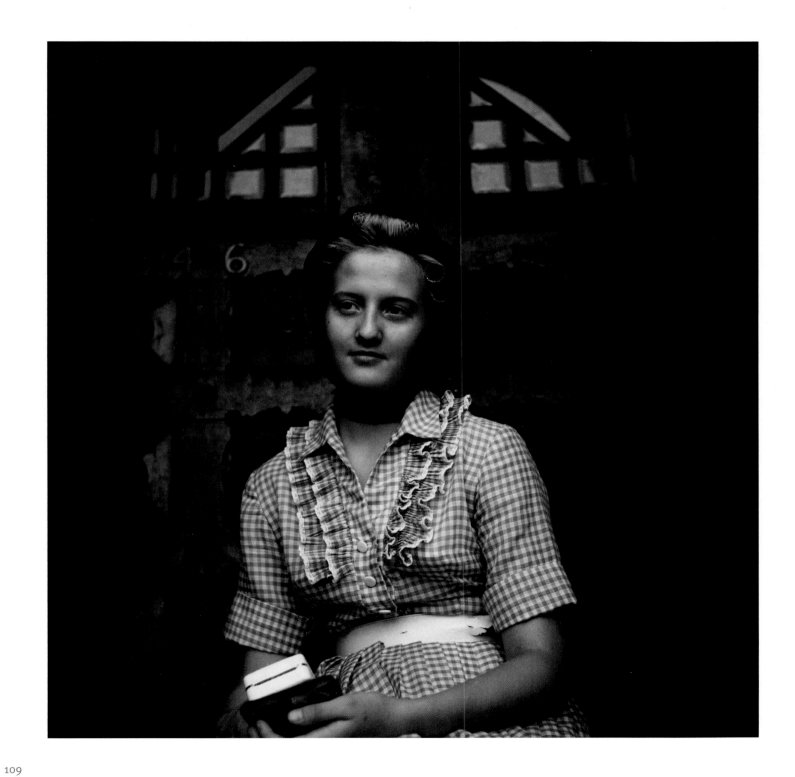

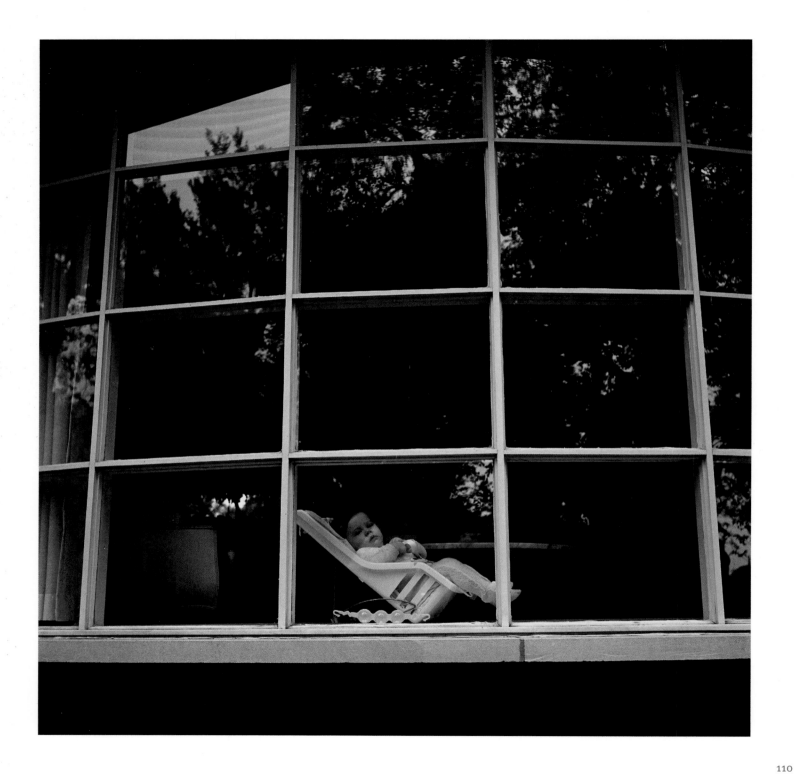

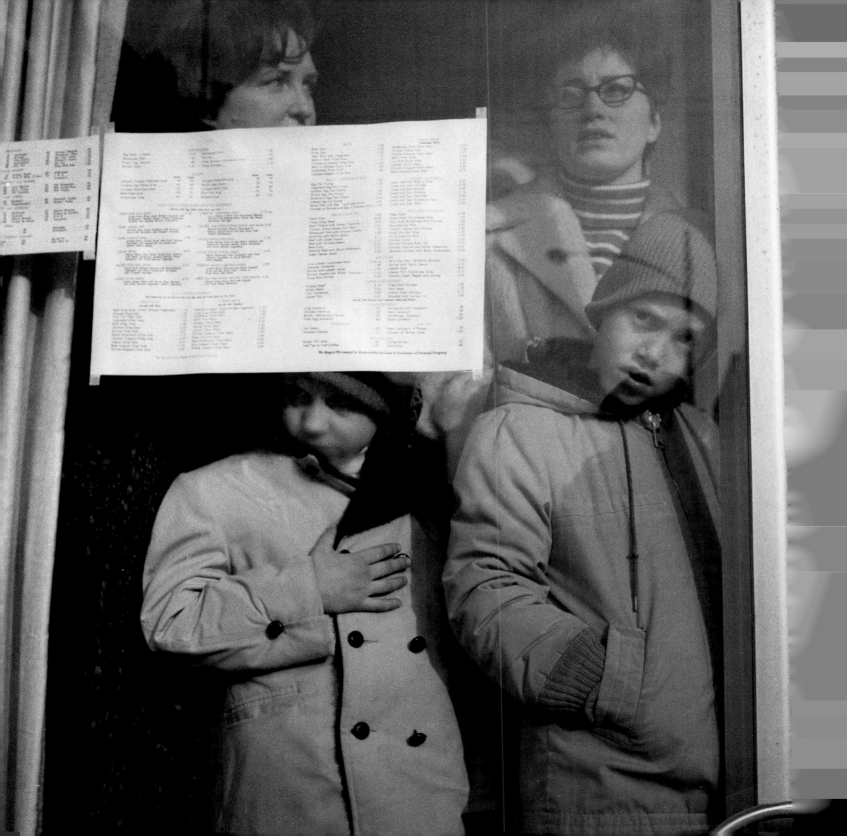

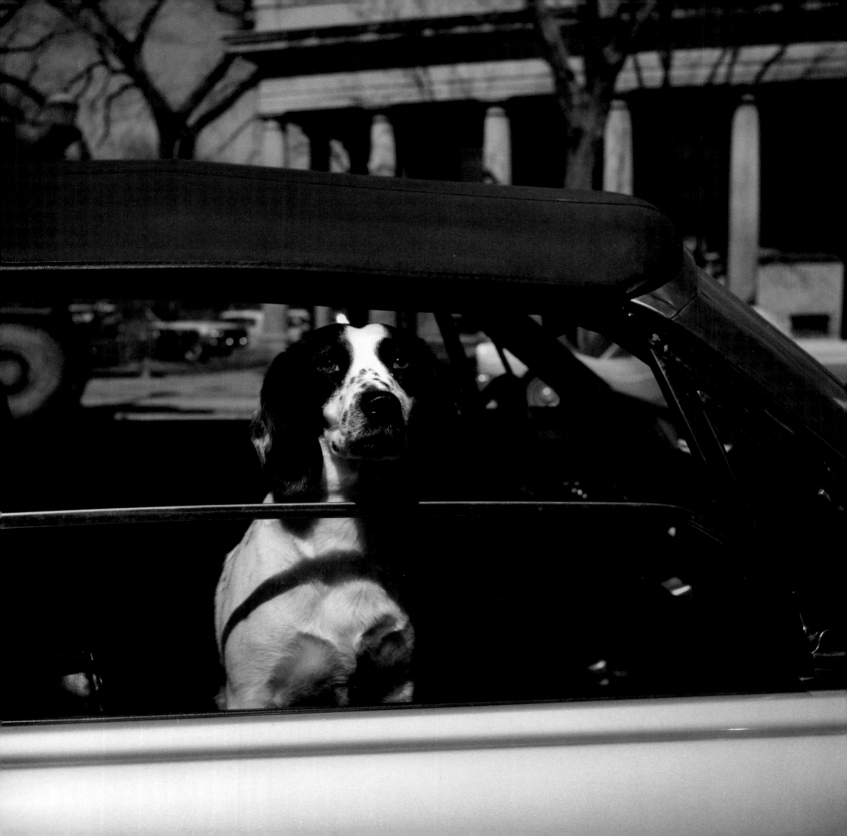

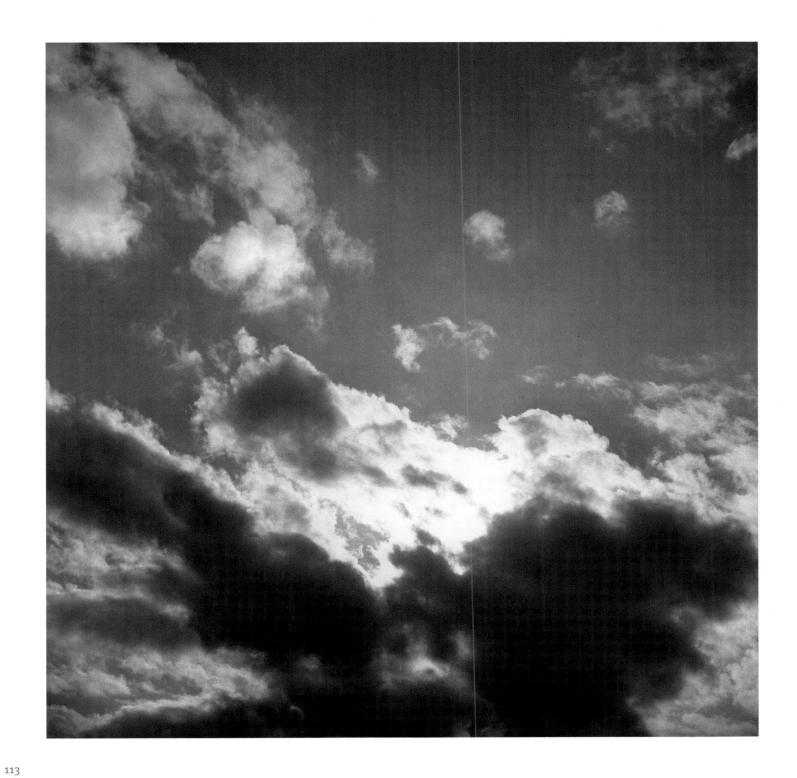

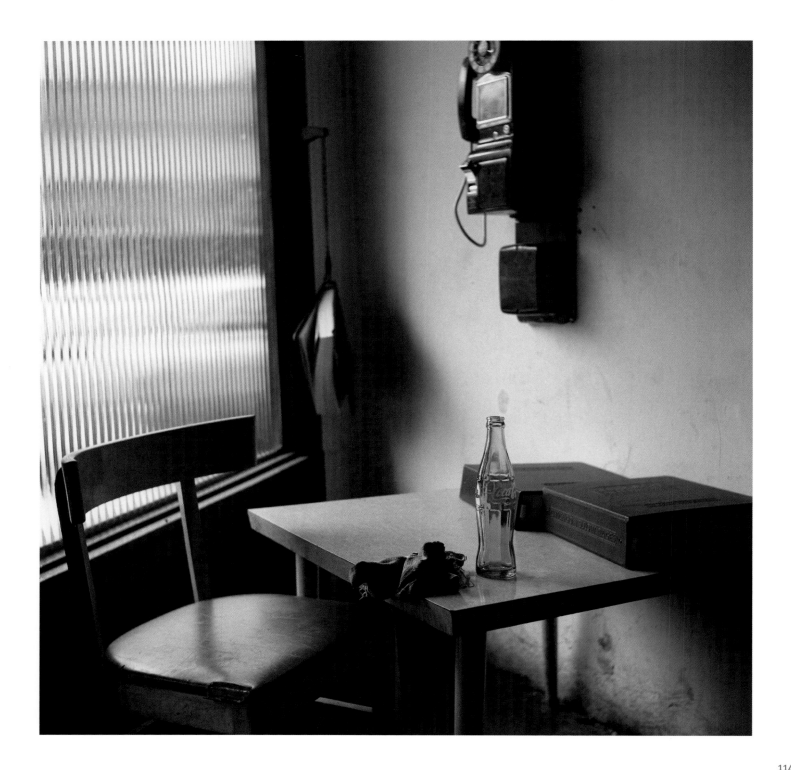

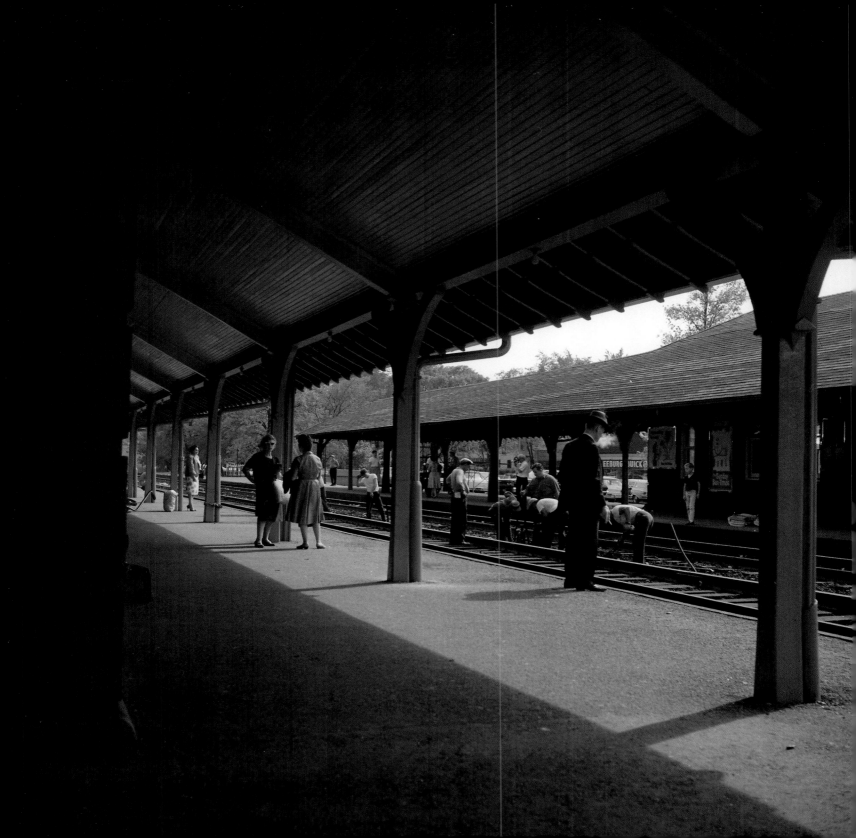

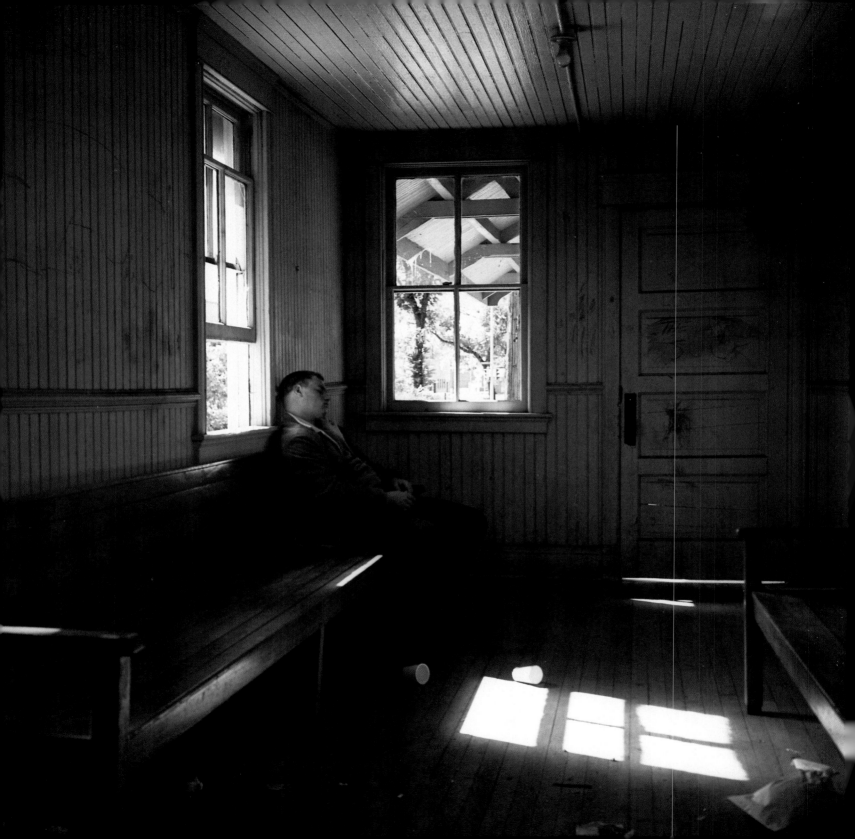

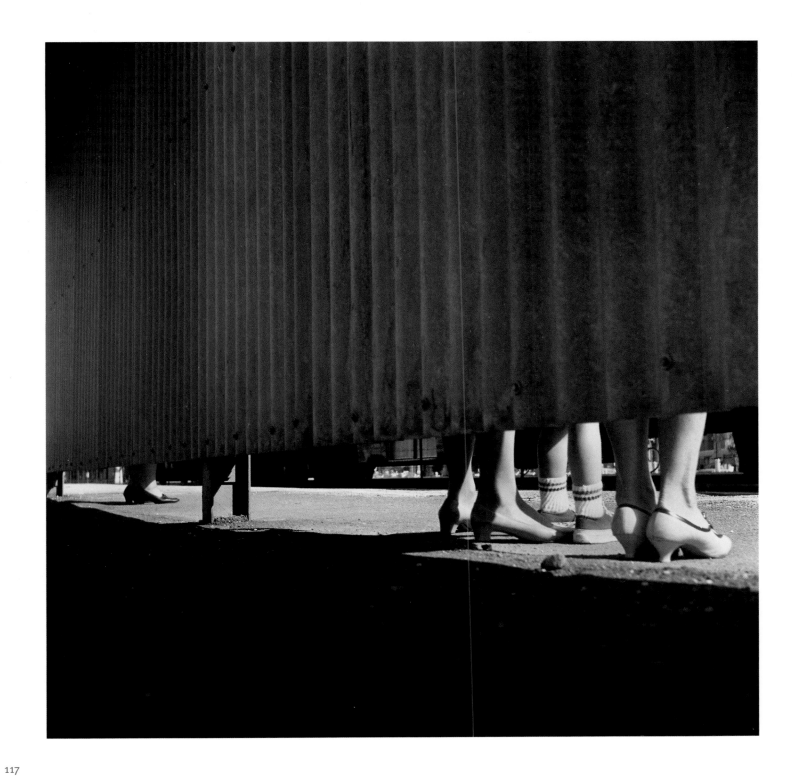

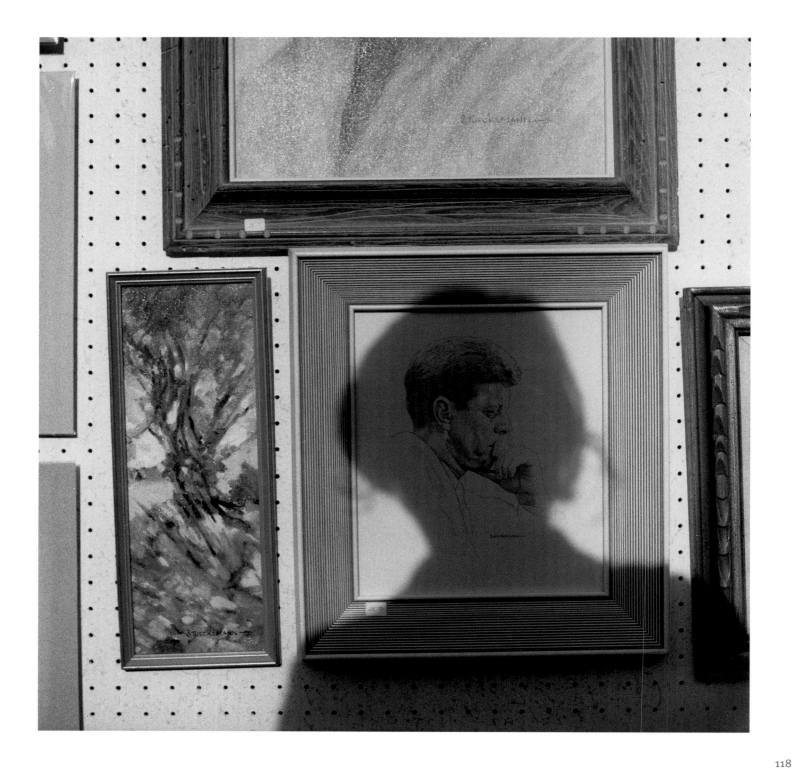

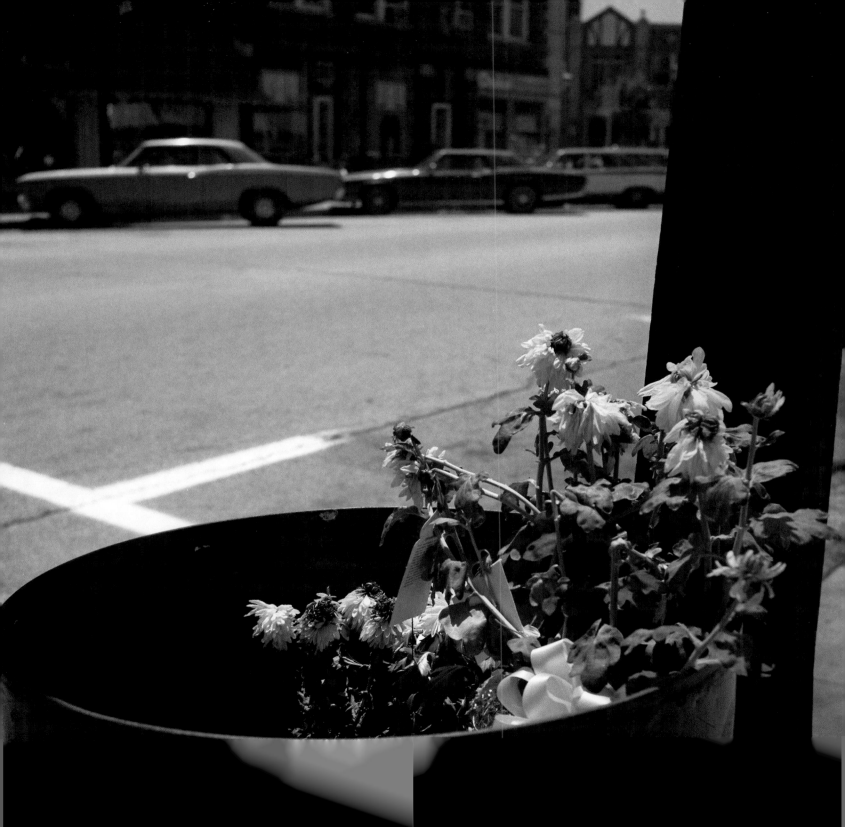

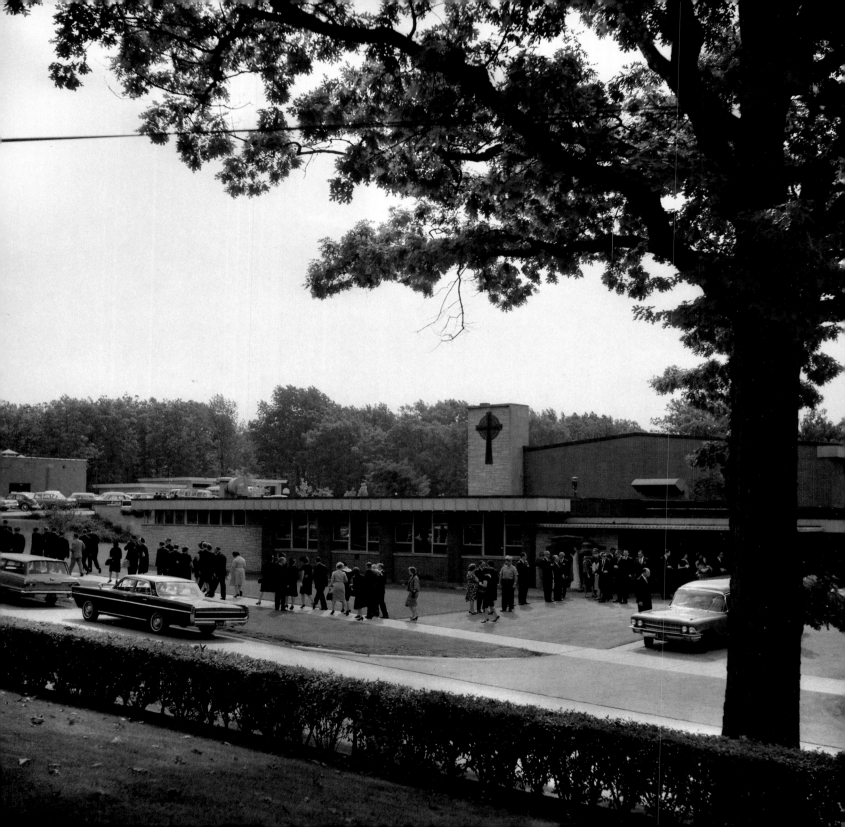

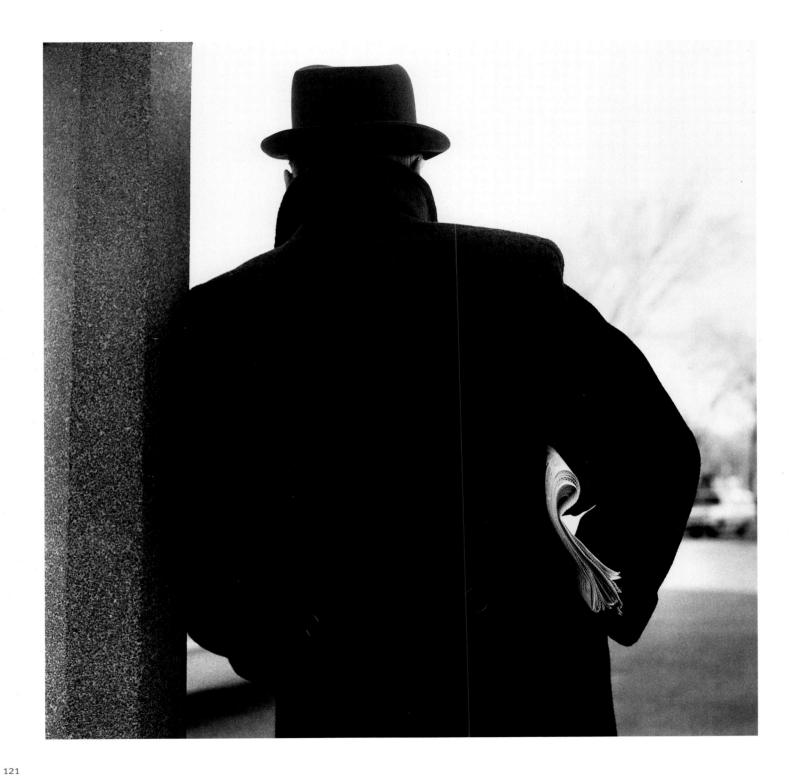

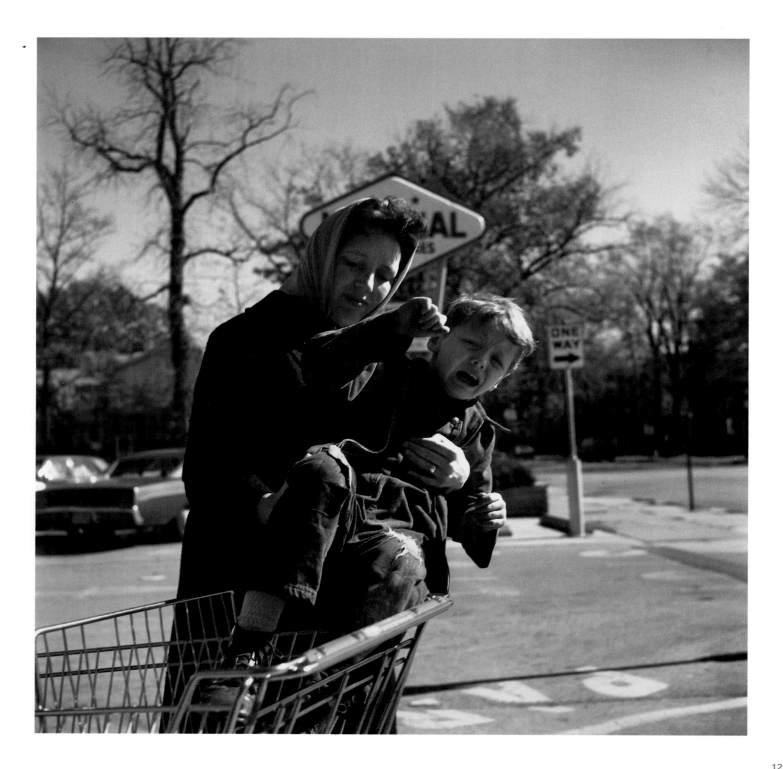

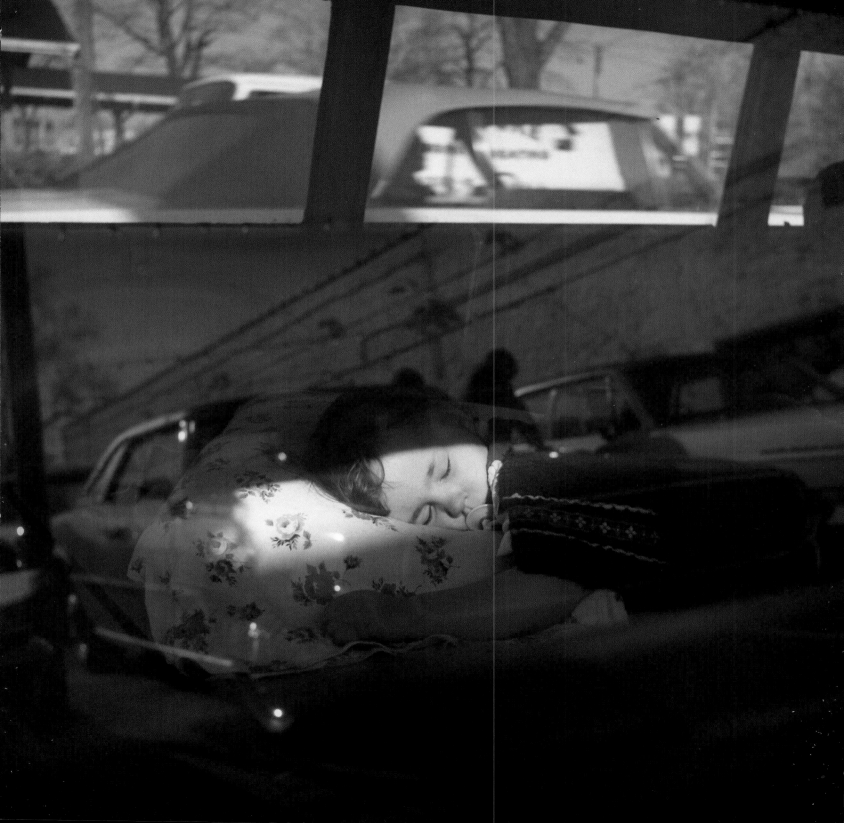

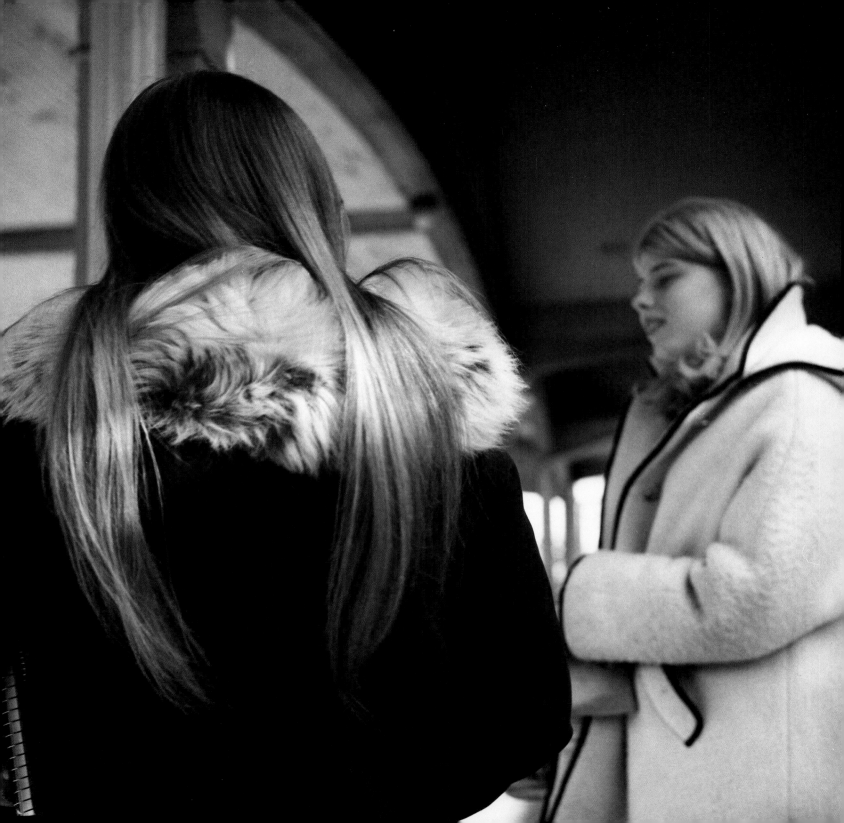

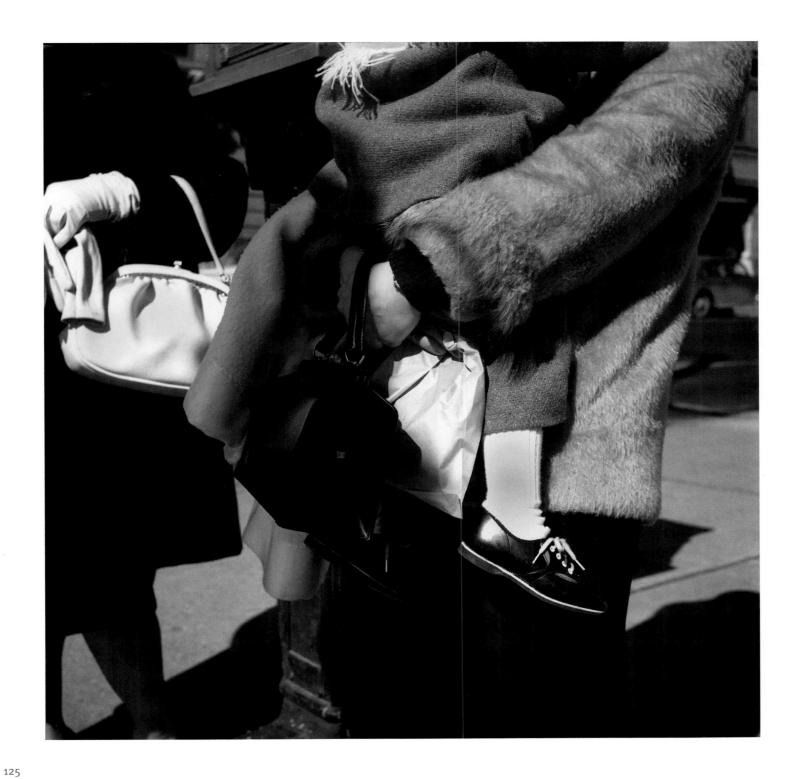

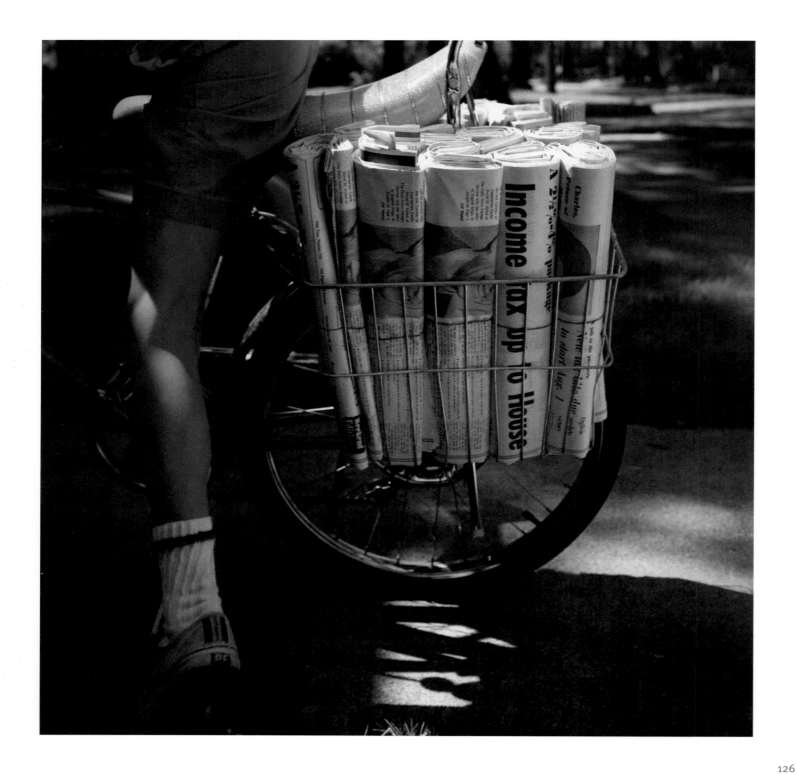

126

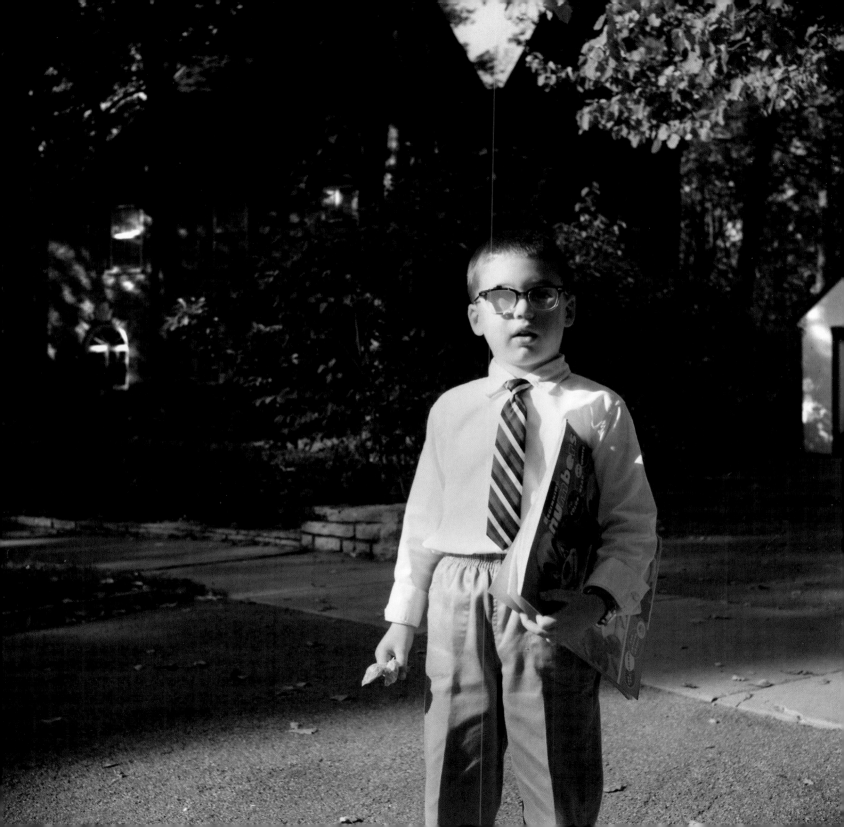

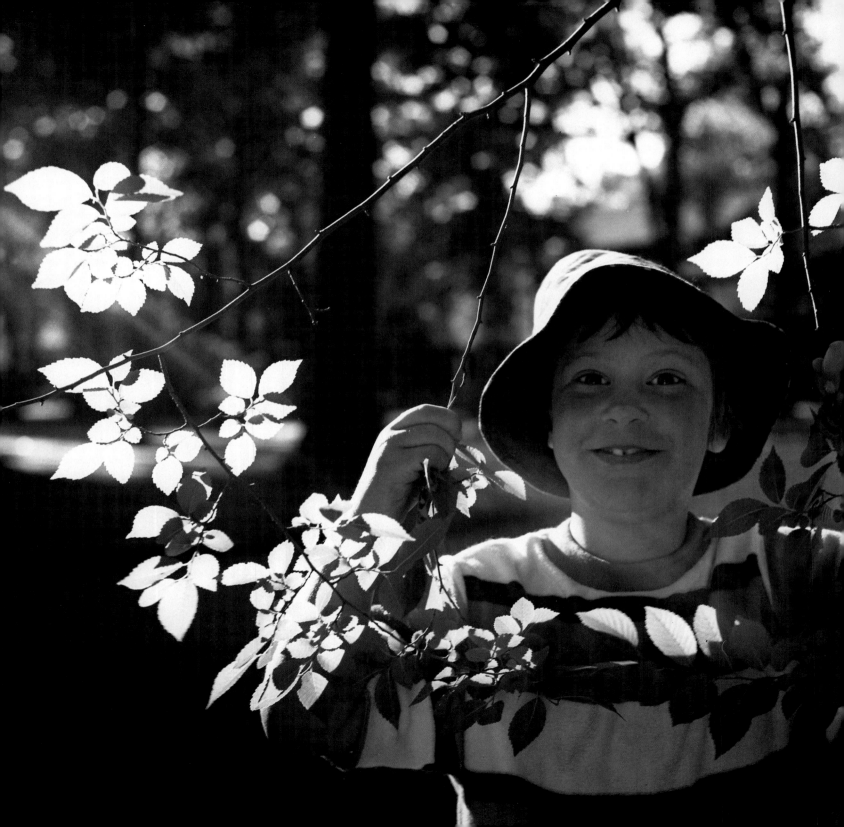

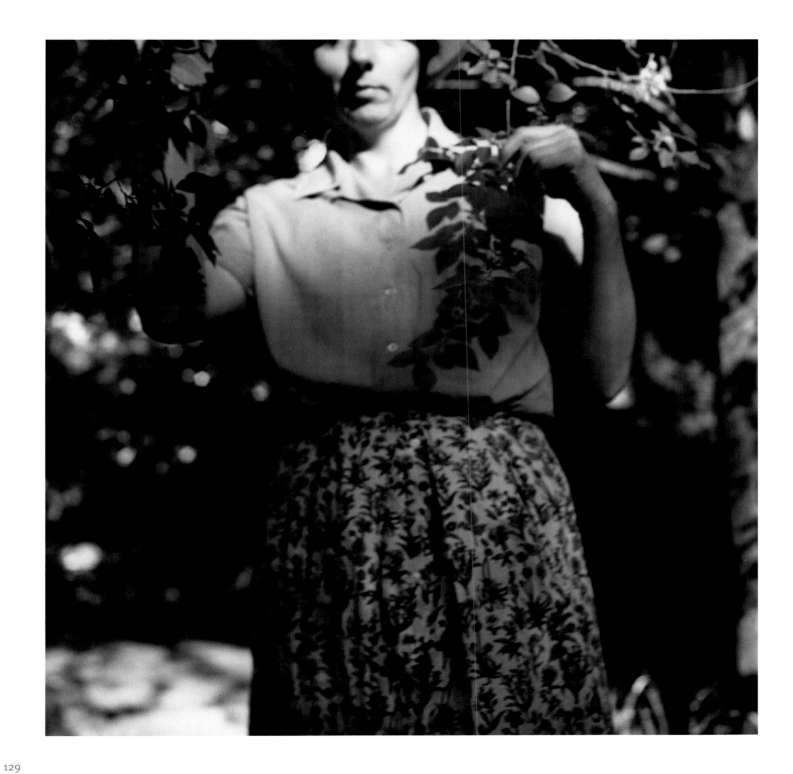

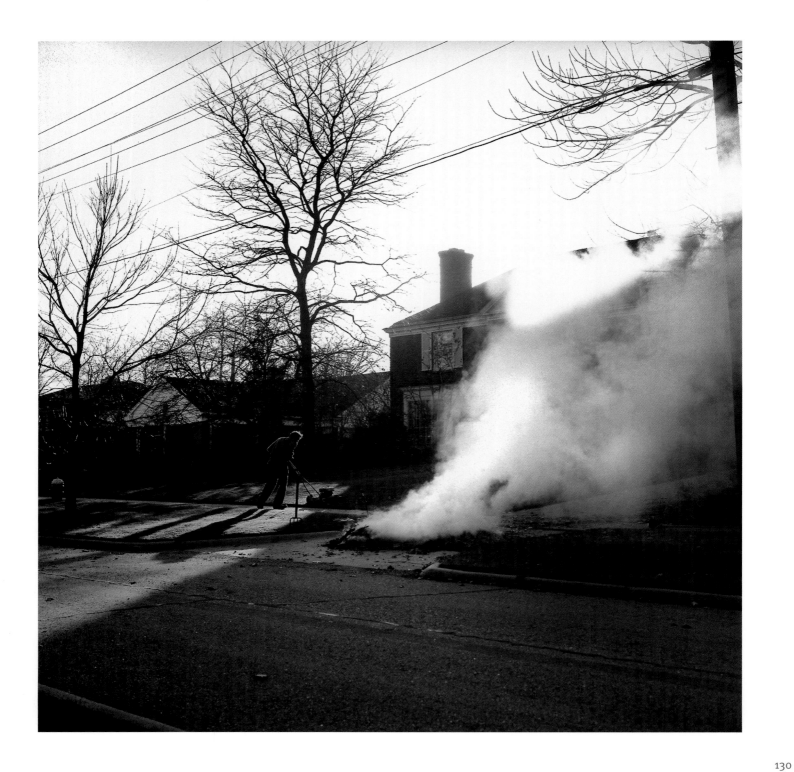

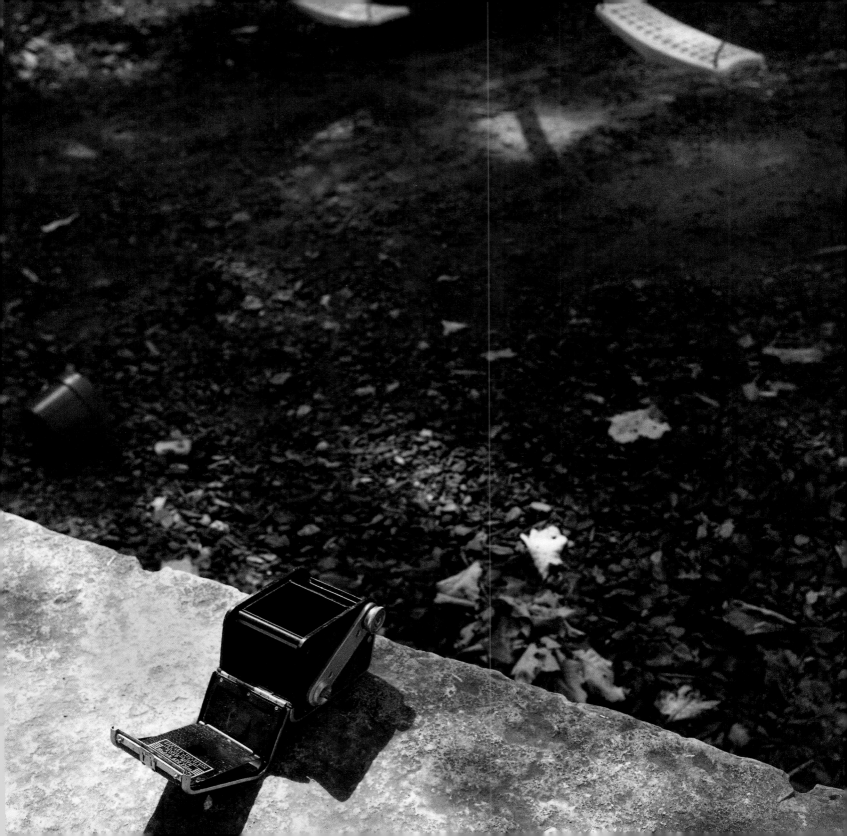

MAXWELL

The suburbs could not contain Vivian Maier.

The dutiful domestic did not drive, but she often took the Chicago and North Western commuter train into the city on her days off. She was drawn by the workers who walked the downtown canyons, and she enjoyed roaming the neighborhoods around the Loop. On Sundays, she headed to the Maxwell Street Market, an open-air bazaar where Jewish vendors sold leather coats and nylon stockings and African Americans from the South sang the blues in vacant lots.

It was just the kind of place that called to Maier.

If Chicago is the melting pot of the Midwest, then Maxwell Street was where the cauldron boiled. For decades, it attracted photographers, who chronicled the endless stacks of toilets, the overripe grapes, the old tires and hubcaps that were offered there. Maier came for the people: thousands of them packed into the small area on Sundays, rich and poor, the hucksters and the insane. Some came to shop; Maier came to look. She would arrive near dawn as the stalls were being set up and stay much of the day. She photographed Arvella Gray, a blind musician who played his all-weather steel guitar; boys selling windup bullfrogs ("Jumps All Day") for a quarter; and the Chicken Man, an alcohol-emaciated showman who accompanied his trained chickens on the accordion.

The Maxwell Street that Maier knew is gone now. Its smell (of greasy Polish sausages, fried onions, and Vienna red-hots with mustard) and its look (sagging awnings, street fires, and weather-beaten shacks) were considered a blot on the city. The market was finally swept away around 2000.

Maier's photos are unexpected in that she elevates the market. In that land of extreme pathos, no questions were asked and decisions were lightning fast. Maier shows that every decision and every person—those struggling to make a quick buck and those needing to buy secondhand to clothe their families—mattered. Maxwell Street was a lifeline for Chicagoans who could not afford to shop in regular stores. For them, it was their salvation, their Sunday church.

From the market, Maier took the Halsted Street bus about a mile and a half north to Madison Street. This was, in the words of the Chicago writer Nelson Algren, a walk on the wild side. Maxwell Street might have been something of a destination for amateur photographers and filmmakers, but this was not so for skid row. The flophouses,

pawnshops, and saloons along Madison were off-limits to most cameras. Even newspaper editors wouldn't send photographers there on their own. It was a dangerous place where anything could happen. Maier arrived—as usual—alone, and the drifters she photographed appear provoked by, amused at, or unaware of her presence. Her pictures certainly do not sugarcoat the hard realities, but she conveys her high regard and empathy for those dismissed as "bums" and "winos." Perhaps because of her difficult upbringing, poverty was never far from her mind. She bought discounted bruised fruit for herself when she went grocery shopping and said she felt uncomfortable going to the doctor when so many did not have the money for medical care.

"I think honor was very important to her," said Lane Gensburg, who recalled Maier talking often about poverty and survival. "Being treated equal was very important to her. She was generous to excess, and she didn't have much to give. She fought, in her own way, for the downtrodden. I know she did. That's why she would talk to homeless people all the time. She felt she could steer them onto the right path."

By the early 1970s, Maier was depending on camera shops to develop and process her film. "Of all the characters who came into the store, she was singular, the most identifiable," said Don Flesch, whose family owned Central Camera in downtown Chicago. She hardly ever made small talk and would almost never answer questions about herself. "In the early years, it was like she had blinders on," he said. "She was only interested in her own world."

During the week, Maier stopped by suburban camera stores. Pat Velasco remembers her from the camera department in the basement Hoos' Drug Store in Evanston. She usually came in the early evening—probably after work. At the time, Maier owned two full-size Rolleiflexs and one Baby Rollei, a version of the Rolleiflex that produced smaller negatives. With constant use, the cameras got beat up quicky.

In those years Maier was extremely formal. She insisted on being called Miss Maier and did not discuss her work. Velasco gleaned that she was a nanny from her photos. "It was fine work," he said. "You could see this was not somebody who was fooling around." But he also saw the financial strain Maier was under. She would always pay in cash, but that became more and more difficult. "Sometimes she broke open a roll of quarters," he said, "and sometimes we wondered if she would have to take off her socks." It was during this time that Maier started to fall behind. When she died, she left more than a thousand unprocessed rolls of film. She never could keep up with what she was seeing.

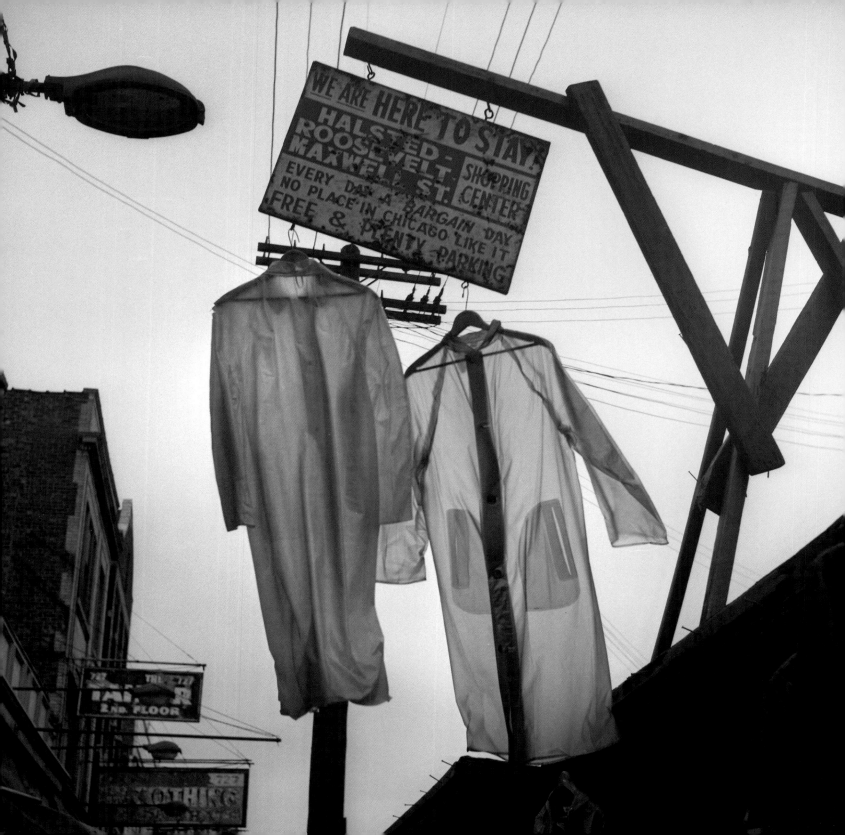

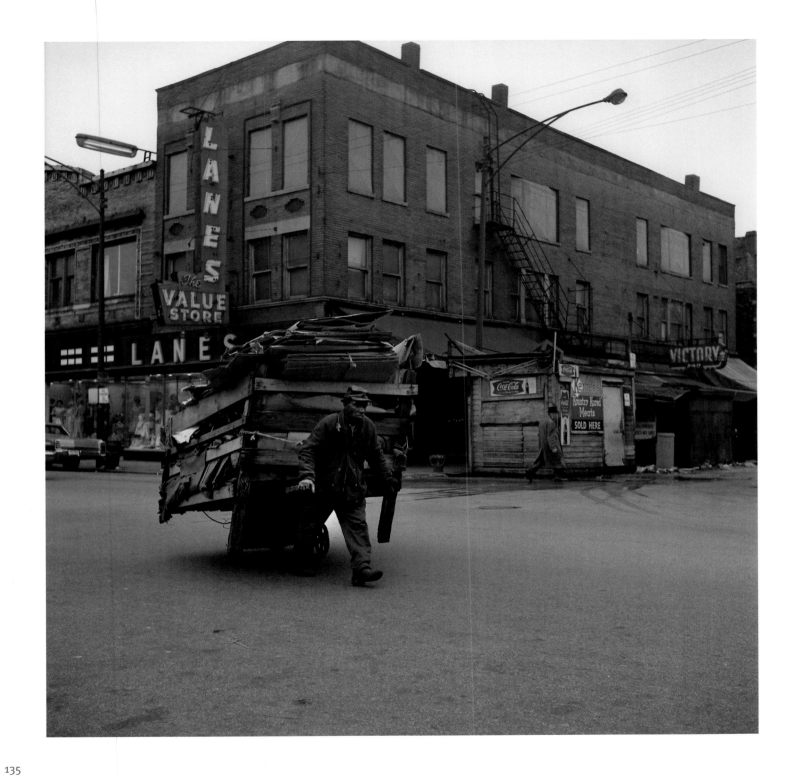

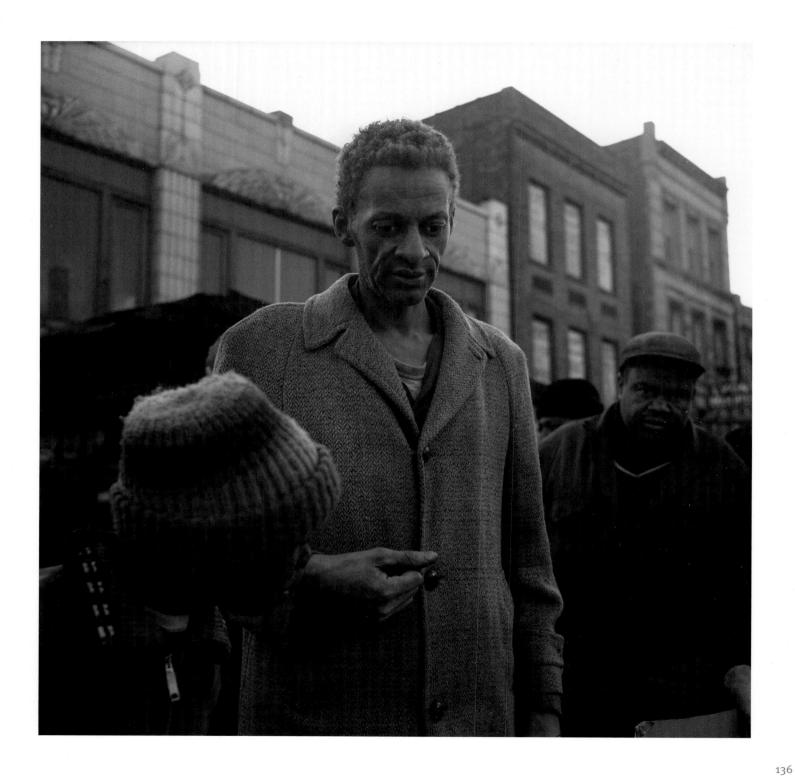

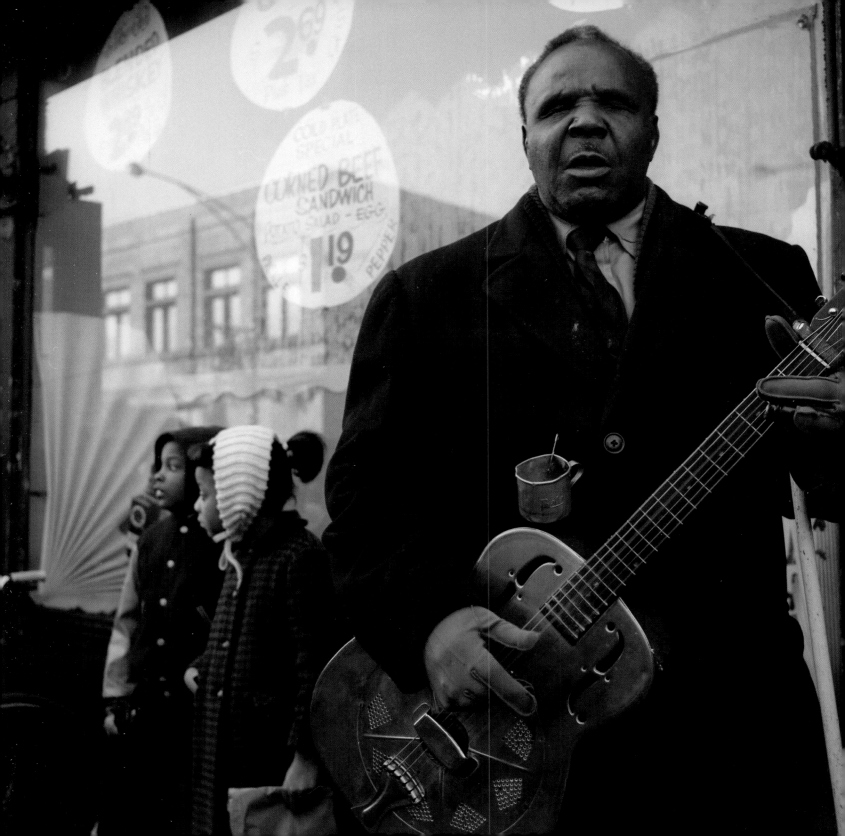

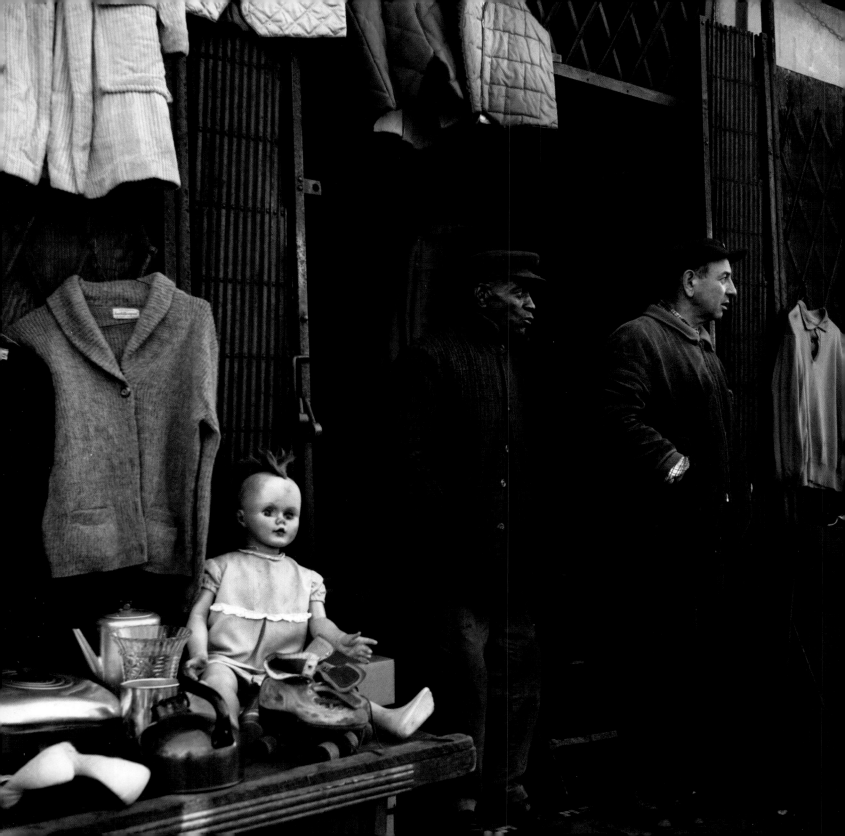

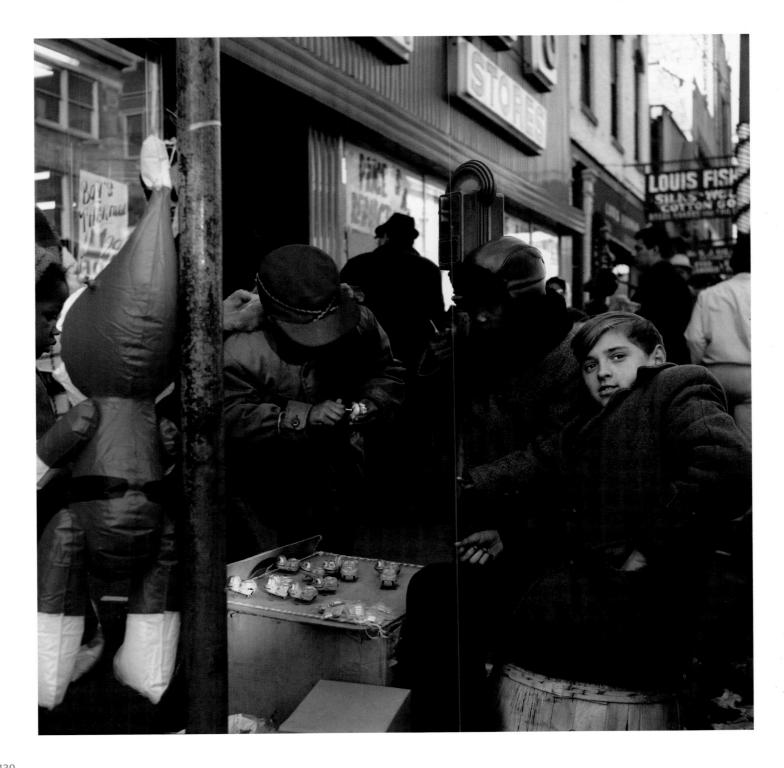

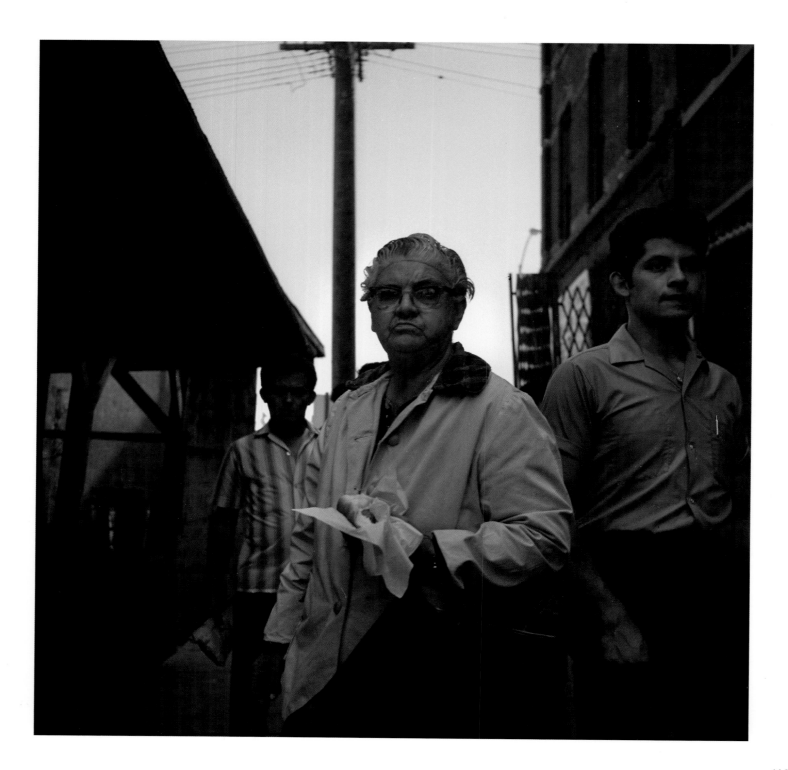

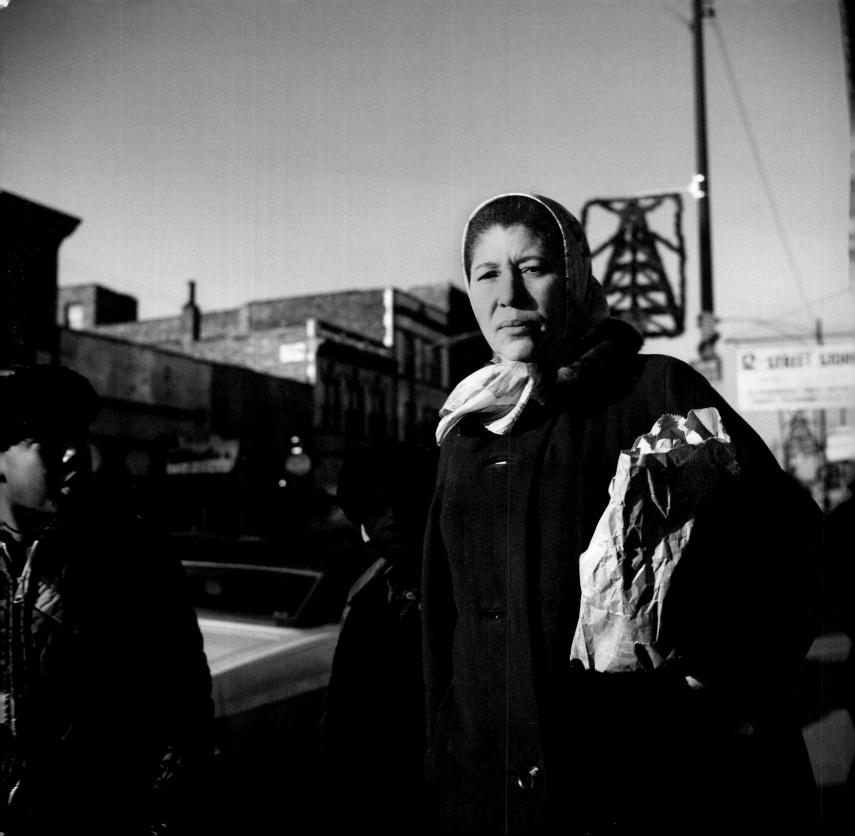

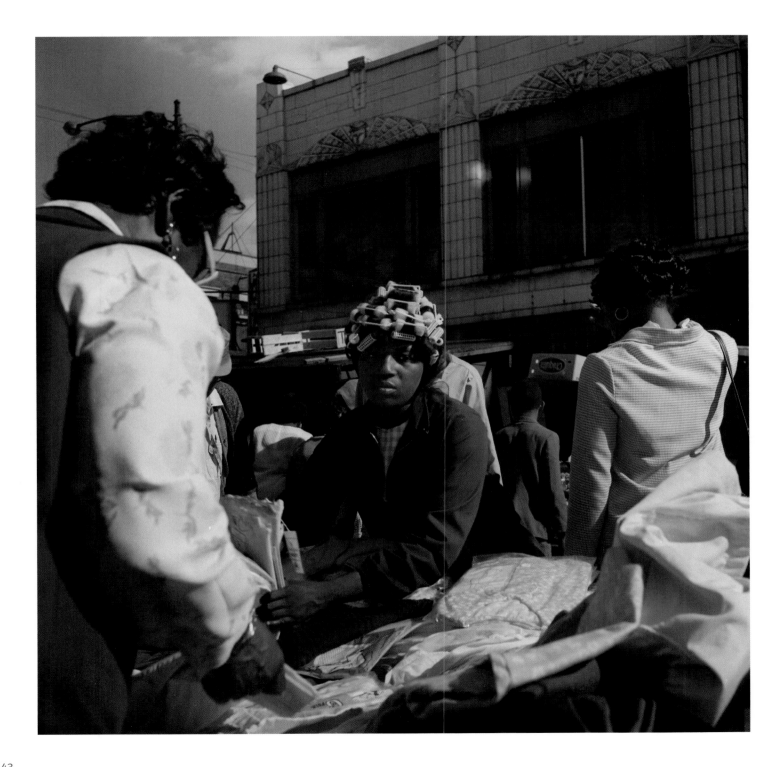

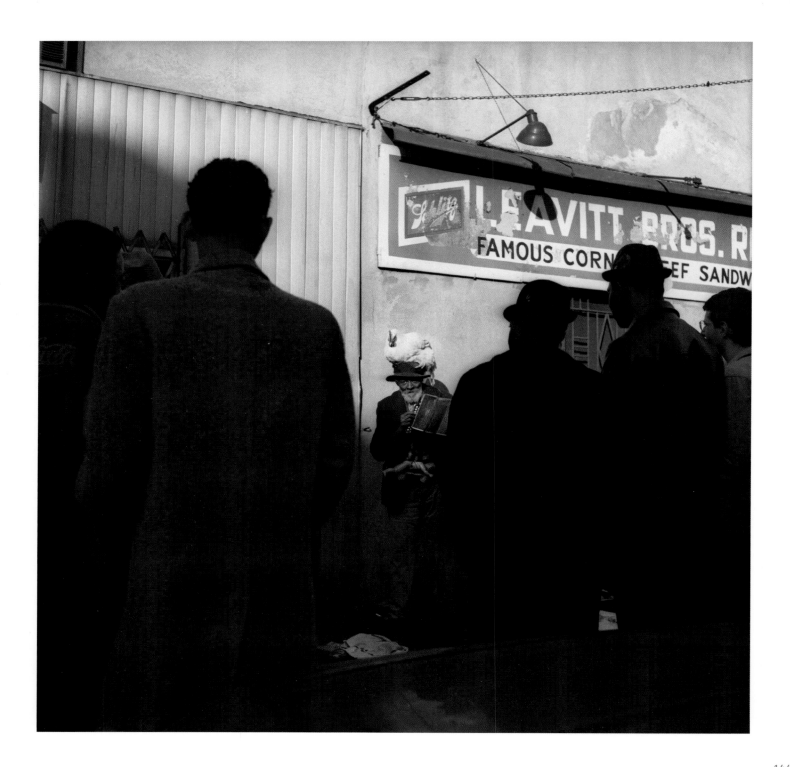

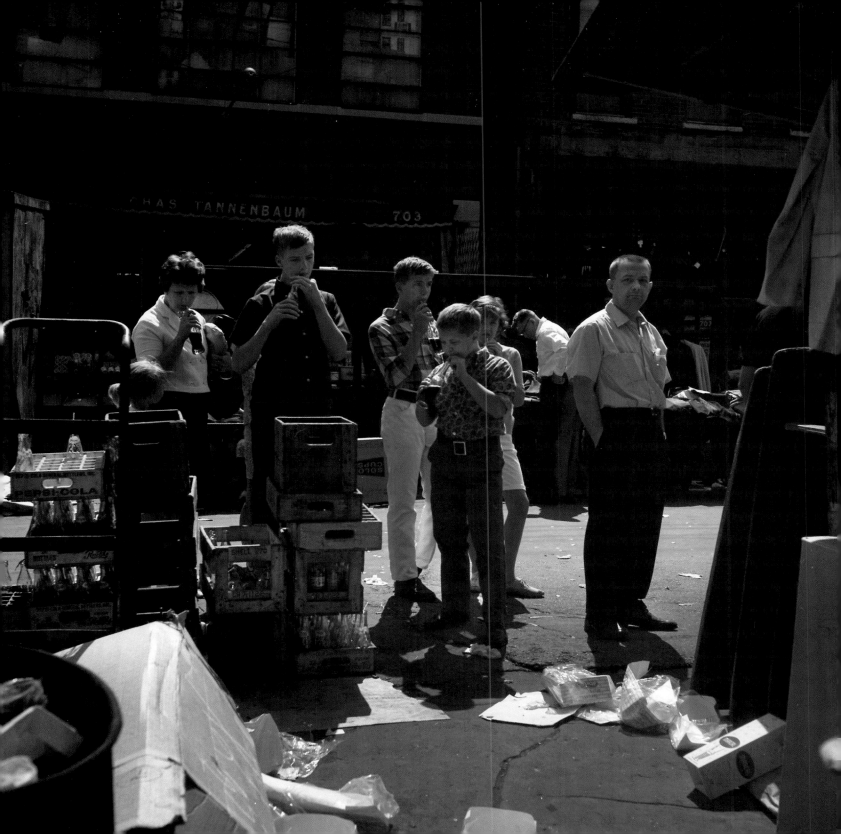

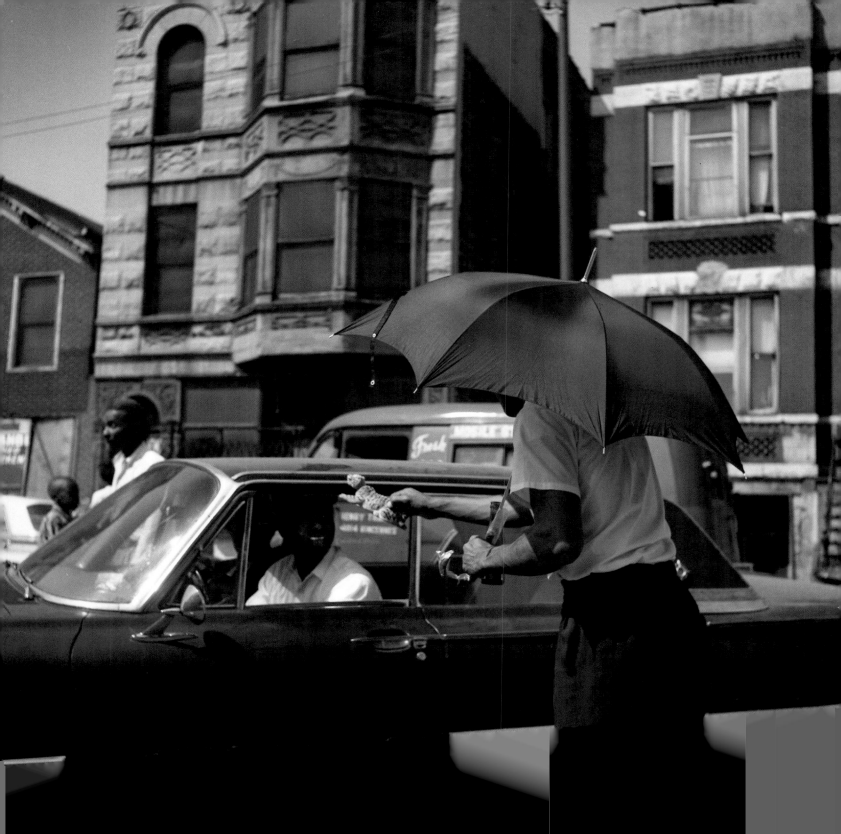

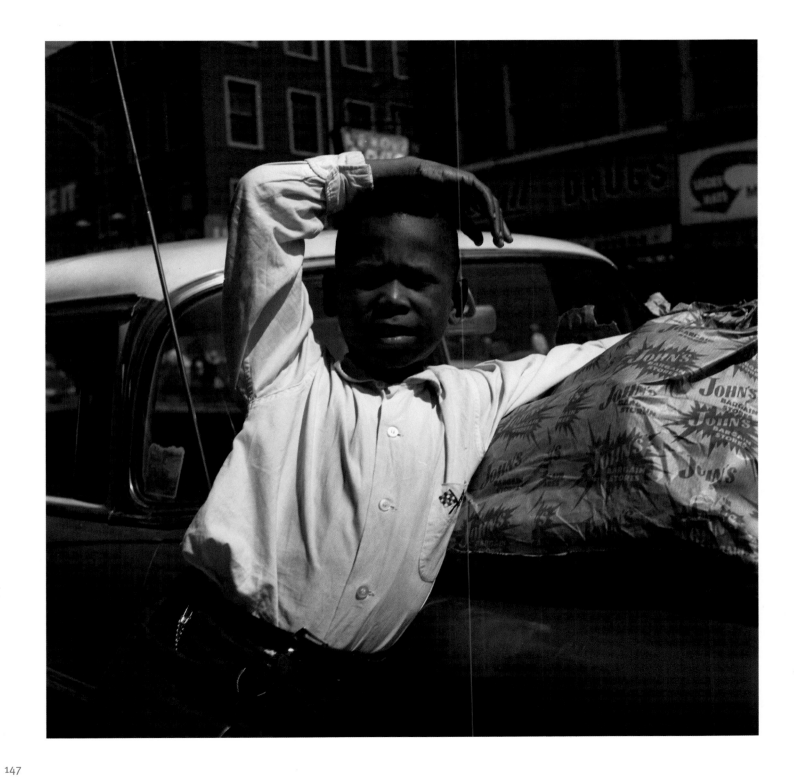

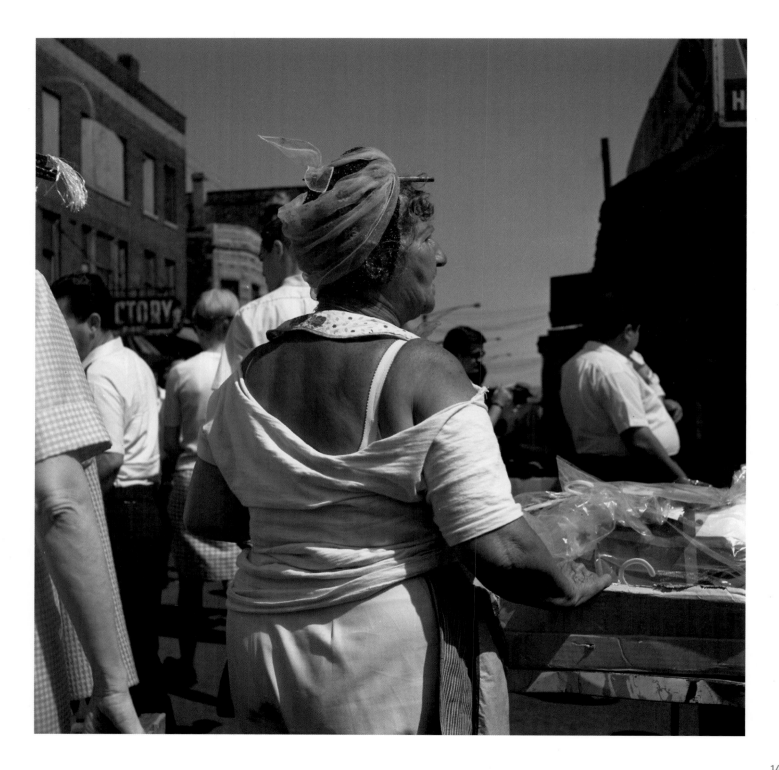

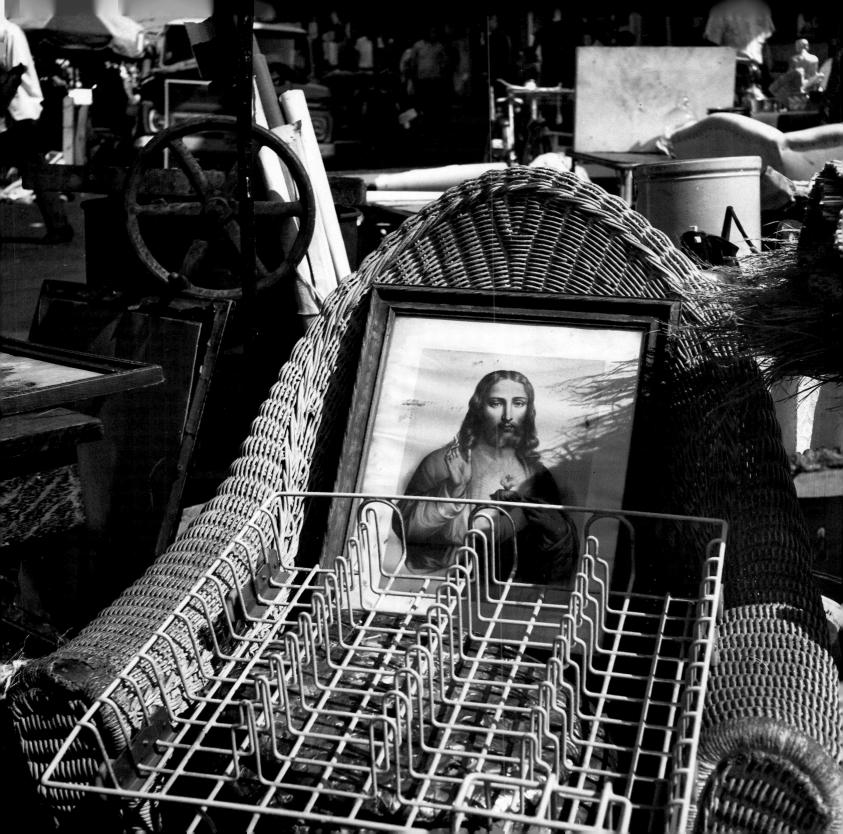

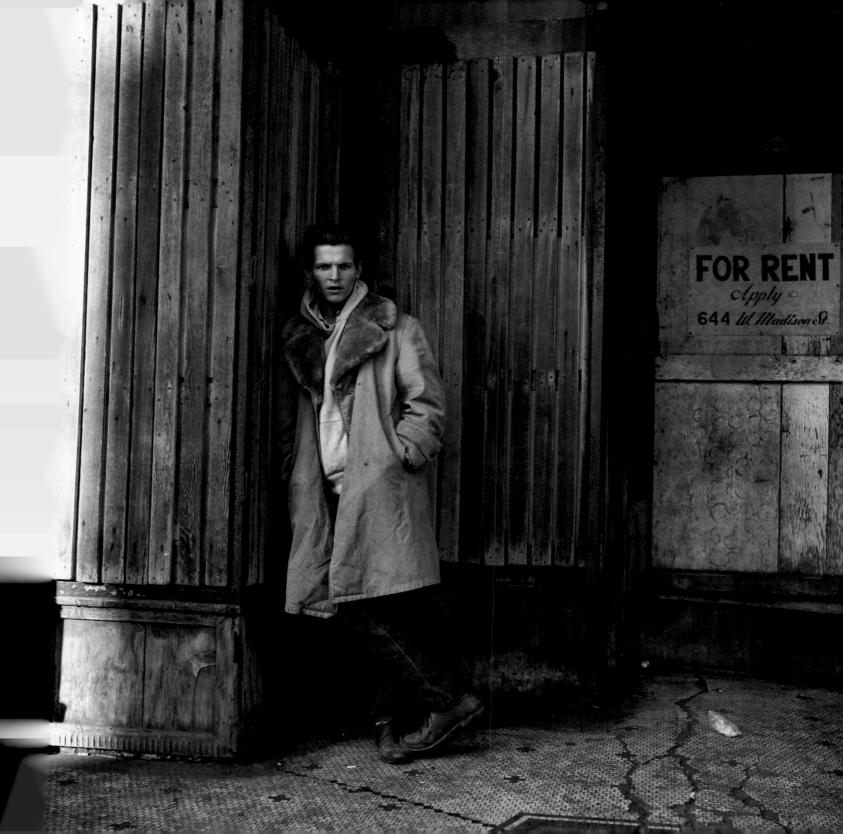

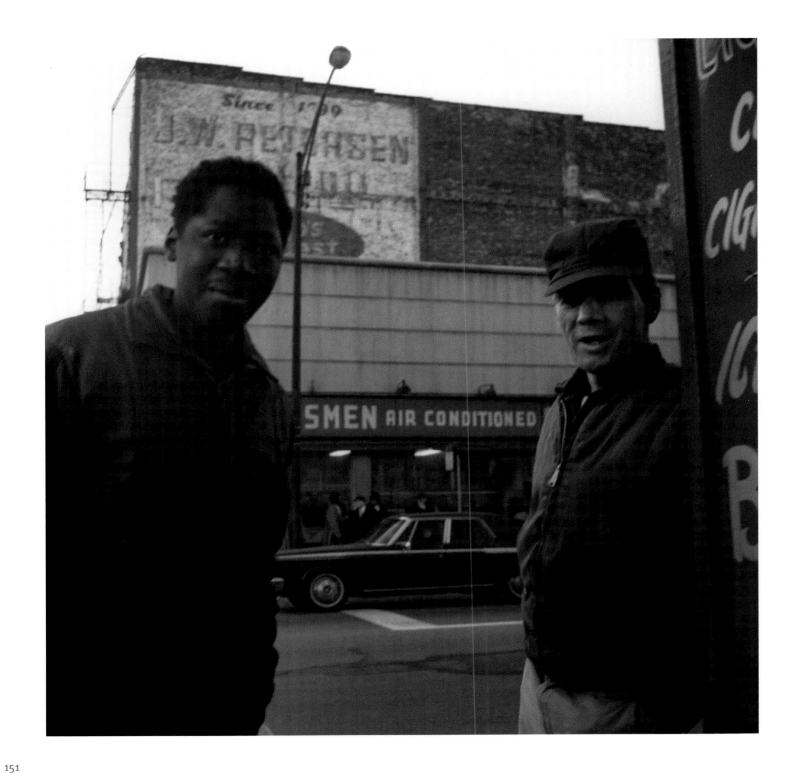

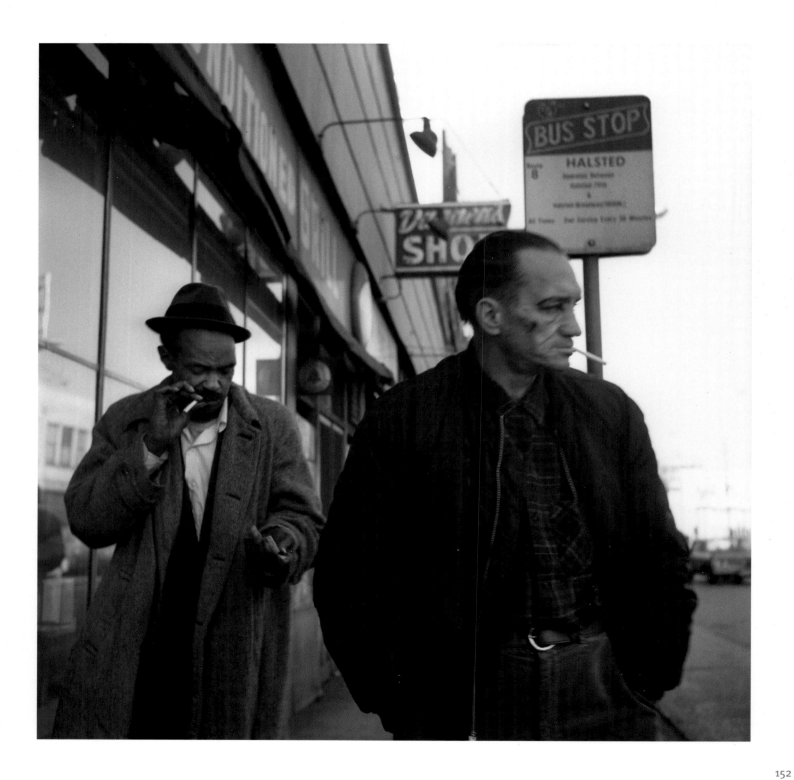

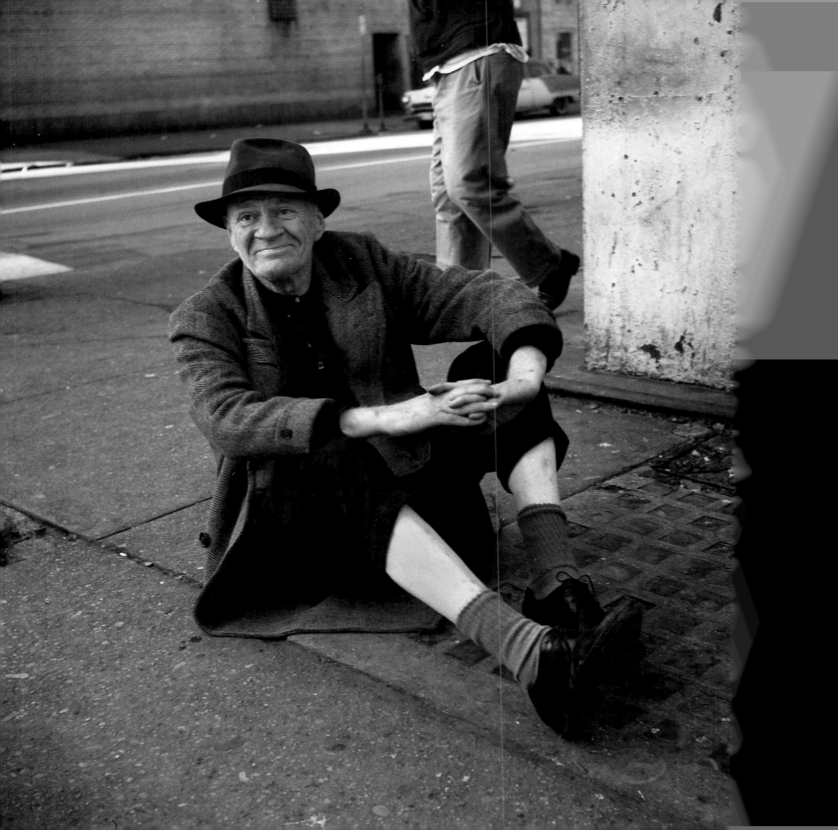

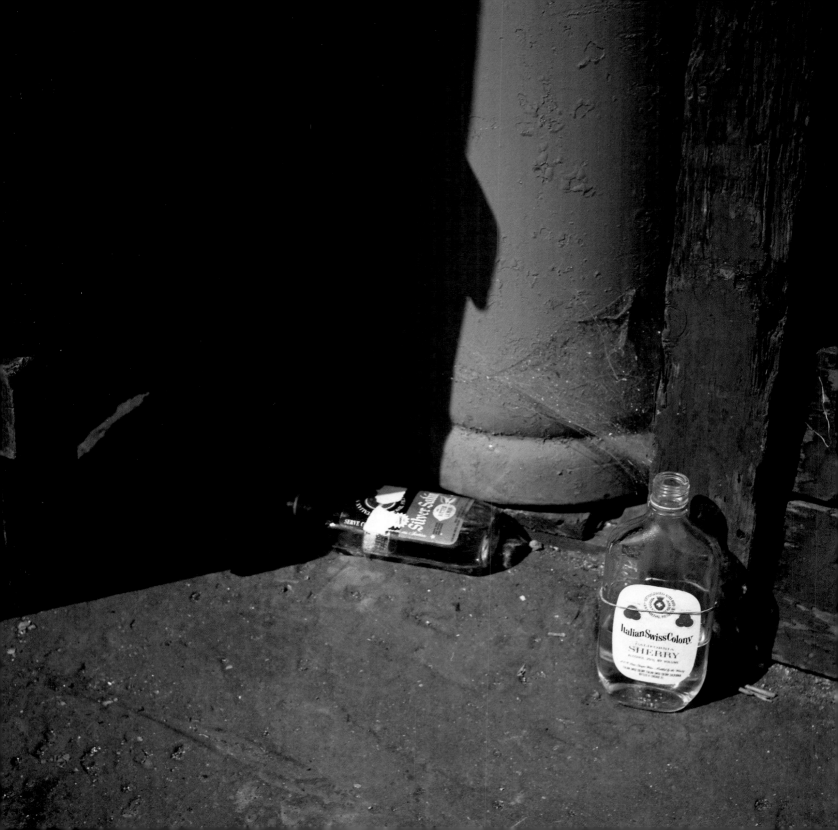

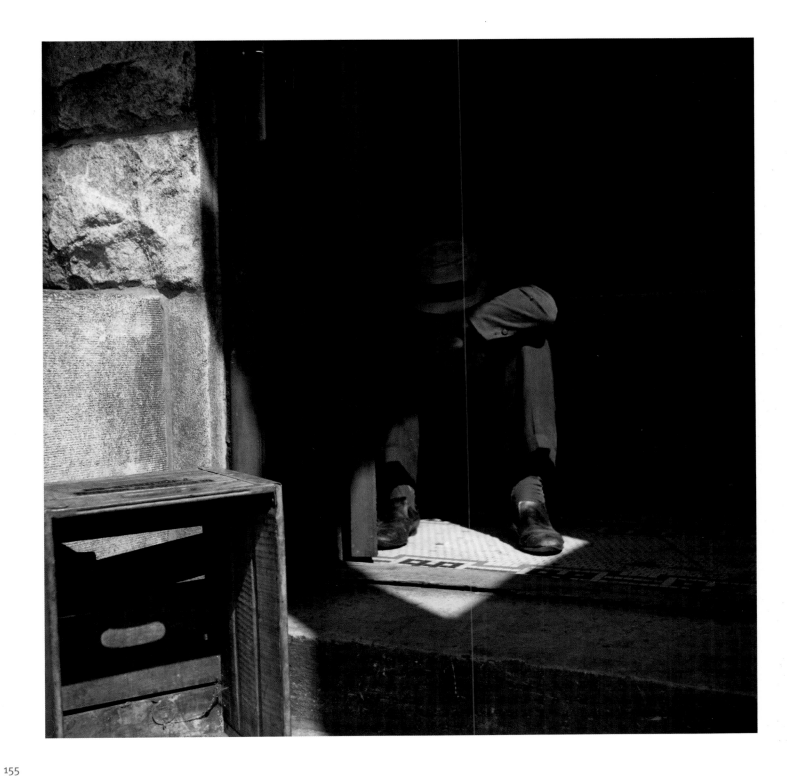

BEACH

Twenty miles north of the Maxwell Street Market was an entirely different world, one that exerted an equal pull on Vivian Maier.

The beach along Lake Michigan in Wilmette's Gillson Park, just east of Sheridan Road and north of the Baha'i House of Worship, was a favorite spot of hers. For many years, she lived or worked near the beach and would walk there in all seasons. During the winter, she'd bundle up her charges and watch them ride plastic sleds down to the icy waters. But it was in the summer that the beach came alive.

Her photos show how in tune she was with the world of children. Here she photographed parents tiptoeing their toddlers on the sand, boys burying themselves to their heads, moms giving babies their first pat of lake water. This was where kids grew up, where preteen girls wore two-piece bathing suits for the first time and boys took their G.I. Joes out on missions in the lake.

Although Maier seldom donned a bathing suit for these trips, she disarmed the kids and their parents with her camera and was welcome in their world. Teenagers let her into their cliques, posing for her or snapping her picture. She made many pensive self-portraits over the years; the ones at Gillson Park show a carefree Vivian.

Almost all her beach pictures were taken while she was caring for Inger Raymond, whose house on Central Street was about a mile away. "We went to the beach nearly every day," Inger said. "We were there all the time. It was cheap. It was a nice place to go, and I loved being out in the water."

Many of Maier's pictures feature Inger, always in a bathing cap, exploring or watching the older girls cut through the waves. Maier explored, too, with her camera. She surveyed the culture of the beach the way she surveyed the culture of Maxwell Street. This was a place of sand castles and sun umbrellas. Of floating and hiding. Of pushing girls and being pushed back.

Maier was hired by Inger's parents after they'd gone through a series of babysitters for their five-year-old. Inger's mother, Marjorie, worked as an editor at the local newspaper. Her father, Walter, was a dentist and kept his office in a small outbuilding behind the family home. Maier was given a room above the practice. Because she was still living with the Gensburgs, she used it for storage, cramming it with the newspapers that she saved. Walter ultimately had to install floor jacks so her room wouldn't sag under the

weight of her accumulated possessions.

Even at her age, Inger knew she had an idiosyncratic nanny, one much too stern to be considered a Mary Poppins. Blunt and opinionated, Maier used lemon juice and vinegar to wash her hair, wore men's shirts because she claimed they were made better, never shaved her legs, swore in French, and could recite entire O. Henry stories from memory.

Maier taught Inger to sew and cook (Danish fruit pudding, white sauces, empanadas, and cheese soufflés) and instructed her on hitchhiking and other unconventional survival skills. "She made an effort to teach me about the good things in life and the bad things in life," Inger said. "She took me to a diamond store to show me good quality, and then showed me what to take out of the garbage."

Determined to give the girl life lessons beyond her suburban sphere, Maier shepherded Inger all over Chicago during the six years she was in her care. Most of their outings were ordinary: to museums, to a baseball game at Wrigley Field ("That was kind of boring," Inger said), to see the rerelease of *The Sound of Music*. They made many trips to the beach and downtown Wilmette. One day, they spoke to a European émigré who told them about Kristallnacht. On another, Maier took Inger to see *Madame Butterfly,* a questionable choice given her charge's age.

In 1971, Maier and Inger went to the Union Stock Yards on Chicago's South Side. Maier wanted Inger to see it before it closed. "I know she didn't tell my parents we were going there," said Inger, who, decades later, clearly recalled the experience of standing next to the chutes as sheep were unloaded from a trailer truck into the huge yards before being slaughtered. "I remember them poking and prodding them," she said. "After they got done, one was dead. It dropped at my feet." Her memories are confirmed by a home movie Maier made of that day.

Not infrequently, Inger's nanny would work herself into a dark depression, shutting herself up in the den. "She was a good person, tried hard, but had serious frustrations in her life," Inger explained. The little girl learned to stay away or risk Maier's wrath. It was another life lesson.

Inger is certain that Maier loved her: "She wouldn't say it—she would never say something like that—but she showed it by actions, not words." Maier raised Inger to be strong and independent, to be able to survive in any situation. "She taught me skills to live, to exist, to understand people, and to understand situations. So I think that was what she taught me. To be a person."

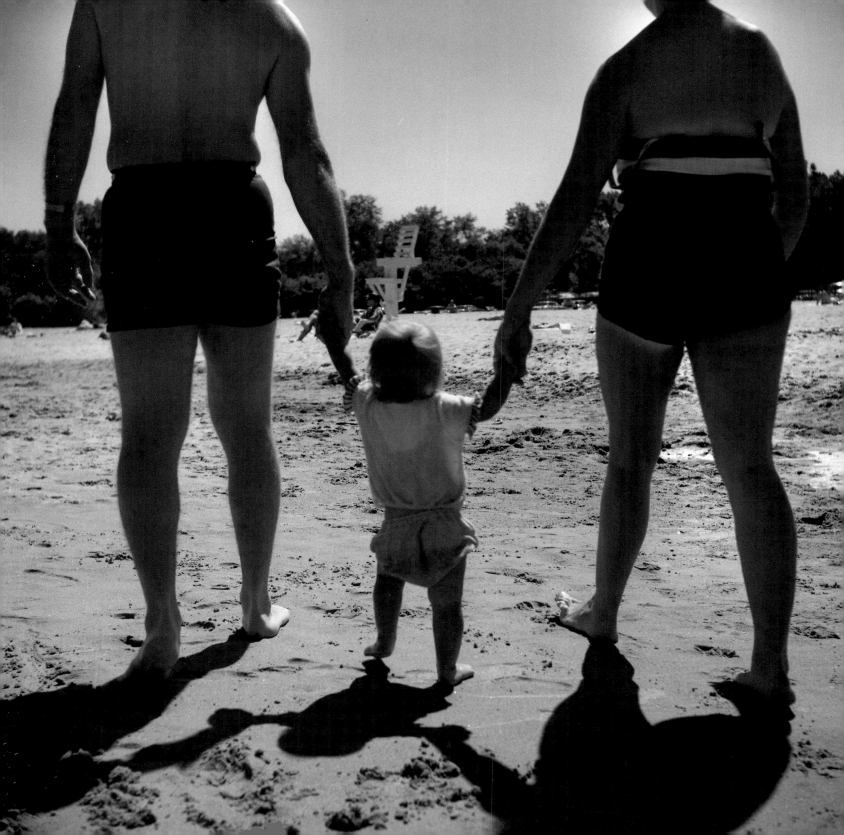

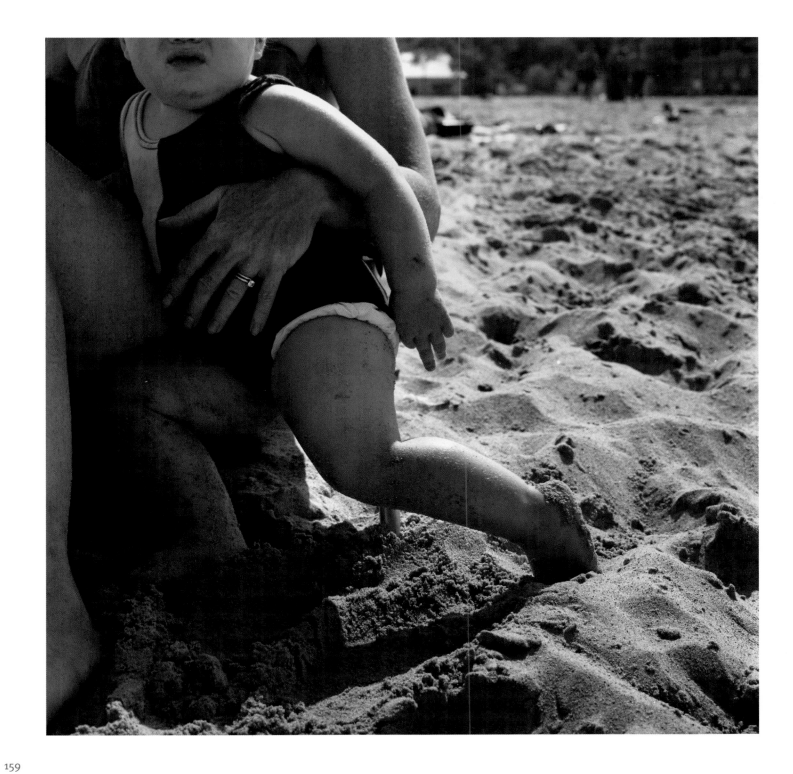

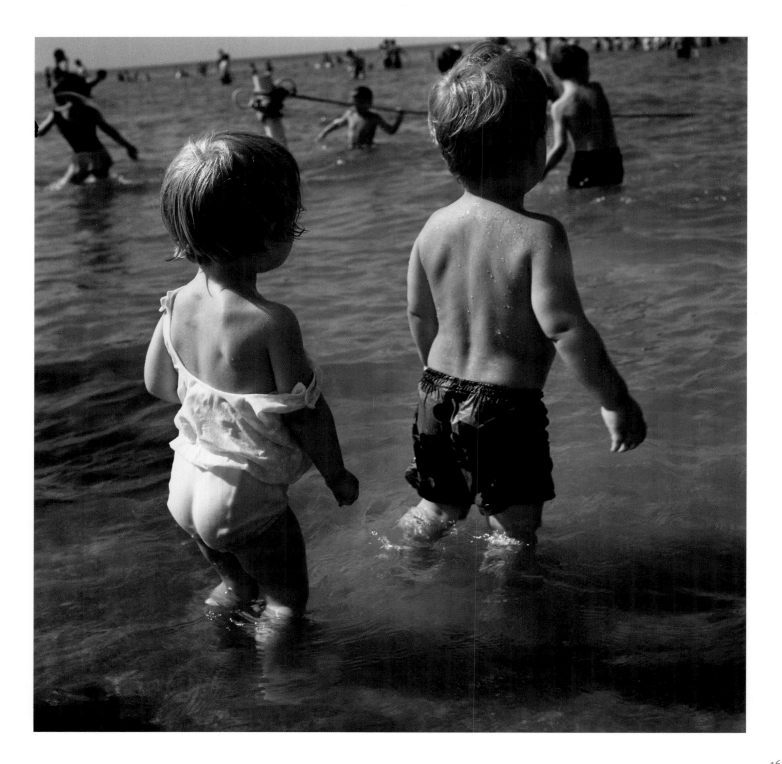

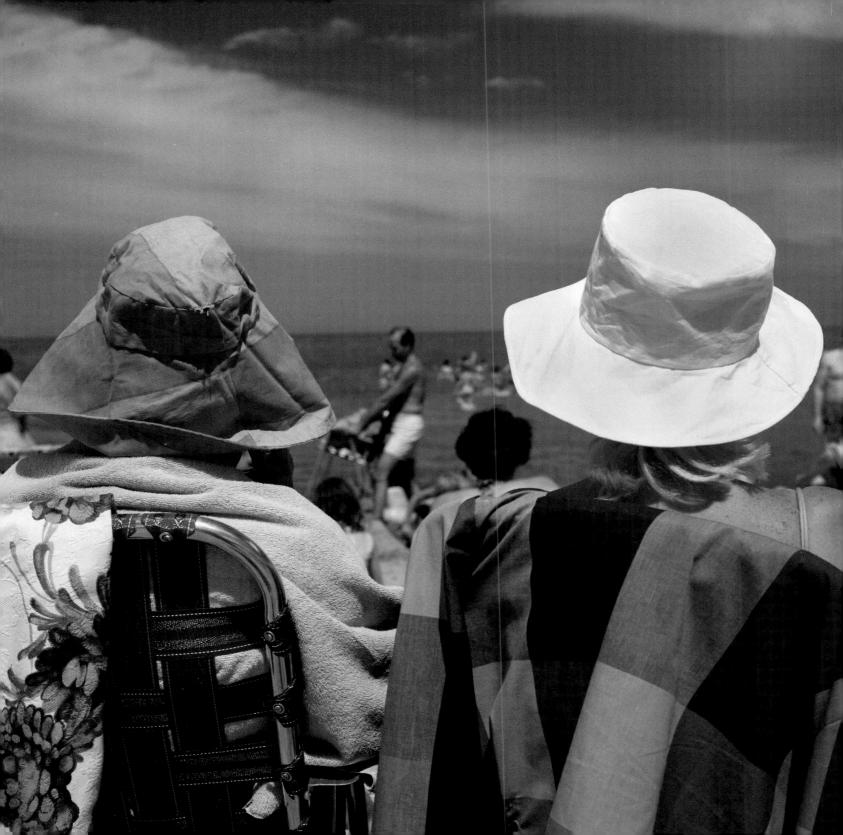

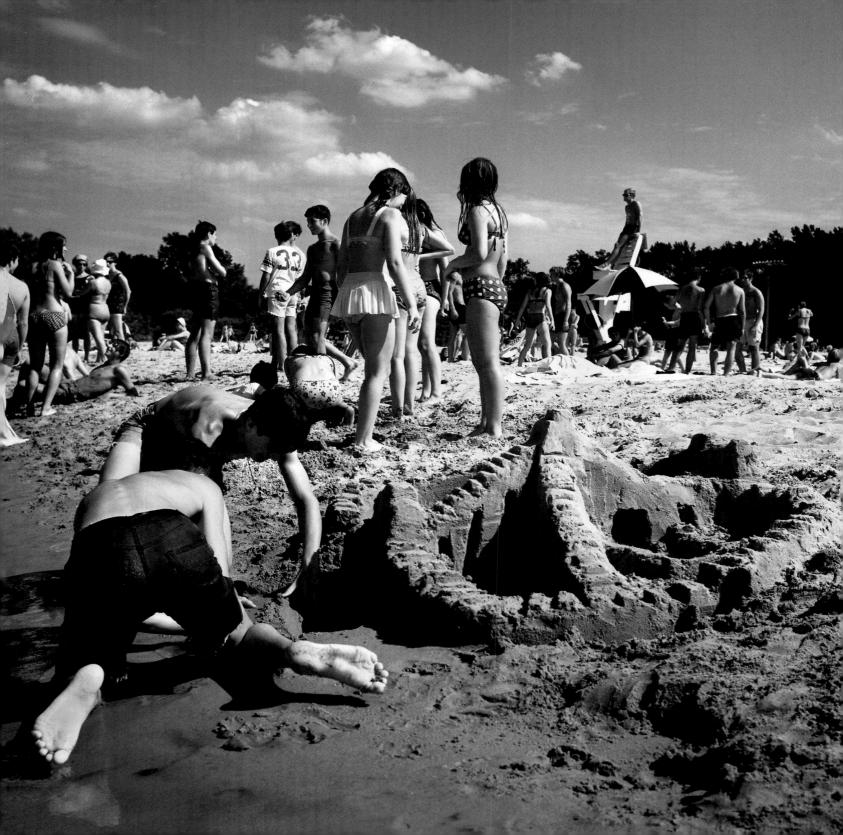

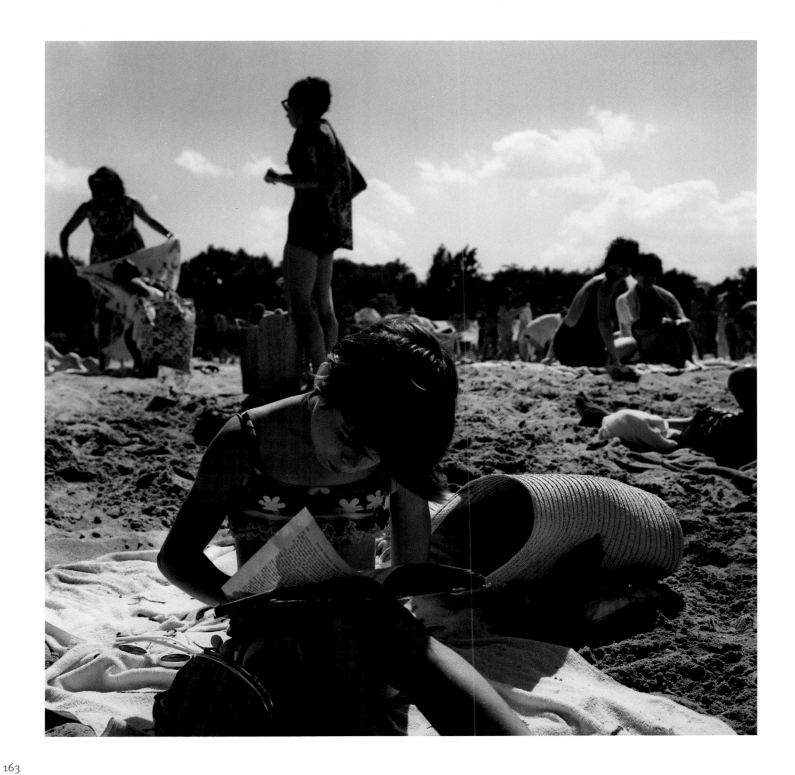

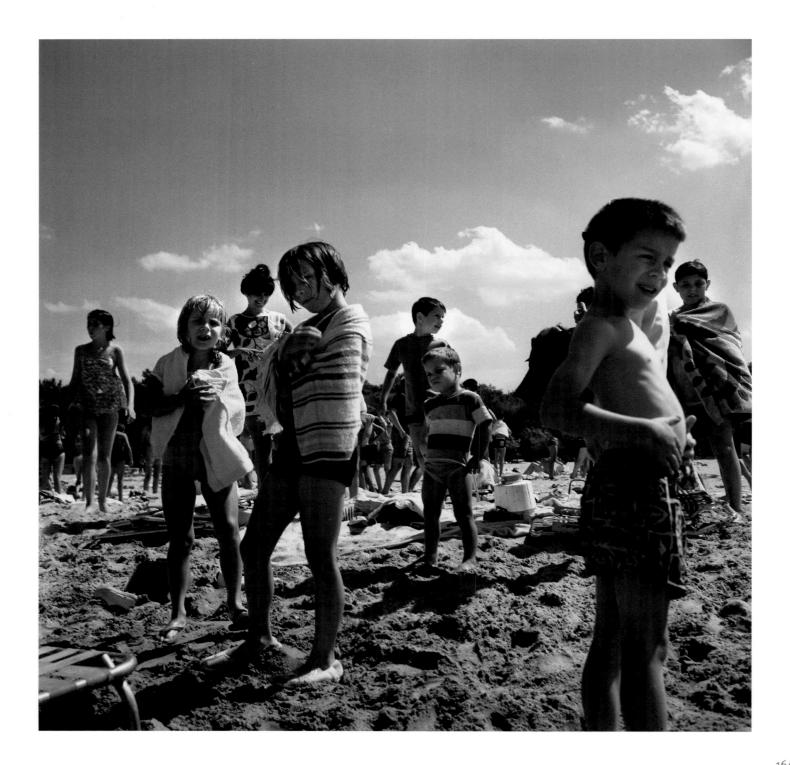

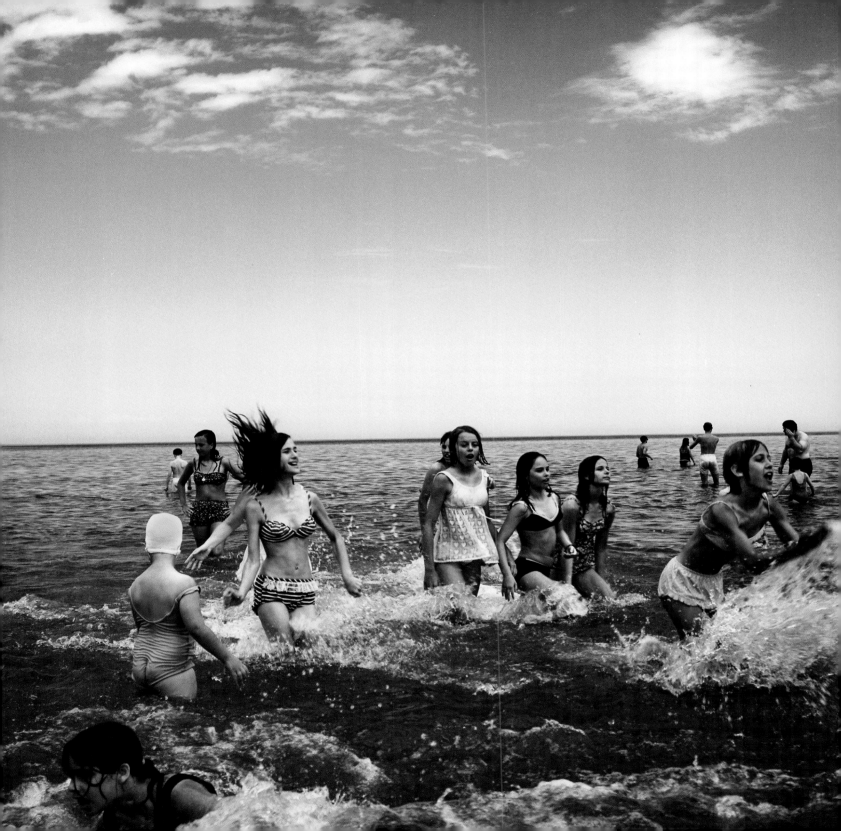

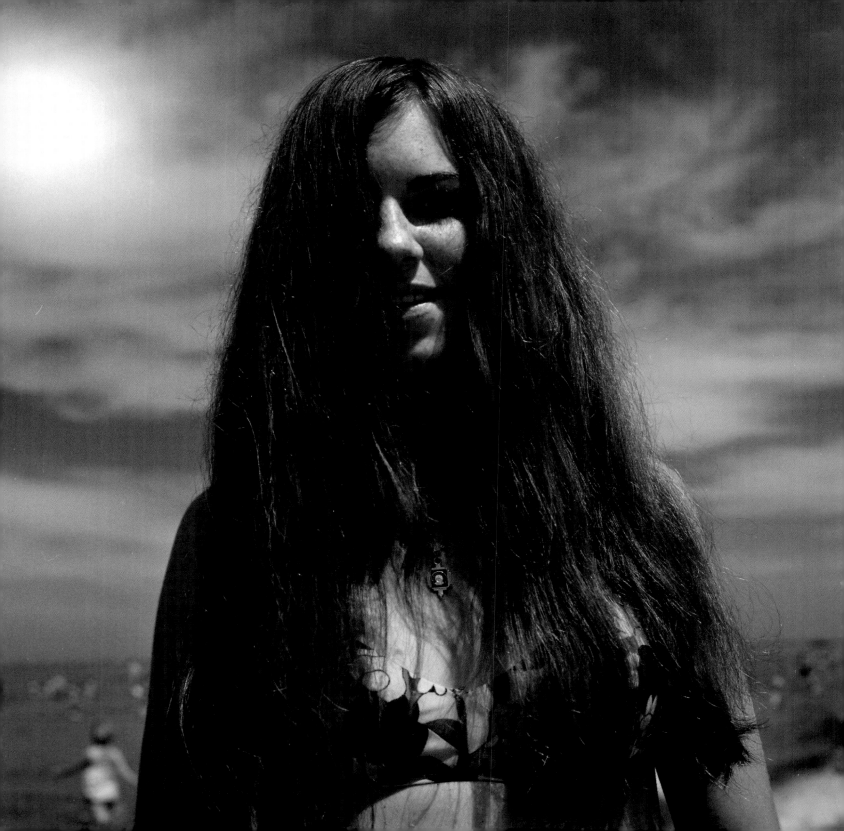

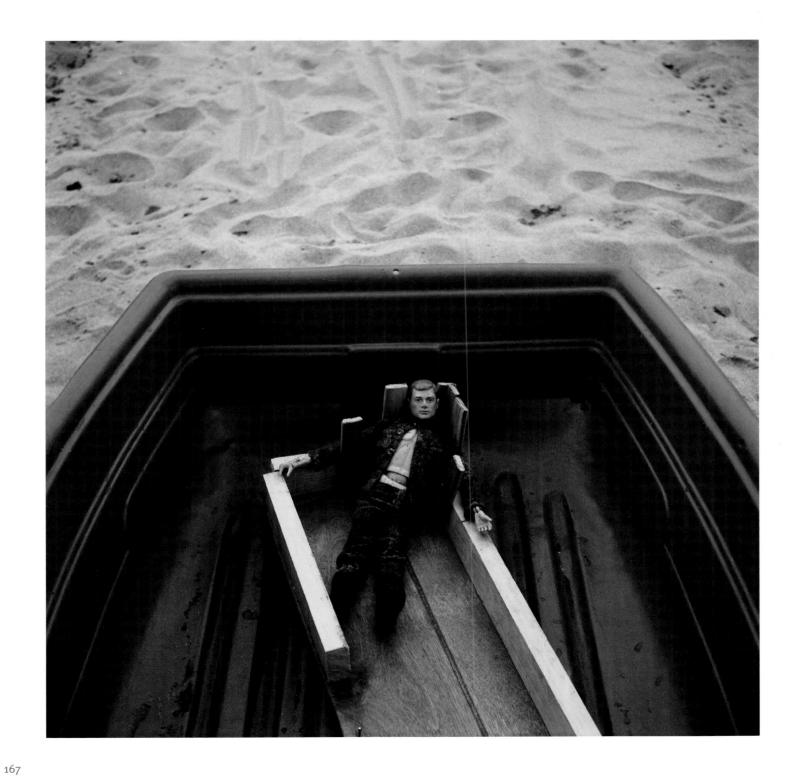

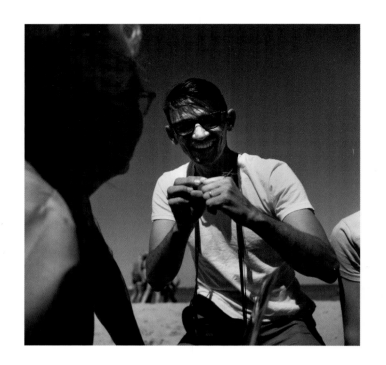

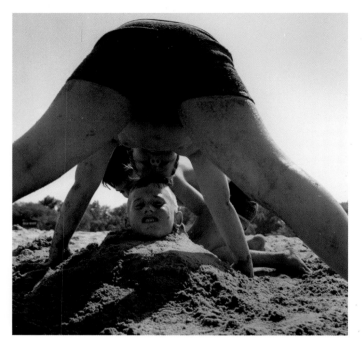

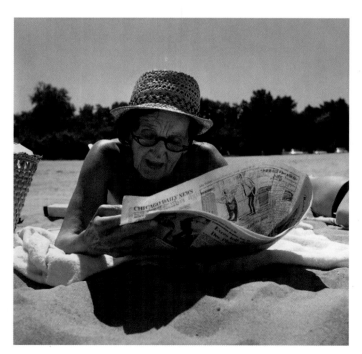

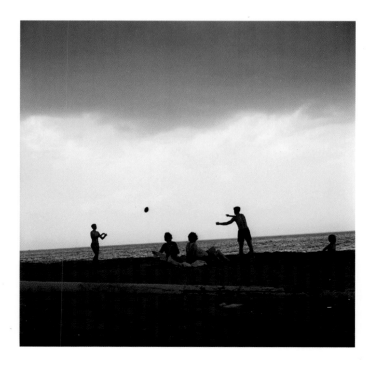

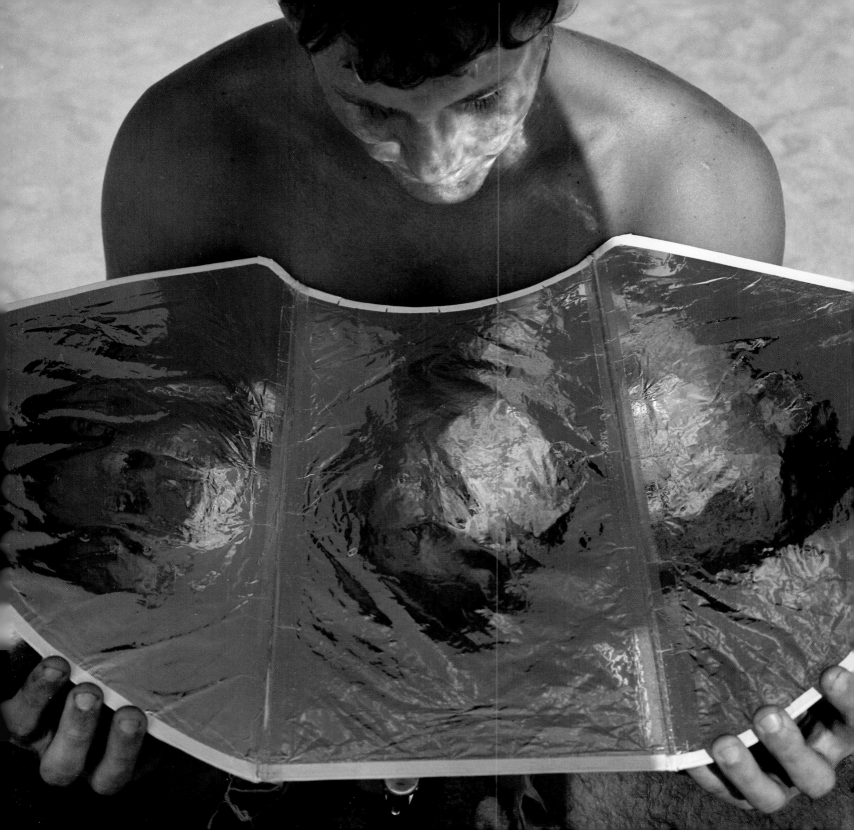

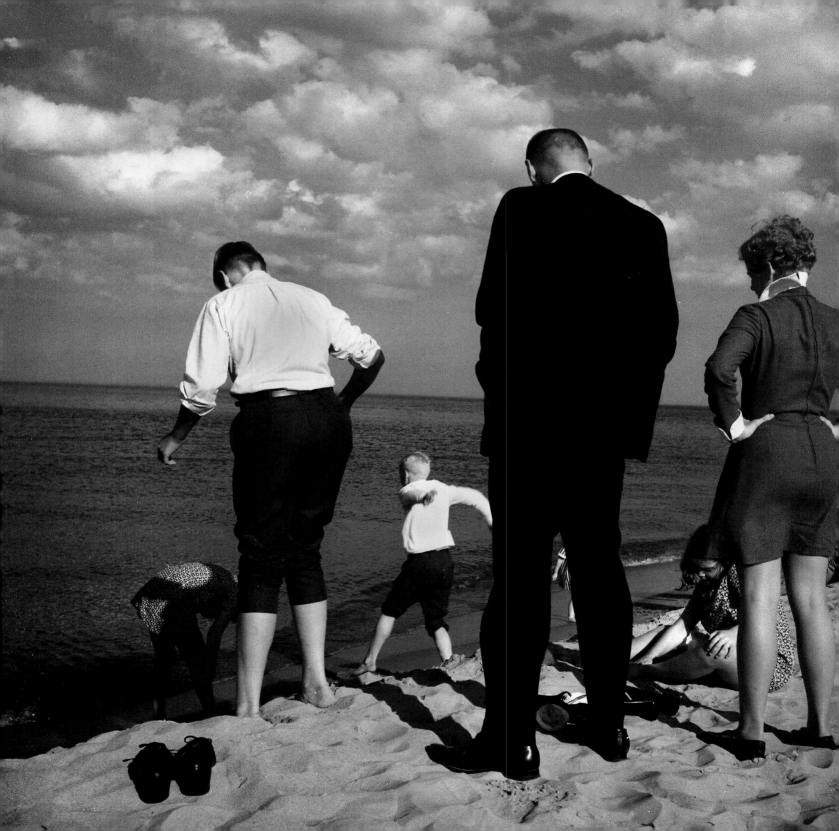

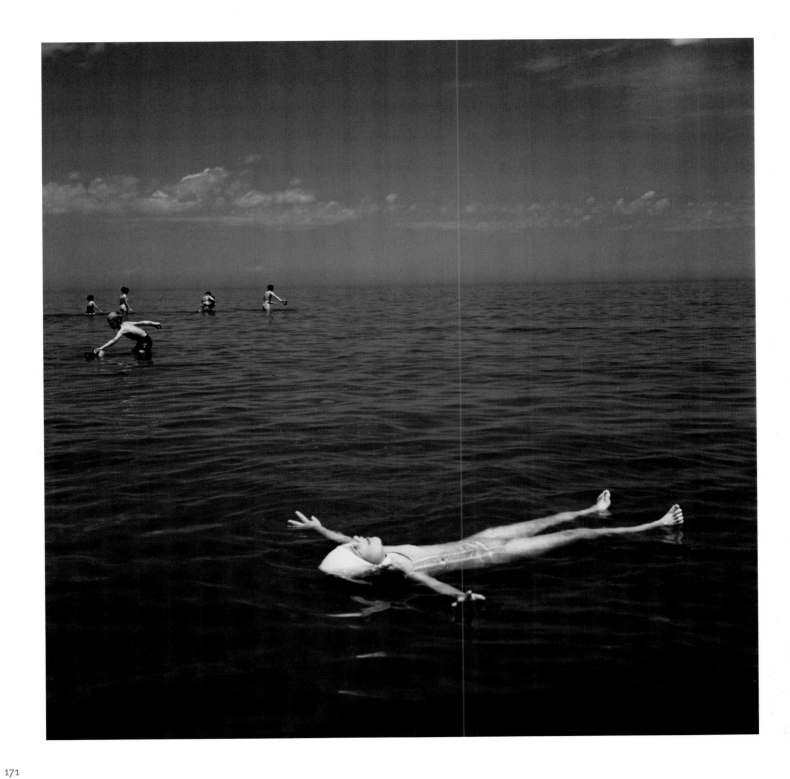

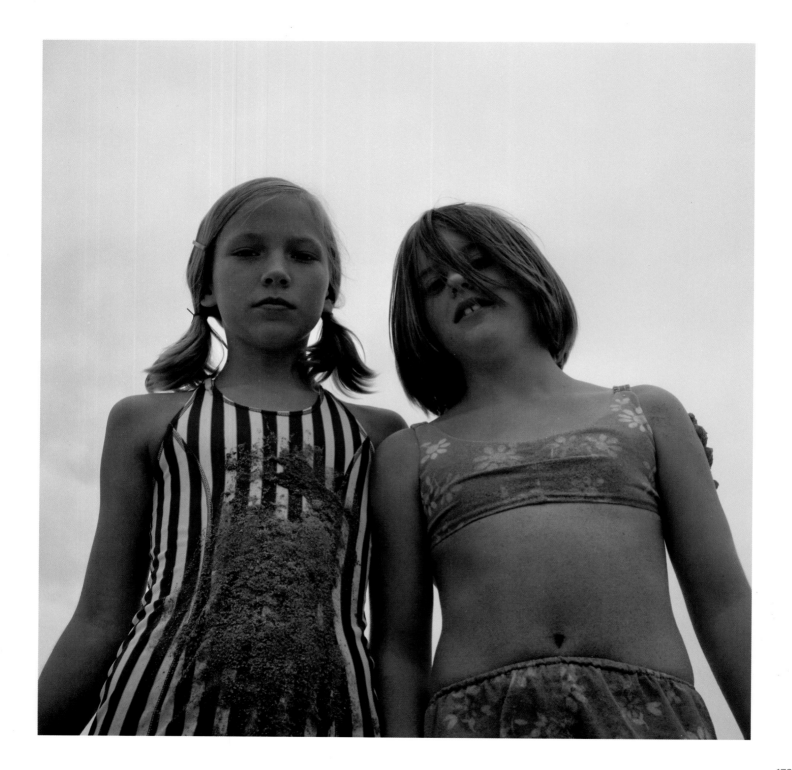

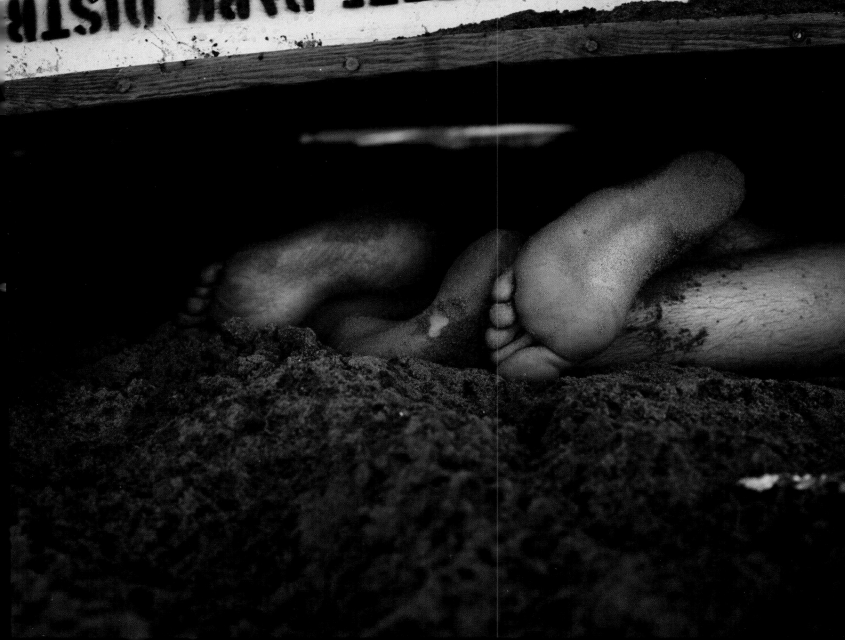

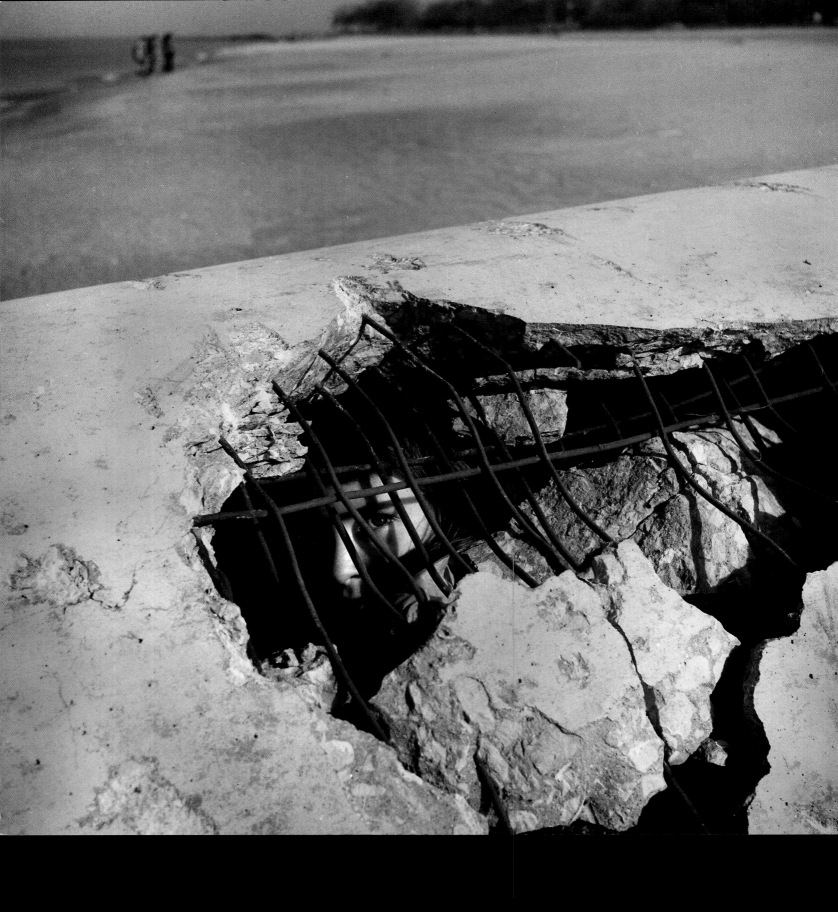

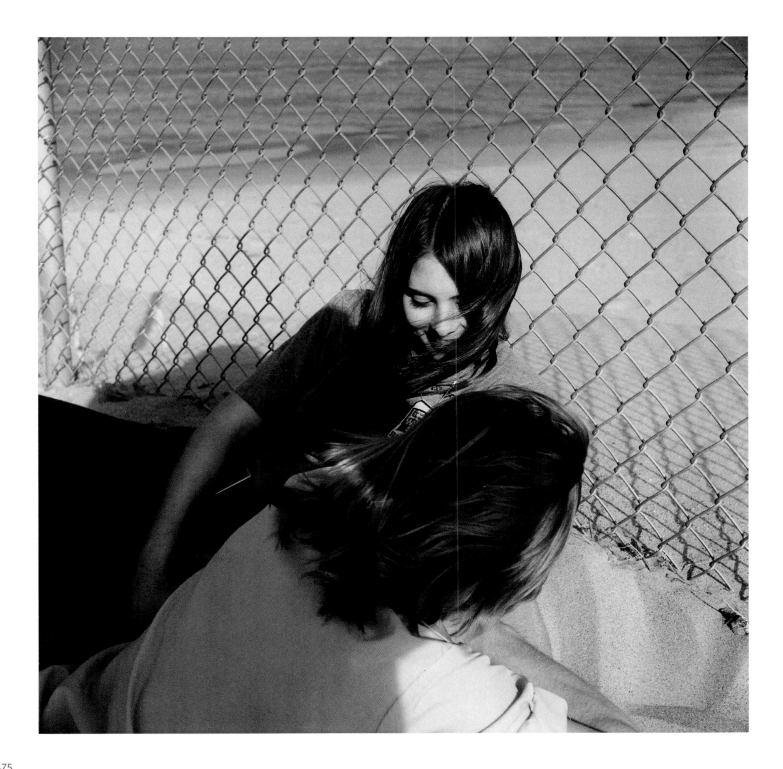

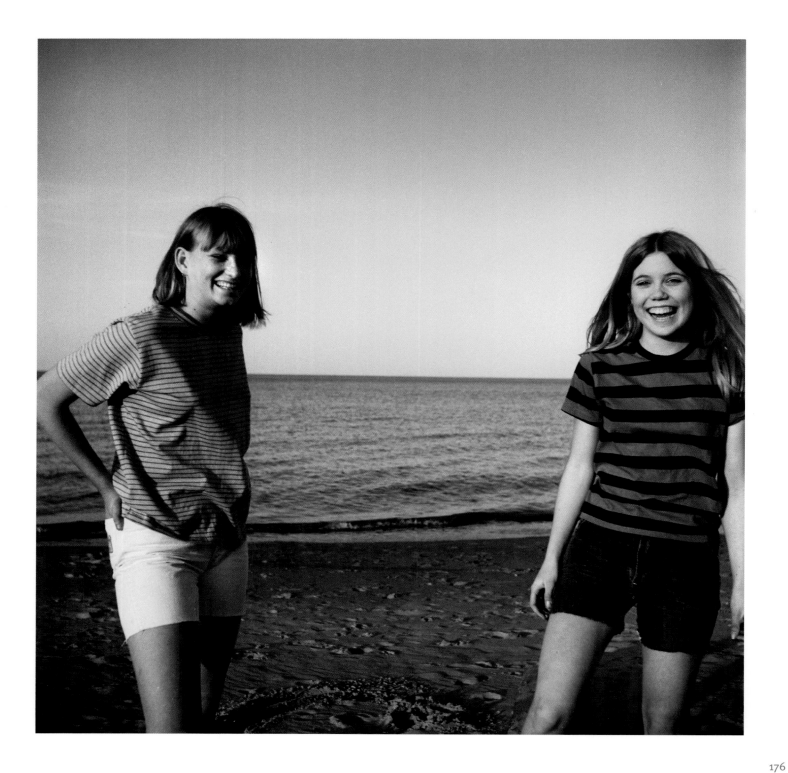

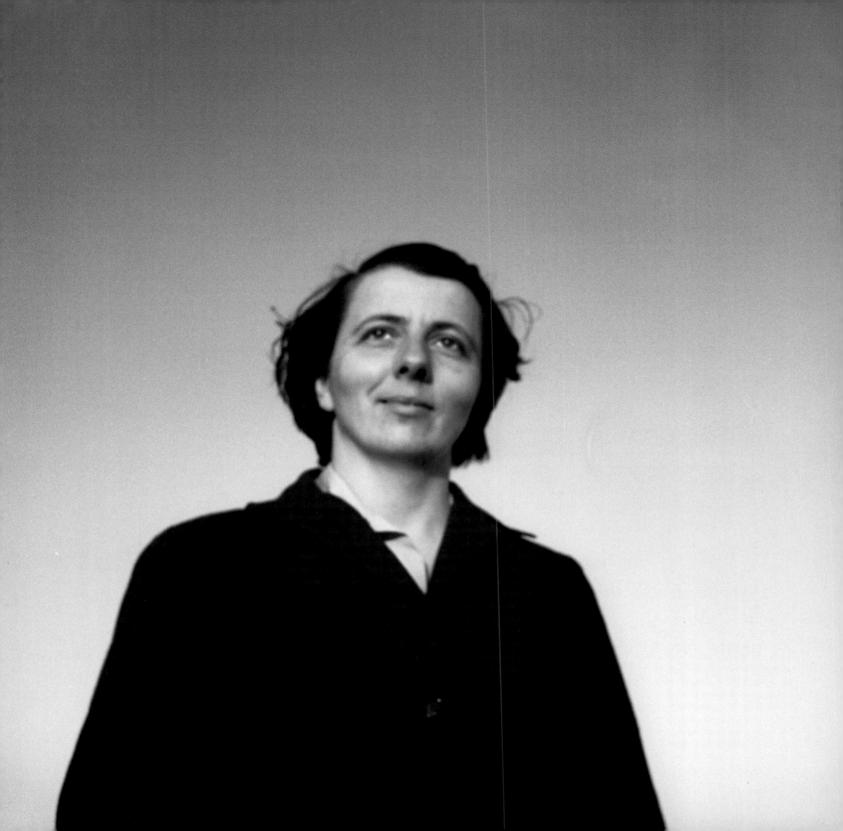

1968

For most anyone who lived through the last half of the twentieth century, the year 1968 was momentous. It was when everything changed. Suddenly current events were intruding on people's lives and the world seemed at a crossroads. And nowhere was that more apparent than in Chicago during four tumultuous days at the end of August.

The year started with tens of thousands of North Vietnamese regulars and Viet Cong guerrillas pulling off a surprise attack on cities and towns across South Vietnam, including a raid on the U.S. Embassy in the capital city of Saigon. When an Associated Press photographer caught the execution of a handcuffed prisoner in the streets of Saigon, it was clear that the war had spun out of control. On March 31, President Lyndon B. Johnson announced that he would not seek another term.

A few days later, the civil rights leader Martin Luther King Jr. was shot and killed on the balcony of the Lorraine Motel in Memphis, Tennessee. The next day, race riots erupted in a hundred cities across the United States. Thousands of African Americans swarmed the streets of Chicago's West and South Sides, looting businesses and setting buildings on fire. Almost every structure along a two-mile stretch of Madison Street was destroyed, leaving the West Side looking like a war zone. Eleven people lost their lives, hundreds lost their businesses, and more than a thousand lost their homes in a civic tragedy that drew Vivian Maier and her camera.

She arrived within days of the riots. Order had been restored, but National Guard troops still patrolled the streets, and the area was in disarray. Maier's photos begin with those she snapped out the window of the Madison Street bus she took to the West Side. She got off around California Avenue and walked slowly west. She shot smoldering rubble, torn-off burglar gates, looted grocery stores, workers stacking bricks, the demolished lobby of the 4-Star Theater, children congregating outside their burned-out apartment buildings, and troops with carbines and rifles. The scene was hard to fathom.

Maier, a private person, was curiously attracted to public events. She had a paparazzo streak in her: she staked out the actresses Zsa Zsa Gabor and Gloria Swanson, photographed Richard Nixon and Lyndon Johnson when they campaigned in Chicago, joined the throngs welcoming the Gemini astronauts at a ticker-tape parade downtown, rushed to local car crashes, and took the train to the Chicago suburb of Crystal Lake after a tornado ripped through it. She carried no credentials, but she pushed her way into or around lines of

press photographers and was never stopped or harassed.

By 1968, the news was very much in her blood. Her photographs reveal how much she cared about the presidential campaign of Robert F. Kennedy. Although thousands of miles away from the Democratic primaries, she documented his victories by photographing front pages of newspapers throughout May. When Kennedy was assassinated in June, she commemorated his life by taking pictures of the small makeshift memorials and of the newspaper accounts of his death and funeral.

The record that Maier compiled of that year could not be complete without her photographing the 1968 Democratic National Convention, the culminating event of one of the wildest primary election seasons ever, which was held in Chicago from August 26 to 29. The whole world was watching, and so was Vivian Maier. Vice President Hubert Humphrey battled Senators Eugene McCarthy and George McGovern for the Democratic nomination. Humphrey represented the establishment; McCarthy and McGovern, who opposed the Vietnam War, represented change.

The establishment would win on the convention floor, but Maier was more interested in the forces of change battling outside. Although she had photographed the site—the International Amphitheater, near the stockyards on Chicago's South Side—a few days before the convention opened, she spent most of her time downtown: in Grant Park, home of protesters, and outside the Conrad Hilton Hotel, home of the Democratic Party. Maier missed the main action surrounding the convention as the police, with billy clubs and tear gas, routed protesters out of Grant Park and Lincoln Park, on the city's North Side. She did not photograph the riots, but she did take pictures of the federal troops who were brought in to keep order and of the demonstrators who challenged that order. The protesters were described as wizened hippies and yippie agitators conscripted to incite violence, but Maier's photos—of young people sleeping in Grant Park, reading newspapers, or considering their next move—show a more mainstream-looking group, many in polo shirts and gym shoes. They appear young and innocent, ambivalent and disoriented. Maier apparently took little Inger Raymond with her to Grant Park. "I was afraid police were going to kill us," Inger recalled, "so she finally had to take me away."

The damage caused by those clashes between protesters and the police helped defeat the Democrats. Months later, Maier photographed a Democratic torchlight parade through the streets of Chicago, but by then their cause was hopeless.

There are more pictures from the year 1968 in this collection than from any other. The year defined Maier and gave her new direction. By the end of it, her optimistic view of life—so apparent in the first two decades of her work—was forever altered.

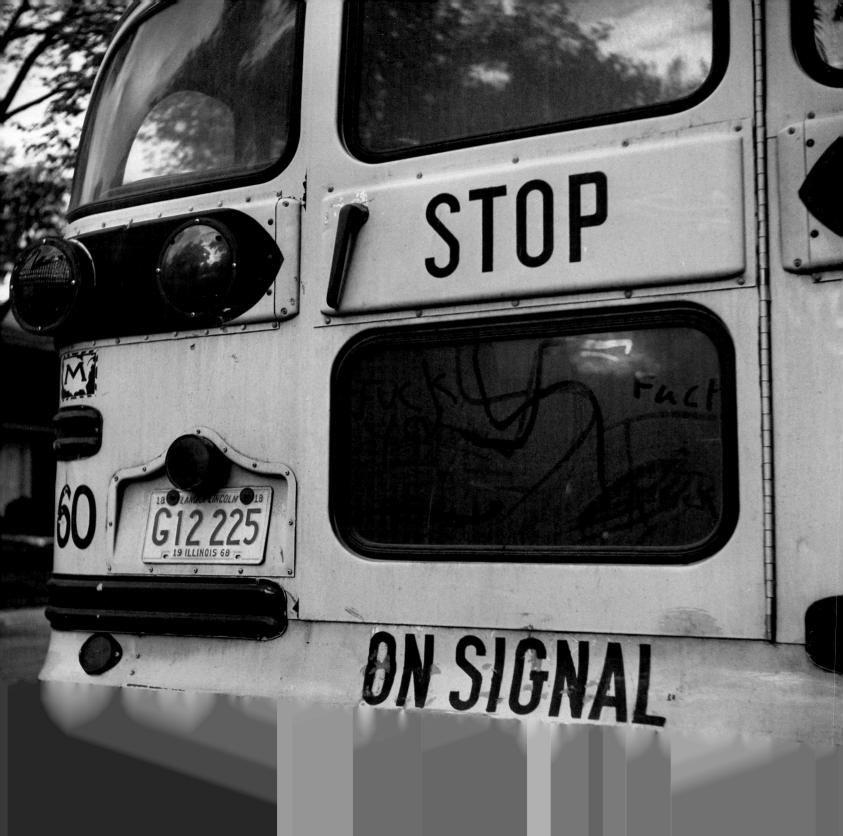

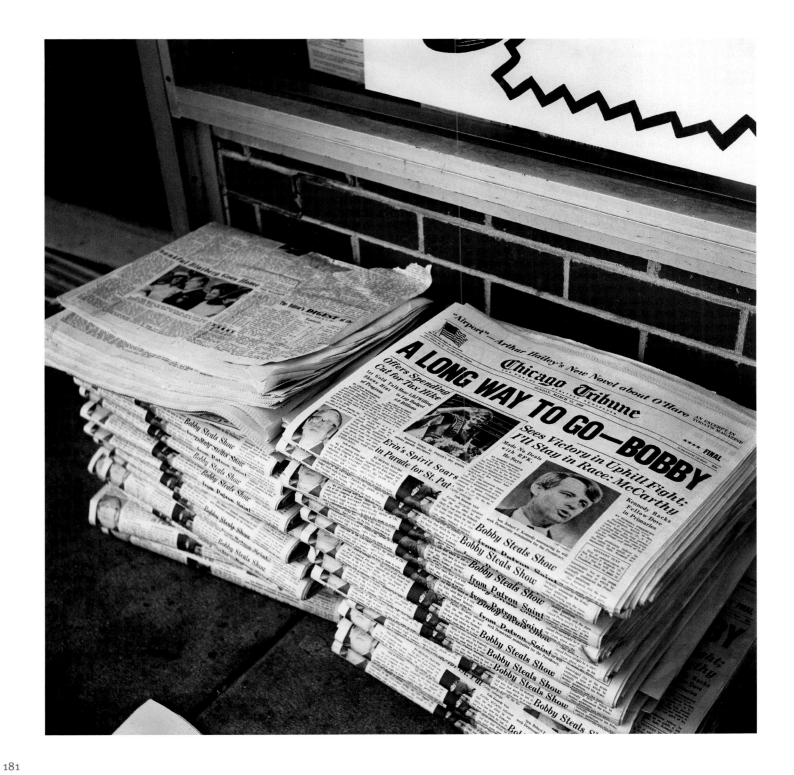

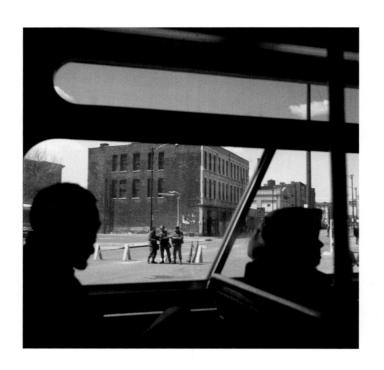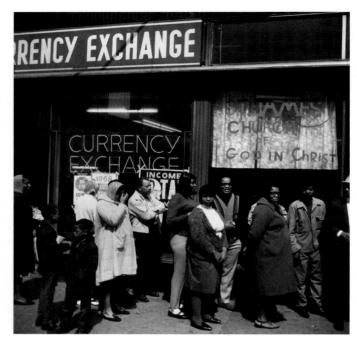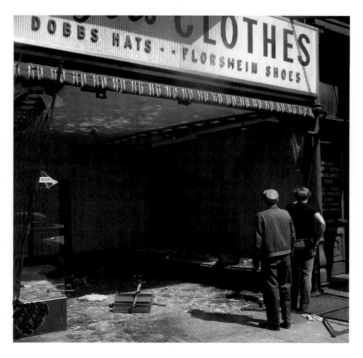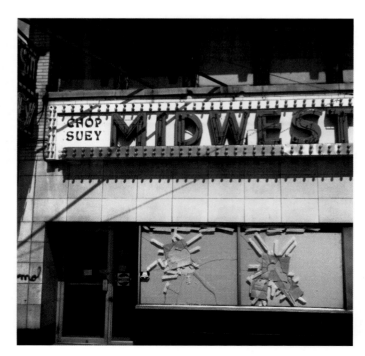

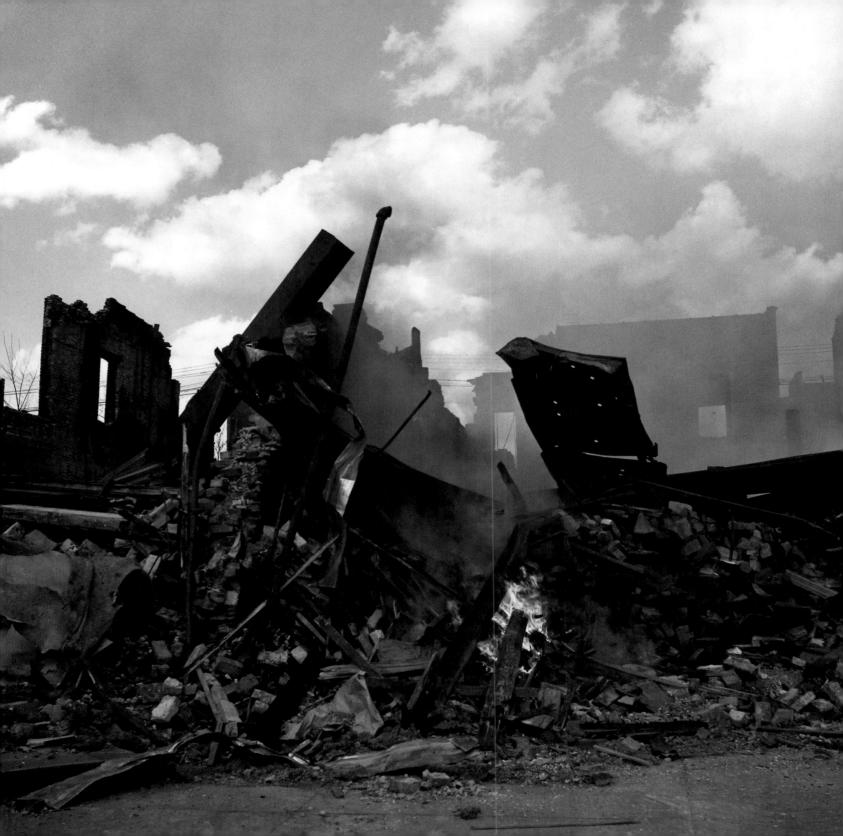

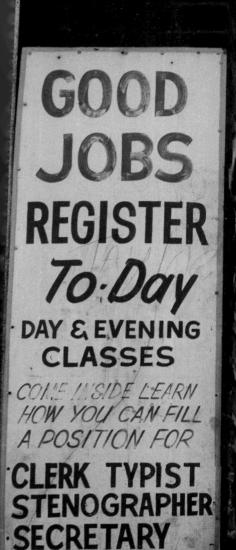

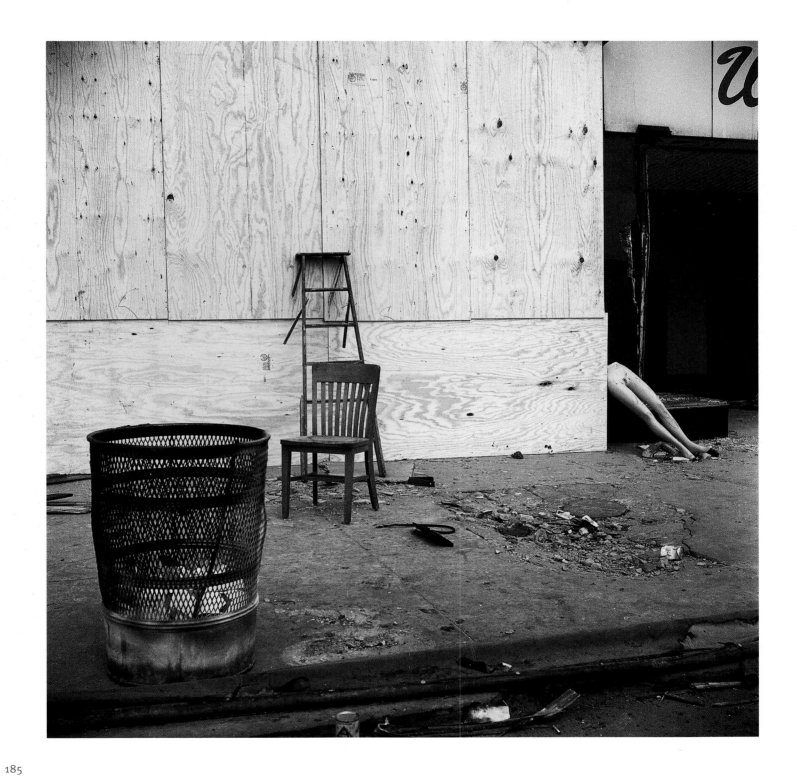

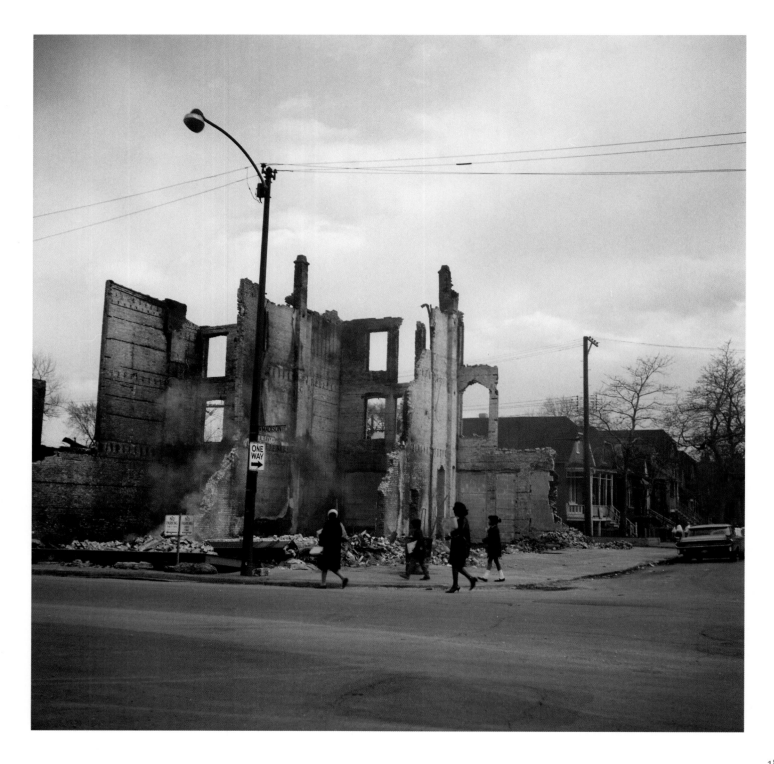

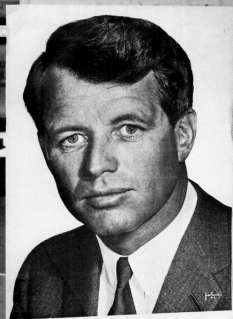

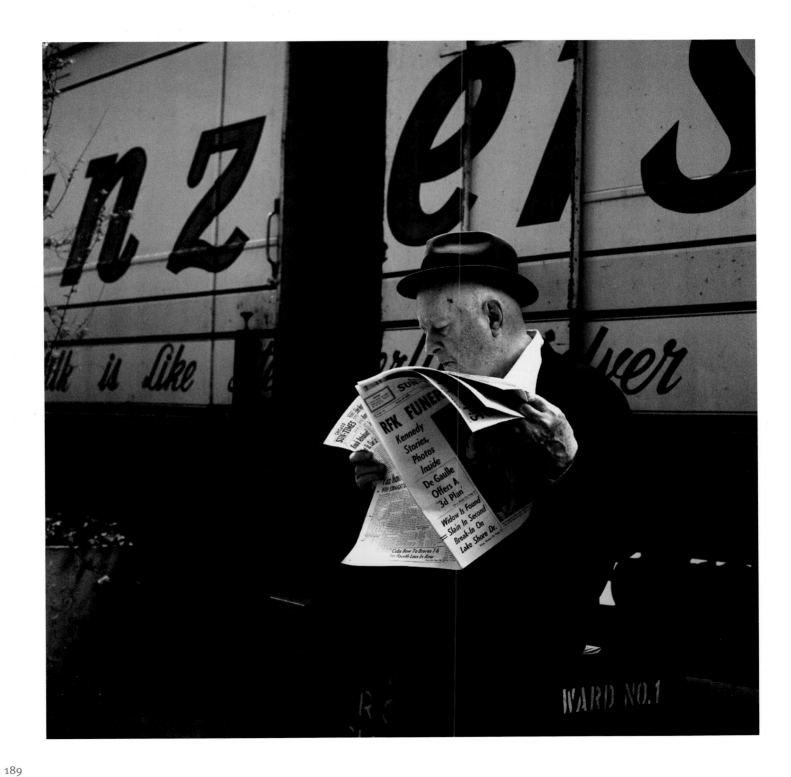

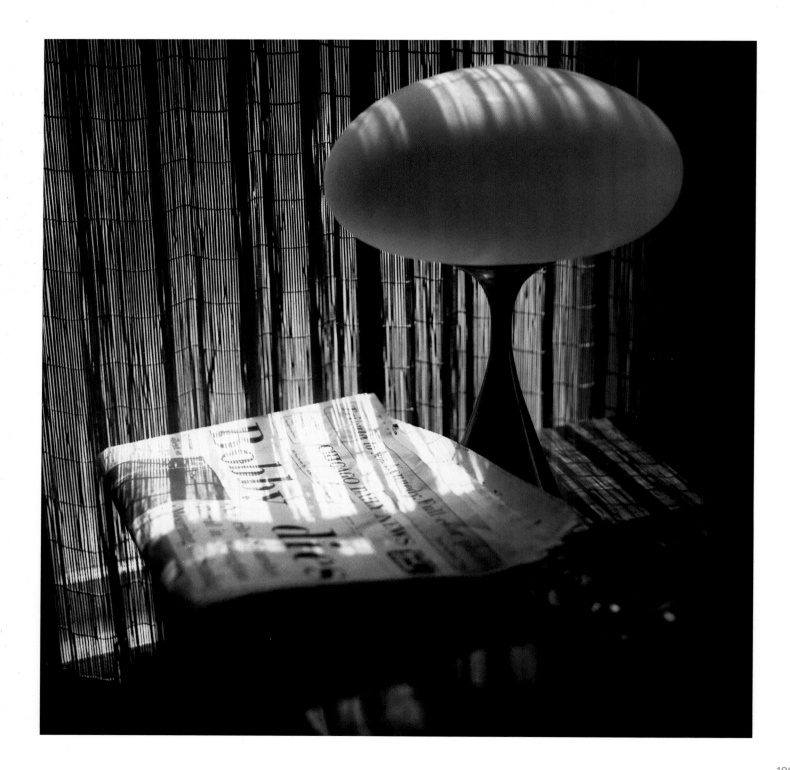

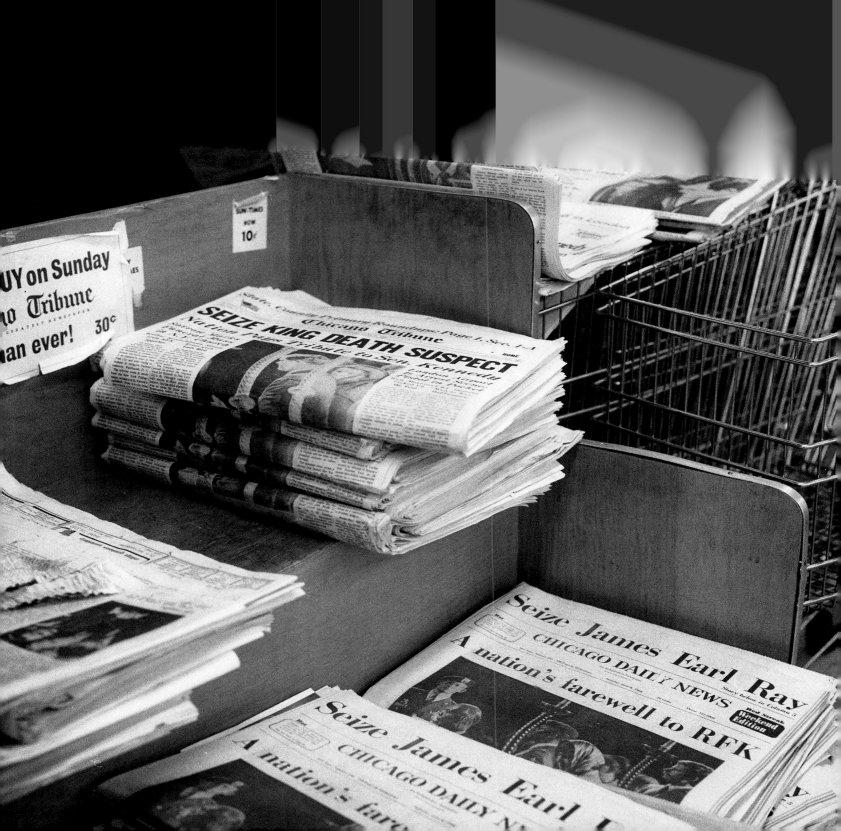

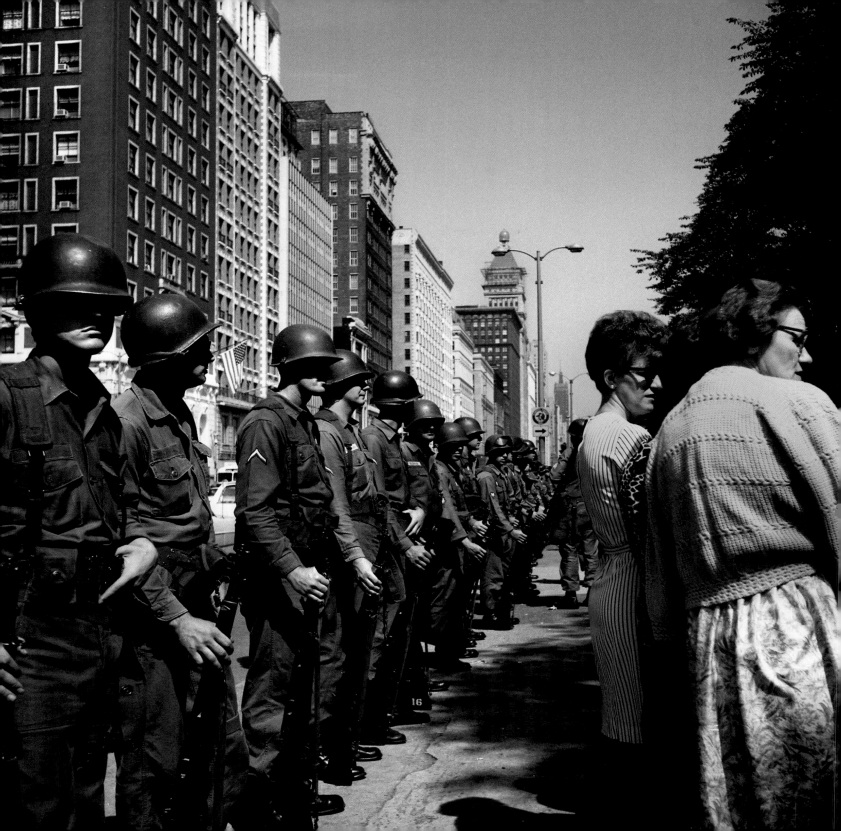

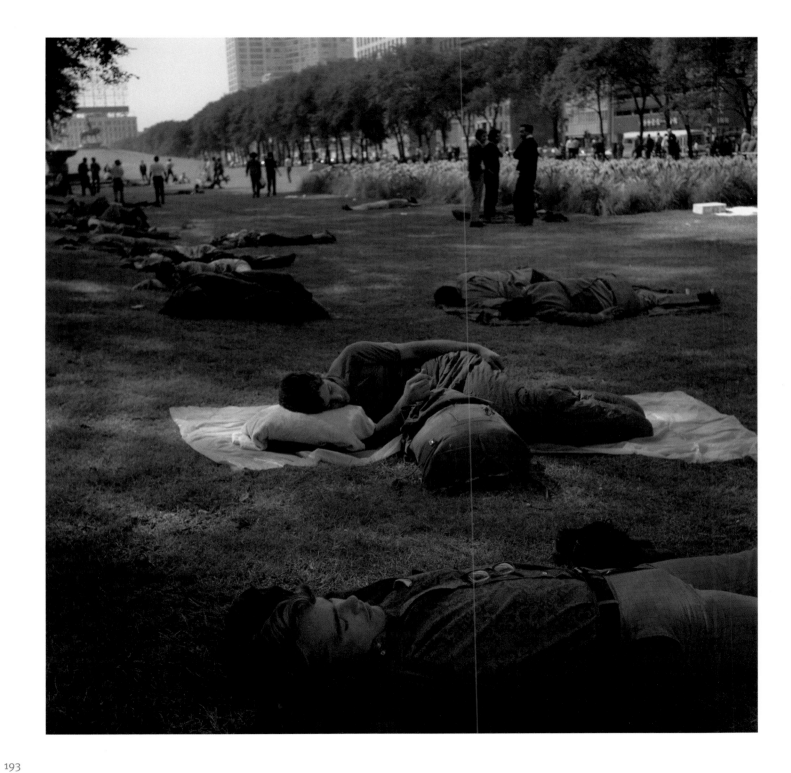

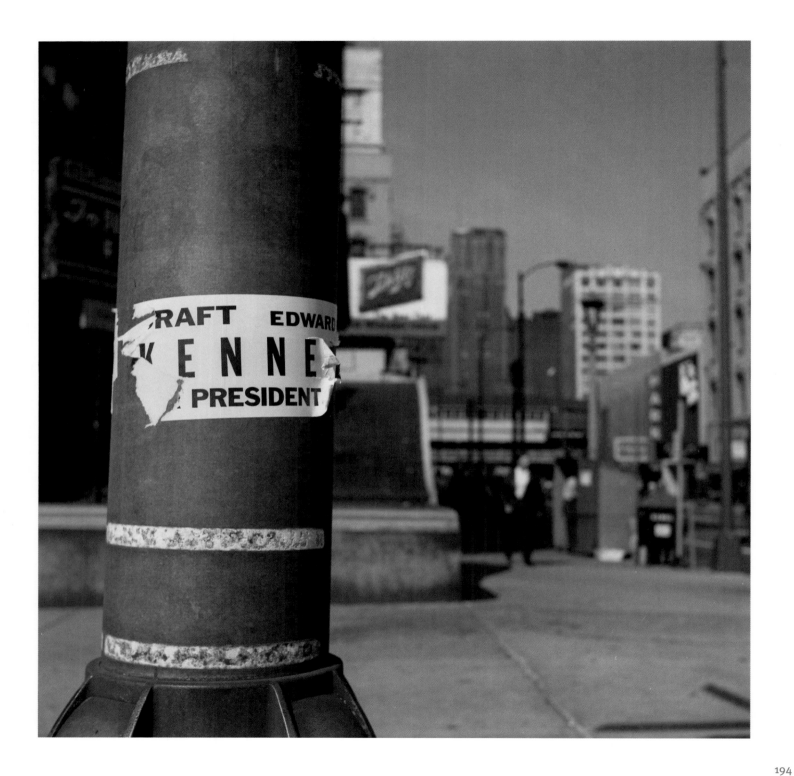

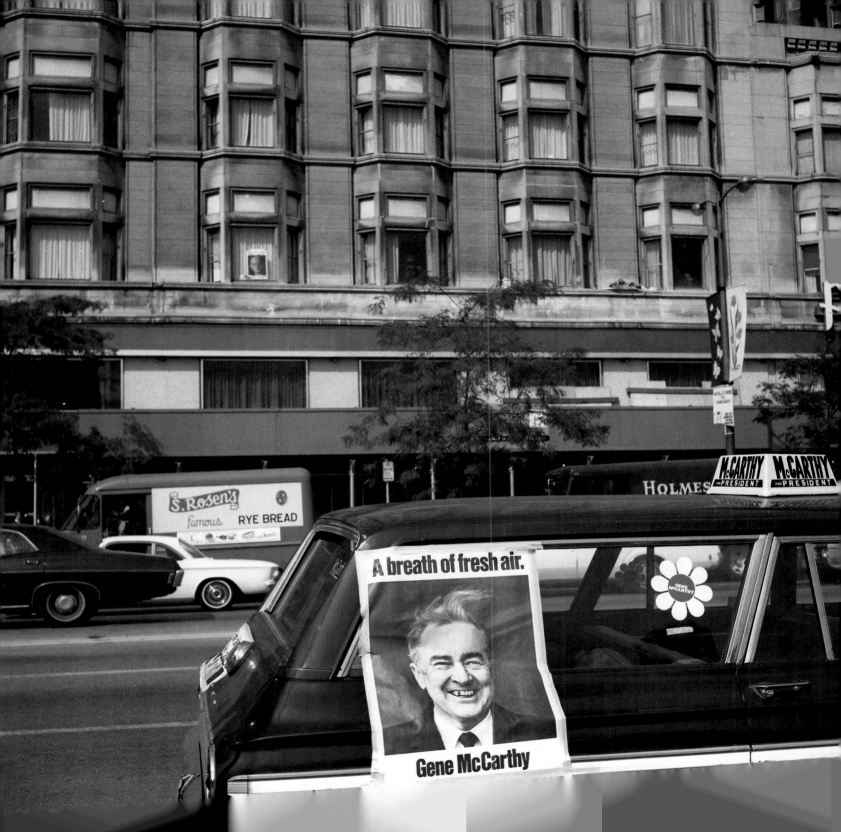

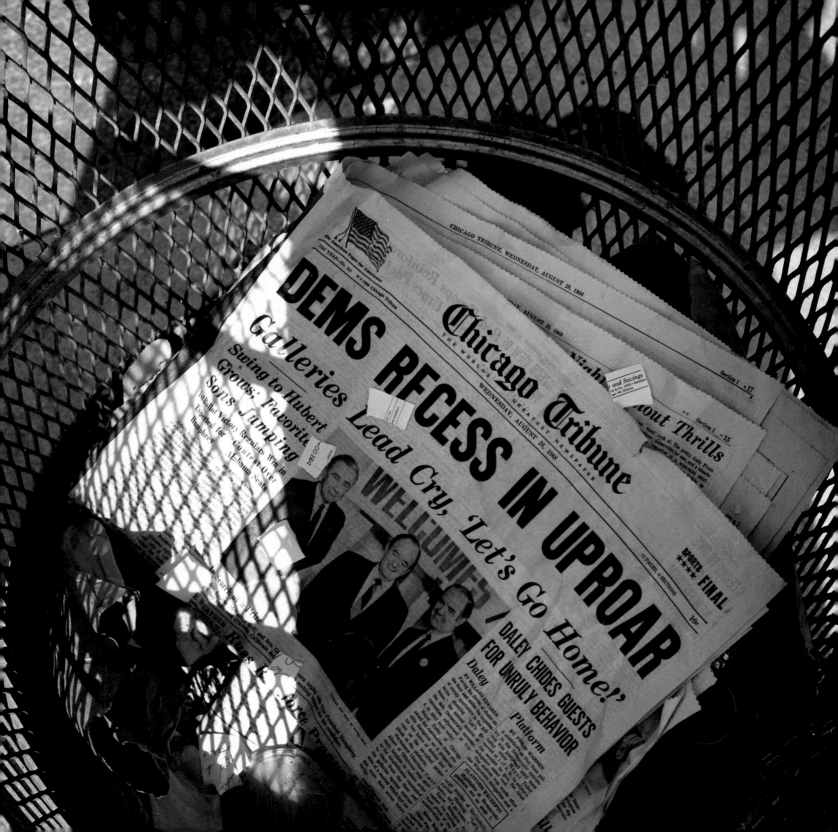

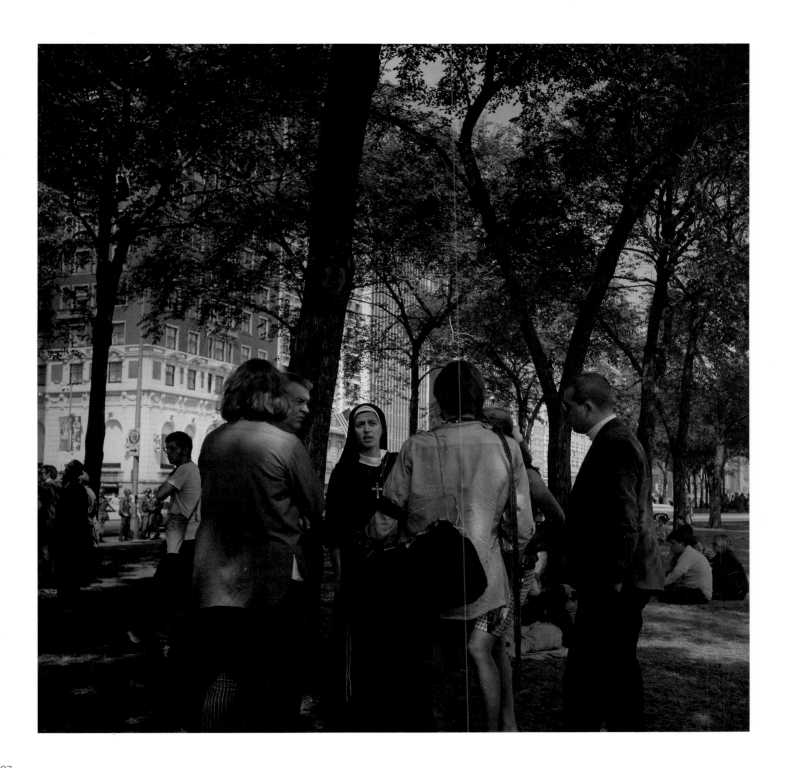

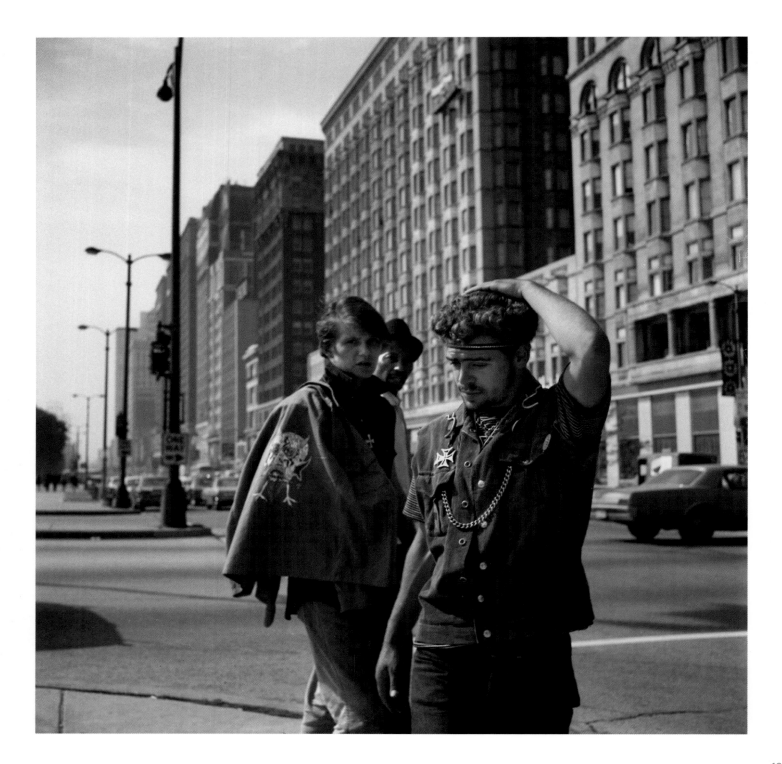

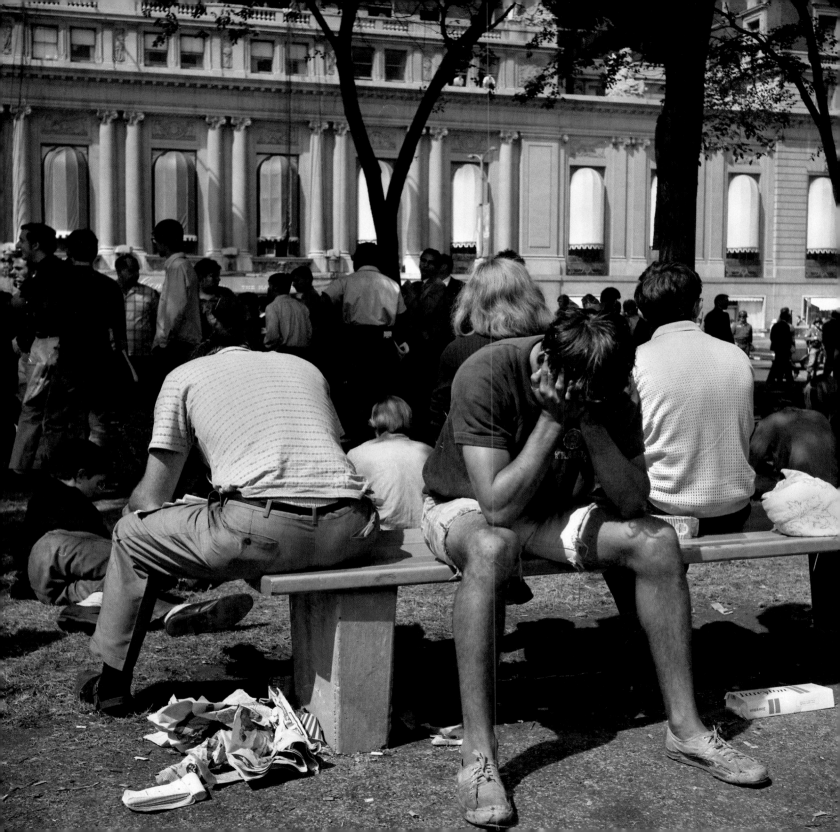

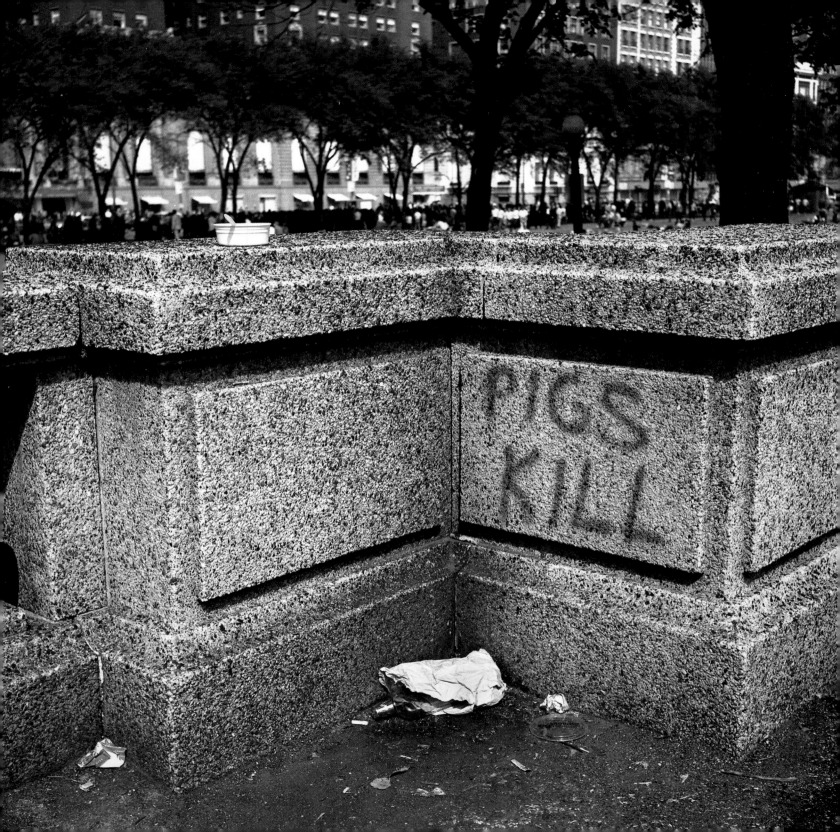

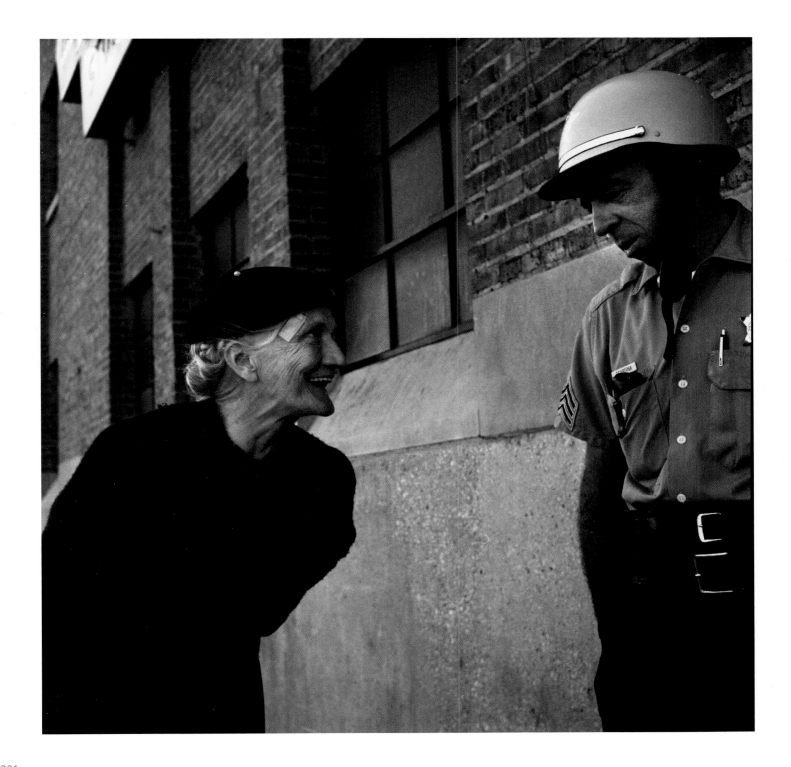

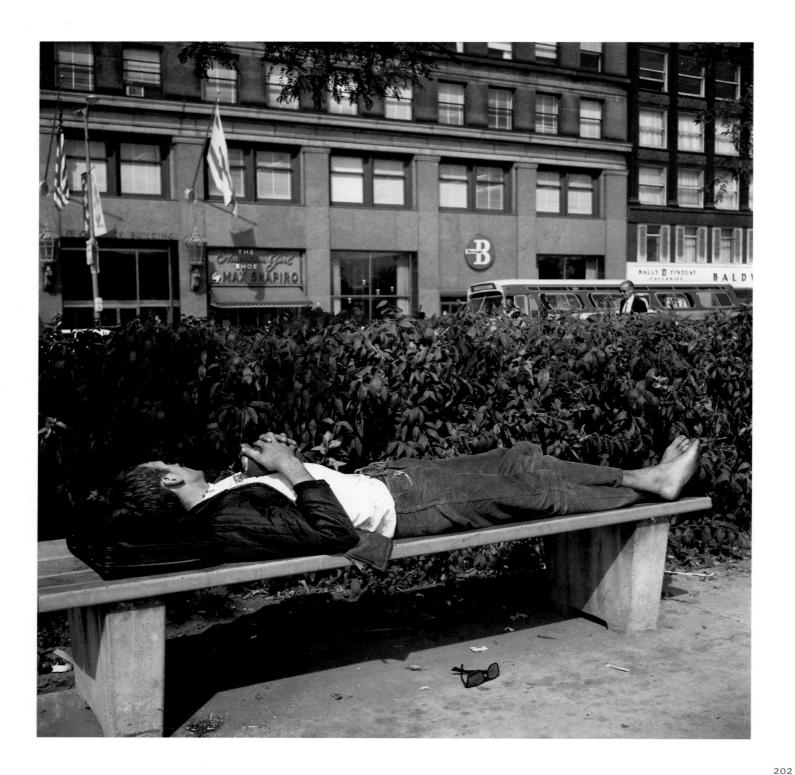

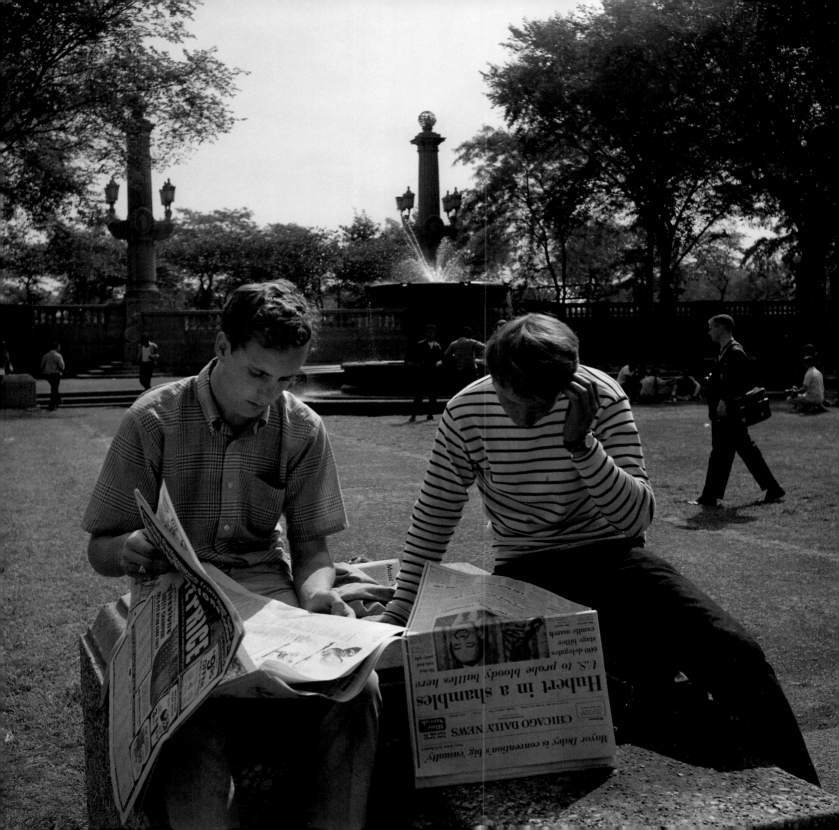

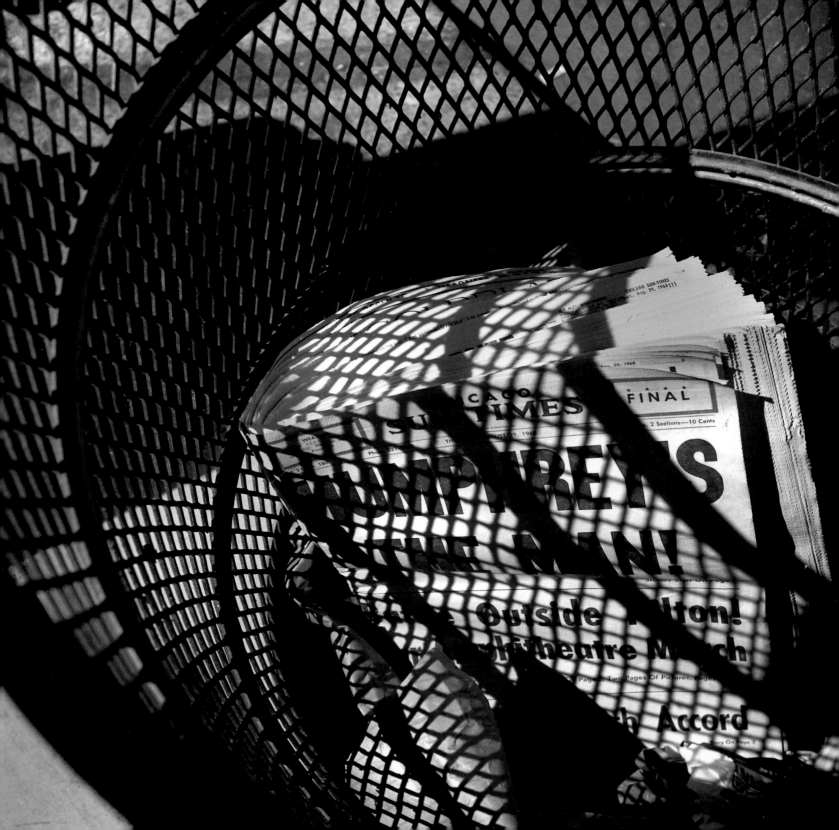

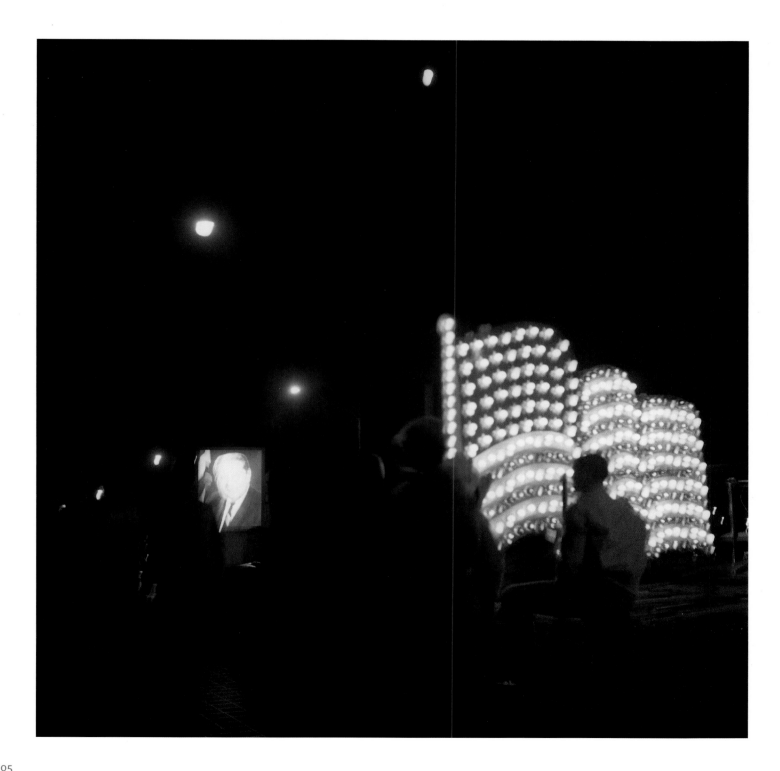

DOWNTOWN

Vivian Maier's sense of anticipation as she approached downtown Chicago is evident. The trip by commuter train from Wilmette or Highland Park took about half an hour. Maier usually began to ready her camera as the train passed a railroad siding in an industrial district on the Near North Side, a mile or two from downtown. Signs—a billboard for Hamm's beer, an ad for Polonia Coal and Fuel Oil—signaled that she was getting close to the heart of the city, and that is where she often shot her first photographs. As the bi-level Chicago and North Western rounded its last curve, she would look east across the Chicago River at the Loop. She had arrived.

The downtown that Maier photographed has changed. Gone are the ladies in gloves and the gentlemen in fedoras, the movie theaters playing newsreels, the Woolworths counters, the strip clubs and nightclubs. Maier took her camera there to share life. She relished plays and movies, but here was real drama. This was her stage.

Unlike many street photographers, Maier was interested in more than the hustle and bustle of city life or the ironic juxtapositions of people and their surroundings. She came downtown for the humanity. She was drawn to people high and low: the sublime and the serious, the shifty and the shy. She watched them—their carriage and their condition, their gestures and their glances. She photographed women holding hands, a man checking his fingernails, transients who had drifted into the Loop. These were not the nostalgic pictures she took in France or New York a decade before. Maier was older now and more knowing.

The camera gave her "a charmed presence," in the words of the critic Allan Sekula. "She had this ability to be there without signaling threat or invasion, to be accepted or at the very least tolerated and ignored," he wrote. In that way, she could see people behaving naturally.

Maier made instant decisions about whom to photograph. "Street photographers have an instinct," observed Joel Meyerowitz, who trolled the streets with a camera for decades. "They are pulled by who is out there or pushed to others. We all have our inner casting director. This one here you don't care about. This one has dignity, tragedy, bearing. Something speaks to us. It's like following a divining rod."

Meyerowitz, coauthor of *Bystander: A History of Street Photography,* was one of the first to appreciate Maier's work. He notes that all serious street photographers go out not to make photographs but to feel alive. "In a split second, you have a glimpse of truth. Something

reveals itself, some infinitesimal thing—manifestations of human behavior that have real meaning. If you've accumulated a few hundred moments of these, that's a lifetime."

The hubbub of the Loop was the antidote to her pleasant but white-bread life in the suburbs. From her first days in Chicago, it was downtown where she went most. She returned to the same street corners for decades, photographing in the deep shadows of the el tracks, by Loop newspaper stands, under the clock at Marshall Field's, outside the Art Institute. Sometimes she stopped and talked; sometimes she just shot. Maier felt at home there. Sifting through the crowds—seldom noticed, always noticing—was intense work. Planted among them, she could look into her Rolleiflex at a perfectly square world. People would enter and leave her world, gone forever—unless she pressed the shutter.

Maier has been likened to many who preceded her. Some say her close-ups recall the work of Lisette Model in the 1930s and that she drew her empathy from New York's Photo League of the 1940s. And some say she was inspired by Chicago's Harry Callahan in the 1950s or romantic French masters such as Robert Doisneau, André Kertész, Brassai, or Henri Cartier-Bresson. Like Diane Arbus in the 1960s, Maier had an uncanny ability to make the grotesque seem radiant, and like Garry Winogrand in the 1970s, she possessed a voraciousness for all things photo.

But time plays tricks, and it is unclear where and how Maier developed her style. Her early work predates that of many of her supposed inspirations, and it is unlikely that she would have been exposed to much of their work. The books she left behind indicate she was well-read in art and photography, but when she began her serious work in the early 1950s, the magazines *Life, Look,* and *U.S. Camera* were the arbiters of taste and few photo books were easily accessible. The most influential of the time were Weegee's *Naked City* (1945) and *Weegee's People* (1946), but that tabloid photographer and Maier could not have been more different. Weegee looked for chaos and craziness. He showed the extremes of life in his flash photos. Maier, using daylight, sought only the ordinary.

Comparisons fall flat because Maier's work is distinct. Her pictures of the streets of New York, which caused such a stir when they were first shown online, represent only the start of a long and serious life in photography. Ultimately, Maier developed her own singular style—heartfelt pictures filled with a sense of wonder and curiosity. You can tell a Vivian Maier photograph. She had a way of knowing just how close she could come to her subjects in order to pierce their façade without exploiting them, as well as a savant-like ability to perfectly compose her frame. Remember: she was the mystery woman.

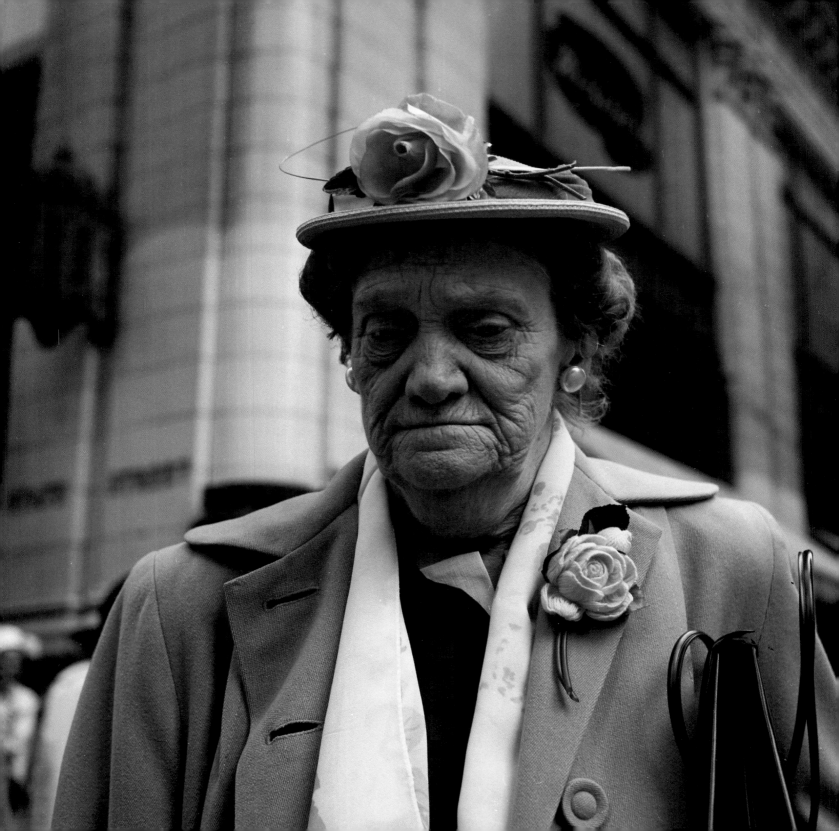

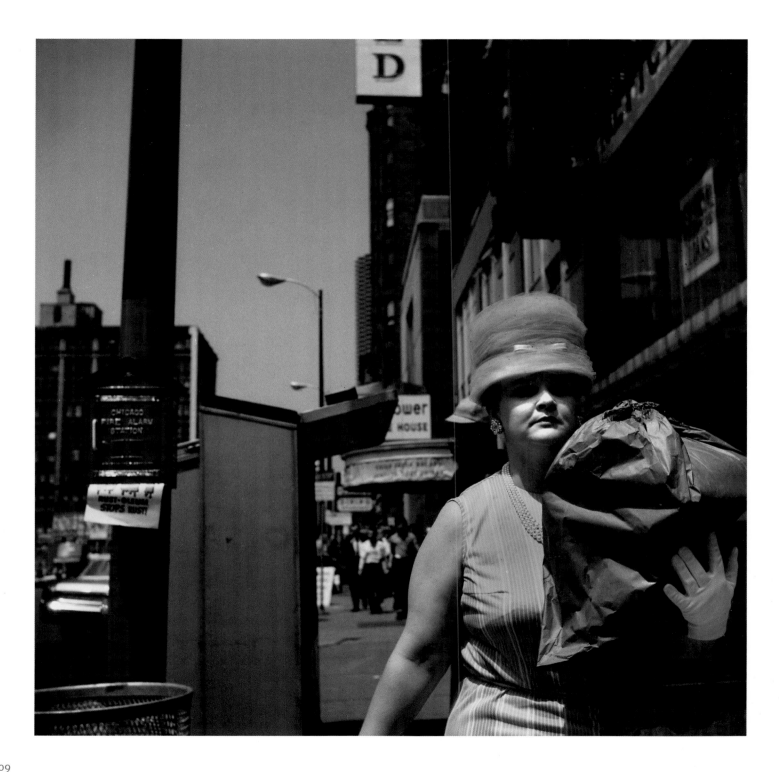

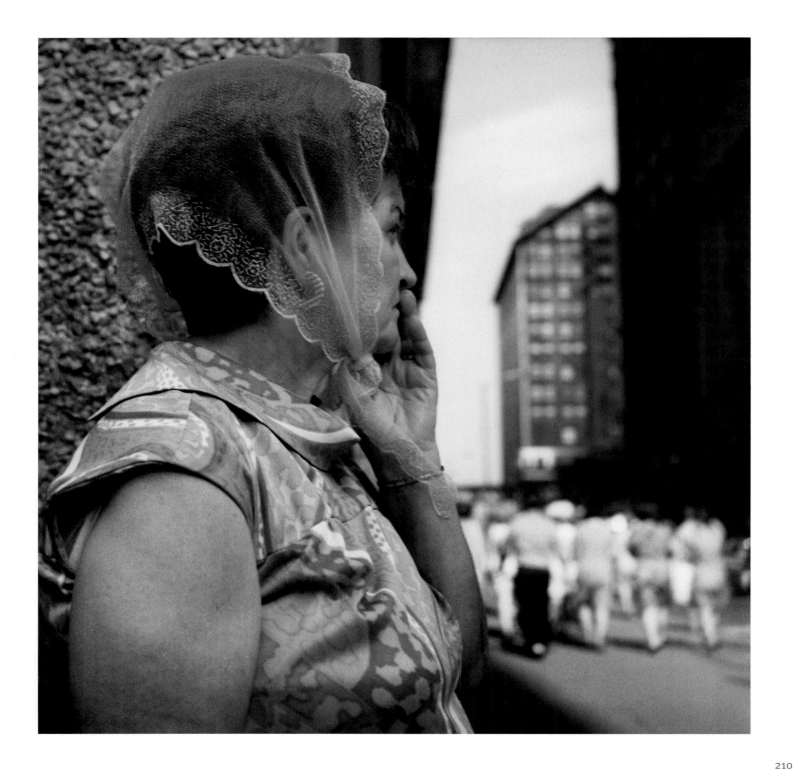

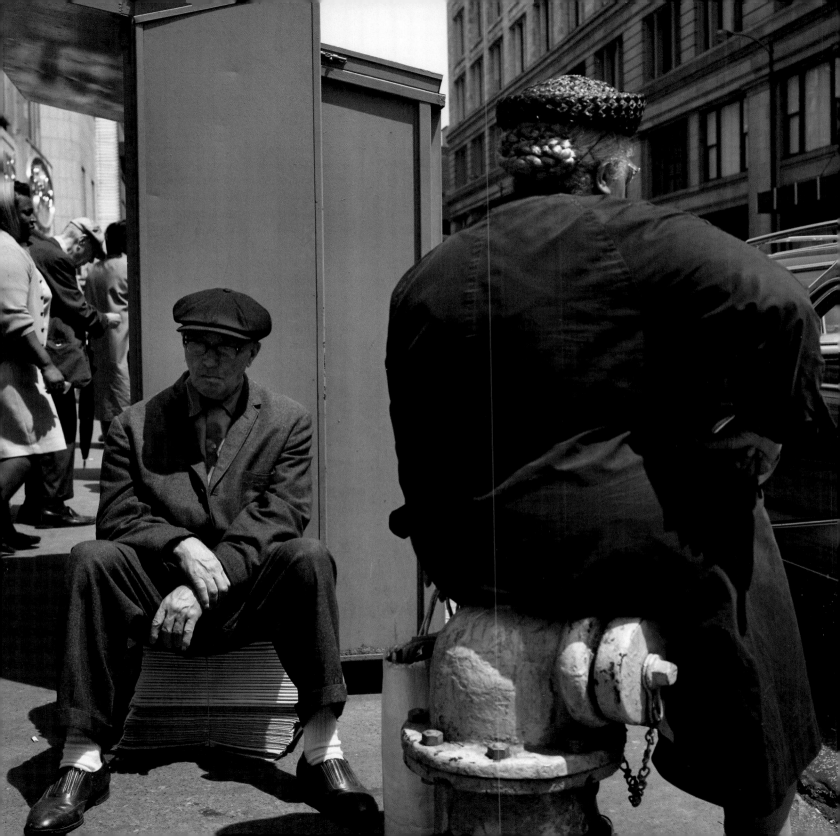

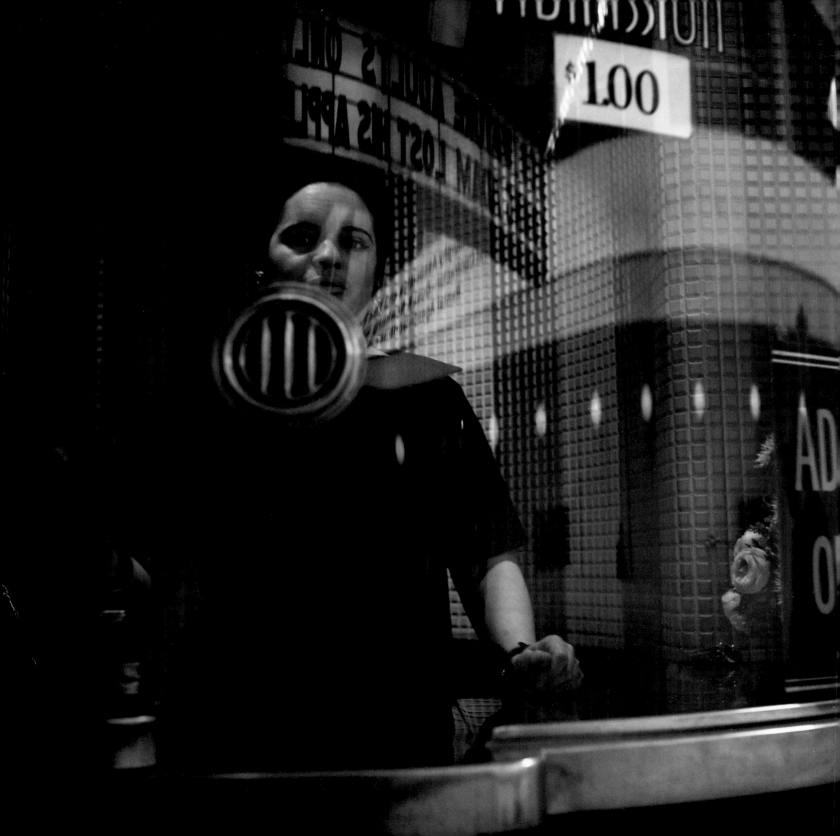

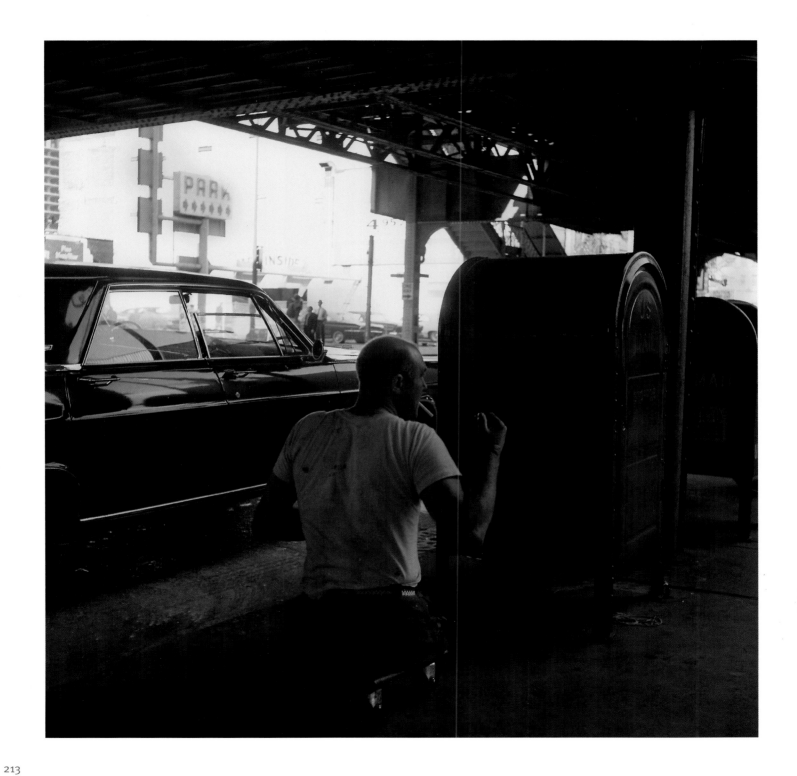

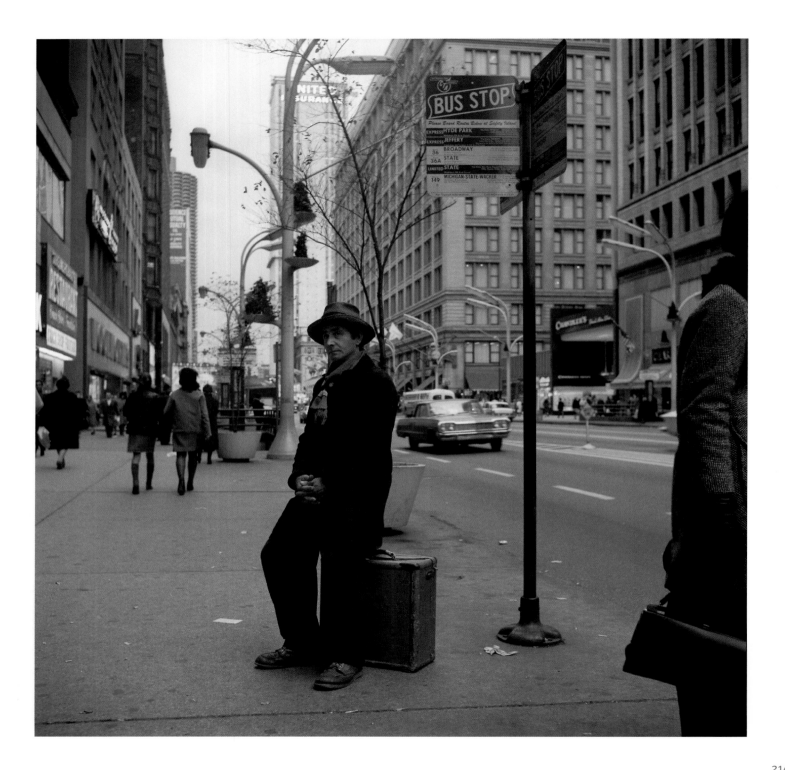

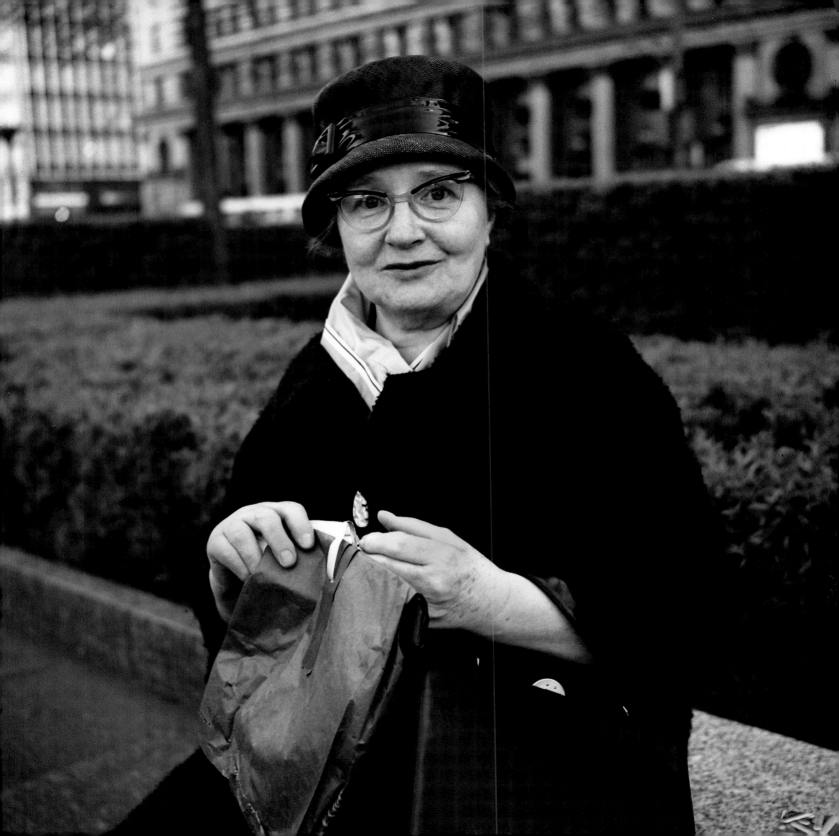

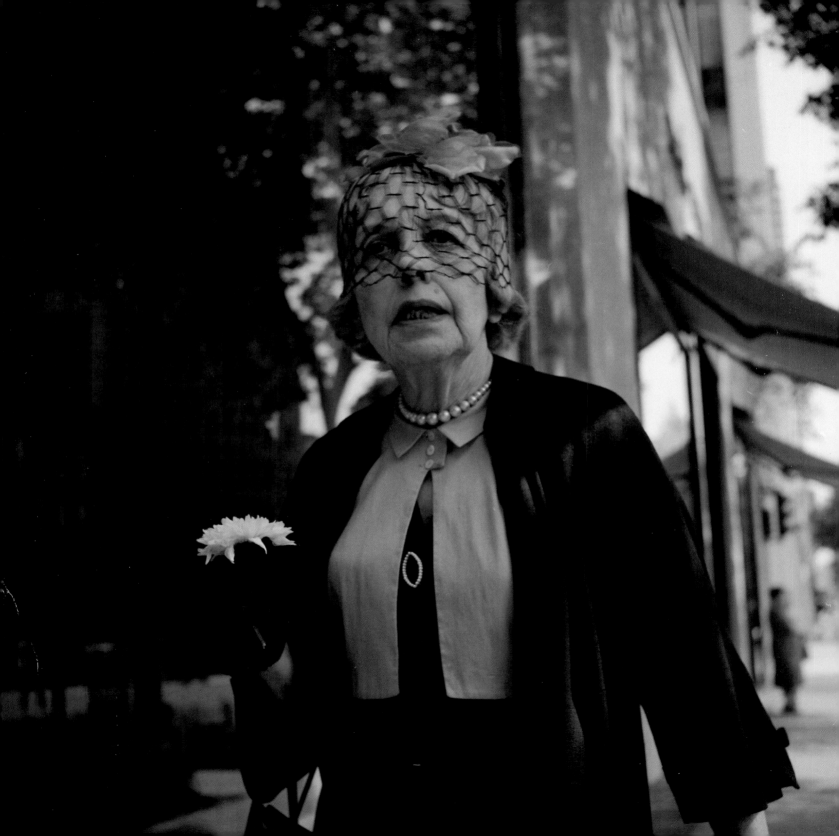

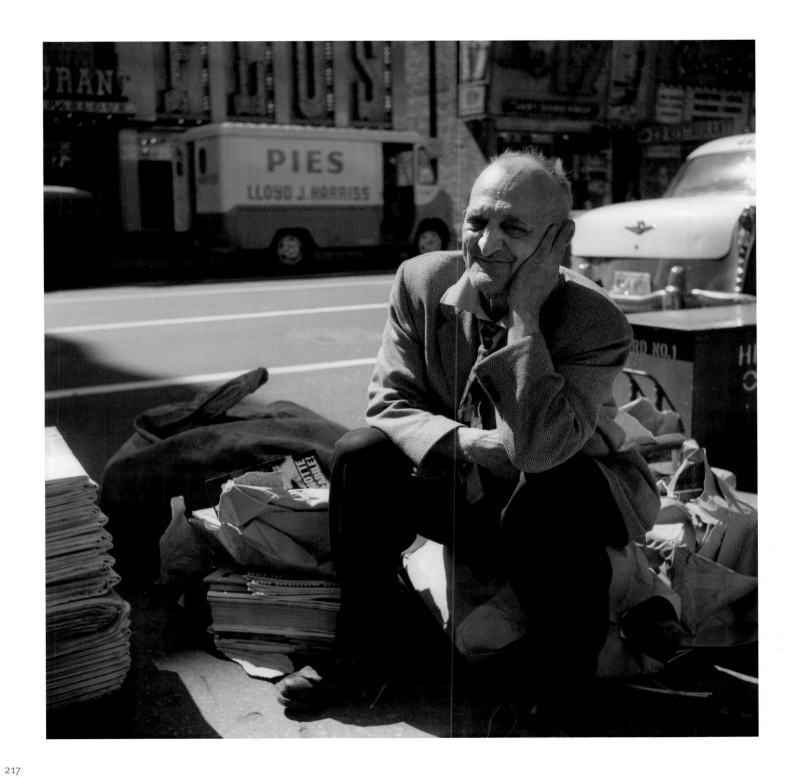

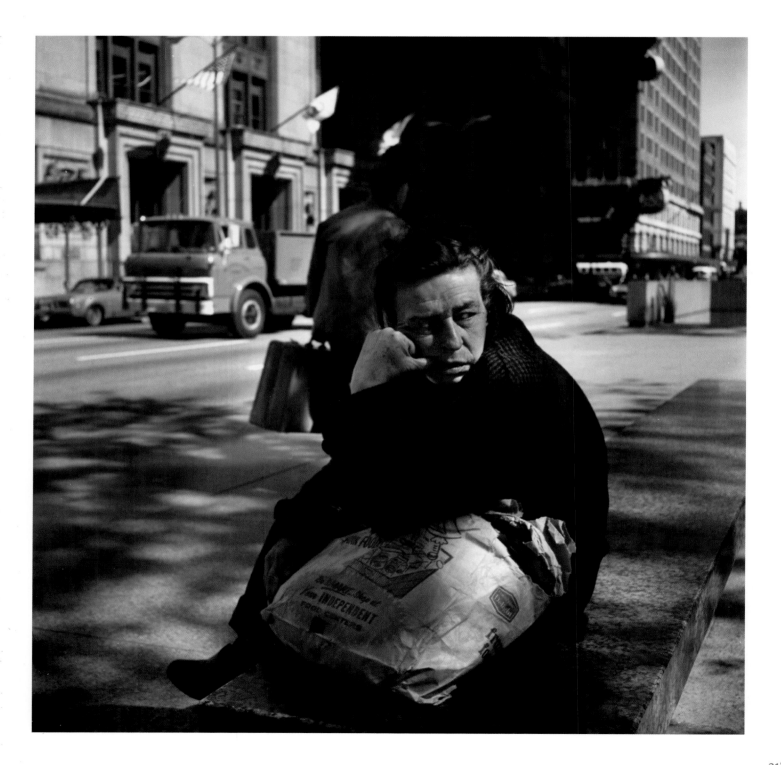

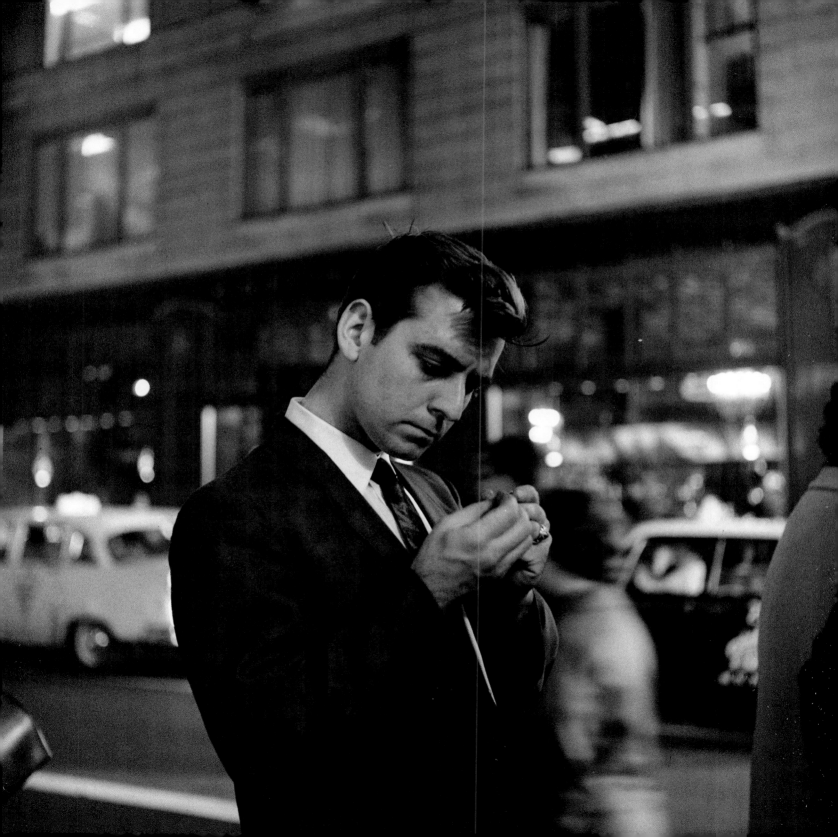

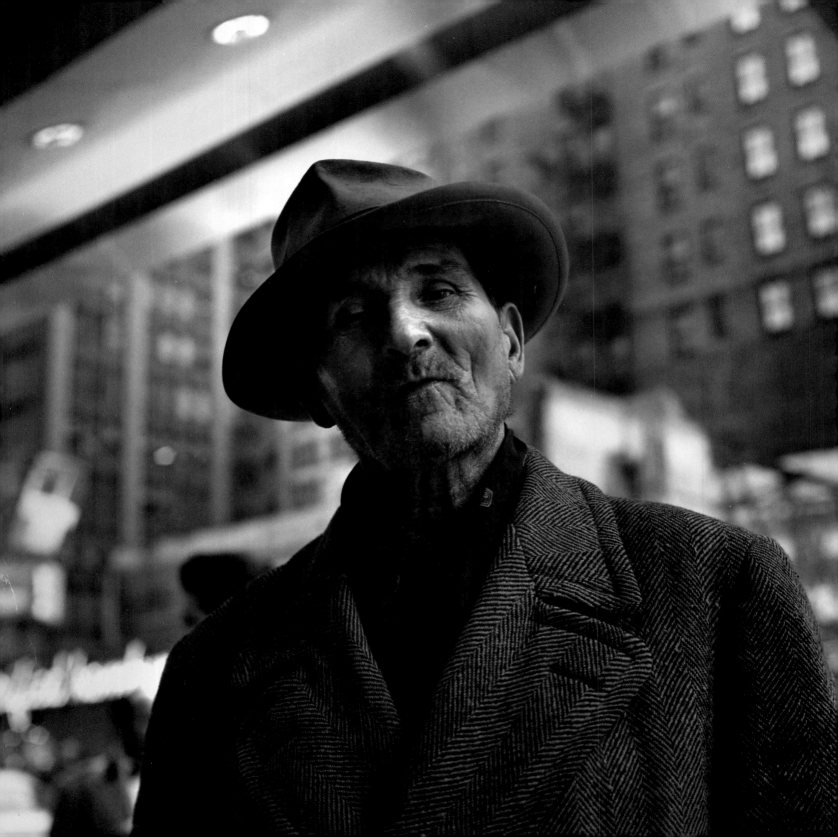

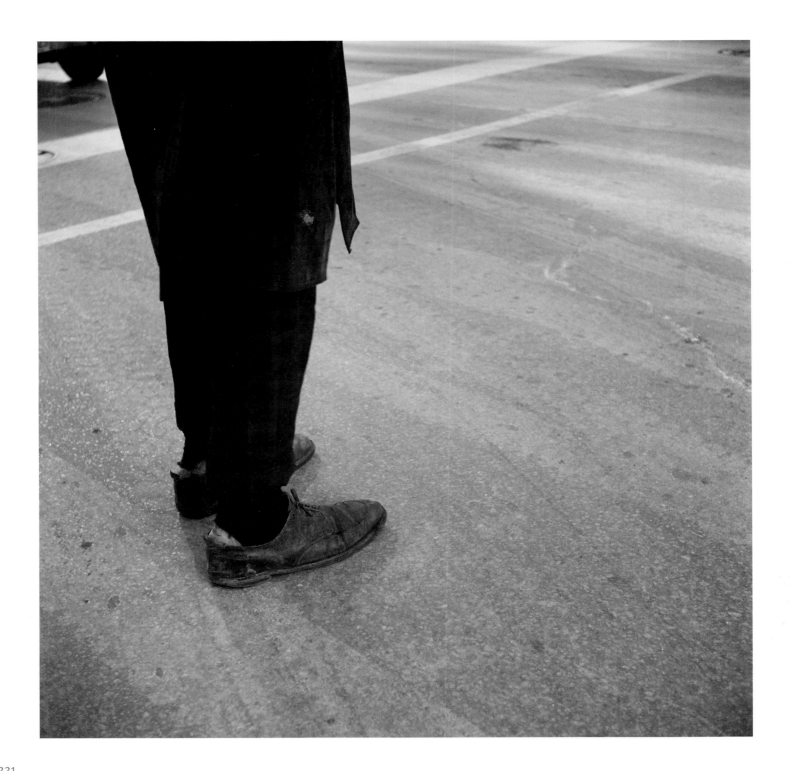

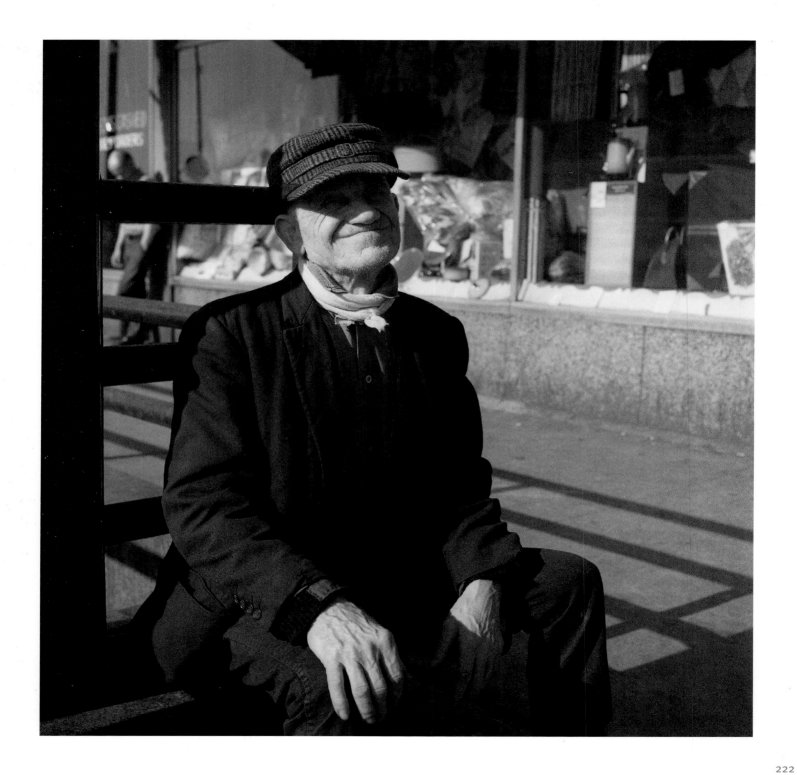

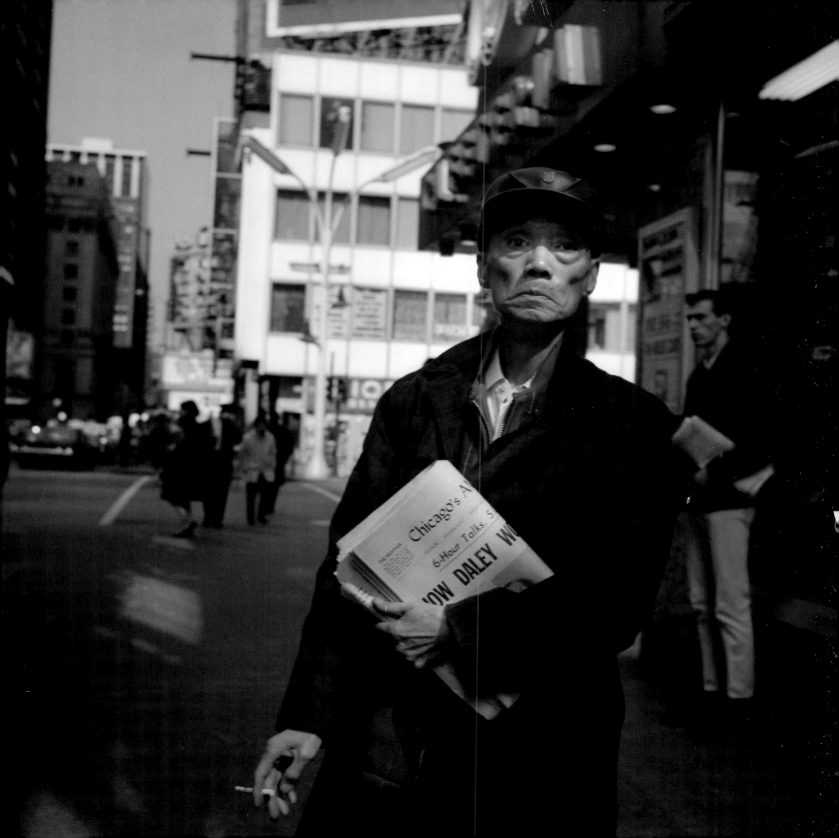

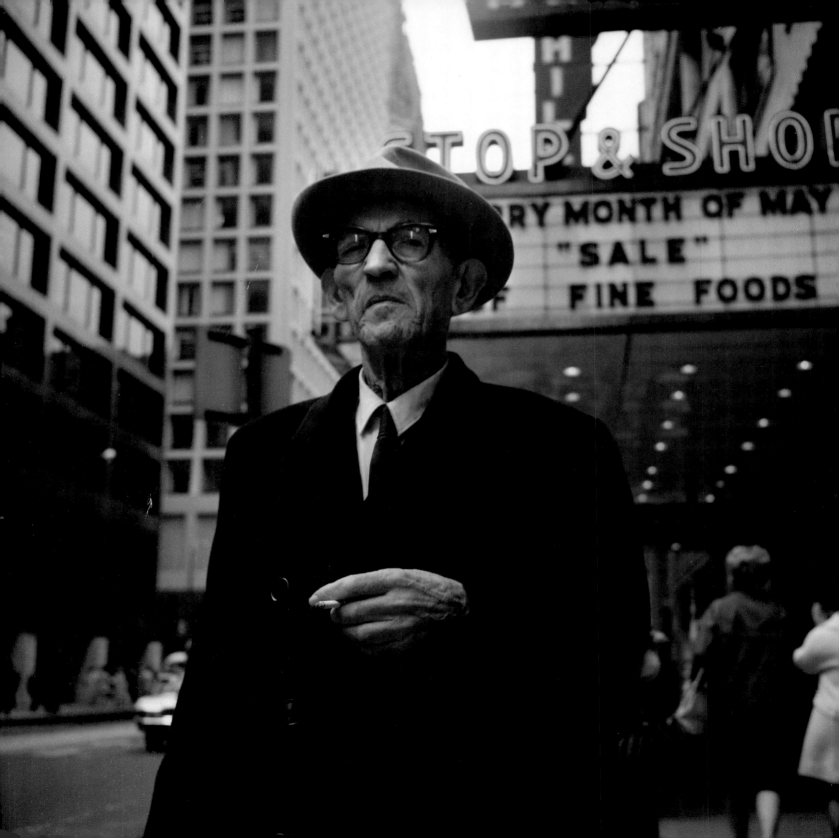

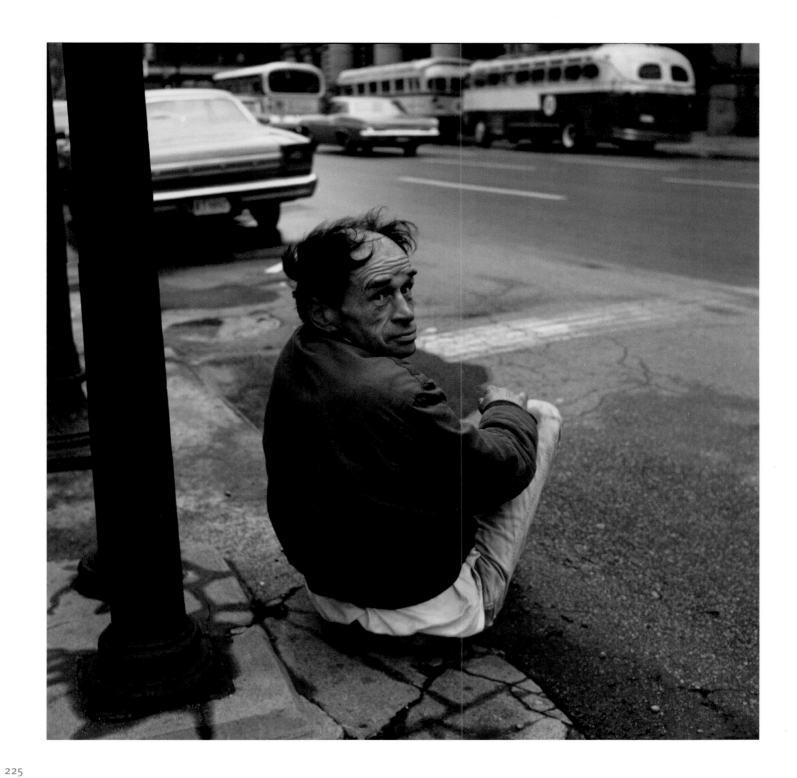

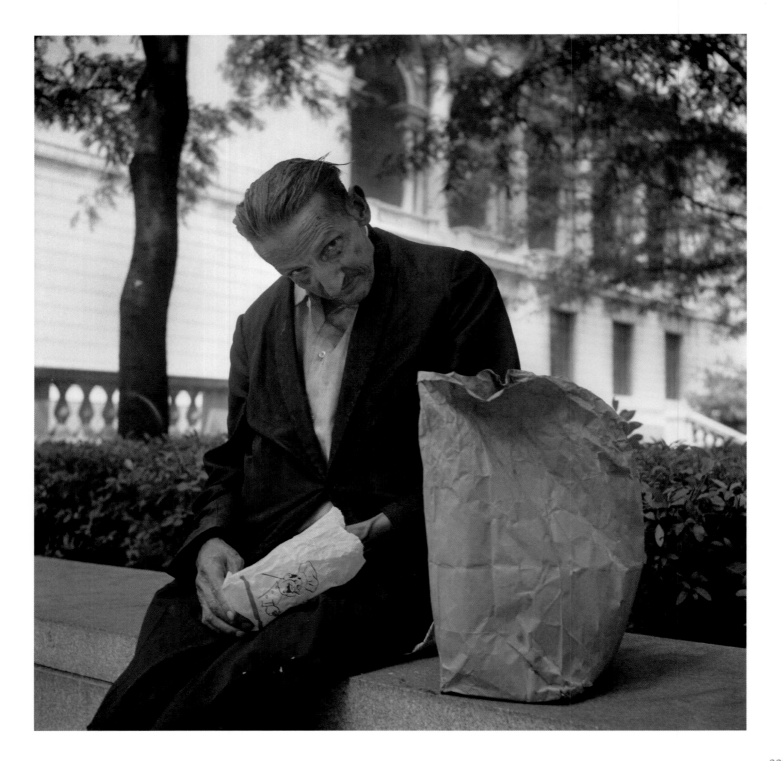

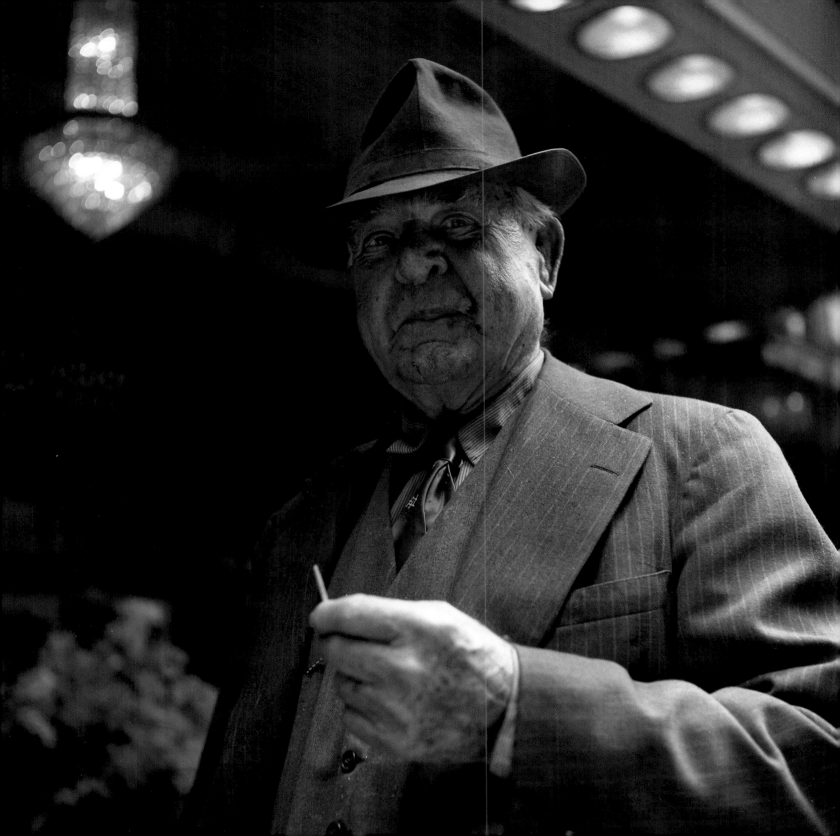

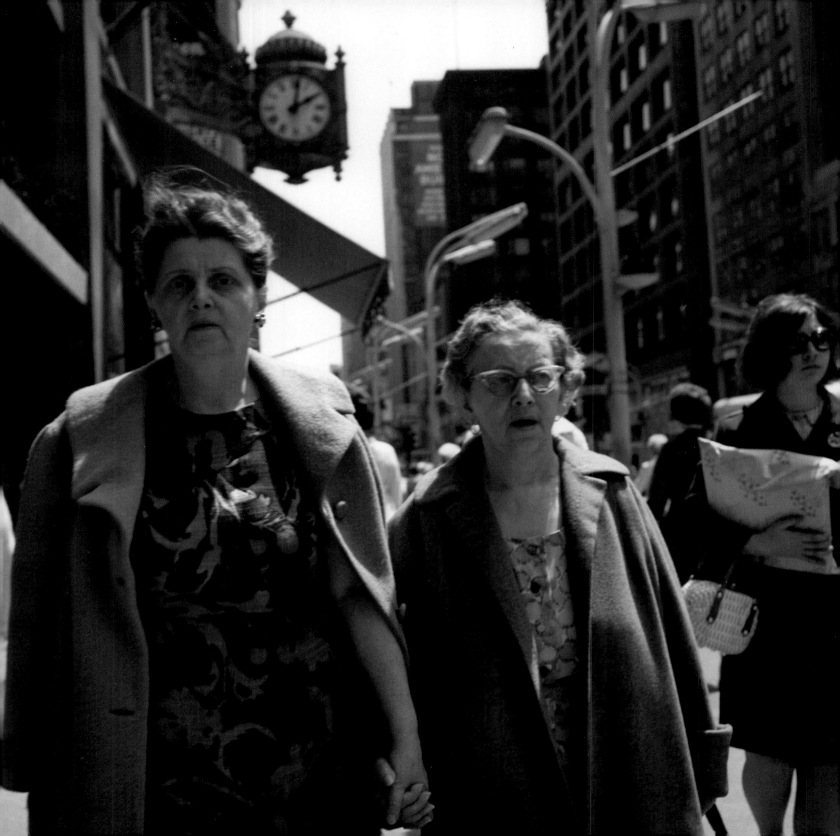

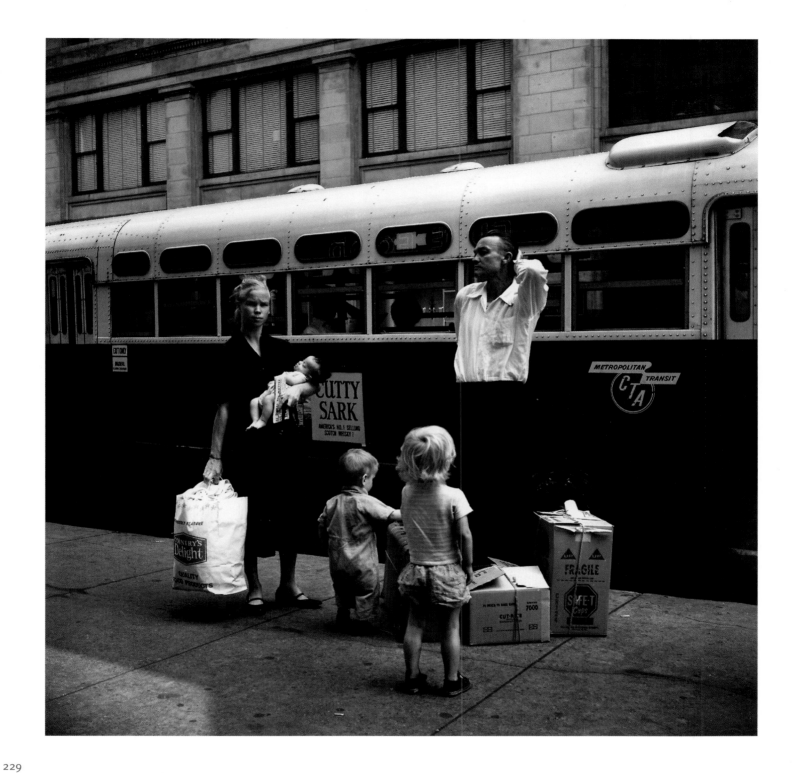

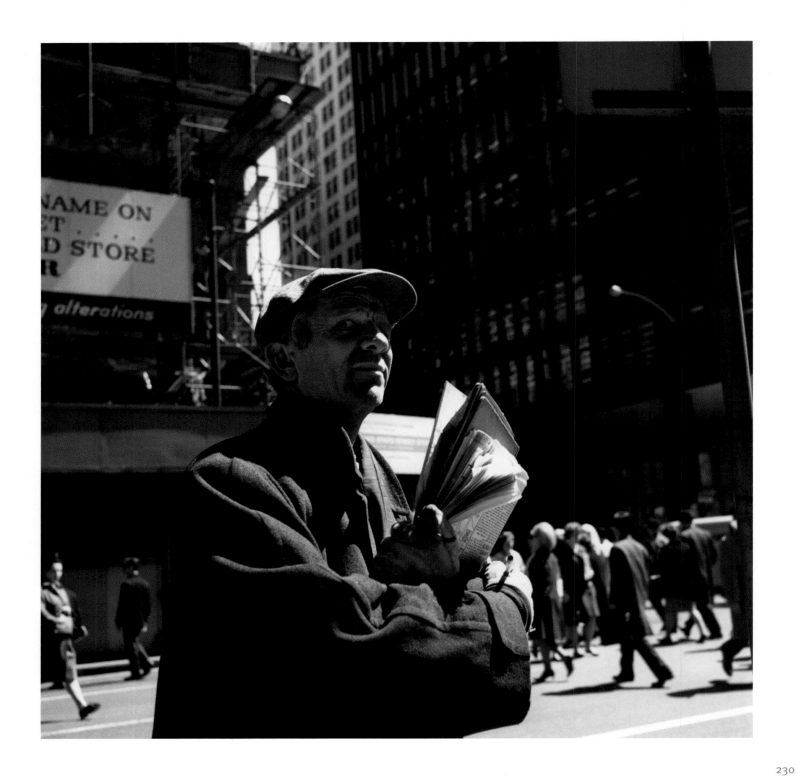

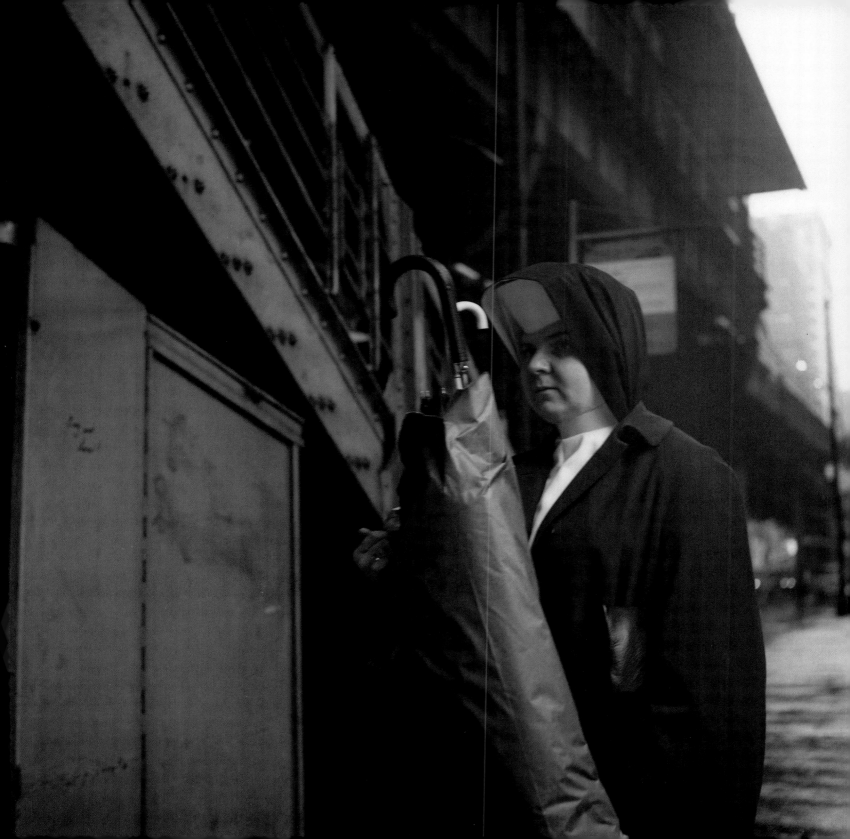

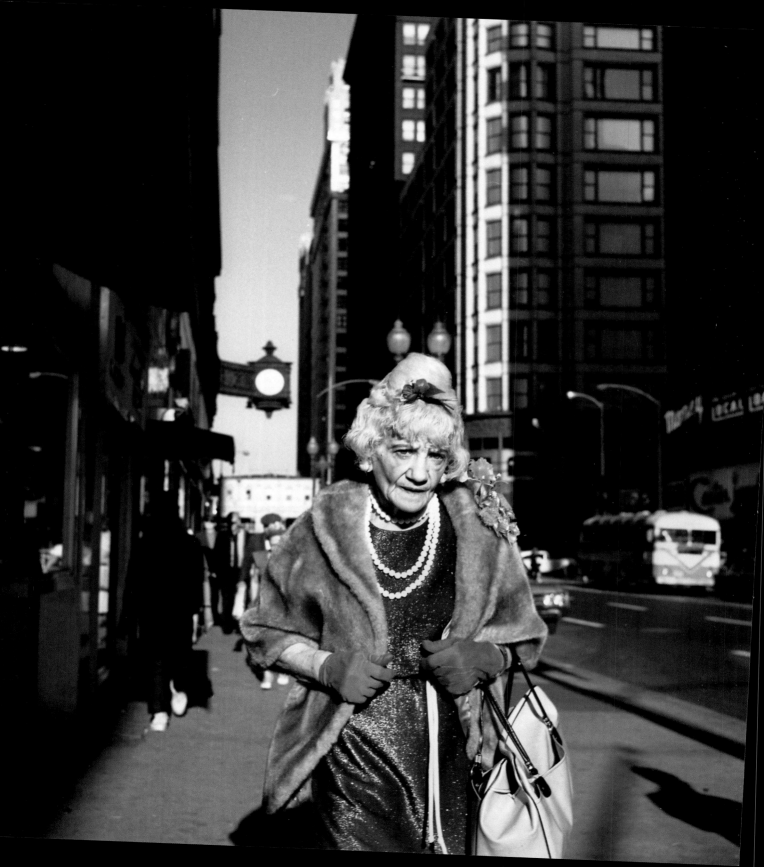

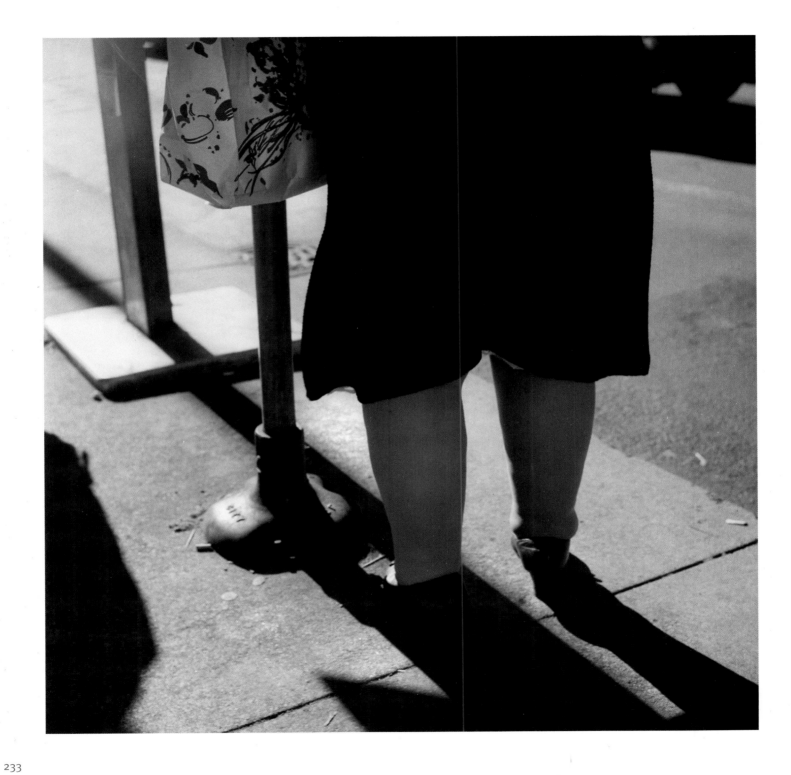

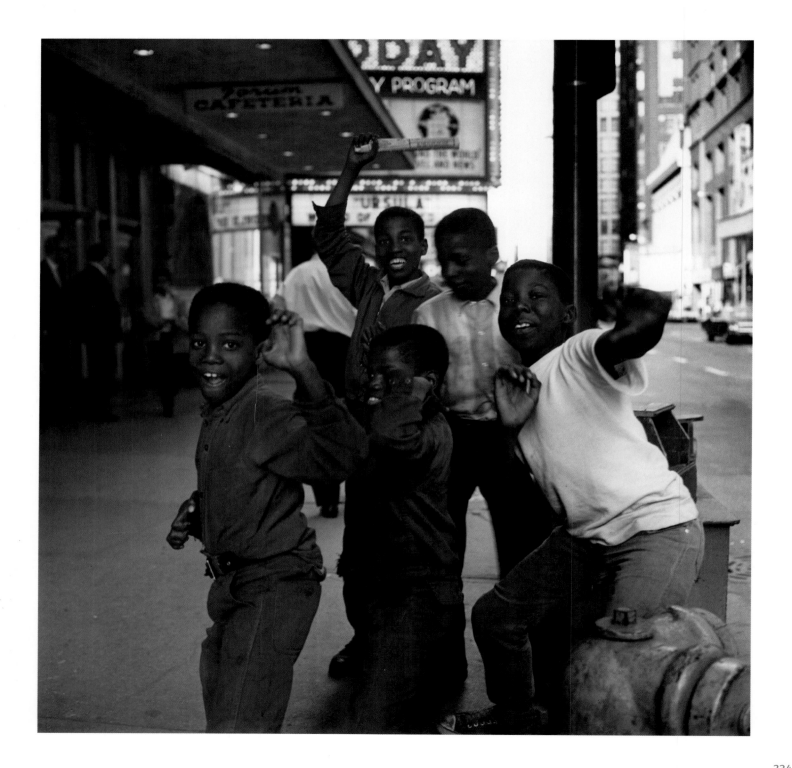

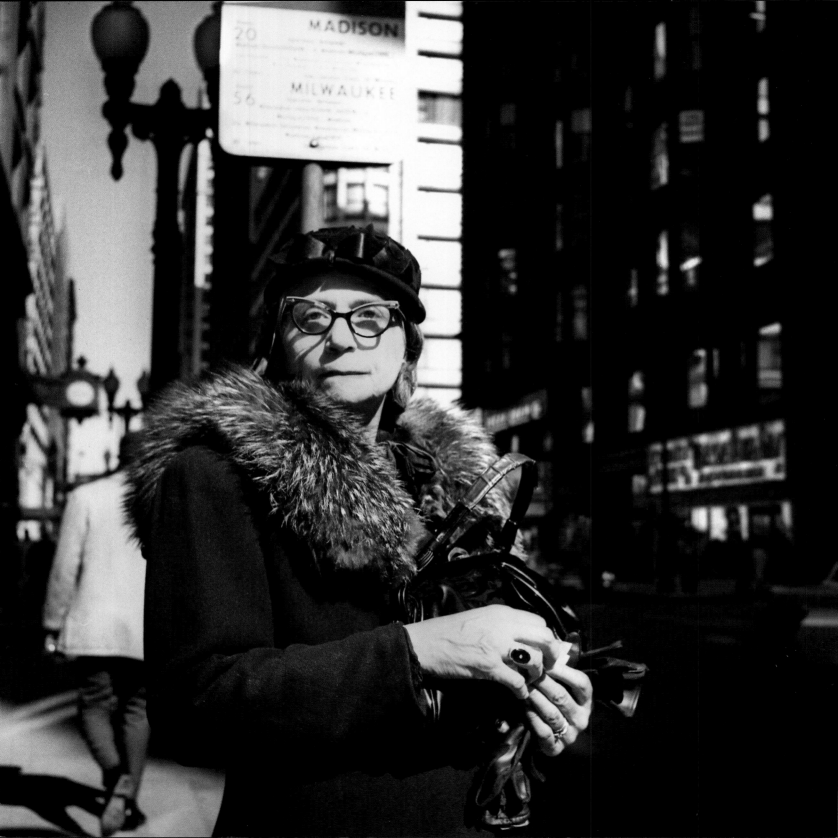

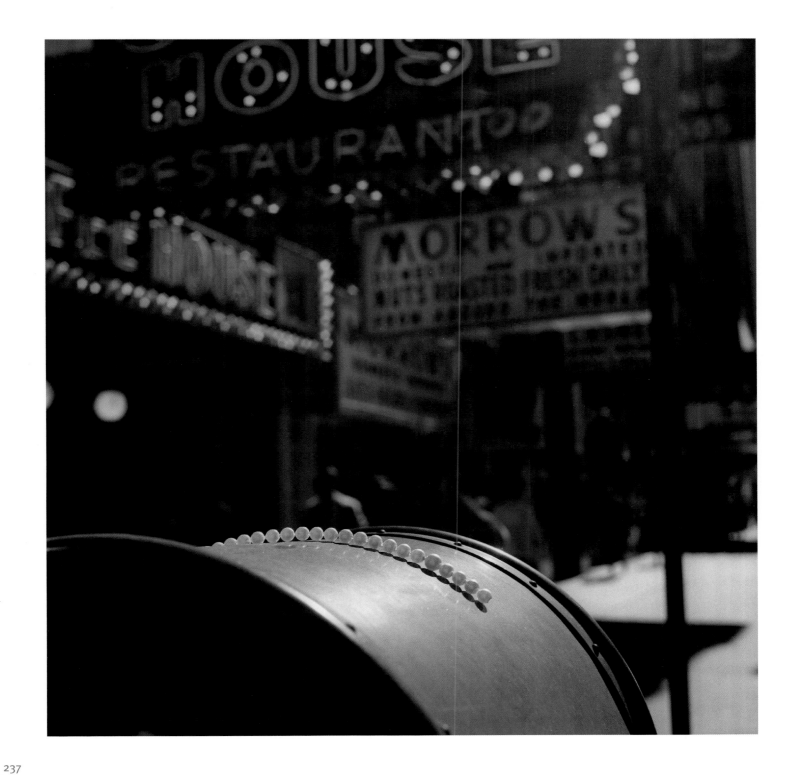

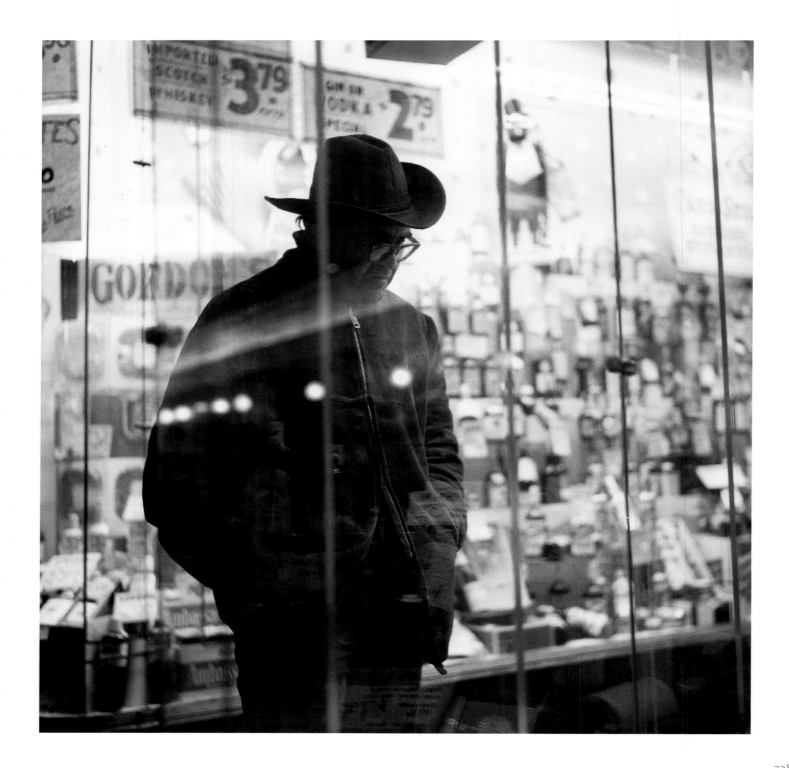

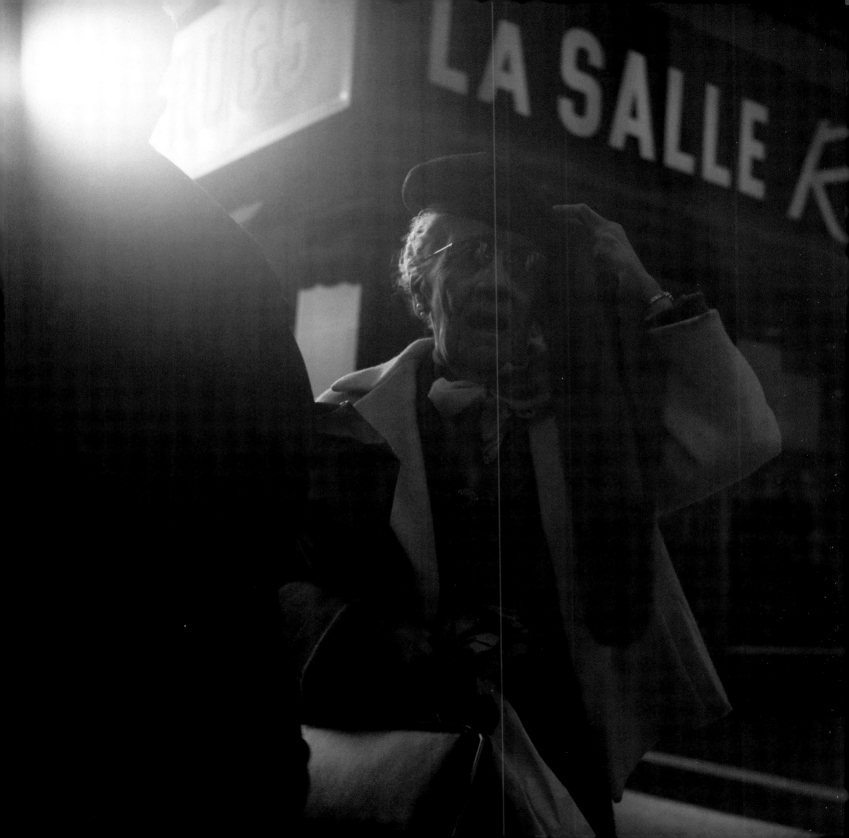

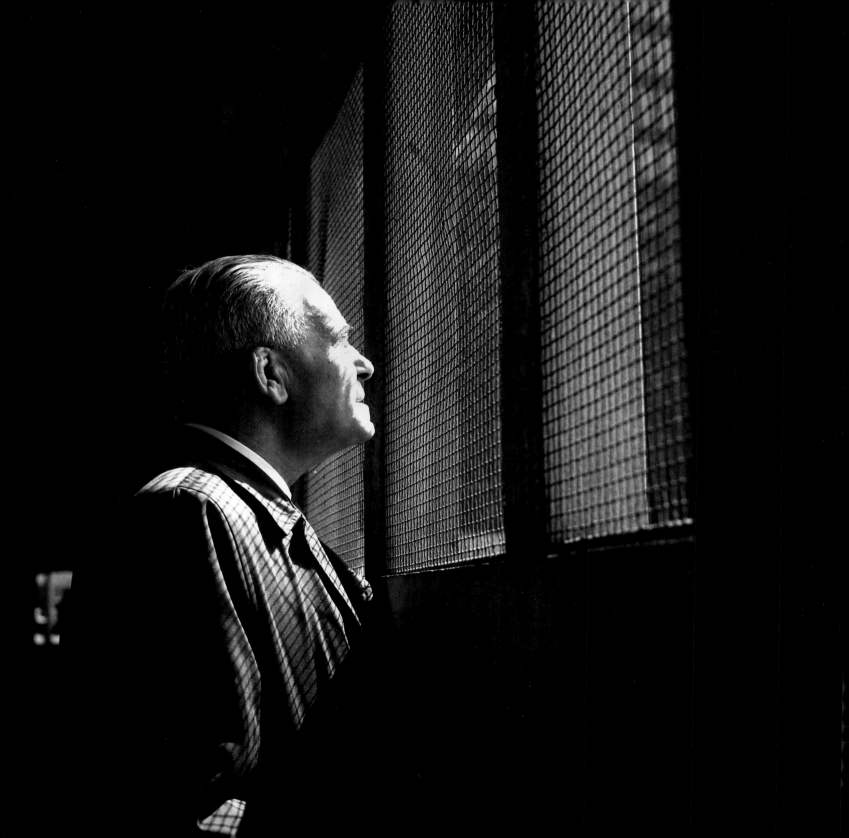

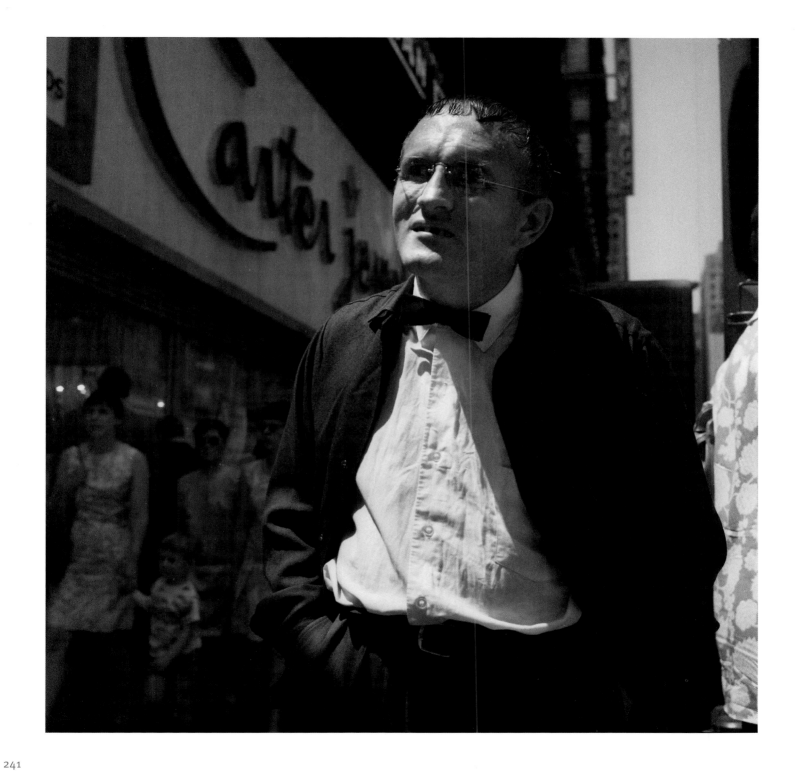

WALKS

The early years in the suburbs must have been gratifying for Vivian Maier. As a governess, she played a valuable role in the lives of the Gensburg and Raymond families. Her photographs from that period show that she felt comfortable in Highland Park and Wilmette. In the mornings, after the children went to school, she often took long walks on her own— photographing the ravines in Highland Park or the sidewalks salted for winter in Wilmette. The woman who'd traveled the world was not above noticing footprints and tire tracks or watching the seasons turn. She was fascinated with snow puddles and shadows, and she took many pictures of a symbolic single leaf that dared to be alone. It was the perfect time to be living in these small towns, just a train ride away from downtown Chicago.

Things began to change in the late 1960s. Maier started saving more and more newspapers. The bucolic pictures she once took of the suburbs now came with an edge as she photographed discarded dolls, fallen garbage cans, and tossed-off scraps and debris. If this was her diary, then it was apparent that her life was taking a sharp turn.

After her tenures with the Gensburgs and Raymonds came to an end, she found getting new jobs difficult. She lasted less than a year with the family of Phil Donahue, who hired her to watch his four boys at their Winnetka home, just north of Wilmette. (The TV talk show host recalled that Maier photographed him at her interview.) Life was particularly chaotic for his family during the 1970s. He had just separated from his wife and moved his show to Chicago. His boys, three teenagers and a twelve-year-old, saw no reason that they should need daily direction. "The women who came into my life as nannies didn't last too long," he told *Chicago* magazine. "No matter who they were, the kids hated them. They were rent-a-mothers."

The Donahue boys especially disliked Maier. They disparaged the way she dressed (like Maria von Trapp in *The Sound of Music*), the way she muttered under her breath, and the way she put apricots on peanut butter sandwiches. They watched her leave the house on Pine Street in a black hat and black boots, taking odd photographs of trashcans and coffee cups. Their father had little more appreciation. "I once saw her taking a picture of the inside of a refuse can, like a public refuse can, and I thought, 'Well, you know, they laughed at Picasso. Or how about Pollock? If he can drip this stuff, why shouldn't she be able to do that.'" No one was too upset when she left, he recalled.

As her life changed, Maier found herself drawn to the litter she saw on the ground,

focusing on the message—intended or not—these discards left behind. By the 1970s, many of her photos in the suburbs featured written declarations. Some ("Peace of Ass," "Respect Your Local Bartender," and "Love Thy Neighbor, but Don't Get Caught") were humorous; others ("The VanDells Suck" and "Cousin Brucie Is Juicy") were pointed.

Roaming around town photographing garbage earned Maier, always regarded as something of an oddity, a less generous reputation. She became more out of place in the suburbs, and she could feel it. In her long coat and snap-brim fedora, she was often pointed out on the street. Jane Garron, who used to watch Maier in a park near Fourth Street and Maple Avenue in Wilmette, said Maier had a severe smile that put people off. Her life was changing, and the pictures she took showed that.

After her departure from the Donahues, Maier was hired by William Dillman to take care of his severely disabled wife and four children, but her experience there was no better. William, who lived in Evanston, the first suburb north of Chicago, said Maier came to the family with great credentials but little warmth. "She was very businesslike," he said. "I remember when I was negotiating with her, she made it clear she wanted Social Security. I paid both ends of it—hers and mine."

Maier sent her cherished belongings, those that had filled the Raymond home and office, to a fireproof warehouse in Evanston and moved into the Dillmans' maids' quarters, an area that was off-limits to the family. The house had a working darkroom in the basement, but she never asked to use it. By the 1970s, she was no longer processing her own negatives. When she could afford it, she sent her film to a photo lab.

Her main job was to keep an eye on Jean Dillman, who had suffered brain damage following a heart attack and could barely carry on a conversation. Maier sat with her, did the laundry, watched the family dog, and made dinner. She required the family to gather at the dining room table. The food, said William, was not suitable for his children. "She cooked fish with the heads on," he explained. "The kids would not say anything. They looked at it, but never ate it."

Donna Dillman Newlin, the oldest of the children, said that those were difficult days for Maier and for her siblings, who—like the Donahues—did not do well with a stand-in mother and refused to take orders from her: "She walked into a house of wild Indians." Basically, the children avoided her, she recalled. Almost a year into the job, Maier complained about the children to their father. She told him she would quit, and he told her she was fired.

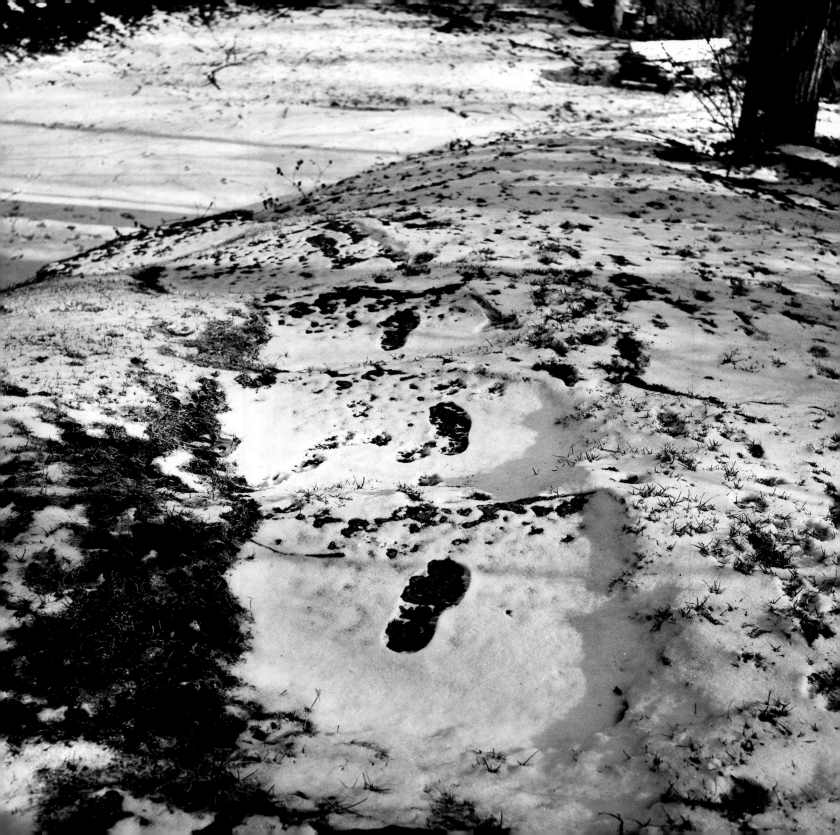

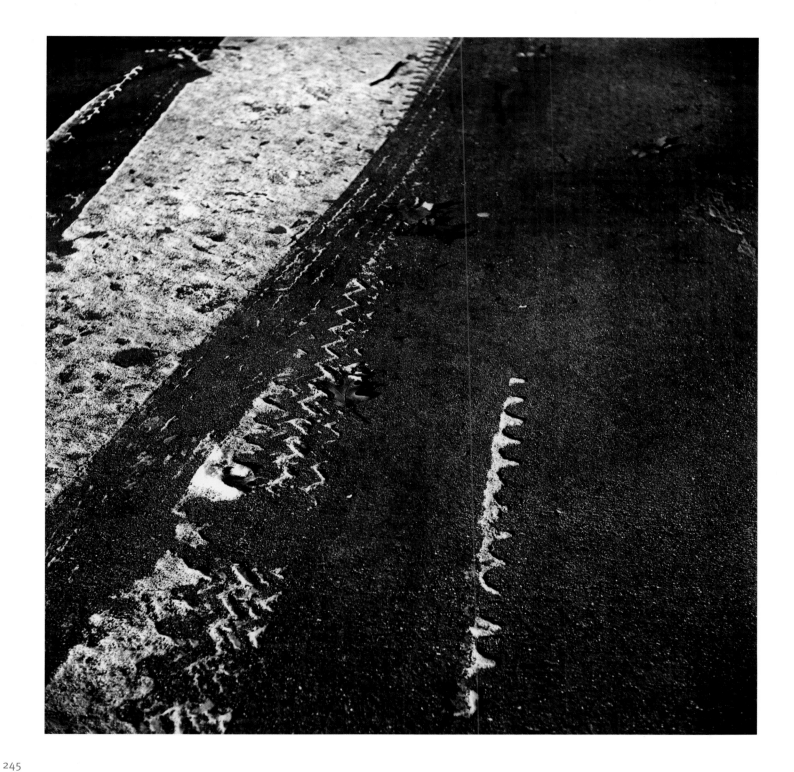

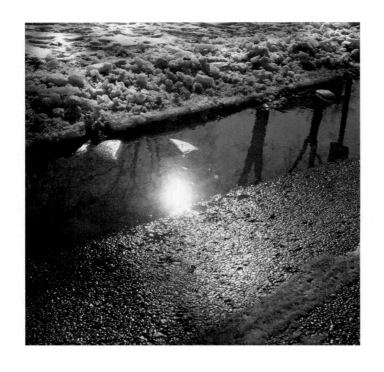
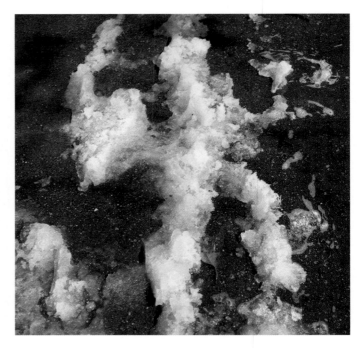
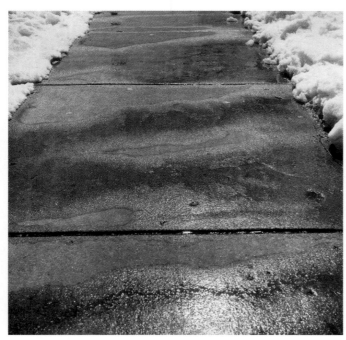
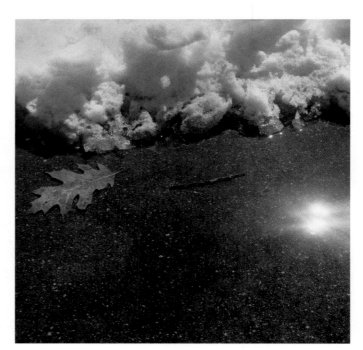

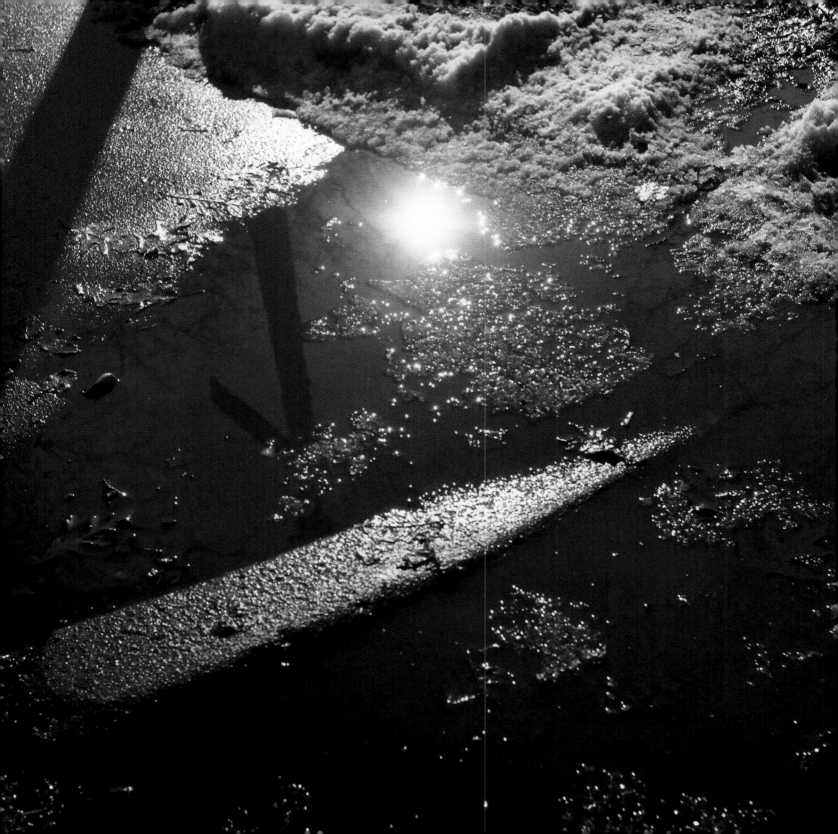

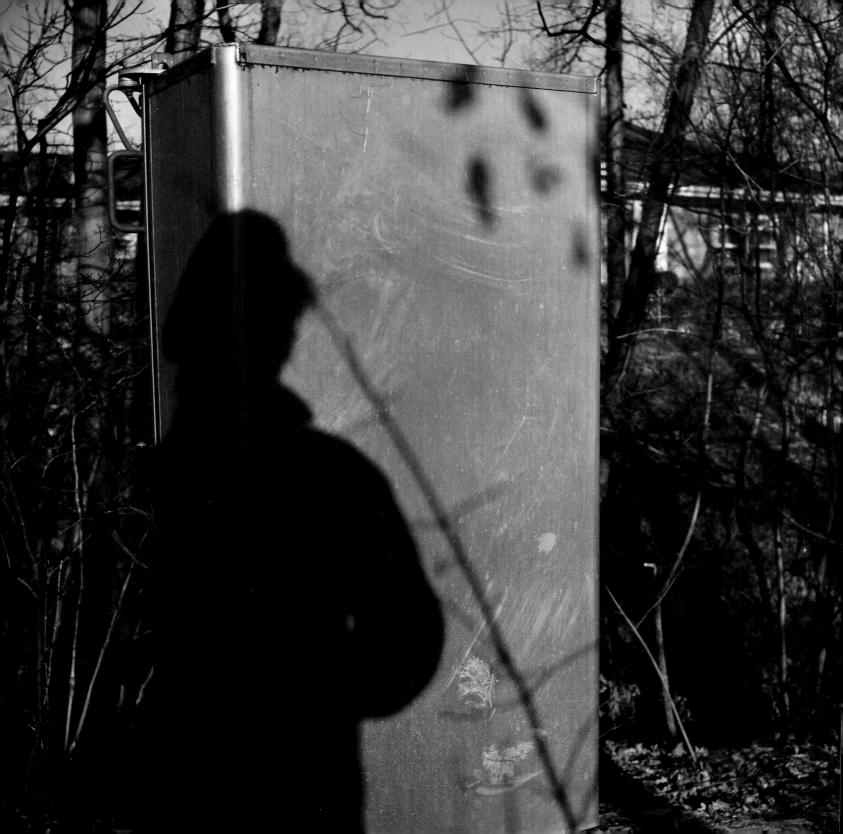

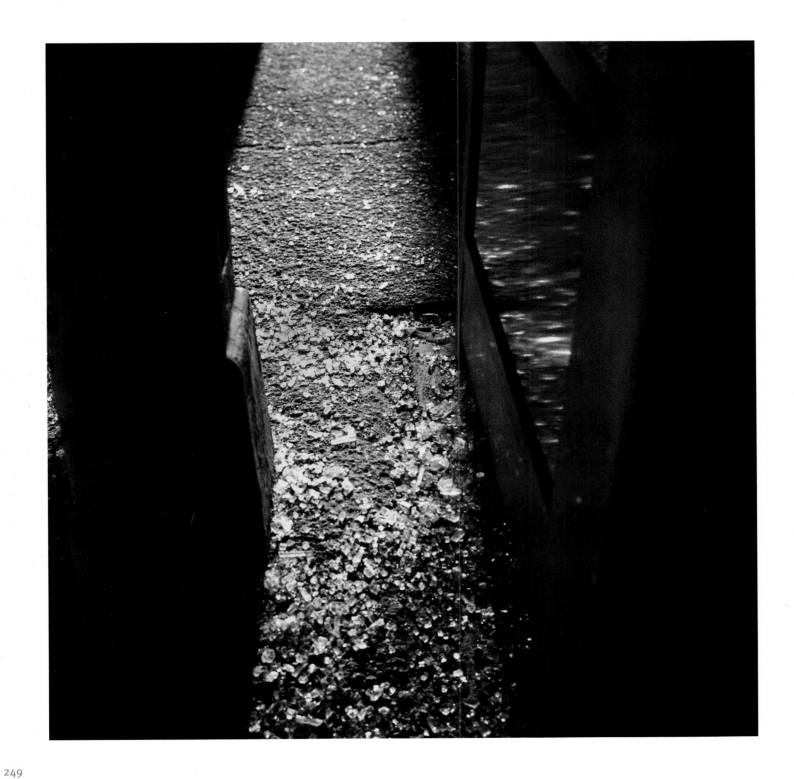

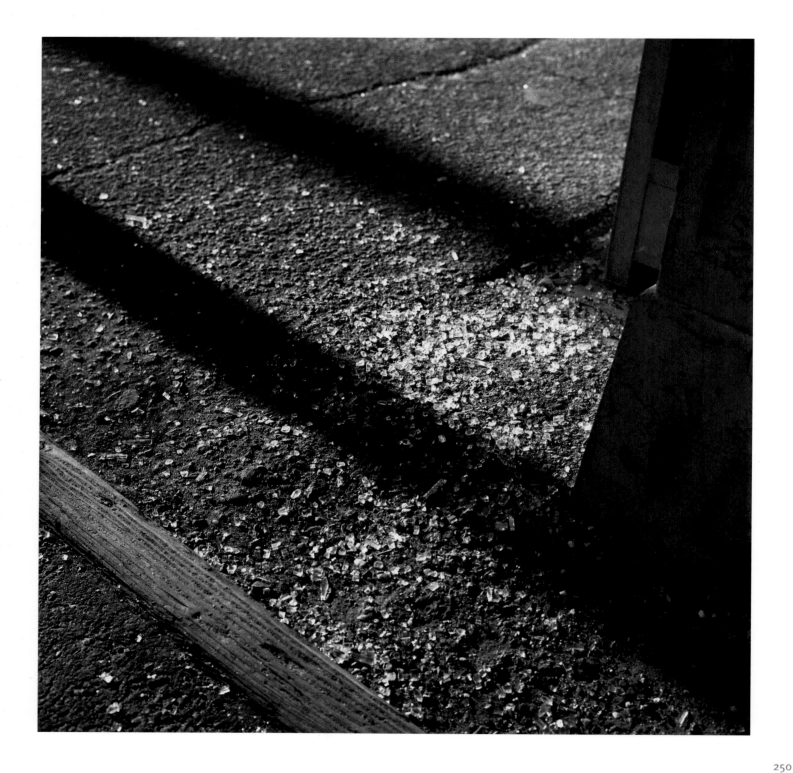

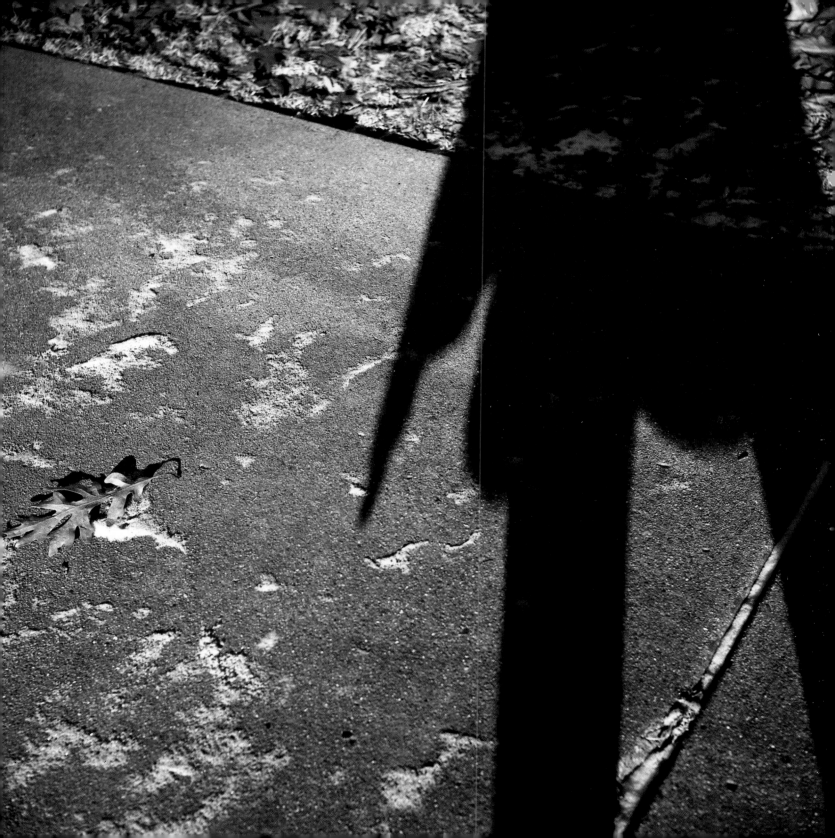

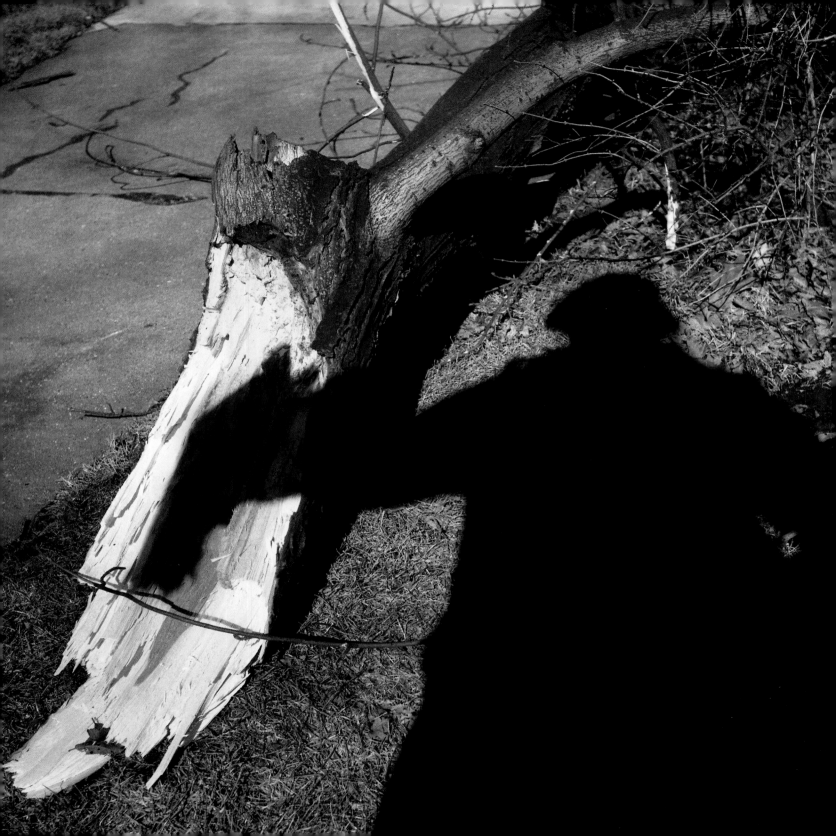

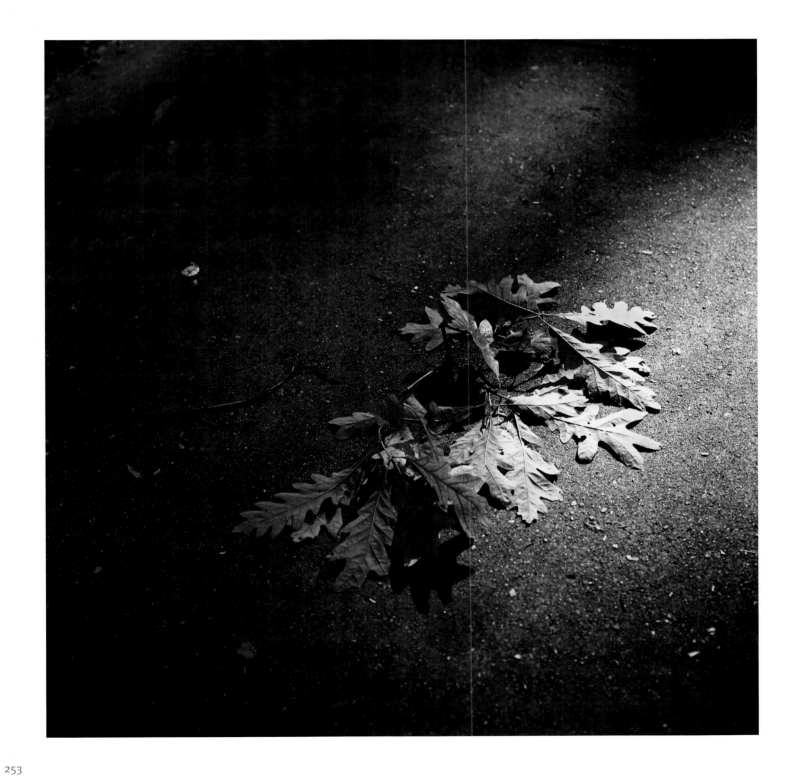

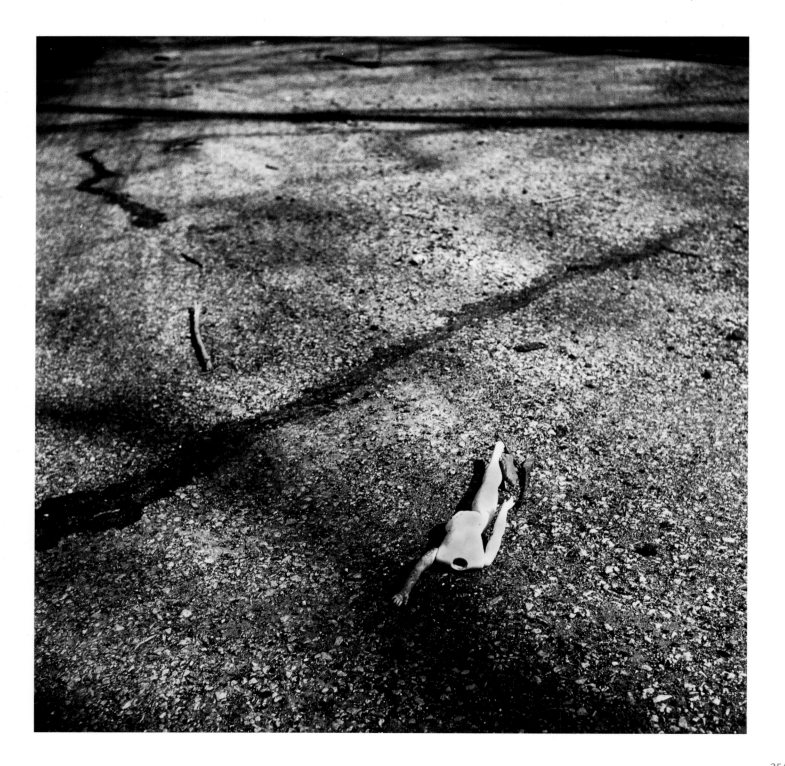

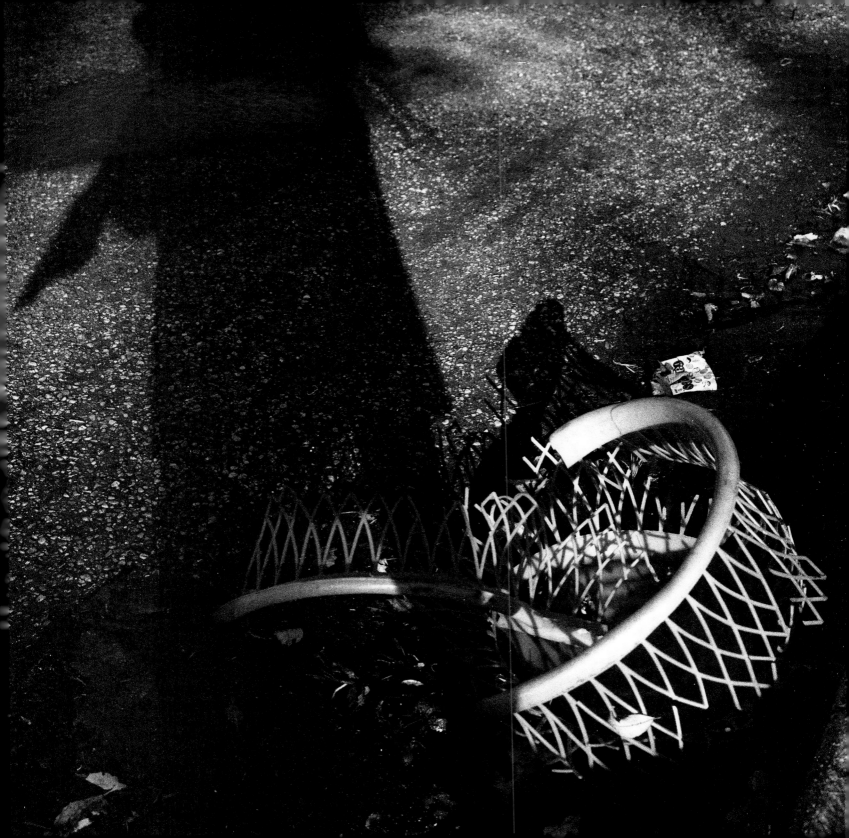

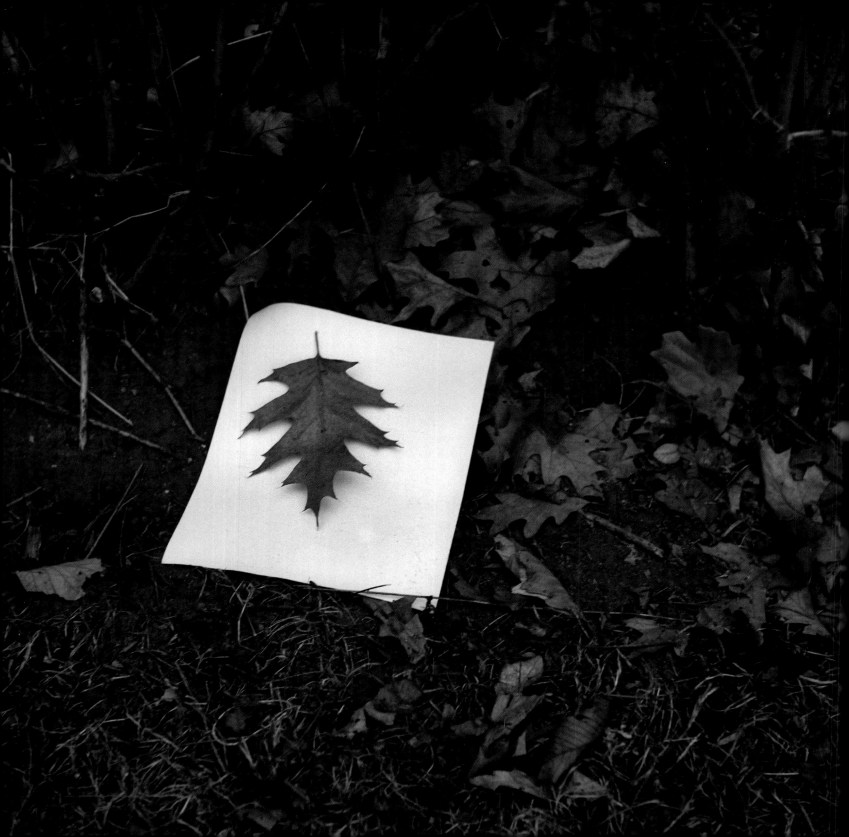

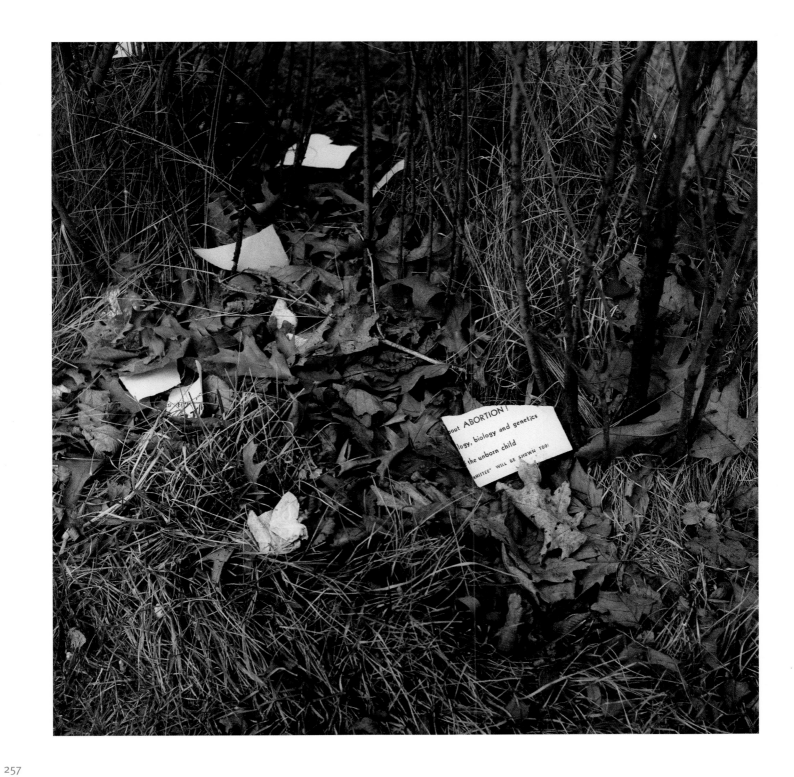

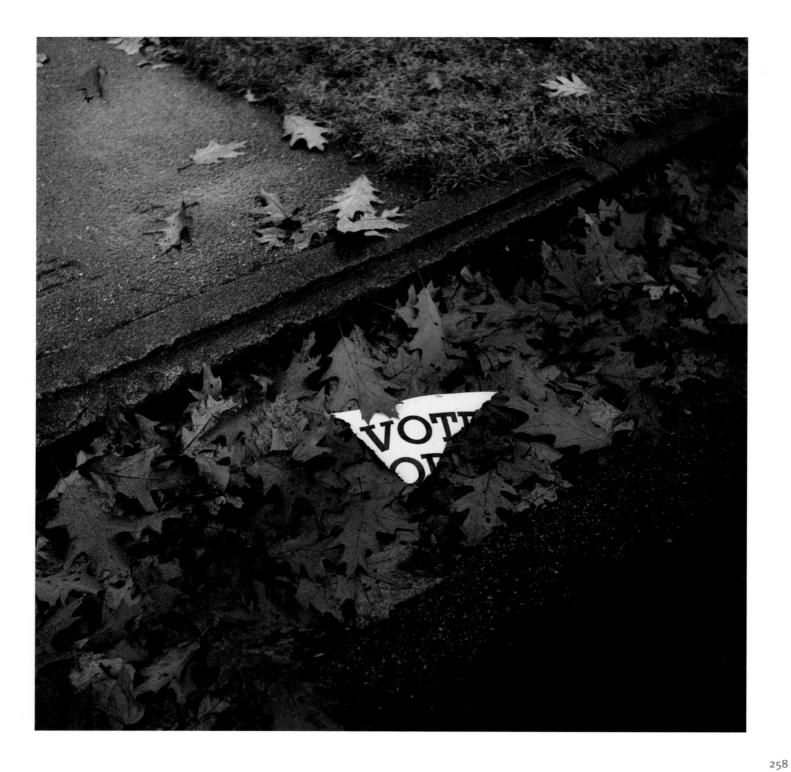

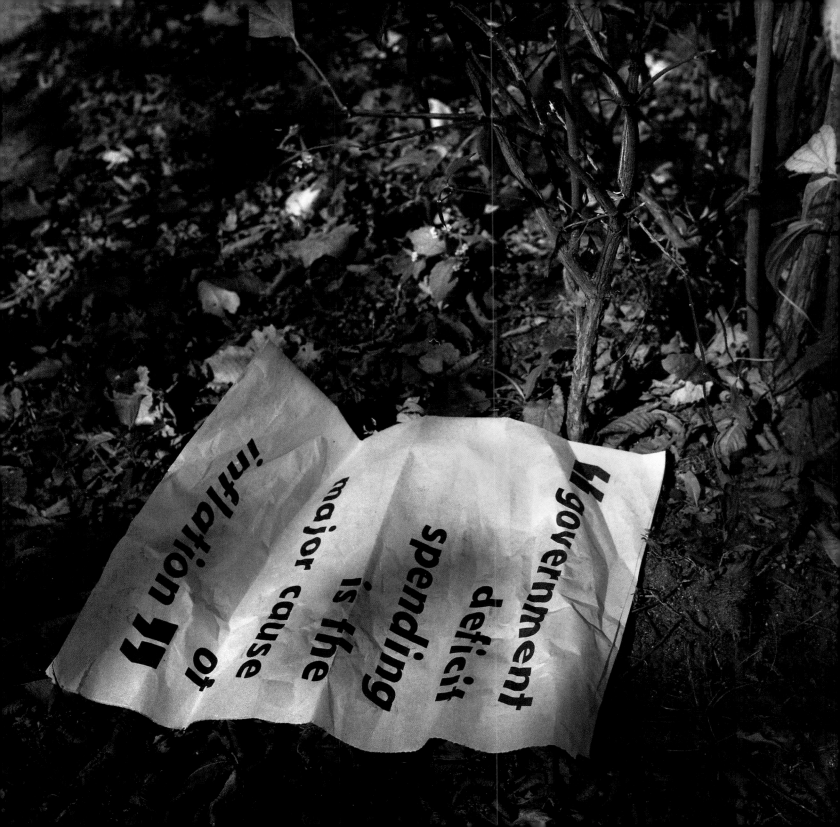

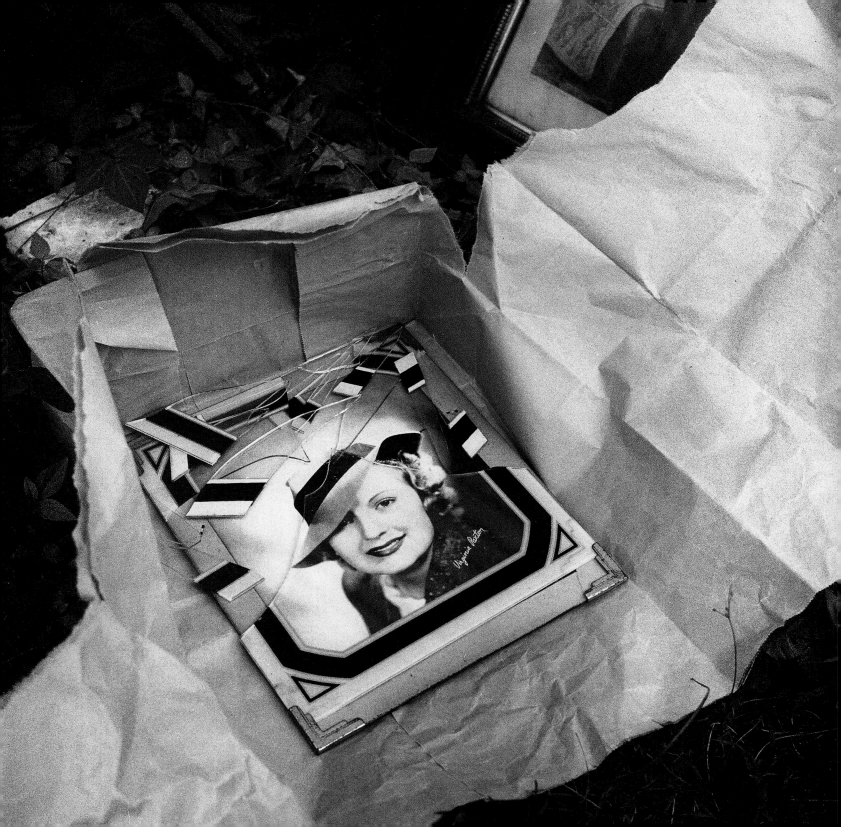

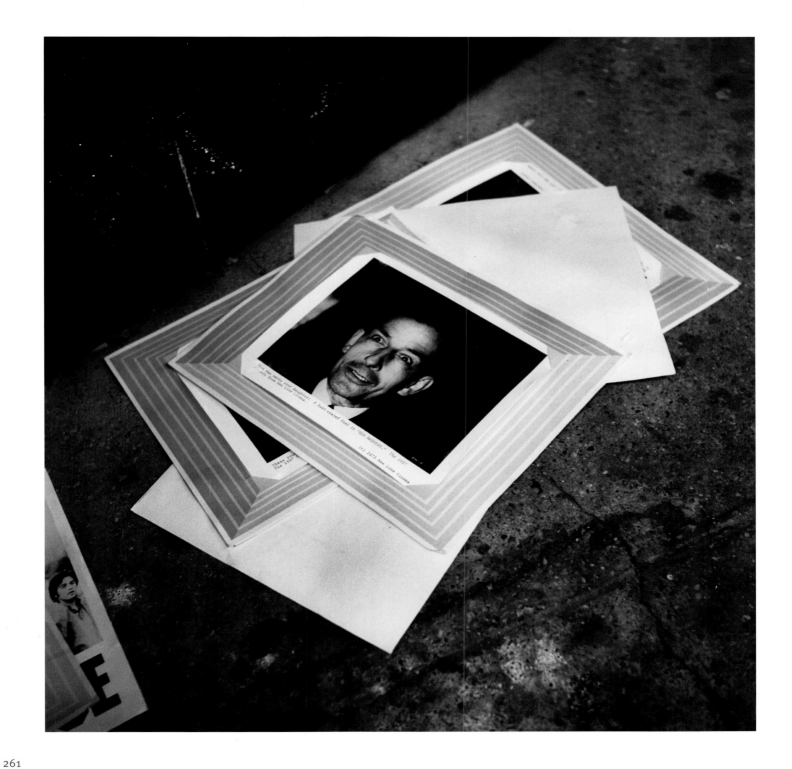

NIGHT

It's the end of the day. The TV has been flipped on. A small fire is tended in the backyard. The marquee of the Wilmette Theater is being changed. Parents' night at the local school is wrapping up. The children are asleep as Vivian Maier heads home with her camera by the glow of the streetlights.

Maier continued to document her life throughout the 1980s and 1990s. She shot Ektachrome film, packing tens of thousands of the color transparencies into sleek yellow Kodak slide boxes. But her days with the Rolleiflex, with which she had taken her most personal and important photographs, were mostly over by the late 1970s.

Work, too, continued. When Zalman and Karen Usiskin interviewed her to be their housekeeper and babysitter in the 1980s, she announced: "I come with my life, and my life is in boxes." Zalman told her that would not be a problem since they had extra room in the garage. "We had no idea how many boxes," he later said.

Around 1990, Maier took a job caring for Chiara Baylaender, a teenage girl with severe developmental disabilities. Maier was good company for her: they played kick the can and amused themselves with pop beads. Maier dressed Chiara in mismatched clothes from the Salvation Army. "But it's Pendleton," Maier told the girl's older sister when she protested. It didn't matter. "My sister looked like a junior Vivian," she recalled. And Maier proved an uninterested housekeeper, too. "It's just going to get dusty again," she would say. Having filled the Baylaenders' storage room, she piled her bedroom five feet deep with books, leaving only a narrow path to her bed. Then she covered that—and slept on the floor.

In the mid-1990s, Maier went to work as a caretaker for an elderly woman. After the woman moved to a nursing home in 1996, Maier stayed on in her Oak Park house for a couple of months to get it ready to sell. Maier made overtures about working for the family of the woman's daughter, but she was not needed.

Over the years, leaving was never easy. The Gensburg boys grew up, and life at the Raymonds' became strained after Maier got into an altercation with a man who tried to help her down from the ledge in a parking lot as she was taking a picture. She punched the man when he reached for her, according to Inger. He was taken to the hospital and threatened to sue the family. She stayed with the family for another year, when they moved out of state.

Acquaintances recall Maier as an imposing, confident, stolid woman in her later years.

With little saved and no family of her own, she was determined to keep living independently, so she took jobs well into her seventies. Jim Dempsey, who worked the box office at the Film Center of the School of the Art Institute, saw her hundreds of times during the 1990s. She would dig through her purse looking for money before a movie, sighing until Dempsey usually let her in. She often stopped to talk—about movies, life, anything but herself—although he never got her name.

Bindy Bitterman, who ran an antiques store in Evanston, knew Maier only as Miss V. Smith, the name she gave to hold her layaway items. She was the only customer who ever bought *Ken*, a long-forgotten liberal magazine from the 1930s. Roger Carlson, who ran a bookstore nearby, knew her full name but was scolded when he used it to introduce her to another customer. She visited his shop as late as 2005 and bought *Life* magazines, talked politics ("Her judgment was pretty harsh on everyone"), and agonized about how difficult it was to find work. "She was a fighter to the end," Carlson said.

The boys who had thought of Vivian Maier as a second mother tried to keep track of her for years. They made overtures to help, but she resisted. She loved the Gensburgs and kept up with the family—going to weddings, graduations, baby showers—but it was hard for her to ask for help.

Because of her pride and her need for privacy, Maier remained elusive for years. When the Gensburgs found her, she was on the verge of being put out of a cheap apartment in the western suburb of Cicero. The brothers offered to rent a better apartment for her on Sheridan Road at the northern tip of Chicago, but they told her that she needed to clean up her Cicero place before she left. She agreed, showed them the Clorox and rags, pulled up a chair, sat back with *The New York Times,* and told Lane to start with the walls and bathroom.

Even in her new apartment, Maier made it difficult for the family to keep track of her. The Gensburgs bought her a cell phone, which she refused to use. So they just dropped by when they wanted to see her.

In November 2008, Maier fell on the ice and hit her head not far from home. She was taken, unconscious, by paramedics to St. Francis Hospital in Evanston. When she came to, she refused to tell the emergency room staff what had happened and demanded to leave. Lane Gensburg was called. Doctors assured the family that she would recover, but she never did. For the next several months, she resisted eating and was barely responsive. Too weak to return to her apartment, Maier was transported in late January 2009 to a nursing home in Highland Park, where her health continued to decline. She died there on April 21, 2009.

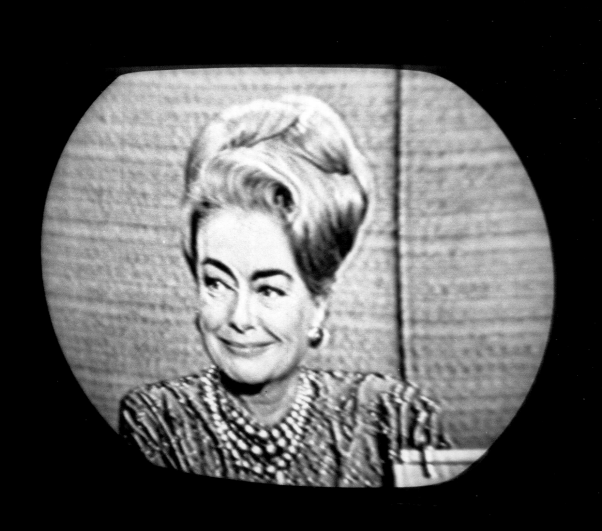

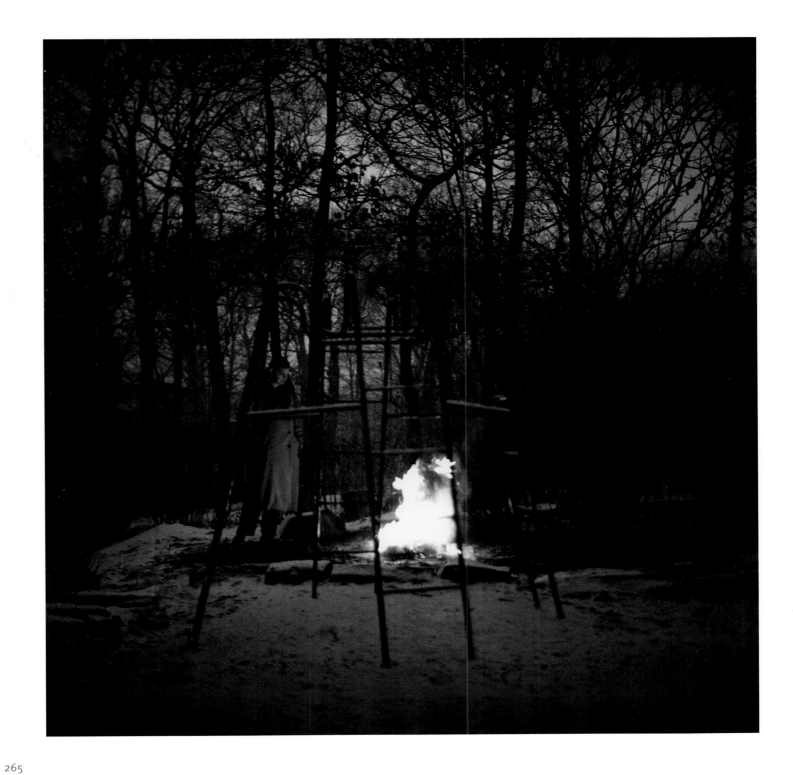

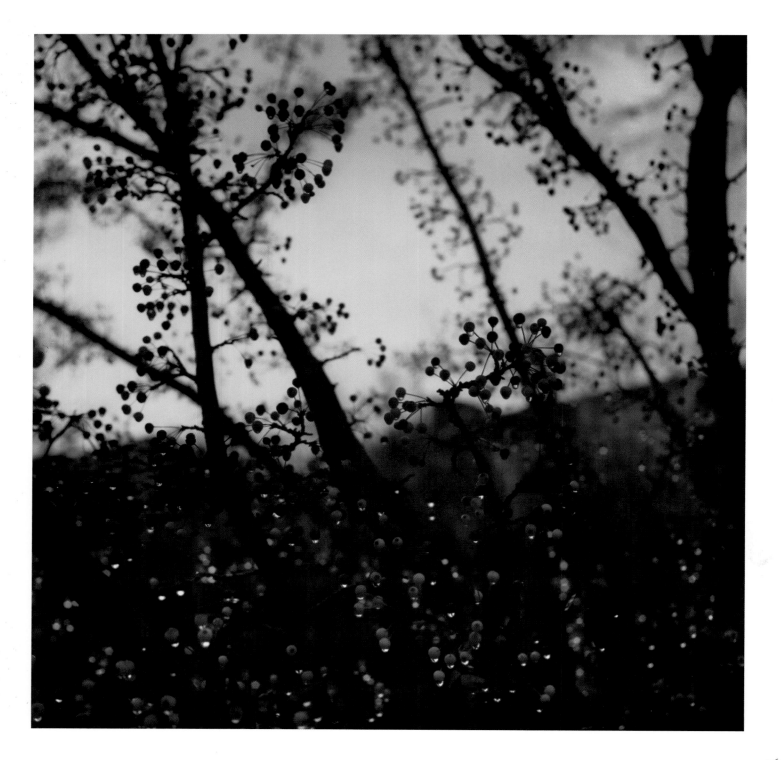

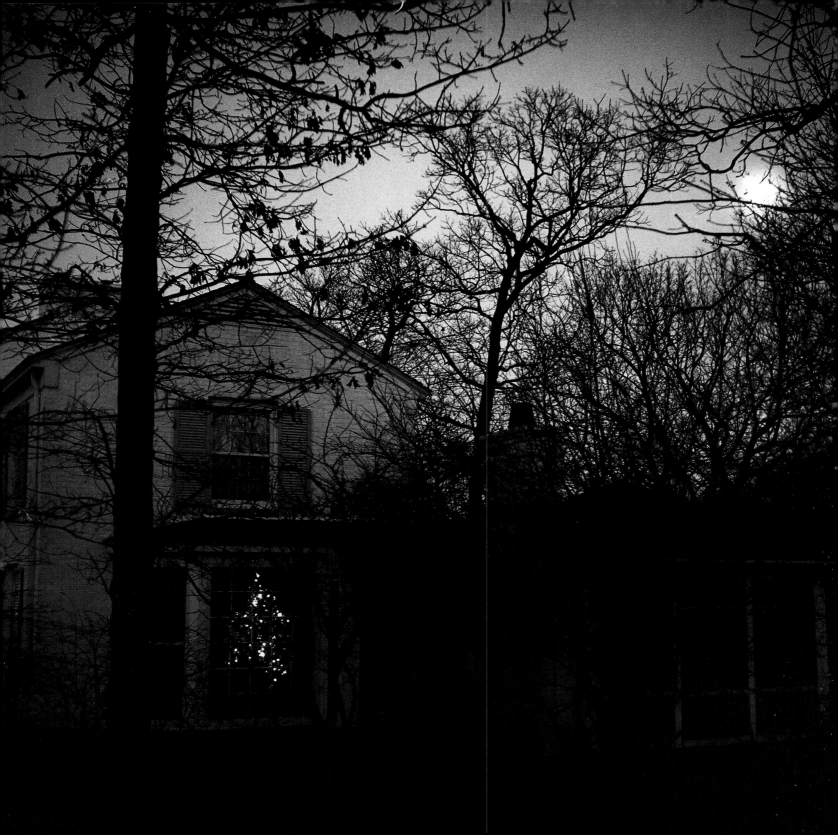

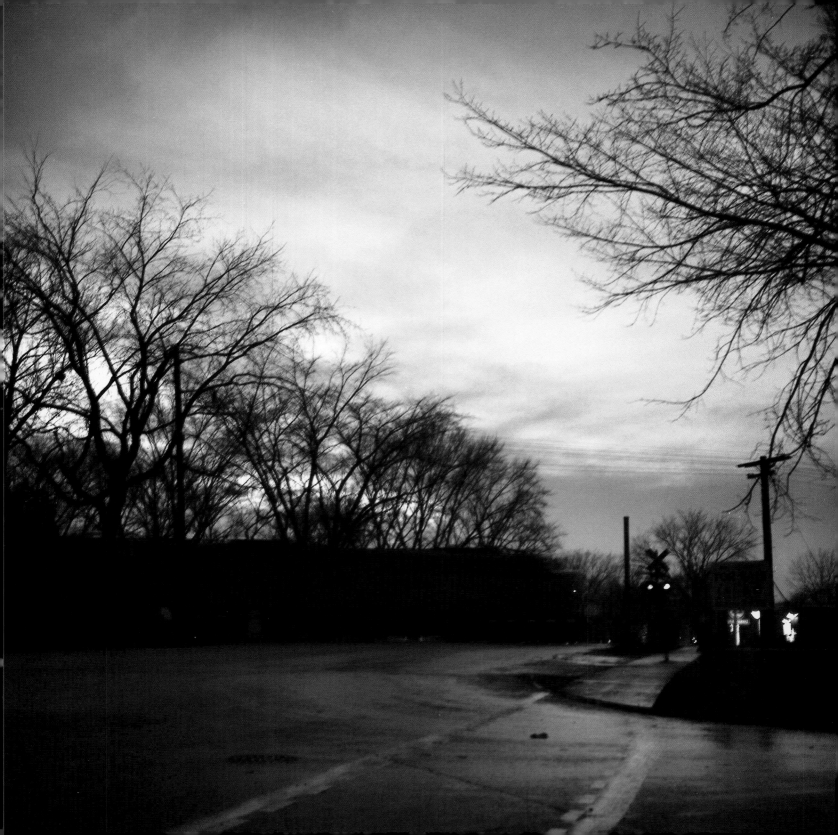

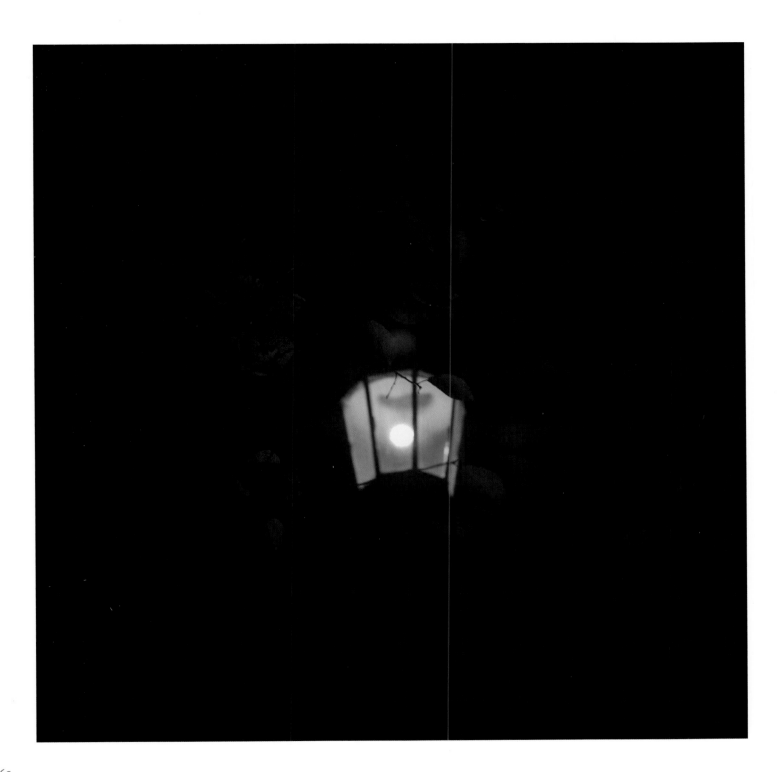

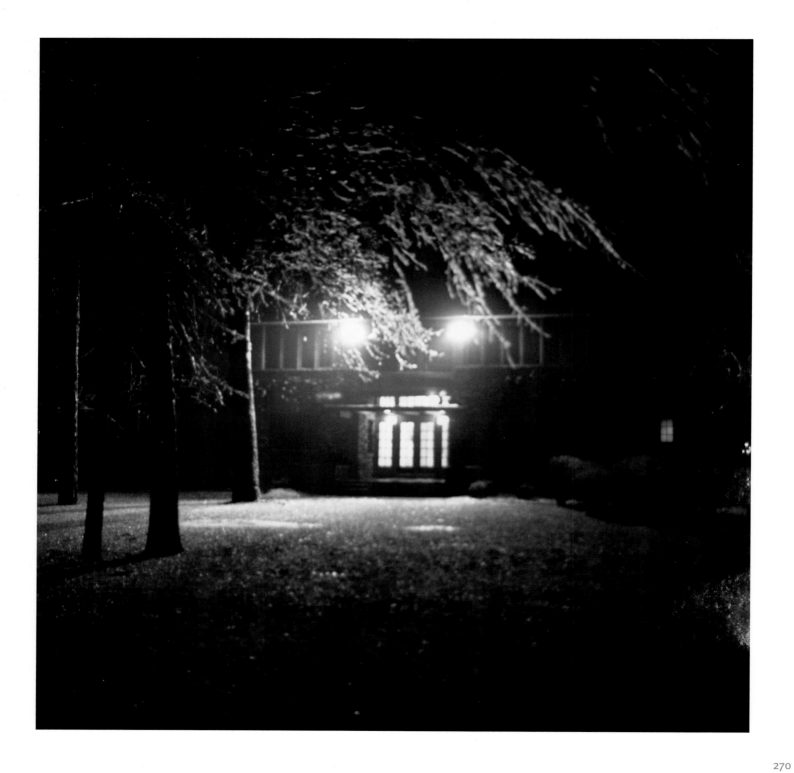

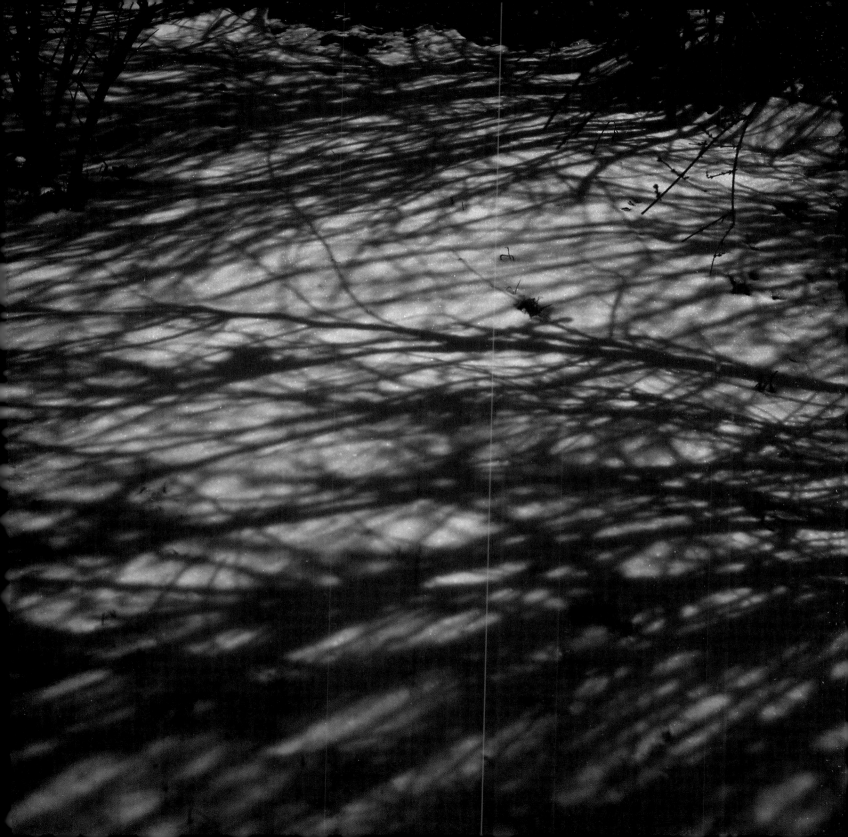

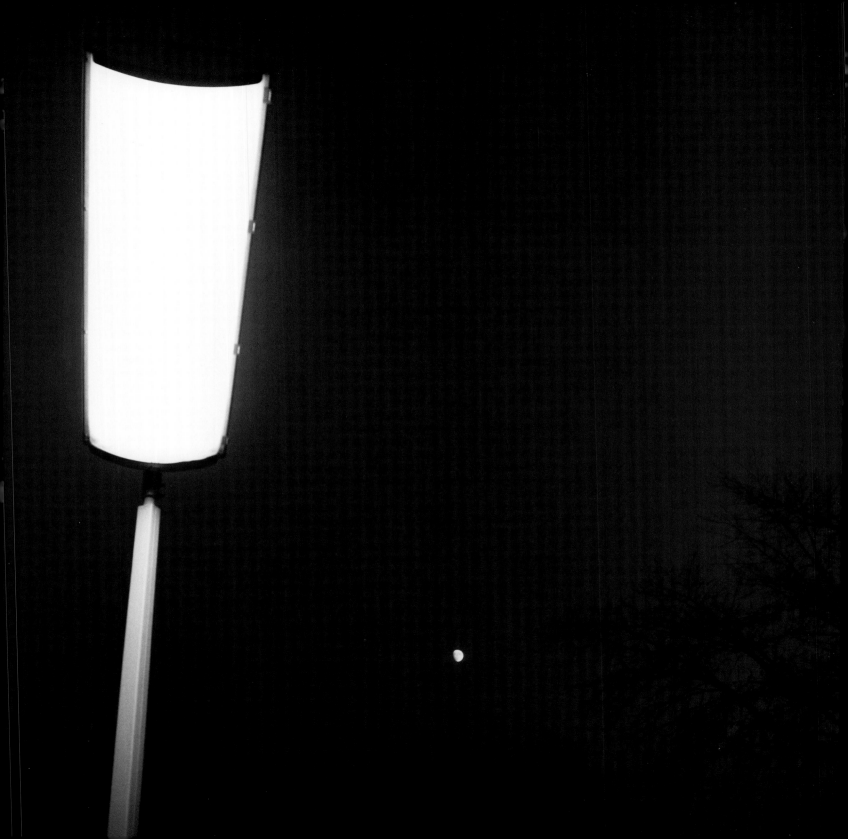

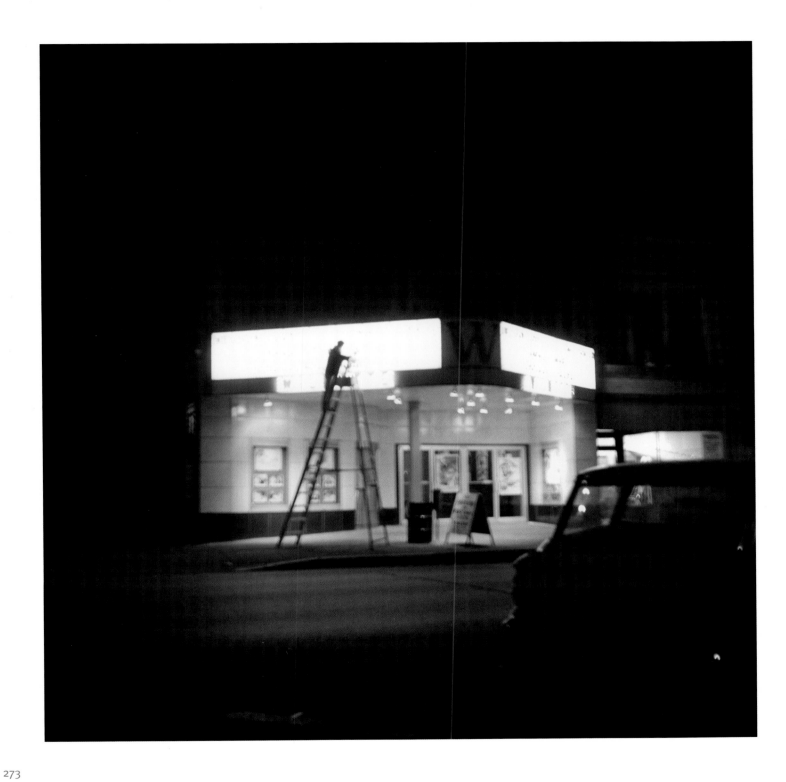

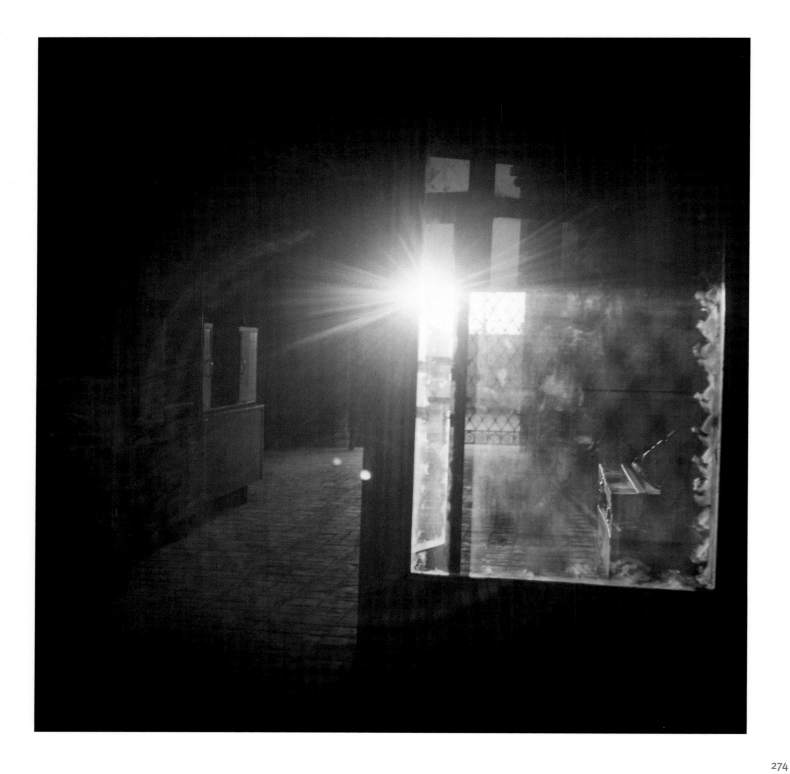

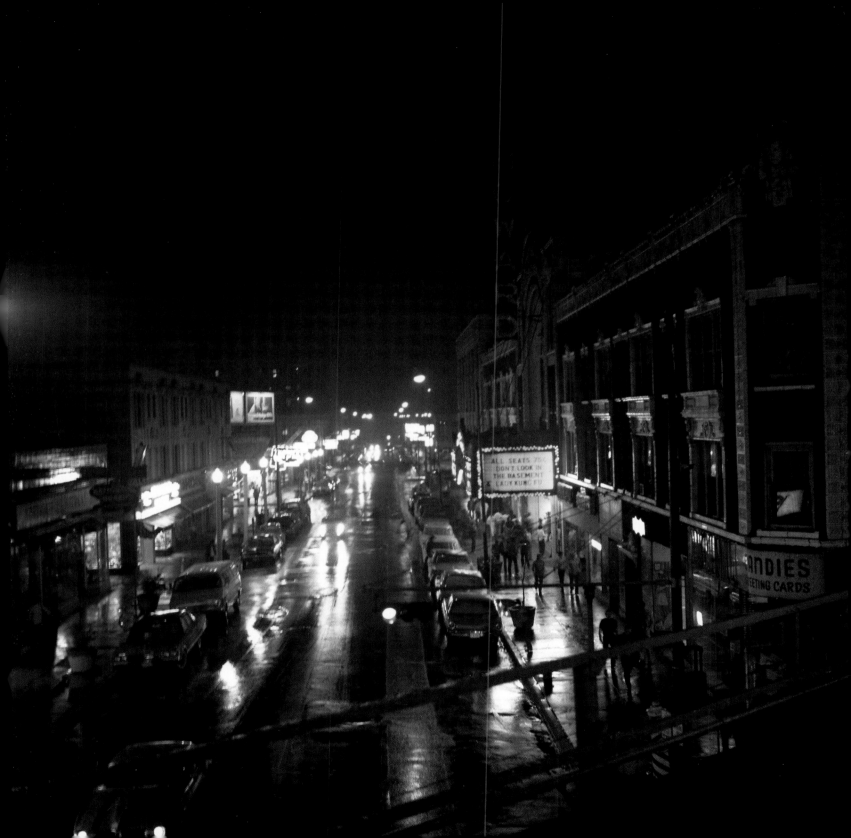

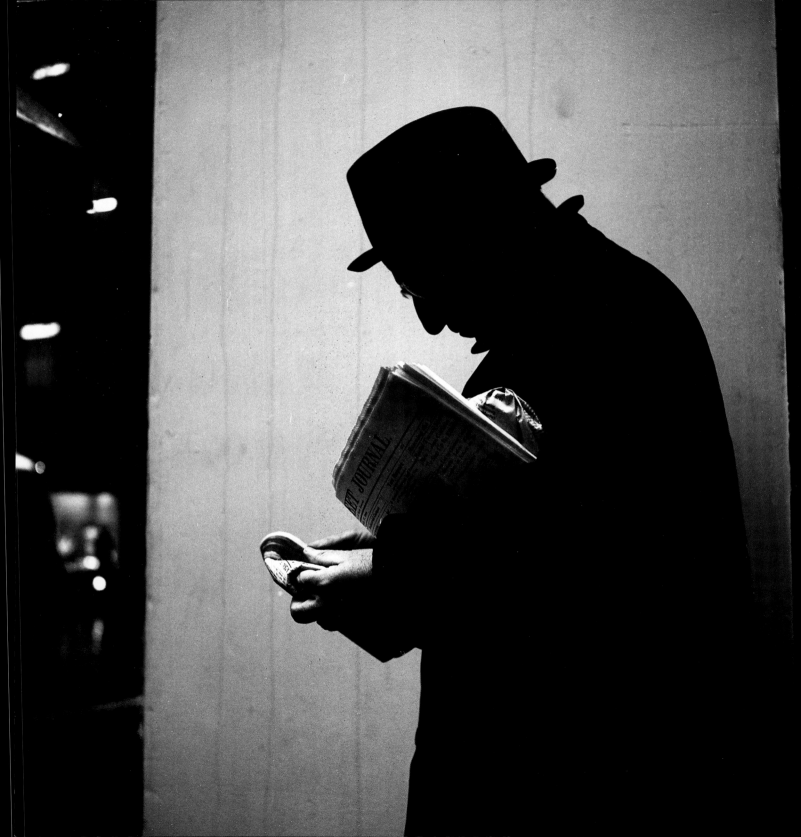

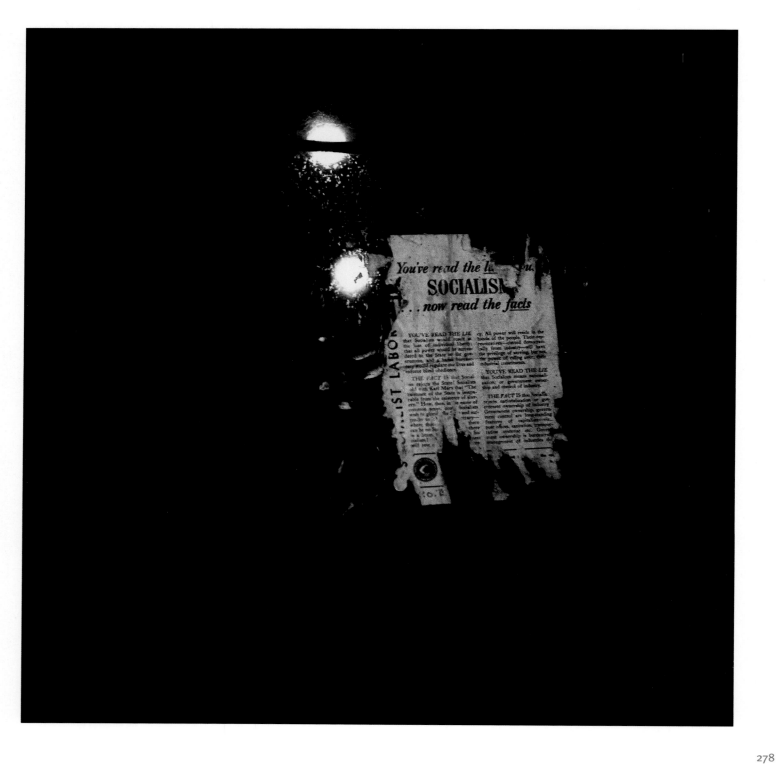

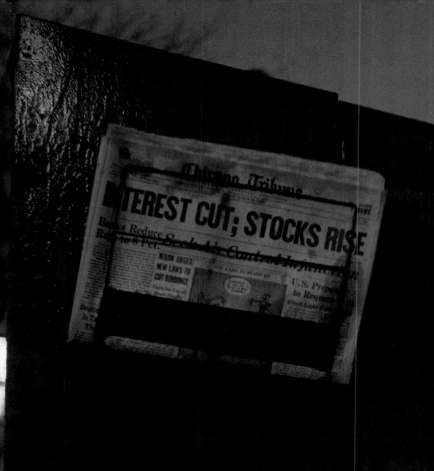

INTEREST CUT; STOCKS RISE

Banks Reduce Seek to Control Inflation

NIXON URGES
NEW LAWS TO
CUT SPENDING

U.S. Prepares
to Region
Effort Could

Stocks up 16.

CHICAGO DAILY NEWS

Air 'strike'
flights at

CHICAGO DAILY NEWS
ON SALE HERE

Controle
O'Hare flights

Banks cut
prime rate,
stocks soar

$750
state
for p

Chicago
toda
Amer

SERVICE

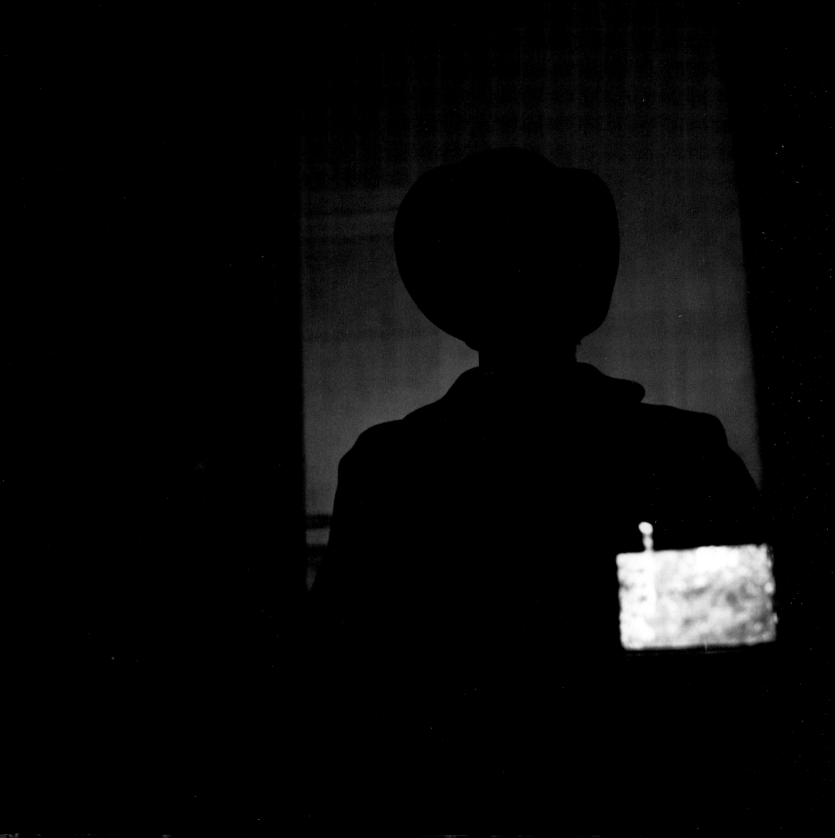

THE GENSBURGS HAD VIVIAN MAIER CREMATED and scattered her ashes in a forest where she'd taken the boys fifty years earlier. They considered having a funeral but knew she would have abhorred such an observance. So they paid for a death notice in the *Chicago Tribune*: "Vivian Maier, proud native of France and Chicago resident for the last 50 years died peacefully on Monday. . . . A free and kindred spirit who magically touched the lives of all who knew her."

To the faithful Gensburgs, Vivian's story had come to an end. To the world, it was just the beginning.

EPILOGUE

In 2007, two years before she died, Vivian Maier forfeited the storage spaces that she'd rented on Chicago's North Side. Roger Gunderson, owner of the small Chicago auction house RPN Sales, bid on the five units after he noticed an antique suitcase with labels from Paris. "It looked like old papers, books, and old trunks," he said. "I was taking a gamble." He had to make three trips with his truck to haul away all Maier's possessions.

Three auctions were held in 2007, and most of Maier's negatives, film, and cameras were purchased by photo collectors: John Maloof, Ron Slattery, and Randy Prow. Maloof placed an absentee bid of $400 on the biggest box, which turned out to contain about thirty thousand negatives. "I came back toward the end to find that I had won the box of negatives," he later wrote. "I was hoping to get them but my heart was not set on it." Maloof tried to contact Maier, whose name was written all over the collection, but was unable to find her for two years. He did not learn of her death until he read the notice in the *Tribune*. He sold about two hundred of her negatives on eBay, but stopped when photo critic Allan Sekula contacted him and advised that the work was too valuable to sell piecemeal.

Slattery, the only person to attend all three auctions, bought hundreds of prints, more than a thousand rolls of undeveloped film, slides, negatives, and a few home movies. He has since sold some of them. Slattery was the first to exhibit Maier's photos online, posting six slides on his website in July 2008. He wrote: "Every day, I look at these boxes and wonder what kind of goodies are inside."

Randy Prow paid $1,100 for about eighteen thousand negatives at the third night of the RPN auctions. He held on to the negatives until 2010, when he started selling his collection to Jeffrey Goldstein. Since Vivian Maier came into their lives, Goldstein and Maloof have quit their jobs and devoted almost all their waking hours to sorting through and figuring out what Maier left behind.

INGER RAYMOND REMEMBERS THE DAY WELL. She was sitting alone in her home in early 2011 when *CBS Evening News* broadcast a report about the discovery of a remarkable cache of photographs. She glanced up and caught a glimpse of an old Rolleiflex and knew right away whose camera it was. "It's really good that people are seeing this," she recalled thinking as she looked at the images Maier left behind.

A year later, clear across the world, on a street in Montparnasse, a sandwich maker is stopped for directions. In the course of conversation, the Parisian says he loves photography. "Have you heard of Vivian Maier?" he is asked. He pauses. "She makes me cry."

PHOTO NOTES

FOR PAGES WITH MULTIPLE PICTURES, PHOTOS ARE LETTERED CLOCKWISE FROM TOP LEFT.

LEAD PHOTOS

PAGE 2. C. 1955, NEW YORK CITY
3. C. 1960, CHICAGO
4. C. 1967, CHICAGO
5. C. 1967, CHICAGO
6. 1961, CHICAGO
7. C. 1961, CHICAGO
8. 1970, WILMETTE, ILLINOIS
 (PORTRAIT OF VIVIAN MAIER, PROBABLY TAKEN BY INGER RAYMOND.)
10. 1968, WILMETTE
12. EARLY 1960S, HIGHLAND PARK, ILLINOIS
14. 1963, HIGHLAND PARK AND CHICAGO
17. MAIER SELF-PORTRAITS THROUGH THE YEARS
18. EARLY 1960S, NORTH SUBURBS OF CHICAGO
21. 1965, HIGHLAND PARK
 (MAIER ALSO PHOTOGRAPHED CHECKS, PASSPORT AND VISA APPLICATIONS, TAX FORMS, LEDGER SHEETS, AND CORRESPONDENCE.)

SNAPSHOTS

28-33. 1949-1951 France

28C DRAC RIVER NEAR SAINT BONNET-EN-CHAMPSAUR
28F. LE ROCHASSON SECTION OF GAP
29A. CHAMPSAUR VALLEY
29B. MISSION CROSS IN FRONT OF L'AIGUILLE AT LAYE-EN-CHAMPSAUR
29C. LE ROCHASSON SECTION OF GAP
29E. LAKE OF CASTILLON
30A. CAMERA SHOP IN THE ALPS
30B. MAILLET FAMILY IN SAINT-BONNET-EN-CHAMPSAUR
30C. WOMAN IN SAINT-BONNET
30D. GAP
30E. GIRL AT A RELIGIOUS FEAST IN PONT DU FOSSÉ
30F. WORKER FROM NORTH AFRICA IN GAP.
31A. NICOLAS BAILLE, MAIER'S GRANDFATHER
31B. WOMAN IN PONT DU FOSSÉ
31E. FAMILY IN SAINT-BONNET
31F. MAN IN SAINT-LAURENT-DU-CROS
32B. BEAUREGARD ESTATE IN SAINT-JULIEN-EN-CHAMPSAUR
 (THIS WAS THE ESTATE THAT MAIER INHERITED AROUND 1950. PROCEEDS MADE IT POSSIBLE FOR HER TO TRAVEL THE WORLD.)
32D. BENEVENT CEMETERY WITH MAIER'S ANCESTORS
32E. SHEPHERD IN LES RICOUS
32F. FAMILY ALBUM IN BENEVENT
33. MAIER PORTRAIT IN FRANCE

34-39. 1950s New York City and Long Island

34D. QUEENSBORO BRIDGE
35B. SOUTHAMPTON, LONG ISLAND
35C. MAINE MONUMENT ON COLUMBUS CIRCLE, NEW YORK
35D. CENTRAL PARK, NEW YORK
35E. WOLLMAN RINK IN CENTRAL PARK
35F. CENTURY APARTMENTS OFF CENTRAL PARK
36B. 1955, MACY'S THANKSGIVING PARADE, NEW YORK
36C. SOUTHAMPTON
 (SOME AFRICAN AMERICAN WORKERS AND THEIR FAMILIES LIVED IN WHAT IS KNOWN AS THE HILLCREST AREA OF THE VILLAGE OF SOUTHAMPTON.)
36D. SMOKESTACK NEXT TO QUEENSBORO BRIDGE, NEW YORK
37B. SOUTHAMPTON
37E. ARTIST SALVADOR DALI
38A, B AND F. CENTRAL PARK
39. CONEY ISLAND, NEW YORK

AMERICA

42-57. 1955 Los Angeles

44. A GIRL THAT MAIER LOOKED AFTER
45. MACARTHUR PARK
46. FARMERS MARKET
47. RICHARD WIDMARK AT FARMERS MARKET
49. GRAUMAN'S CHINESE THEATER
55. SELF-PORTRAIT
57. SOUTH BROADWAY AVENUE

58-69. 1950s New York City

58. EAST RIVER AND UNITED NATIONS HEADQUARTERS
63. ANOTHER GIRL THAT MAIER LOOKED AFTER
64. TIMES SQUARE
65. CENTRAL PARK
68. PIGEON
 (ALTHOUGH MAIER USUALLY TOOK ONLY ONE PHOTOGRAPH OF HER SUBJECTS, SHE TOOK MORE THAN ONE ROLL OF FILM TO PHOTOGRAPH THIS DEAD BIRD ON THE STREET.)

70-77. 1963 Miami Beach, Florida

78-85. 1967 Sturgis, South Dakota

DAY

88. 1973, WILMETTE
89. 1972, WILMETTE
90. 1969, WILMETTE
91 AND 92. 1967, WILMETTE
93. 1968, WILMETTE
94 AND 95. 1969, HIGHLAND PARK
96. 1972, WILMETTE
97. 1968, WILMETTE
98. C. 1961, HIGHLAND PARK
99. 1968, WILMETTE
100. 1969, WILMETTE
101. 1967, HIGHLAND PARK
102. 1971, CHICAGO
103. 1972, WILMETTE
104. 1968, WILMETTE
105. C. 1967, WILMETTE
106. 1968, WILMETTE
107. 1968, HIGHLAND PARK
108. 1968, WILMETTE
109. 1960S, CHICAGO
110. 1970, WILMETTE
111. C. 1968, CHICAGO
112. 1968, WILMETTE
113. 1968, WILMETTE
 (MAIER FIRST PHOTOGRAPHED THE DOG, THEN TURNED THE CAMERA ON THE CLOUDS IN THE NEXT FRAME.)
114. 1968, WINNETKA, ILLINOIS
115. C. 1961, HIGHLAND PARK TRAIN STATION
116. 1968, WILMETTE
117. 1970, WILMETTE
 (MAIER TOOK TWO VERSIONS OF THIS PHOTOGRAPH. IN THE FIRST, A DISAPPROVING WOMAN PEERED AROUND THE WALL OF THE TRAIN SHELTER AS SHE CROUCHED TO TAKE THE SHOT.)
118. C. 1968, WILMETTE
 (TAKEN AT AN ART FAIR IN THE PLAZA DEL LAGO SHOPPING CENTER.)
119. 1970, WILMETTE
120. C. 1961, HIGHLAND PARK
121. 1969, WILMETTE
122. C. 1967, WILMETTE
 (AT THE NATIONAL SUPERMARKET, A FAVORITE PHOTO LOCATION.)
123. 1968, WILMETTE
 (YOUNG GIRL SLEEPS IN THE BACK OF A STATION WAGON IN THE NATIONAL SUPERMARKET PARKING LOT.)
124. 1969, CHICAGO
125. 1968, CHICAGO
126. 1973, KENILWORTH, ILLINOIS
127. C. 1964, HIGHLAND PARK
128. 1968, WILMETTE

ACKNOWLEDGMENTS

This book is our response to the discovered photographs taken by Vivian Maier. Her work constantly delights and surprises us. She, of course, is most responsible for this book. We will miss spending time feeling her spirit. We're honored for the opportunity to delve so intimately into her life and imagery.

Artist Ed Paschke orchestrated the connections that made this book a reality. We met Paschke in his rambling studio in 2003. After showing us around, he introduced us to his neighbor and best friend, Jeffrey Goldstein, who ran a painting studio just down the hall. Goldstein is a carpenter, cabinetmaker, and studio painter. More to the point, he is a collector of the eclectic—from books, prints, and paintings to arrowheads and paintbrushes. He also collects good stories and friends. After seeing our early work, Goldstein added us to his collection of artist friends.

We were among the first he called when he made his initial acquisition of Vivian Maier photographs in 2010. Soon after loading the material into his car in Evansville, Indiana, he checked into a Super 8 motel in nearby Vincennes as tornadoes swept through Indiana that night. Goldstein worried that all the photographs and negatives would be sucked away, this time forever. "The storms passed, and I was awake the rest of the night," Goldstein told us after his return. "I thought this was the worst mistake I had ever made."

It took him two years to archive and catalogue the work. Toward the end he called to see if we would consider putting together a book. Negotiations lasted less than a second. It was a handshake deal; no money changed hands. We knew that working with Vivian Maier's photo archive was a chance of a lifetime.

Goldstein and Anne Zakaras, coordinator of the collection, have shared all of their thoughts and ideas about Maier as well as every one of her negatives, prints and the paperwork that came with the purchase. They, too, made this book possible. Goldstein does not actually believe that one person can own art. "You are basically the caretaker for the next generation," he says.

To understand Vivian Maier, we depended on four people who did groundbreaking work tracking down her past. They are genealogist Susan Kay Johnson, Philippe Escallier, Jean-Marie Millon, and Monique Escallier.

Johnson, who lives in New York City, followed all the United States leads. She is a writer who also works as an independent researcher. Her specialty is women in the arts. She feels as comfortable in the National Archives at New York City as you might at your local grocery store.

Philippe Escallier, president of *Les Amis de Vivian Maier,* and founding members Jean-Marie Millon and Monique Escallier live in the Champsaur Valley. Escallier fields our cross-Atlantic questions every day. Jean-Marie and Monique joined Philippe in figuring out the location of thousands of Maier photographs taken in France. They led us on a genealogical journey following Vivian and the Jaussaud family back centuries and took us on an unforgettable adventure through the valley. They showed us where Vivian lived and went to school and where she photographed. There is no more beautiful place in the world than the French High Alps. It is yet another mystery that Vivian left.

Our French friends brought with them a team of people to help, including *Les Amis* association members Pierre Castelli and Michel Clement as well as Eliane Denante, president of the Association Généalogique des Hautes-Alpes. They take genealogy seriously in this part of France, where records go back millennia. Vivian is very much a daughter of the valley, and the valley is quite connected to the United States. Many of its young men and women have journeyed to North America to find work. Some are lucky enough to return to the Alps and purchase land.

In France, we met Jean-Claude Reallon, who showed us where Vivian Maier's grandfather, Nicolas Baille, lived in nearby Les Ricous, and told us the legends of the man who owned two shotguns and set up a trap door in his house for safety. In the valley, we met Jean-Marie Gentillon, who farms near the former homestead of Jeanne Bertrand's family, and Ferréol (Youyou) Davin, who posed for Maier. We also met many of young Vivian's friends and acquaintances, including Aimée Pellegrin, Marie Armande Chabre Daumark, Amédée Simon, Raymond Pascal, Bertrand Germaine, Denis and Huguette Gras, Louis and Marie Jeanne Brochier, Cécile and Marie Escallier. Jean-Pierre Jaussaud, one of the first French researchers who tracked Vivian, gave us a beautiful compact disc of his French accordion melodies. It serves as a soundtrack to our work.

In New York City, we relied on several people who put Maier's work in perspective. Steven Kasher, who too has been fortunate to see all the pictures in this collection,

helped open our eyes further to the meaning of Maier's photos. Joel Meyerowitz helped us understand how Maier worked and what she was thinking as she photographed on the street. Mary Ellen Mark shared her enthusiasm for the work, and Sean Corcoran, curator of prints and photographs at the Museum of the City of New York, helped us identify where Vivian took photos. We were also aided by Sachiko Clayton of the New York Public Library, Karen Marks and Howard Greenberg of the Howard Greenberg Gallery, and Ira Glass, who brought Vivian's story to life on his program *This American Life*.

Thank you, too, to Wendy Harrison, Laura Danforth, and Pamela Walker for sharing memories of Southampton, as well as to Michael Lesy of Hampshire College and Allan Sekula of California Institute of the Arts for taking a look at our manuscript. William J. (Jim) Leonhirth, of Murfreesboro, Tennessee, shared his extensive research on Maier and Jean Bertrand. He was the first to figure out many important details in Vivian's life.

In Chicago, we relied most on Nora O'Donnell, whose 2010 *Chicago* magazine article was the first full-length treatment of Maier. Nora offered insight into Maier's life and shared interviews she conducted. She could not have been kinder.

Roger Gunderson, Ron Slattery, Randy Prow, and John Maloof shared recollections of the storage locker sale and subsequent auctions. Their pivotal involvement is what saved Vivian Maier and her work from obscurity.

Vivian's favorite camera guys—Pat Velasco of Hoos Drug Store in Evanston, Peter Skalski of Phototronics, and Don Flesch, Joe Gallina, and Mani Kavukattu of Central Camera—explained their long connections with Maier and her special relationship with the cameras they sold and fixed for her.

To better understand Maier the nanny, we found the families who hired her and spent time with her. Most helpful and insightful was Inger Raymond, who can remember in detail the years she grew up with Maier. "We were co-conspirators," Inger says now—and that is clear from the hundreds of photographs Maier made of the little girl. Maier handed the camera to Inger many times so that she and Vivian could take turns making pictures of one another. Inger dreaded those moments. The camera was heavy and it was difficult to figure out the focus, but Inger's portraits of Vivian are touching and beautiful.

Also helping remember Maier as a caretaker were William Dillman and his daughter Donna Dillman Newlin, Richard Baylaender, Maren Baylaender, Carla Phillips, Zalman Usiskin, and Sue Lutz. Remembering her as a friend or acquaintance was Carole Pohn and her children, Jennifer and Robbie Levant, as well as Jane Garron, Jim Dempsey, Roger Carlson, and Bindy Bitterman. Also helping were Frances Brent, Steven Garmisa, Dom Najolia, and Hector Aiza.

Pamela Bannos of Northwestern University, Sharon Cohen of the Associated Press, and Lanny Silverman, curator of the 2011 Vivian Maier show at the Chicago Cultural Center, filled in missing details. Also providing insight were Nicholas Osborn, Bob Horn, and Tim Anderson.

We would also like to thank Richard Babcock, Mark Jacob, Caleb Burroughs, and Amy Schroeder for editing the manuscript. Sunny Fischer, Peter Handler, and Kim Romero make it possible for us to balance our responsibilities.

Our appreciation for financial support goes to Robert A. Wislow of U.S. Equities Realty and also to Richard H. Driehaus, who has enthusiastically encouraged our work for years.

Most important are our families. Our wives, Cate Cahan and Karen Burke, make CityFiles possible. Equally supportive and understanding are our children and grandchildren: Elissa, Claire, Aaron, and Glenn Cahan; Caleb and Madeline Burroughs; Chris, Daisy, and Caedan Jinks.

And we would like to thank the members of "Team Vivian," who help keep the Goldstein Collection developing. They are John Bennette, Jeremy Biles, Russell Bowman, Michael Bullis, Owen Davies, Syrna Ditkowsky, Eric Dong, Mark Duran, Parker Geissler, Jessica Goldstein, Marsha Goldstein, William Goldstein, Richard Gordon, Ron Gordon, Jack Helbig, Kaitlyn Herzog, Richard Hunt, Frank Jackowiak and the photography department at the College of DuPage, Jane Lowum, Agnieszka and Thomas Masters, Clyde Mlodoch, Paul Natkin, Lalo Navarrete, Rick Nigro, Gladys Nilsson, Jim Nutt, Tom Palazzolo, Sharon Paschke, Steven Poster, Jim Sampson, Paul Shanks, Anna Walker Skillman, Sandra Steinbrecher, Jerry Tulchin, Dorr St Clair, Chris Walters, Gerri and Phil Wicklander, Lee Mac Wilson, Lisa Vogel, and Sigalit Zetouni.

THIS BOOK IS DEDICATED to our true loves, Cate Cahan and Karen Burke, and to all those who hope to leave something of value behind.

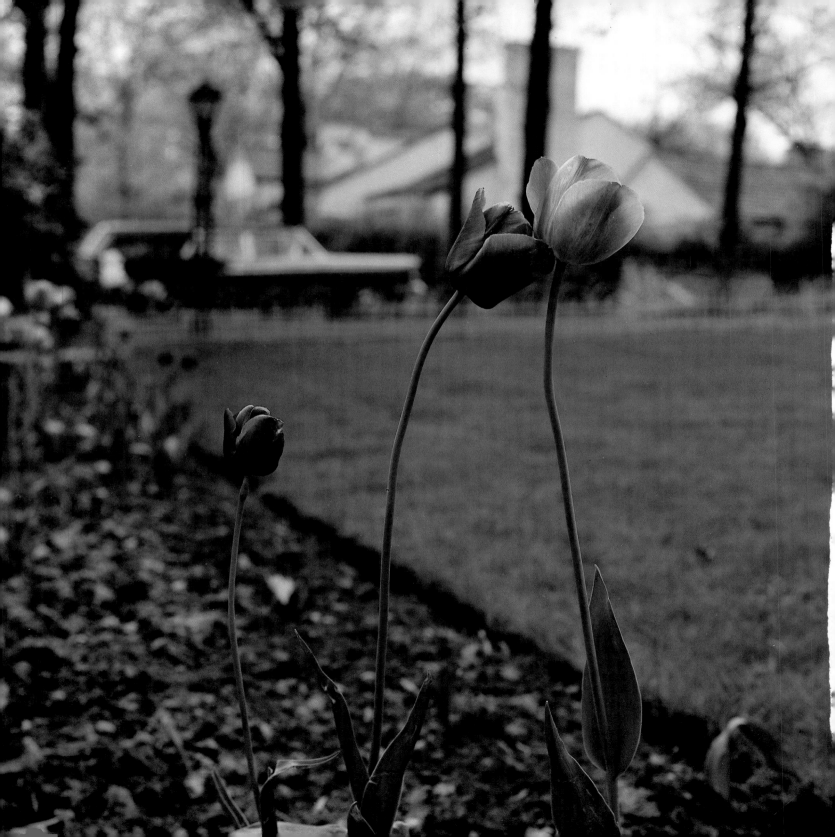

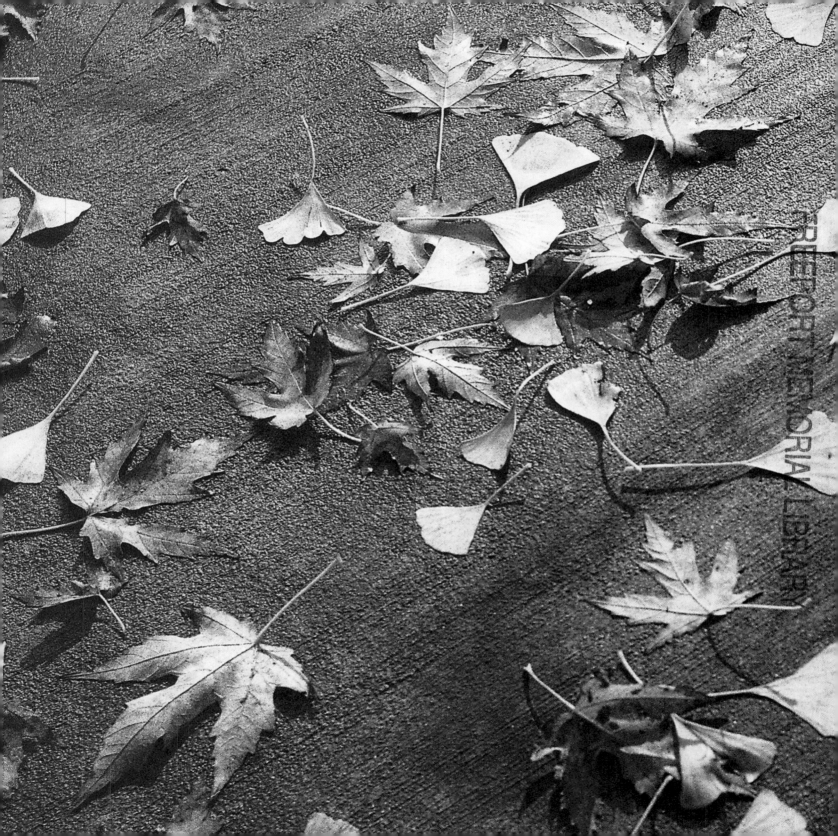